KISS OF THE
ART GODS

KISS OF THE ART GODS

A twenty-year struggle to find my way as a contemporary figurative sculptor

DAN CORBIN

Published by Gatekeeper Press
3971 Hoover Rd. Suite 77
Columbus, OH 43123-2839
www.GatekeeperPress.com

Cover Design: Gary Edward Blum

ISBN: 9781619846593
eISBN: 9781619846708

Printed in the United States of America

CONTENTS

KISS OF THE ART GODS

THE ART GODS started playing with my mind when I was ten. I received their cryptic call to the arts while I sat on the living room floor of my parents' rebuilt ranch house. As I sat in that pleasant, refurbished room, it was hard to believe the space had been the epicenter of a catastrophic flood only nine months earlier. The flood was of the once-in-a-hundred-years variety, so powerful that the raging brown waters not only destroyed all things material but also shattered the well-being of the people who suffered its fury. That was the beginning of my troubled alliance with the Art Gods. It's ironic that the creative and destructive forces that came to pass in that room would ultimately join within me and propel me, sustain me, and eventually hold me back on my three-decade-long struggle to find my way as a figurative sculptor.

It was a warm rural Northern California September afternoon in 1956, nine months after the Christmas flood, and I was standing on the front steps of our rebuilt house dressed in blue jeans and a brown stripped T-shirt. Green eyes, dark brown hair cut short, parted on the side, and a nose covered with a mass of freckles completed my country boy appearance. I was preparing to enter the living room via the rebuilt front door—one of the last items to be renovated. A piece of plywood had been screwed to the door, protecting the remaining unbroken pane glass for the five-month phase of the house's reconstruction. The door, now restored, showcased a new thumb-operated latch. I slowly opened the door from the outside.

My dog Sammy eagerly tried to follow me in. I was keeping him at bay with my foot while saying, "No. Stay. Stay. You can't come in yet." My mother was a firm taskmaster, and her edicts continually rang in my ears. "Keep the dirty dog out. We have a brand new house," she had decreed. I negotiated my way past my dog, closed the door behind me, and flicked the thumb latch a couple extra times. I was on a mission to browse our brand new books and skirted along the replaced bank of pane windows on the north side of the living room. Defused light filtered through the new windows and made me feel special. The light created a mysterious secretive space. Mom had recently hung white lace curtains, and as my gaze discovered them my youthful imagination began to soar. I bet those are new curtains, I thought. There's no way those could be the old ones. No one could wash all the silt out. Besides, that's where the telephone pole smashed through the house while floating on five feet of water . . . through all of that glass.

At ten years old I knew our lives had entered a new unsettling era after the flood, but I still liked to entertain boyhood flights of fantasy. Imagine the story I'd have to tell if we hadn't evacuated, but stayed put, high and dry in our barn's upper deck. I would know just how Sammy managed to survive for two weeks in the house before he was rescued. Heck, he probably rode in on the telephone pole as it busted through all that glass. If we would have stayed, I could have ridden in with him, and Sammy and I might have been plucked off the roof of our house by helicopter just like our neighbors, I envisioned.

I skipped five paces past the propane central heater and looked at the hardwood floor, trying to figure out which warped and buckled boards had been replaced. My destination was the brand new set of Encyclopedia Britannica books. Dad replaced the old Book of Knowledge set, which had been wrecked by the floodwaters, with a replacement set. I preferred the up-to-date Encyclopedia Britannica books, since they contained higher-quality pictures in a better variety. The dark brown encyclopedias exuded that new book smell, and the covers were embroidered and trimmed with what appeared to be real gold. I was on a mission to look at every picture on every page. The

last time I had browsed the encyclopedias I left the "C" book—my favorite back then—slightly out of alignment so it could be easily retrieved at a later date. I favored that book because it contained great cartoon pictures of Goofy and Mickey Mouse. I pulled out two or three volumes and continued my quest to absorb every picture in the entire set. I quickly thumbed through the pages until I found an interesting photo, immersed myself in its magnetism, and then tried to cram that image into my memory. Soon, I worked my way to the sculpture section of the encyclopedia set. My eyes fed upon the next twelve pages, which unveiled to me image by amazing image a pictorial review of world sculpture.

At that moment the Art Gods began their sublime introduction, and I was receptive. It began as a slow burn. Over the decades it reached the point of obsession, taking over and possessing my whole being. No sacrifice was too high a price to pay in the pursuit of the perfect sculpture. The sirens' call lured this unsuspecting youth onto the rocks of unattainable gratification.

I sat on the floor turning pages, working my way through the primitive sculpture photographs and ending up at the classical sculpture pictures. Suddenly I felt chills. The sensation crawled over my legs at first and then coursed through my entire body. The hairs on my neck stiffened. I could only focus on the book. It was as though I had seen these stunning sculptures before or simply knew about them somehow, as if they were emerging from a dream. Then *slam!* The sound of the back porch screen door pulled me out of my wonderstruck state.

Mom was approaching, hiking through the kitchen and into the living room. I was a secretive kid by nature, and this was a private moment. In a rush I began putting the books away. Upon entering the living room, Mom plopped down a wicker basket full of fresh clothes she had retrieved from the clothesline. To me my mother was perfect and beautiful. She had dark hair, wide shoulders, a striking smile, and tanned olive skin, which seemed to radiate due to the white summer blouse and white shorts she was wearing.

"Danny, can you get the paper? Dad's coming home early today,"

Mom said. She was trying to settle me in to a normal routine after the flood, and getting the newspaper was the right medicine. During the rehab of the house our family had been split up between relatives, and only now were we getting back to together as a family unit. Looking back now, fifty years later, I believe something mystical happened to me on that day. It is one of my unresolved life mysteries, and perhaps that's the way it should remain. Rationally, I think I was momentarily taken from my boyhood perspective and given my first glimpse of a larger order of things.

I flew out the living room front door. Sammy was eagerly awaiting some action. He was a cross between a dachshund and a cocker spaniel and was the ideal multipurpose ranch dog. He was shaped like a hefty, low-to-the-ground beagle and possessed a unique coat of short blond hair. He retained the hunting and retrieving abilities from the spaniel line; from the dachshund side, woe to the creatures who lived underground on our land. I gave him his name and raised him from a pup. We loved all things natural. Better than any person, Sammy understood my primordial yearnings. Together, we explored the passion and wildness contained within us. In later years we shared the ultimate in companionship: the upland game hunt. In that magnificent adventure, pheasants, doves, ducks, and geese were our quarry.

I trained Sammy to get the paper because I was afraid of the dark. The high green hedge running the length of the long driveway could be especially intimidating. Who knew what kind of monsters lived in its prickly mists on a dark, foggy night? The new gray gravel crackled under our feet as we shuffled along. The long driveway intersected with Township Road, a medium-sized paved country motorway. A forty-foot-tall English walnut tree stood at the intersection, and in the higher branches a small gathering of gregarious magpies frolicked. As we neared, the ones on the lower branches joined the merry birds at the top. They acknowledged our presence with lively conversation. All of the birds were chatty. They kept asking the same question over and over: "Magg? Magg? Magg?" Upon our approach, in no special hurry, the magpies began to fly. Their greenish, iridescent black tails

streamed behind them and large white patches flashed in their wings as they casually flew away.

The magpies' behavior made the day seem ordinary. However, as we walked I couldn't help but notice how different things were after the flood. I looked to the right, where our private fruit orchard once stood. All the trees were now gone, replaced by barren, sun-drenched, bone-dry, tilled earth. Most of the flood debris scattered about the ranch had been removed. The weird, moldy, decaying smell was finally starting to dissipate due to the large number of one-hundred-degree days we experienced during the summer. Things were beginning to dry out, but still lingering was an ominous, depressing feeling that seemed to permeate the landscape. Was the unusual sensation a residue of past events . . . or perhaps a premonition of events to come?

My childhood could be measured in roughly equal segments of time. Nine years before the flood and nine years after it. The years before the flood were blissful, romantic, and loving. The years that followed were turbulent, stressful, and unnerving.

As we approached the end of the driveway Sammy came and turned in circles, anticipating his command to fetch the paper. When he could wait no longer I prepared to give the word—but I decided to test him with a new command.

"Magg? Magg?" I imitated.

Sammy stopped turning in circles, tilted his head, and gave me an inquisitive look. I waited a couple of seconds; then, in a high voice, as though it was all one word, I commanded, "Get-The-Paper!" He sprang into action, returning with the paper in his mouth and acting as though he wanted to keep it all to himself. He gently shook the newspaper from side to side as we walked back. I recognized that gesture. He used a similar motion to kill ground squirrels. Occasionally, he would cut off a squirrel on a mad dash to its hole, and in a swirling cloud of dust he would bite the squirrel from behind on the neck. The squirrel would twist and squirm, to no avail. A few powerful shakes from Sammy, and the ground squirrel was finished. I let him carry the paper. He seemed so happy to participate.

As I approached the house I looked down the driveway past the

barn into what used to be a lush, twenty-acre peach orchard. Now, it was a barren field a quarter of a mile long. Heat waves rose from the field, blurring your vision if you tried to make out objects such as our pump house. I tried to make out the pump house anyway, and a mirage appeared beneath it and the pump house seemed to shimmer and float above the ground. This emblematic vision was to follow me for the rest of my life. The peach trees had been pulled from the earth and burned in big piles; orange flames had shot fifteen feet in the air as they singed and turned slowly to ash. The only vegetation that now grew on the fallow land was exotic weeds, the product of alien seeds brought in by the floodwaters that thrived on the barren, sun-drenched soil. When we arrived at the front door, I bent to pat Sammy on the head and take the paper from him. He surrendered it willingly, leaving a small residue of saliva on the paper. "Good boy," I said, wiping the newspaper dry on my jeans. My mind began to wander back to what our place looked like prior to the flood.

A pre-flood aerial view of our Township house would have shown it as the centerpiece of a twenty-acre, family-owned peach orchard. We referred to our place as a ranch rather than a farm, because it sounded better. All our neighbors did the same. A much longer aerial view, starting at our property and expanding outward, would have revealed our farm to be in the middle of the fertile Sacramento Valley of Northern California. Our ranch sat between two mighty rivers: the Feather River on the east and the Sacramento River on the west. The two rivers ran from north to south between two majestic mountain ranges: the grandiose Sierra Nevada Mountains on the east and the dry, foreboding Costal Range on the west. As a child I viewed Sierra Nevada as the mother, where the sun rose and the day began. In contrast, I viewed the western mountains, the final destination of Egyptian Ra boats, as a desolate place where the day died. Those mountain ranges created an enormous watershed. Over eons of time the two tempestuous rivers carved and eroded the mountains, carrying silt and debris and creating a flat alluvial soil valley running hundreds of miles, which arguably held the best soil in the world.

As my hypothetical areal shot—that I can now see in my mind—

closes in on the Corbin Ranch, a green quilt begins to appear. A mosaic of square and rectilinear green and tan shapes, mostly twenty- to forty-acre family-owned farming plots, stretched as far as the eye could see. The different shades of green represented the different types of crops, mostly fruit orchards in our location. The deep, sandy loam was meant for orchards. There was a dairy down the road from our peach orchard and an alfalfa field to our south. Further to the west, the open expanse of rice fields began, and beyond that was the Sutter Bypass, with its huge, twenty-foot-high levee system. Beyond the bypass the tree line of the Sacramento River stretched. These natural environments and landscapes that I describe with fondness were instrumental in shaping my personality and bliss as a child. The beauty and wonder of my youthful surroundings influenced the way I walked forever after.

Where I grew up orchards were the prized agricultural undertaking. Almonds, pears, walnuts, prunes, and peaches all grew in perfectly lined rows. A certain type of geometry and symmetry was superimposed on the flat land. Later on, in my mature style as a figurative sculptor, I overlaid and superimposed symmetry over the human figure. This stylistic obsession with equilibrium probably came from my childhood years of working in the orchards.

Peaches were the predominant cash crop. They were still king living out the last of their glory years. My father knew how to grow the highly productive peach tree, a thoroughbred of agriculture engineering and hybridization that yielded large, ripe, delicious fruit. In some ways peach trees were fragile trees, and in others they were an alien species due to all the human-driven tampering.

I'm writing this book as a memoir. I'm portraying my life as I remember it. I've tried to be as accurate as possible, reconstructing dialogue and representing events that took place as truthfully and as objectively as I can. I've changed the name of one institution and also changed the names of some friends, relatives, acquaintances, and businesses. Even though I'm willing to tell all, especially the embarrassing and sensitive situations that occurred in my life, I'm not sure the people who have trusted me throughout the years are willing

to be rendered as characters in my tell-all book. I think it's also my responsibility to protect people who wish to live their lives in a certain type of anonymity. I have given former adversaries pseudonyms since they may still hold a grudge against me or see events in a totally different light. They can write their own book. This is my story, and I'm telling events as I remember them.

CALIFORNIA, THE MYTHICAL PARADISE

THE SACRAMENTO VALLEY is a semi-desert with a Mediterranean climate—a perfect setting for something magical to start. The last thing needed to make that Garden of Eden grow was water; the area is blessed with an abundance of it. Underneath the fertile soil and running the length of the valley is an aquifer. As a child I drank the pure, cold, crystal-clear water as it was pumped gushing from the bowels of the earth, and could generally gauge the depth of the wells. The deeper the draw, the more the water tasted of minerals. In fact, the water produced by certain wells was so distinct you could smell its effervescent mineralized aroma a quarter mile away. Some of these deep aquifer waters originated with the last ice age. Orchards could be sustained on water pumped from the ground; however, my father preferred irrigation water, which came from large river canals. The water was never-ending and inexpensive. Fresh canal water was diverted from the Feather River. That strikingly handsome and at times brutish river flowed only four miles from our ranch on Township Road.

My parents also owned and farmed another thirty acres of orchards ten miles up the valley. The second, older farm, which we called the Larkin Ranch, was located next to the Feather River. There, mature peach and prune trees grew in sandy soil. The wild and uninhabited river bottoms began at the edge of our Larkin Ranch property and ran a quarter of a mile through a lush—and in places impregnable—riparian habitat before reaching the pure, cool channel of the river.

This captivating riverside property brings back my fondest memories of childhood.

When it comes to nature and the environment, the Native Americans and I share a common spiritual notion: We are from this place, and there is a shared spiritual reality and an interrelationship between all things natural. To me when I was a kid and visited the river bottoms, spirit was embedded in the trees, rocks, and river. The solace of nature has always had the power to comfort, inspire, and rejuvenate me. Land and nature guides me spiritually, acts as my cathedral and continues to provide passion in my life.

The Feather River was given its name by an indigenous band of Yuba Indians who originally inhabited the area. During the summer months they migrated close to the river for the coolness and for the abundance the river offered. The riverbanks were lined with stately sycamore trees, oak trees by the thousands, black walnut trees, locust trees, and cottonwood trees with tiny balls of cotton-like fibers that filled the air and floated on the slightest breeze. Willow trees and blackberry bushes grew closest to the water. The river's ecosystem had given birth to an ecology teeming with wildlife, and was still vibrant when I was a kid. Cottontails would run from the protection of the thorny blackberry bushes, and coveys of quail would scatter and fly low in all directions. Doves two at a time swooped down from the treetops and nervously landed on the sandbanks, picking up a few grains of sand for their craws and then quickly and apprehensively taking flight, fearing a bobcat or a fox was waiting to snatch them as a snack. Small herds of deer hid in the vegetation. As a child I envisioned a clump of oak trees as a group of friends cheering me on, or a sycamore tree saying "imagine what you could see from our heights," or deer whispering "if only you could run faster you could play hide and seek with us."

The name Feather River came from an imaginative Indian observation. In the fall, Sycamore trees start to lose their leaves. The fallen leaves landed on the placid lake like slow-moving river waters, and seemed to float like feathers. In the summertime the Feather River meandered down the long valley. The Yuba, the Bear, and the

American River joined the Feather River and became tributaries of the mighty Sacramento River. The river waters eventually make their way to the San Francisco Bay, returning to the source: the body of "Mother Ocean." In an abstract way, I see the volatile river as it has always been: an agent of change. The brown waters that brought destruction and trauma to my youth were the same ones that brought me the gift of survival skills. The river inadvertently gave me the strength and endurance to scuffle year after year in an effort to prove myself as an artist.

The farmers I grew up with and who worked these orchards in the post-World War II era were a rugged bunch of enterprising individualists from all corners of the globe. The ancestry of the student body at my small country elementary school was diverse. Most of my friends' families were of European descent. I also had childhood friends of East India, Japanese, and Mexican heritage. It didn't seem to matter the culture of origin; all the kids wanted to be Americans. The irresistible draw was the bountiful land, freedom, and the possibility of a new start. We all believed that with enough hard work, the sun and soil would provide. One of John Steinbeck's literary themes portrayed the worn-down Depression era migratory workers who sought a new start by working the orchards of California. My story is about what happened to the next generation, the baby boomers who grew up in those same orchards.

California has shaped me as a man and as a sculptor. The name California originated as a beautiful mythical place in the imagination of an artist. Garcia Montalvo was a popular Spanish writer during the fifteenth century who wrote about an imaginary, mythological place he called California. It was inhabited by exotic people, a terrestrial paradise of unbound riches—especially gold. Forty years later in 1534, the Spanish explorer Cortez, who was familiar with Montalvo's writing, gave this mythological name to what is now present-day California. Five hundred years later I believe the fascination and magnetism of California still calls out.

The allure of fertile land and a new start brought my father and

his father to California during the Great Depression. My father, of Irish descent, a barreled-chested man, attended the University of Colorado for two years. He was proud and shy and considered himself a common man with American working values. His political leanings were left of center; he was a proletariat who championed the working-class struggle. My father and mother truly loved Roosevelt. He gave them hope and the New Deal. My father didn't care for the politics of Eisenhower. Dad called him the "do-nothing president looking out for the rich guy."

Dad was a strong man with a big frame; he was capable of hard work, but his poor eyesight was an extra burden for many farm activities. As a result he wore round, gold-rimmed glasses, beneath which his light blue Irish eyes shined with intelligence—my dad's biggest asset in life. He had a natural ability to organize, analyze, and interpret. My fondest memories of Dad were when I was a kid, wedged in beside him on his recliner as he read *Alley Oop* ("King of the Jungle") to me nightly from the newspapers comic section.

Prior to arriving in California, my father decided to remake his image. He changed his first name from Lum to Dewey to avoid being associated with the new influx of destitute migrants fleeing the dustbowl. My father and his father, Daniel Corbin, whom I was named after, came to California with a plan of action. Grandfather Corbin was a man of diverse skills, a practicing blacksmith by trade. I remember Daniel Corbin as a bald, stout older man with big ears and strong hands who was a master craftsman and could expertly use every tool. I remember how amazed I was after he showed me how to sharpen a hoe to a razor's edge by placing it in a vice and stroking it diagonally with a file. He was an enterprising hustler who had started out as a horse trader. He knew the value of things and could visualize the potential value of things in another setting. When they set out for California, they did so in style. Old family photos of their trip to California do not show a car piled high with mattresses, pots, pans, and barefooted children. The pictures show two stylish men and a nice-looking car. They were dressed to the hilt with high-top lace boots, suit jackets, and Fonda hats. Dressed in their Colorado attire,

they looked like transplanted Bavarian gentry out on a leisurely drive to California.

When the dynamic duo arrived in Northern California, they acted on their plan: working depressed properties for a percentage of the crops. After five years of hard work they started buying properties of their own. Fifteen years later they worked their way up to five hundred acres of rice and eighty acres of producing orchards. Pop was a hustler and the go-getter. He even negotiated with the agents of Roy Rogers and Gabby Hayes, two renowned cowboy movie stars, to hunt pheasants on his rice fields. Pop would only agree to their terms if his grandson, my older brother, Robert, who was six years old at the time, was allowed to go with them. So, Robert, equipped with this toy pistols, went along on the hunt. The pheasants were thick that day. The hunting party jumped ten birds at a time. Roy and Gabby stayed in character, using their six-shooters to blow pheasants out of the sky.

My grandfather had enough work by then, and he decided to cash out and retire. He and my father agreed to split up. Dad chose the orchards, and Grandfather took his fair share the rice-lands cash out and moved back to Missouri to start a dude ranch. The amenable split was not fortuitous for my father. When Pop decided to go back to Missouri and raise prize horses, it was an unforeseen loss for my dad. Grandfather was a visionary and my father was an organizer. Dad was not able to change and adapt to new situations. Years later, after Dad's good fortune had faltered, I asked him why he didn't become a teacher when he arrived in California, considering his college education. "I liked the freedom and challenge of ranching," Dad answered, sitting in his recliner, taking a puff off his tobacco pipe.

Dad met my mother when he first started working farm properties near the Feather River. One of the river bottom properties he worked was located next to the Leko Nursery. My grandfather on my mother's side, Zack Leko, started the nursery with the help of one son and nine daughters. My mother, Katie, was one of his efficient, hard-working children. I couldn't get a handle on who Grandfather Zack was. I studied an old family portrait for insight. The large, oval-shaped, black and white, retouched family portrait showed a handsome man

with my same dark hair, dressed in a 1920s suit, but he was void of expression. The photo had been altered. All wrinkles removed. His skin was flawless and his cheeks and lips were tinted pink. The only feature showing temperament was his worn but steady eyes.

I knew Zack was an immigrant from the Croatian region of Yugoslavia. He landed in Galveston, Texas, as an immigrant teenager in 1904 and worked his way across the country as a miner. I typed in "Yugoslav immigrant miners" in to a search engine and a string of photos popped up, and in a flash I understood the grit I'd seen in his worn eyes. One photo showed twenty ragtag miners carrying picks and shovels while entering a tunnel cut into a gloomy, solid-rock mountain. Instantly I sensed the sacrifices my grandparents made to become Americans. He ultimately settled in Northern California, where he used his experience with explosives to blow tree stumps to prepare land for farming in the valley.

Zack met my grandmother, Jelena, in the Yugoslavia section of San Francisco. Old photos show Jelena with long black hair and large, passionate eyes. By coincidence she had been raised in a village only forty miles from my grandfather's village in Croatia. They married in San Francisco and moved to Northern California, starting a nursery specializing in walnut trees. Zack dabbled in winemaking and bootlegging during Prohibition, but he changed his old-world ways after federal agents knocked on his door. I've come to the conclusion that my bootlegger and blacksmith genes were necessary to my success as a sculptor.

Orchards, fertile soil, and close proximity brought my parents together. I would have loved to have seen my father's face when he first caught sight of those fiery, vivacious, olive-skinned, barefoot, and scantily clad Yugoslavian girls working in the nursery four or five at a time, budding walnut trees in the hot, sandy river bottoms while Zack gave out orders in his thick Yugoslavian accent. My father must have thought a river with everything he needed in life ran right next to him.

My parents fell in love, despite the fact that my father was ten years older than my mother. When Mom turned eighteen they eloped to

Reno and married. Upon returning home they didn't tell anybody for a week. In some ways it may have been a marriage of convenience as well as love. My mother lost both parents at an early age. Katie lost her mother, Jelena Leko, when she was only fourteen. Jelena died of mysterious circumstances that were only revealed to me when my mother was in her late seventies. Katie's best friend on her deathbed gave me a tightly held secret, no doubt so I could better understand my mother. The cause of Jelena's death, as it was told to me, explained certain bizarre aspects of my mother's behavior that had perplexed me as a child.

My grandfather, Zack, died of emphysema at age fifty-five. This left my eighteen-year-old mother and the rest of her siblings virtually orphans. Circumstances were tough on most people in the latter part of the Great Depression, and people made the most of what they had. I'm sure my parents had many loving years before bad luck, midlife crises, and financial troubles began pulling them apart.

After getting married my parents moved to the Larkin Ranch property next to the uninhabited and wild Feather River. The property came equipped with an old house, an enormous barn, outbuildings, and thirty acres of orchards. It was a typical small farm at the time. Robert, who is seven years older than me, was born on this property. As a kid Robert was buck-toothed and skinny and had acne. However, he inherited the family's brilliance and was driven. Later in life he became an attorney. Robert was devoted to family, and as an older brother he gave me a much appreciated leg up in life.

My other brother, Phillip, who is five years my senior, was also born on the property. Phillip was a low-key, robust, freckle-faced kid with big ears. I was closer to Phillip in age and temperament. He taught me friendship, and showed me how to swim. I remember the day I learned to dog paddle. An aching sensation caused by cold river water shot up my nose as I struggled to keep afloat. Phillip stood on the sandbank urging me on. "Keep your head up, work your hands faster," he instructed while illustrating with a twirling, animated dog paddle gesture. I was the baby of the family, which no doubt benefited my journey to become an artist. There is less pressure to succeed

placed on the baby child. They have more time to indulge in their imaginations and fantasies.

Situated far into the countryside in Live Oak, California, and close to the Feather River, the Larkin ranch property was wild, adventurous, and remote. Only ten to fifteen people lived within a four-mile radius of the ranch. In the evening a pleasant river smell permeated the property, and many of the local indigenous wild animal populations roamed our land, leaving tracks in the sandy soil. At nine o'clock every evening you could hear the coyotes yipping. A fast-flowing canal of river water bordered the property. Four miles up the river, the cool, clean water was diverted into a thirty-five-feet-wide, six-feet-deep canal that flowed swiftly and in which only the strongest swimmers could swim upstream. The canal was endless joy for anybody who wanted to cool down and refresh at the end of a long, hot harvest day.

For a real adventure we would hike a half mile to the river, through the wild, raptorial vegetation, for a nighttime frog hunt or a trip to catch catfish. In the daytime we'd retrieve our wooden boat stashed along the riverbank and go for a boat ride.

Huckleberry Finn's locale had nothing on our property. The fertile soil produced peach trees so big and productive that a man could pick peaches on a four-trees set an entire day and not pick all the peaches. My granddad designed a special twelve-foot ladder for those monster trees.

Our property was a small piece of an 1844 Mexican land grant. The original land grant included five leagues (or thirty squares miles) and ran for ten miles along the western bank of the Feather River and for three miles inland, a big rectangle encompassing some of the best farmland in California. The land grant eventually landed in the hands of Thomas Larkin, California's first entrepreneur and politician. After he found out that the land contained no gold, he lost interest in the Larkin Rancho, moved to Monterey, and pursued a more civilized life. Time lost track of a historical treasure. A mile from our ranch location and on Larkin Road, as it is known today, was the original Larkin land grant ranch house, built in 1845. It was one of California's oldest

historical buildings. The lumber used to build the house was shipped around the horn, brought up the Sacramento River by steamboat, and carried by horse and wagon to the building site.

That little-known, rustic historical building was owned and inhabited by a crusty World War I veteran named Grover Pelican. He was an authentic, one-of-a-kind character, and one of my dad's exotic friends. As a child I inadvertently insulted Grover's rustic house by asking him, "Why did they take so much trouble to haul a bunch of bent and crooked wood all that way on a ship?"

Grover was six feet, two inches tall, very skinny, and had a bent nose. I remember that he always wore red suspenders to keep his pants up. He was standing in his dimly lit historical house at the time with his thumbs wrapped around his suspenders. He pulled both thumbs off the suspenders in a *Can you believe this?* gesture, causing the suspenders to let out a resounding snap. "Hell fire. You kids don't know anything these days. I thought General Black Jack Pershing was the biggest ignoramus who ever lived. It was 1844, for Christ's sake. Nothing was here. No stores, no sawmills, no lumber, nothing. I mean nothing. Just weeds, berry bushes, wild animals, butt-naked Indians, and . . . and dumbass horses," he declared, his hands circling over his head as he gushed in a raspy grumble.

For some reason Grover never liked horses; he ran them down and bad-mouthed them every chance he got. To me that seemed a peculiar, unresolved contradiction in his personality. Other than his dislike for horses, a real humanity emanated from his being. He was the kind of guy you trusted immediately with your property and well-being. Here's a unique endearment Grover had: He tamed wild blue jays by lying out on an army cot face up. The cot was situated on his back porch. Daily he would sprinkle breadcrumbs on his bare chest and held still while the blue jays pecked it clean. Most amazing, he saw action during the First World War at the Battle of Verdun. In my mind the trench warfare he struggled through made his humanity. In some twisted way I believed the war also shaped his dislike for horses. My best guess was that he associated the mindless conduct of horses with the barbarianism of war, or maybe he blamed horses

for the accidental death of one of his buddies. I never quite figured it out. Grover had a taste for alcohol and good times; the effects of both were etched on his rugged face. Grover was my first grown-up buddy. In later years, Grover became a warm inspiration for my artistic awakening.

My parents kept the Larkin property but moved our residency to the newly purchased Township ranch in the early 1940s. That farm had the best all-around house of the two properties. Its additional rooms and space and better school district were a better fit for a growing family with young children. The Township land was an established farm, built and designed by people who understood the topography and circumstance of the valley. The house's orientation took into consideration the path of the sun. Black walnut trees that stood sixty feet high lined the south side of the house, providing shade during the scorching summer months. A rose garden, lawns, hedges, and a fishpond embellished the property. Appropriate exotic plants and shrubs were planted around the cooler sides of the house, letting in light while providing as much shade as possible. My mother, being the daughter of a nursery man, added more exotic plants, bushes, and flowers.

An incident happened next to the rose garden that influenced and shaped my outlook and disposition for the rest my life. It was during harvest time, the year of the flood of 1955. One of the unique plants in the garden was a two-foot-high mirabilis plant, nicknamed "Little Red Riding Hood." The shrub produced one-inch-long, red, trumpet-shaped flowers by the dozens. The blooms opened at dusk, as the sun was setting and twilight began. The plant's fragrance permeated the house as the coolness of evening overtook the burning hot days. The scent was irresistible to insects and hummingbirds who craved its nectar. One day, a large, gray hawk moth, with iridescent green wings and a long proboscis, darted in and out of the shadows, securing its nectar.

Fascinated, I watched it movements from the cover of a lilac bush. A numbskull farmhand with a Mohawk haircut, dressed in blue jeans and a plaid shirt, had just delivered a message to my father and was

approaching along a garden path. He walked past the rose garden toward me.

"Shaa. Shaa," I whispered, putting my fingers to my lips, drawing his attention and pointing out the large moth. To my utter dismay he snuck up on the moth, pulled a comic book from his back pocket, and swatted it out of the air. Then, he picked the victim up by two hands—one on each wing—and lifted the moth straight up in the air and began moving it side to side as though showing it off like a trophy to an unseen audience. He then ran off twirling in joy.

I was only nine when this event occurred, but it taught me a valuable lesson. In later years it became a pillar of my art career. Don't let people in on the things you really care about or you might get hurt. This event also initiated my philosophy of man, framing my social perspective. Humans have an equal capacity to create and to destroy. In later years I added politicians to my social perspective, believing that they perpetuate propaganda and thrust civilization in destructive directions for the purpose of securing personal power.

The inside of the house was practical and functional. It had four bedrooms and a bathroom with a large porcelain tub. Our spacious living room was heated with a central propane heater, and our kitchen was equipped with a modern electric stove, a refrigerator, and a large floor freezer chest. The chest's main function was to store food, mainly butchered meat items. On the other side of the kitchen was my favorite room as a small child: the porch. A washing machine with a top-mounted roller kept me company there, and near to it were two large, cement, wall-mounted tubs, intended for washing. Underneath the wood floor of the porch was a concrete basement with descending steps. The cool basement was used to store preserved items. I never went down there, underground. My imagination visualized disturbed creatures waiting for me in the shadows.

The porch functioned as a transitional space. Enter the porch from the muddy outdoors, take off your coat and soiled boots, open the door, and step into the tidy kitchen. My transition from baby to childhood was assisted by the porch. It became my gateway to the thrilling outdoors. The screened-in space of the porch—a necessity

due to the abundance of mosquitos—was exited via a wire screen back door that could be easily opened with your foot. Sammy let himself in and out at his leisure.

My brother Phillip and I improvised an interactive game. At dusk, dressed in long-sleeved flannel shirts, we'd run out into the weeds, stir up as many mosquitoes as possible, and let them chase us as we ran for the protection of the porch. Once we were safely inside, the mosquitoes would land on the porch door and blacken the screen with their prickly, itch-inducing little black bodies, hairy little feet, and long proboscises poking through the wire mesh. Phillip and I often studied that vibrating and undulating mass of vermin.

"Look at those little guys. They're trying to get at you, Danny," Phillip teased the first time we enacted the game.

"We should do this again sometime. That was really fun," I replied, swatting at imaginary mosquitoes.

"Maybe next time we can have a little surprise for them," Phil suggested with a mischievous smile.

"Like what?" I asked. Suddenly I had an idea. "We could spray gas on them and . . . light them on fire," I exclaimed, envisioning the prospect.

Phil shook his head. "No gas. No fire. But maybe we could make a concoction of pesticides. We will think of something," he promised. He knew of my fascination with fire and probably thought, *This kid can't get fire off his brain.*

When the mosquitoes became unbearable we called the abatement district. A vehicle motored by with some kind of putt-putt atomized sprayer and misted the ditches beside the roads with DDT. "You couldn't have survived in this country without DDT," my father said years later.

Of course, no farm is complete without a barn. Our barn on Township was a world-class, multipurpose one with three big bays. The end bay was open to the outdoors and was used mostly for raising farm animals such as our milk cow, Bossy. After she died Phillip and I simply went across the street and picked up fresh milk at our neighbor's dairy. They were our closest neighbor; the next house was

a quarter of a mile away. We raised and slaughtered an assortment of animals over the years such as pigs, chickens, geese, and turkeys. Most years we raised a brood of rabbits, so a portion of the barn was lined with rabbit hutches. The butchered meat eventually made its way to the large freezer chest.

We bred a unique and rare bird, a cross between a banty hen and a wild rooster pheasant. Phillip and I gave the hybrid offspring a nickname: Split Head. He had a symmetrical color pattern and a dual personality, and he could fly better than a chicken. During the day Split Head liked to scratch around on the ground with his chicken cousins. At night Split Head roosted in an olive tree near our house. Late one evening Phillip and I crept up on Split Head with a flashlight. We shined the light on him as he roosted chest to chest with his wild pheasant cousins in our olive tree. In some ways I shared a spiritual kinship with the bird. He was able to function in different worlds but was not at home in any, a rare bird hardly ever seen, charting its own course, leading a one-of-a-kind existence.

The middle bay of the barn was used for parking cars. During the early '50s we parked a brand new 1953 Chevy in the middle bay. That year we received a bountiful harvest. After doing the taxes Mom said, "We're rich! We're rich!" In celebration we bought the new car.

The end bay of the barn was our shop. My sculpting career began in that bay, which is where I first learned three-dimensional techniques. Laid out and organized by my blacksmith grandfather, the shop was well equipped with a welder, torch, forge, grinders, steel worktables, benches, an anvil, shelving, and a woodstove. A block and a tackle hung from the ceiling, and the floors were concrete.

The farm on Township featured twenty acres of peach trees in all varieties and of various ages, all producing valuable fruit. The farm included two pump houses with centrifugal pumps, a chicken coop, and a small house used to accommodate farmhands. The Township ranch was a well-organized and efficiently run family-owned farm.

I was born in 1947 and raised on the Township ranch. My father, mother, and their friends were of the World War II generation. I was a baby boomer and absorbed my father's politics. My earliest years

were spent during the Eisenhower administration during a very conservative, safe, and carefree time. I don't think we ever locked the front door of the house. I came of age and entered college during the late 1960s.

I have painted the backdrop of my ancestry and detailed the environment in which I was raised. Now, on to how this country boy learned how to become a contemporary figurative sculptor.

THE CIRCLE OF FIRE

ACCORDING TO MY older brother, Phillip, who was assigned the task of watching me, I was crafty and unmanageable at an early age. I simply remember my early childhood as a big adventure of discovery, and I couldn't wait to see what the next day might unveil. My first memory was of a sunny day at the Township ranch. It felt like I'd been kept prisoner in the house all winter, but with the beginning of spring I would finally be allowed to go outside— although only with full supervision. The grass was green as I played in diapers near the barn. Phillip was watching me, but I slipped out of his sight and ran to the far side of the barn, where the eight-foot ladders were vertically stacked. I climbed a ladder one foot at a time, using my hands to pull myself all the way to the top. After reaching the top of the ladder, I momentarily enjoyed my accomplishment before Phillip found me.

"What are you doing? Get down from there. Come on down. Take it easy . . . one step at a time," Phillip urged, rolling his finger in a come-down gesture.

I showed Phillip my form by taking a couple of steps down. Then, I stopped and leaned all the way back, extending my arms and holding on by two hands.

"What are you doing? Come the rest of the way down," Phillip pleaded.

I let go of the ladder and fell six feet, landing on my back on the soft ground. It's a good thing babies are made of rubber. The wind

was knocked out of me, but I wasn't hurt. The one thing I distinctly remember to this day is that I purposefully let go of the ladder in some kind of baby bravado meant to impress my older brother.

The first time I tried to fly was at the age of six. It was summertime. My trike was my first taste of freedom. If I was trying to get away with something I always attempted it early in the morning, ahead of blanket supervision. I woke at daybreak, put my trike in the driveway, and put on my riding gear: a long, white bathrobe. I planned to use the bathrobe as wings to assist in my inaugural flight. I peddled down the driveway, turned right onto Township Road, and rode off into the breeze. The bathrobe started to billow as I rode into the wind. Picking up speed, I rode past our neighbor's dairy, letting out my engine sounds: "Varoom! Varoom!" I imagined myself flying over the landscape on magic wings to our Larkin ranch ten miles up the river. I was nude under the bathrobe, and the neighbors saw everything and called home.

Once again my two older brothers got into trouble for not supervising me and lost their ice cream privileges for a week. Phillip, always a nice guy, protested when Mom informed him of his new punishment.

"But he's impossible to watch," Phillip said matter-of-factly.

"It's your guys' job to watch him. You better find a way to do it," Mom retorted.

At an early age my body showed signs that it was capable of producing an excess amount of energy. I would wake in the morning and drink a glass of water, which my body would somehow convert into a twelve-hour, hardwired, magnificent, boom-boom energy drink. This constant level of animation was a natural gift, which sustained me throughout my young life and later propelled my art career.

I received my unfair reputation as a pyro when I was seven years old. It happened on a Sunday morning during a pancake breakfast. Dad was an early riser, and on that morning a project called him away from the breakfast table. Our Sundays were typically leisurely family days, and all the kids would crowd around the kitchen table and wait

for Mom to make pancakes. We'd stack them three high on a plate. It was Robert's job to retrieve fresh eggs from the chicken coop. Mom would fry the eggs sunny-side up and then place an egg on top of our pancake stack. In between the pancakes we poured in generous amounts of syrup. Then, we would dig in and wash it all down with fresh chilled milk from our neighbor's dairy. That was a harmonious time for our family. The biggest arguments were over who'd get the first mushy undone pancakes and whose turn it was to do the dishes. That morning we stuffed ourselves with as many pancakes as we could eat. When the meal was over, we began cleaning up and moving on to other tasks.

Mom gave out the cleanup orders. "Phillip, you and Robert do the dishes." She turned to me. "Danny, I have a special job for you today. I want you to take out the trash and burn it." Mom confidently handed me a large, brown paper bag filled with pancake boxes, newspapers, assorted paper trash, and a couple of tin cans at the bottom.

I grabbed the paper sack from Mom.

She then held out a box of wooden Diamond matches. "Take them," she ordered.

This was the first time I was officially granted the right to use fire, which was a rite of passage on the ranch.

As soon as the box touched my hand, Phillip, not willing to give up his favorite job, pleaded, "Let me show him how."

"He's old enough to handle it," Mom reassured.

"If he catches the place on fire it's not our fault," Robert interjected.

I put the matches in my front pocket and grabbed the bag with both arms, careful not to rip it open. I opened the kitchen door and out the back porch I flew, soon arriving at the garbage pit.

I wasn't there to hear the kitchen conversation but was later told it went like this: Mom reassured my brothers. "There's not enough paper in there to get him in trouble anyway." To Phillip she said, "Go out and check on him in five minutes."

Phillip pursued his case, grumbling, "I can't believe—"

"You have to give him responsibilities to help him grow up," Mom said, cutting Phillip short. "He will be okay."

Arriving at the burn pit, I threw the paper bag to the bottom and jumped in after it. I ripped open the brown paper sack to get at the newspaper, reached in my pocket, and pulled out the sacred box of Diamond matches. I pushed open the box and selected one of those beautiful wooden-stemmed matches with the red and white phosphorous tips. The first match that rubbed against the gritty striking surface broke in half. The second match I tried to strike was a failure as well—the red and white tip just hissed and broke off, ablaze at a weird angle. The third match I stroked evenly against the striking surface until it burst into flames. I dropped the head of the match, letting the flame climb up the wood, and then positioned the match in the newspaper, where it caught fire, burning the contents of the paper sack in two minutes.

After climbing out of the burn pit I hiked around a small hedge and headed in the direction of the back porch. Before reaching the porch I stopped at a concrete slab, where our old family car was parked. The green '48 Ford coupe was parked on the slab at a slight angle, with two wheels up on the slab and two wheels off. The Ford had recently been filled with gasoline; the gas cap was on the lower side of the car and was leaking fuel. A miniscule amount of gas ran down the side of the car and along the undercarriage. From beneath, near the middle of the car, gas slowly dripped from the frame to the concrete slab below. Every ten seconds another drop would fall.

I poked my head under the car to watch the drip-drip-dripping continue. I knew that gas burned from watching Dad employ old gas to magically start fires. I crawled underneath the car headfirst, thinking I'd light one drip to see if it would burn. Once again, one perfect stroke led to one lit match. I let the match gain momentum and then put it on a drip as it fell. The drip burst into a three-inch flaming circle. I watched in fascination as it flamed out, enlarging into a six-inch burning circle. To my amazement the fire leapt from the concrete onto the car's undercarriage. Trying to get a better look, I raised my head and bonked it hard on the gas tank. The flame moved slowly, as if it were alive, fluid and flowing. At that moment Phillip

came outside via the back porch screen door. I was so engrossed I didn't hear the porch door slam.

Seeing my feet sticking out from underneath the car, Phillip asked, "What are you doing under there?" He grabbed my feet and started pulling me out from beneath the car. In a loud voice he started yelling, "Fire! Fire! Fire!"

Mom and Robert came running.

"He set the car on fire!" Phillip yelled.

Mom ran back to the kitchen to retrieve a fire extinguisher. It malfunctioned.

Robert, now the only one with a plan of action to extinguish the fire, took off running into the orchard. I was trying to get back underneath the car to see more fire. Phillip, afraid the gas tank might blow, dragged me out of the area. The fire had worked its way from the undercarriage to the side of the car, and flames were now rising from around the gas cap.

Robert returned with a bucket full of soil he'd scooped up in the orchard and threw it on the gas cap area, putting the flames out.

"Did you see it? Did you see it? It was right there," I gasped excitedly.

Mom, exasperated, grabbed me by both shoulders and looked me in the eyes. "Danny, you can't light the car on fire."

I was curious to a fault, energetic, and observant as a kid, but I understood little in the way of boundaries. I believe my parents didn't want to stifle my enthusiasm and curiosity. My guess is that they hoped I'd grow out of my natural naïveté. They realized I was a little different and tried to work with me inside of those parameters instead of trying to change me or break my spirit. I was able to keep my lively temperament without challenge, and I wasn't afraid of trying something new. I believe it was their loving care that set me on the course of becoming an artist at an early age.

The shop was central to our family's existence. Our competitive edge was reliant on our ability to build innovative farm equipment. We built implements that allowed us to efficiently pursue the task of raising and harvesting fruit. The gifts of construction expertise and know-how arrived at the ranch after the war. My father and

his best friend, Earl Sexton, were exempt from active duty because they had children and were farmers; however, they helped in the war effort by working at the Mare Island Naval Shipyard in Vallejo, California, during the war. Earl, a muscular, medium-sized man, was an ingenious, mechanically gifted fellow who benefited greatly from working at the ship construction sites.

Our shop was most active during the winter months after the summer harvest, when things slowed down. There was always a project in progress—a truck engine being rebuilt, old equipment being repaired, or new equipment being designed and constructed. At eight years old I became their designated grease monkey and loved it. My job was to know how every tool worked and retrieve it at a moment's notice.

One project I remember was the construction of a pallet wagon. The trailer contraption was designed to haul 240 fruit boxes out of the orchards, onto paved roads, and finally over to the cannery. The pallet wagon had to be well constructed, capable of bearing the weight of tons of fruit and nimble enough to maneuver through the orchards. Air brakes were a necessity to stop the heavy load once one was on the motorways. I was in on the project from the beginning. Earl, Dad, and I would drive to the steelyard and pick out the various truck parts and raw steel pieces.

It was a mild, clear winter day, and the double barn doors were flung open. Gentle sunlight bathed the cement slab where the project was placed. The makings of a pallet wagon spanned the length of the shop, which included an old truck frame, massive truck wheels with axles, steel rollers, and pieces of I-beam steel, all to be reconstructed into a wagon designed to carry over two hundred boxes of fruit stacked on five pallets. In the corners of the shop were stacks of steel remains from past jobs. A large, wood-burning stove was blazing, providing localized heat.

On this day I was Earl's helper. He planned on using the acetylene torch, my favorite piece of equipment. Earl was dressed in his customary blue overalls, work boots, and welders cap flipped backwards and pulled snug on his head. Earl's most striking feature

was his eyes; they were piercing and blue. His hair was black, and his full, dark lips were loaded with character. An easygoing Midwestern manner shrouded his reputation as a scrappy barroom fighter.

On that day, Earl, suddenly getting serious, said, "Danny, get the torch ready. Turn the gas to forty pounds. We need a little extra today. Find my gloves and the striker."

This was music to my ears. From a distance I watched as Earl double-checked and prepared the torch for action. The eighteen-inch acetylene torch was made of bronze and looked like a specialized sci-fi gun. Two small hoses ran out the back of the torch along the cement floor and up the side and then attached to pressure gauges on the top of two steel cylinders containing combustible gases. Earl picked up the torch and opened one knob, allowing oxygen to flow. The striker shot out sparks and ignited the oxygen. A low-based popping sound announced a one-foot-long lazy orange flame, which spewed from the end of the torch. The flame sent black plumes of carbon circling toward the ceiling. The next sound came when Earl gave the oxygen a test blast of acetylene. It was a shrill and high-pitched noise. Earl pulled the oval-shaped dark goggles over his eyes, then crouched over a four-by-four and three-eighths piece of blue sheet metal that was blocked six inches off the cement floor. The object of his concentration was a large circle drawn in white chalk. He preheated the steel for a minute.

Satisfied the metal was sufficiently hot, Earl gave the torch the maximum amount of gas. The ear-piercing hissing sound produced a three-inch, cone-shaped, pencil-sized blue flame that shot out the end of the torch. Earl began cutting the sheet metal along the chalk line. Red-hot sparks and bits of molten metal began flying out of the underside. Pieces of hot metal splattered and flew out upon hitting the concrete floor. A cornucopia of burning smells produced by the liquefied metal, mixed with burning gases, filled the air. Those intoxicating aromas made the inside of my nostrils numb and wild with excitement. Earl was perched above and floating over the bluish black metal. His hands worked in unison as though they were a mechanized apparatus specifically designed to cut out a red-hot circle.

Abruptly, the two pieces of metal separated. One dropped and crashed onto the cement floor, making a deafening metallic sound.

Earl quickly turned off the torch and flipped up his glasses. "Danny, get that rag over there. No, no. Over there," he instructed, pointing to a smoldering rag ten feet away from the project. A red-hot piece of slag skidded across the concrete floor and started a rag on fire. "Take it outside and douse it in water," Earl instructed in a relaxed manner.

I picked up the rag and ran outside. The faster I moved, the more oxygen the rag received, ultimately igniting it into a ball of orange flames. I dropped the rag on the gravel driveway, ran to the faucet, turned on the water, and pulled the hose to the burning rag. Earl strolled outside to the gravel driveway and watched me play with the rag. I was squirting water on both sides of it instead of on it.

"Try getting some water on the rag. Get it out good," he told me as he nonchalantly pulled a pack of Lucky Strikes from his blue overalls. Earl pounded a single cigarette from the pack and put it in his lips. He retrieved a Zippo lighter from his pocket, lit the cigarette, and returned the lighter to his pocket in one fluid motion. Calmly, Earl took a long hit from the cigarette, inhaling the smoke.

I watched out of the corner my eye to see if he was going to blow smoke rings and wished I was downwind so I could get a good whiff of those Lucky Strikes. They were the best smelling of all cigarettes. The next best in my opinion and a distant second was the Pall Mall brand.

Earl blew out smoke. "Make sure you get the fire out. I catch the place on fire and Pappy will cut back on my Rucus juice." He put the cigarette in the corner of his mouth, letting it dangle down at an outrageous angle.

Pappy was the made-up name I affectionately called Earl. At some point Earl started calling my father Pappy. Everybody was calling everybody Pappy. Rucus juice was their nickname for the red wine the two men shared at the end of the day.

I could hear Sammy barking in the background at this point.

"Make sure it's out. Here comes Pappy," Earl announced.

Dad's green pickup came into view as it turned past the hedge and

made its way toward the shop, crackling over the gravel driveway. Sammy was letting out his welcoming barks as he gave chase. The pickup slowly approached the shop and stopped. Dad, dressed in blue jeans, a red checkered coat, and work boots, opened the door. He grabbed his favorite pipe off the seat and placed it in a coat pocket.

"Pappy, did you get it?" Earl called out as a greeting to Dad, referring to the bottle of acetylene gas needed to complete the job.

"Got it," Dad said, continuing the conversation. "Had to block it twice," he continued, referring to the oblong steel canister of gas that had rolled around in the bed of the pickup truck as he drove home.

I ran up to the back of the pickup, jumped onto the tow package, and looked inside. "That's a big one. How come it's blue?" I asked, referring to the odd color of the new cylinder.

Earl walked up to the pickup, put a boot on the sideboard, and peered at the replacement bottle of gas. "That's acetylene, all right. They can paint it any color they like," he said.

I turned my attention to Dad, eager to give him the good news. "Dad! Dad! Earl cut the wheel wells out of the big piece of steel. You should've seen it. Sparks going everywhere. I helped him put out the fire too." Quickly I realized I had said the wrong thing, since I was trying to live down my reputation as a pyro. "I squirted a lot of water on it with a hose," I added, hoping to recover by mentioning my part in extinguishing a fire as opposed to igniting one.

"Yep, he put it out all right," Earl agreed sarcastically, giving my dad a smile before letting out a puff of smoke.

"Dad, come on. You have to see the steel. I bet it's still hot," I said enthusiastically as I ran off toward the shop. On the way I jumped on the wet rag with both feet to show I knew better than to play with fire, all the while thinking to myself: I hope Dad hurries up and lights his pipe. Can you imagine pipe smoke and Lucky Strike smoke all at once?

My father, engaging in a misdirection ploy, said, "Danny, head out and get the paper and take it to the house." Dad figured the diversion would give him a few moments with Earl out of the earshot of a precocious kid.

I tore down the driveway at a dead run.

"You better hurry up; you might miss something," Earl teasingly called out.

I was on a record-setting pace. No way was I going to miss out on all that beautiful smoking and talking.

As I look back on those long-ago, fond memories, I realize that when I was young things were already falling in place for me to ultimately become a sculptor. I had great technical teachers at an early age, understood tools, and loved the mechanical process. I was curious, liked to work, and had an abundance of energy. There were also signs my mind couldn't always channel my seemingly endless supply of enthusiasm properly. In the coming years it would become one of my strengths—as well as a weakness.

CHASING GRASSHOPPERS

ARL WAS A great mentor. We worked together during the thrilling harvest of the summer of 1955—the year of the flood. Harvest time at the riverside Larkin Ranch was the ultimate experience for me as a child. It was as if the whole world was put there for my enjoyment. That time of year took on the atmosphere of part carnival and part camping trip. Looking at it historically, harvest has always been a special time in the human experience; it owns a kind of primal essence and seems to be imprinted in our DNA. In those days everybody pulled and worked together and summoned extra oomph and vigor to bring in the crops. Through the years I've toyed with the notion that making sculptures is a type of harvest, providing essential nourishment for the human psyche.

A typical harvest day at the Larkin ranch began in the cool, pre-dawn morning darkness before the sun arose. That July morning, as Dad's helper, I was allowed to tag along. The sun wouldn't rise for another half hour. We wore long-sleeved shirts and dressed in layers of light coats—which were later peeled off as the morning advanced into a sweltering summer day. Dad carried tickets and a hole punch in one pocket; in the other he carried large pieces of chalk, which he used to count and label boxes. He inscribed notes on the boxes such as *split pit*, *small*, *worms*, or *top of the load*.

We began the morning by loading a chilled, five-gallon canister of drinking water into the bed of the pickup. The water can was placed in the orchard, providing needed hydration for the pickers. We jumped

into the front cab, started the pickup, turned on the headlights, and drove the short distance to where the peach harvest had stopped the previous day. It was Dad's job to orchestrate the day's harvest by choosing where to start and what trees to pick to ensure the pickers were off to a good beginning. He made sure there were enough boxes, ladders, and picking bags to make it through the day. He then organized the swappers and inspected the loads to ensure they were ready to leave the fields. He ended the day by counting the boxes and paying the workers.

We arrived at the harvest site, turned off the headlights, and exited the pickup. My memories of a peach orchard during harvest time is: it's a dire and dangerous place to walk through in total darkness. Organic smells seemed to stand out more. The orchard reeked of ripe peaches, rotten peaches, musty mud, and the bitter aroma that the peach leaves gave off. At that time of year a slight trace of pesticide could also be detected. In preparation for the harvest the orchard had been irrigated a week earlier and was now just barely dry enough to walk on, though still muddy and slippery. To make matters worse, the soil's surface was covered with peach pits, small pruned limbs, and irregular pieces of wood. A week earlier those items had floated around in eight inches of irrigation water. Now the debris had settled back on the soil's surface, creating a random texture on top of the mud that reminded me of items on a combination pizza. The final irrigation ensured that the peaches would grow big and heavy. Farmers were paid by the ton, and the best way to amass weight was by irrigating the peaches until the last possible moment.

In that complete darkness, even with the aid of a flashlight, you had to be cautious navigating the orchards. Large limbs full of ripe peaches dangled down in front of your face, some so heavily loaded with peaches that they had to be supported by wooden props one-by-four inches wide and eight feet long. The props placed under the heavy, vulnerable peach limbs were locked into the mud at weird angles and became perfect obstacles to trip over. Broken boxes were thrown about. Damaged peaches fell from the trees, landed in the mud, and became half buried and totally rotten. When you stepped

on them they turned to mush, making them quite the slipping hazard. Every four-tree rows a drive was cut through the mud running the length of the orchard. Those thoroughfares were an attempt to flatten and level the land to create access roads for tractors and pallet wagons. The peaches were picked, put into boxes, and stacked along the drive. Then the boxes were loaded by swappers onto the pallet wagons and the loads towed to canneries. Even though it was too dark to see, the best pickers had already entered the fields carrying flashlights and choosing the prime tree sets.

I followed Dad, who had a flashlight in hand. We approached along the drive to where the previous day's harvest had stopped. A flashlight twenty feet ahead in the darkness signaled us by quickly turning on and off. It was Mr. Hegerman, the best peach picker ever. Mr. Hagerman was a high school shop teacher during the school year from the Pacific Northwest. During the summers he picked crops, starting with cherries and apples in Washington and Oregon and then working his way down to California for the peaches. Mr. Hagerman came back every year for the harvest and could pick over a hundred boxes a day. He could out-pick all the comers, especially the young bucks. The man was memorable-looking, with his stout body and wide head that ended in a mass of unruly hair. His lips were as wide as a car's bumper, but his missing index finger was his most unusual characteristic. He liked the adventure and excitement of the harvest, which for him brought back nostalgia of a disappearing and bygone era. Hagerman still carried an Oklahoma twang and occasionally reverted to colloquialisms to make a verbal point. He wore his picking bag up high. Dad really liked Hagerman, for he brought professionalism and a friendly competition to the day's activities.

"Is that you, Dewey?" Hagerman asked loudly.

"Yeah," Dad replied. "A little nippy this morning, huh, Mr. Hagerman?"

"You betcha. Too bad it doesn't stay this way all day," Hagerman replied.

"Nice and cool to about one o'clock," Dad responded genially.

"You gotter there. I'm unforsure, but it's probably going be a

scorcher today." Hagerman's face was barely visible in the early morning light. He was the best picker because he knew which peach trees to pick. He had been working on the best four-tree sets in the orchard the previous day and was anxious to finish them off early.

"About how many boxes you think is left on the set?" Dad asked.

"Oh, about twenty-five to thirty," Hagerman surmised.

"That would be around a hundred boxes."

"Yes. Beats last year. I picked these same trees. The heat sized them up good," Hagerman said. At that moment he lifted his left hand, which cupped a giant peach. He always liked to show me where his missing index finger used to be. I watched him rotate his hand so I could get a good look in the early morning darkness. "Dewey, you grow these peaches any bigger, and I won't be able to get my hands around them." Hagerman flipped the peach over to me. "That's a specimen, son. You might want to think about eating that one yourself." He knew how much I liked peaches. It also gave me an opportunity to use my razor-sharp pocketknife. I'd peal the peach and let the skin dangle off in one long cylindrical peal. Then, I'd sliced off half of the peach and eat that yellow piece of heaven while the juices ran down my face. I just wiped off the sticky nectar with my shirtsleeve whenever necessary.

The first light was beginning to break at that point, and it wouldn't be long until the harvest was in full swing. Out of the darkness I could begin to see the first glimpses of color. Red and yellowish peaches were becoming distinct against the black background.

"I think I'll start on the lower limbs. I can go by feel for the first twenty minutes," Hagerman said as he began stripping a lower limb of its peaches.

Cars with beaming headlights began parking at the end of the orchard. The morning's commotion was beginning. Slamming car doors and people greeting each other could be heard.

"Let's go down and show the pickers where the ladders are stacked," Dad said to me before launching into a full stride. Eventually there'd be twenty to twenty-five pickers in the fields, along with a contingent of small kids and dogs. As soon as the morning harvest began, the noise level picked up, and the orchard's atmosphere became festival-

like. Everything was in motion. Pickers ran up and down ladders. Tongues of wooden ladders flew five feet through the air and then slammed against their wooden frames. Peach boxes banged against one another as they were stacked and filled. Robert drove by on a tractor, pulling a bouncing flatbed trailer with a load of empty boxes; Phillip riding on top of the trailer with his legs apart, using them as shock absorbers, boxes jumped in the air as the trailer bounded along. Idle chitchat and animated voices added to the day's commotion.

Two hours into the morning harvest the burly swappers began to show up. They came from Beale Air Force Base. Big and muscular, the swappers came back year after year, partly for the paid adventure and partly for the workout. They followed the pickers and loaded the fruit boxes one by one onto the pallet wagons, working slowly and methodically until they stacked them eight boxes high, fifteen boxes long, and two boxes wide on five forklift pallets. Everybody gave the swappers a lot of space. They engaged in loud vulgarities, cussing and sweating away the entire morning. They never stopped until the last box was loaded.

Listening to the swappers' profanity was the height of my day. They cracked me up. I would sneak up close and hide behind a stack of peach boxes, eating a peach and eavesdropping as they sweetened a sweltering day with military sacrilege.

That day, one of the swappers got a splinter. "When the fuck they going to make boxes without splinters," he yelled out. They sparred in verbal one-upmanship. Another swapper had lifted a full box of peaches halfway over his head when the bottom of the box burst open, spilling peaches onto him. "Son of a bitch. Jesus fucking Christ. Another broken box," he growled, tossing the bottomless box aside.

The pallet wagon was pulled by a Ford tractor. There were fifty stacked boxes of peaches waiting to be loaded on one side of the pallet wagon, with another sixty-five boxes of fruit on the other. As soon as they were loaded the tractor driver pulled the wagon forward. The high-stacked pallet wagon brushed up against outstretched peach limbs, which briefly got snagged in the boxes. Upon letting go, a few branches swatted a swapper in the head. "Fuck! Another goddamn

limb gets in my face I'm going to cut down all the cocksucking trees myself," he declared.

The swappers were quite talented and athletic. To load the highest boxes, which were stacked eight high on top of the pallet wagon, the swappers hurled up full peach boxes and landed them perfectly in place. The peaches would bounce up in the air momentarily and come back to rest in the box. If the lighting was right you could see the fuzz on the peaches fly off and float in the air after the boxes landed. Peach fuzz and a hot sweaty day do not mix. You itch yourself to the bone. Only a swim at the end of the day in the cool canal can relieve the itching.

As soon as the pallet wagon was loaded Earl stepped in and took over. His job was to cinch down the load of 240 boxes with steel cables and corner irons, then drive the load out of the orchards and onto the paved road, where he would trade out the Ford tractor and hook the loaded pallet wagon to a hauling vehicle. Earl had modified an old Army jeep especially for this job. He beefed up the transmission with a lower gear ratio, fortified the chassis, and installed air brakes. The jeep was painted red—the same color as the pallet wagons.

Earl had hooked up the safety chain and was doing his last inspection of the load when Dad arrived with me in tow.

"I think she's ready to roll," Earl announced.

Dad nodded okay.

"Danny, jump in," Earl invited.

I looked at Dad to make sure it was all right.

"Get in, son. You're riding shotgun," Dad said.

I slid into the jeep; it was really low to the ground.

Dad put his hands on the door, looked at me, and said, "I'm letting you ride along to the station. You're Earl's eyes and ears. He has to drive. Your job is to keep your eyes open and watch the load. Look for anything unusual, like irons popping off. Make sure the cables don't start fraying and make sure the air hoses don't uncouple. Look for a tire going flat. I mean anything." Dad paused a moment for emphasis. "If a bird flies over and takes a crap I want you to tell Earl about it."

Dad had an intensity about him I only saw during harvest time. He patted the jeep a couple of times and wished us luck.

Earl pushed in the clutch and then engaged the four-wheel-drive lever. He grabbed the main gearbox shifting knob, dropped it down into Grandma, revved the engine, and let out the clutch. The slack in the hitch made a popping sound as the full weight of the load came to bear on the tiny jeep. Hauling the heavy load from a dead stop made the jeep grunt and buck, but as soon as we gained momentum our speed picked up steadily.

Earl shifted into second as we gained velocity, and then looked over at me. "Danny, forget what Dewey said about watching for flying birds. I'm more worried about the safety chain. Make sure it doesn't pick up too much slack." Earl pounded the clutch and hit third gear. I glanced at Earl's ecstatic face, and realized we were both experiencing the same rousing adventure.

After lunch the harvest was typically finished for the day, and the Larkin Ranch would transform into a festival, rocking and rolling away the blistering afternoon. The swappers from Beale Air Force Base grouped together and sat under a shade tree. They used overturned peach boxes for a table and made sandwiches fashioned from two pieces of white bread and two pieces of baloney. Then the burly men would pass around a church key to open their cans of beer before digging into their baloney sandwiches. They washed the food down with cold Pabst Blue Ribbon and bullshitted about the day's events. On the radio Elvis Presley played in the background. *Well, I said shake, rattle and roll. I said shake, rattle, and roll. Well you won't do right to save your dog-gone soul.*

I have sentimental recollections of the easygoing migratory workers. Some pickers came from far away, and our place was on their migratory swing. Others were more locally based, and seasonal orchard work was the only way of life they knew. Half of the pickers camped on Dad's property in big tents. Dad gave them use of the barn for shelter, and a wooden outhouse in back was utilized for sanitation purposes. Many of the same people came back year after year. One man who had painted his '48 Chevy with house paint the previous

year returned that season for a touch-up job. He stood there shirtless with a can of beer in one hand and a paintbrush in the other and slathered color on his car in the one-hundred-degree heat. Kids ran around, played, and drank pop. Since they were shoeless they would dash from one shady area to the next to avoid the full brunt of the blistering hot sun. The children's favorite game involved chasing and diving for grasshoppers in the hot sandy soil. Half of the crowd walked to the canal with kids in tow and swam in the cool, refreshing river water, washing the peach fuzz off their bodies. In a few days after our harvest was finished the pickers moved on to other orchards in need of harvesting.

This was the end-phase of white migratory farmworkers and the beginning of the end of small, family-owned farms. Just a few years later all the fieldwork was taken over by inexpensive, hard-working Mexican nationals, and family-owned farms started going out of business.

CURIOUS FRUIT

W E EVACUATED THE Township Ranch on a late afternoon during the winter of 1955. A low gray sky filled with rain hung in the valley. Close to the ground, fast-moving, dark-gray clouds full of tropical moisture blew by. Phillip and I were playing in the barn. It was December 23, two days before Christmas. We were anticipating what present we would open on Christmas Eve. The cruel coincidence of the 1955 flood was that the levee broke on the day of Christmas Eve. My brother Robert was unfairly blamed for the flood. He liked to duck hunt and said, "I hope it rains, rains, and rains. What a hunt I'm going to have. Only bringing home mallards this year." In jest, after the flood we reminded him many times of his misguided request.

The year 1955 had one of the heaviest rainfalls ever recorded in California. The pineapple express, full of tropical moisture, dumped rain nonstop and inundated the levee systems. The levees soon filled to capacity, but it just kept on raining.

My father had been watching the levees for the past two weeks. Every evening he drove four miles to the Feather River, climbed the twenty-foot-high levee bank, and studied how much higher the brown, swirling water had risen. He projected how much rainwater was in the mountains, how long it'd take to reach the valley, and what kind of pressure it'd put on the already besieged levee system. The day before Christmas Eve, after studying the levee, he drove home, convinced the levee would break within the next two days.

When Dad returned, Phillip and I ran out of the barn to greet him.

"We're evacuating today," Dad said in a determined voice, more to Phillip than to me. Phillip's eyes enlarged and his back stiffened. "Boys, into the house," Dad instructed, his gaze fixed on the mission.

I was nine years old, soon to be ten. I didn't know what "evacuation" meant, but I knew it was going to be exciting. Dad carried cardboard boxes into the living room. The Christmas tree lights were turned on, and the tree shined with large, colored metallic bulbs and shimmered with long strains of tinfoil ice. Presents were wrapped and placed under the tree. Dad always made a big deal out of Christmas.

Mom took one look at Dad and asked, "What's the—?"

"The levees are going to break." Dad interrupted. "We're getting out tonight."

This is getting better all the time, I thought.

"What about the cars?" Mom anxiously asked.

"We will take both cars. Throw in supplies for a couple of days, and we'll drive to the Larkin Ranch," Dad replied.

I'm thinking: This is great. I could see myself opening Christmas presents at the Larkin Ranch house.

"But Larkin is next to the river," Mom protested.

"It's high ground," Dad assured her. "It will never flood there. Never has. Never will." Dad then gave out more instructions. "Get the kids to pack some clothes. You and Robert take this cardboard box and pack some food from the kitchen. Get canned stuff, bread, whatever we can use in the next couple of days. We have to hurry up. Let's try to get out of here in the next hour. If we don't get out now, we will never get across the Colusa Highway." Dad was referring to the east-west highway that intersected the road we lived on. "It will be clogged with cars heading to higher ground and blocking our way to Larkin Ranch."

I was standing next to the Christmas tree wondering what could make an evacuation better than a few Christmas presents. Dad had a cardboard box in his hand, which I thought was for the presents. "We could take some Christmas presents. I'll put them in the car," I offered.

Nobody seemed to hear my suggestion.

"Phil, take Danny. You two pack up as many good, clean clothes as you can into this box." Dad handed over the box.

Phillip and I walked toward the bedrooms. "I don't think they heard me," I muttered. "Should I ask again about the presents?" I asked my brother, who did not seem as playful as before.

"Let's just do this. We'll be back in a couple of days. The presents will still be here," Phillip assured as we headed to the bedroom.

I didn't come back for four months. The levee broke the next morning. Our ranch was inundated with five feet of brown, churning, cold water. When Santa Claus flew over the area he must have seen a lake seven miles wide and twenty miles long. Thirty-eight people died. Our neighbors who owned the dairy didn't evacuate. They were lifted from the roof of their house by helicopter. Their dairy cows all drowned. Our pigs drowned. My uncle Gerard, who parted his hair in the middle, was a lean, hard-drinking, tough-as-nails diesel mechanic who lived only a quarter of a mile from where the levee broke. He was evacuated from the high branches of a walnut tree by helicopter. Gerard had stayed home and placed valuable papers up high in case of high water. When he heard the rumble of the rushing water, Gerard took off running along an elevated train track. He was washed off the track, grabbed on to a walnut tree, and climbed to the top. The water eventually rose over the roof of his house. It's hard to believe how much water actually flowed out of the river. Water rushed four miles to our house and another three miles beyond it until it backed up against another twenty-foot-high levee system. The whole area filled up until it became a giant lake. Debris washed back and forth for months. The water eventually drained back into the rivers in March, but the damage had already been done. A floating telephone pole smashed through the north side of our house, breaking out the entire side panel of our pane glass windows.

My Dad and Earl returned to our home two weeks later by motorboat to survey the damage. They followed the telephone poles on Township Road to our farm. There was little they could do but assess the damage. They looked inside the house and found Sammy.

He had been standing on a floating wooden table for two weeks. The family cat was found on the roof with six chickens. Dad climbed up and rescued his favorite cat. Years later when the last surviving chicken died, I gave him a grand funeral. I revered him for his tenacity and his will to survive. Dad managed to get Sammy and the cat into the boat and traversed the long country road back to where they launched the craft.

Temporary sun blindness caused by the water's reflection off my dad's glasses began to affect his vision. As he stepped out of the boat the cat jumped out of his arms and ran off. My father should have run off as well, because mentally he'd never be the same after that day.

Juan Corona, an infamous Yuba City resident, was also mentally affected by the sharp fangs of the flood's death and destruction. He was a handsome Mexican American who worked as a farm labor contractor. After the flood he suffered a psychotic break, during which he believed that everybody died in the flood and that he was living in a land inhabited by ghosts. Years later he took twenty-five lives, slashing a cross on the back of the victim's skull with a machete. He then submerged the victims in shallow graves hidden in peach orchards off of Larkin Road. When I was in college years afterward and read worldwide headlines about multiple graves in Yuba City peach orchards, I instinctively knew it was the legacy of that horrible flood.

The flood damaged to the Township Ranch was immense and devastating. The house was ruined, along with all its furnishings, and had to be rebuilt and refurbished. The electric motors and pumps were ruined. The tractor had to be overhauled, and all the shop equipment was either ruined or damaged. The small house we used to house farmhands was never rebuilt and was left a derelict, never to be inhabited again. Even the brick chicken coop was destroyed, but the financial coup de grâce came four months later, when the water finally dissipated and drained back into the rivers.

Our farm resembled a debris-filled goulash. Drowned animals and wreckage floated around in five feet of water until the debris was snagged in our orchard. As the water slowly receded, bizarre fruit

hung from the limbs of the peach trees. Dead animals and rubble dangled from the trees at weird, grotesque angles. That would be the definitive harvest for those trees. As soon as the water receded the National Guard arrived with amphibious vehicles and collected and disposed of the dead animals.

When I arrived at the Township Ranch four months later it was springtime, and the cleanup was well on its way. Fear of disease had kept me out of the flooded area. The drive down Township Road revealed the devastating damage to property and houses. Massive cleanup efforts were ongoing everywhere. As I arrived at our property I witnessed something quite unusual. Lined up in front of our place and along the road were twenty propane tanks of every size and shape. They had been pulled from our orchard and placed in a line for the owners to pick up. Dad put a sign on the salvaged tanks that read: *If it's yours, take it.*

My experiences that day were transformative. It would be the day that I said good-bye to my childhood ways. I slogged out into the orchard to greet Earl. He was working underneath the International tractor, which was currently stuck in two feet of mud. Ours was the same type of tractor they showed in World War II newsreels, like one I watched one time during which our Marines had just taken a tropical island from the Japanese, and we were building a new airstrip for the Army Air Corps. The news footage featured an action shot of a Seabee on an International tractor equipped with a bulldozer blade, pushing around white coral sand and constructing the new airstrip. After the war ended the tractors were brought back to the United States, and many were purchased by farmers. Dad bought one. We had one with authentic Jap bullet marks on the chassis. I invented half a dozen scenarios to explain how the chassis received those marks.

Earl had rebuilt the tractor after the flood and was now trying to plough a ditch deep enough to drain water off the property. Water oozed from underground to the surface, forming puddles at first and then flowing out.

The tractor was buried in mud up to the chassis. Earl was trying various methods to free the vehicle. He had placed wooden flood

debris under the tracks, then attempted to hook a winch to a peach tree. I was curious if the bullet marks were still visible. My rubber boots were already caked with mud, and with every soggy step they tried to slip off my feet. Earl was trying to place a chain around the trunk of the peach tree as I approached.

"Hey, Earl. Dad wants to know if you want to take a lunch break. Red Cross just came by with coffee and sandwiches," I told him, pointing to the departing Red Cross vehicle.

"Sounds good. Let's get this chain hooked up to the peach tree first," Earl requested, frazzled. "Danny, can you run the chain around the trunk and hand it back to me?"

I grabbed the heavy, mud-coated chain. After my first soggy step the mud pulled me to the ground. I got back on my feet, but that was the end of my clean clothes, which Mom had directed me not to get dirty. I managed to wrap the chain around the tree and handed it back to Earl, though I was a bit puzzled by his plan. The large peach tree directly in front of the tractor was lying on the ground, having been pulled over by an earlier attempt to wrench the tractor out of the mud. I couldn't wait to play on the broken tree. I could build an amazing fort in it with all the wood and flood debris lying around. I tossed that playful thought aside and formulated a cautious question, not wanting to hurt Earl's feelings. "You think it'll work this time? I mean, you think it might pull this tree over too?"

"Doesn't really matter," Earl answered in a resolute tone.

I didn't understand, so I asked, "Why's that?"

"Dewey said we're going to have to pull them all out anyway."

I didn't comprehend.

Earl noticed my puzzled expression and said, "Take a good look at the trees, Danny." Earl believed in the power of observation—it was one of his favorite teaching methods. He continued, "They seem a little off to you?"

I concentrated on the trees and noticed for the first time that they were no longer in a uniform budding and leafing pattern. In a healthy orchard the trees all bud and bloom together within the same week. In the aftermath of the flood, some of the trees were budding, some

were leafing out, some were covered with yellow leaves, and others were doing nothing at all. "The leaves look a little yellow," I observed.

Earl scraped mud off his gloves. "That's right, son. You got it. Sour sap. Too much water. It killed the roots."

I was stunned. To me the trees were like members of our family, each with its own individual personality. This was my wake-up call, the moment I truly realized the seriousness of the flood. "Will they come back?" I desired.

"Maybe, but Dewey doesn't think so," Earl replied, kind enough not to deceive me.

The day's events triggered within me a traumatic awakening. I left my idealistic childhood behind. All of my memories before the day were of a fantasy existence. I gave up playing with toys two weeks later. In the months that followed I developed a mature perception of reality. To this day I have the same sense of awareness. I don't know if I was a nuisance there, or if my parents thought it was too upsetting, or if they were afraid I might get sick, but I wasn't brought back to the Township Ranch until it had been rebuilt and elementary school began in September.

My childhood can be broken up into two facets: the time before the flood and the time after it. I think both were equally important in creating my psychological profile. The first years instilled in me a feeling of being loved and of being someone special. The second segment of my childhood after the flood tempered my psyche. By necessity I learned to be imaginative, resourceful, and self-reliant. I began cultivating an emotional toughness and inner fortitude. Later in life those hard-earned aptitudes made it possible for me to struggle twenty years in the wilderness before putting it all together and finding my way as a figurative sculptor.

After the flood the financial well-being of our family descended into a dismal peekaboo abyss. We thought we could see our way out, but the side walls of our world had collapsed inward, trapping us. The financial outlook for fixing the house, repairing the damaged equipment, and replanting twenty acres was too much for our family to absorb. The flood also coincided with the downturn in family-

owned farms nationwide. Smaller farms were becoming financially unsustainable and started failing in the 1960s. Large, land-owning farmers and corporations began buying up distressed farms, changing the nation's agricultural landscape.

My father tried to hold on to his ranching enterprise, but bad luck continued to hound him. The following year an unseasonably cold springtime froze the prune blossoms, so we had no prune harvest. At some point during this time, so slow and subtle that it remained concealed from our view until much later, Father suffered some sort of a breakdown and basically gave up on a rational approach to his situation. Three years after the flood we began selling off pieces of the Larkin Ranch to help pay property taxes. In his mind, even without proper farming techniques, the Township property, with its small maturing trees, would somehow miraculously save his ranching dream. While he was waiting, time passed Dad by. Ultimately he gave up on ranching altogether and turned the maintenance of the Township Ranch over to Robert and Phillip and eventually to me.

Dad attempted other business ventures, even obtaining a real estate license at one point, but he didn't have the confidence to follow through. He tried to subdivide a piece of the Larkin Ranch into lots, but lacked political skills. He started hanging out with his drinking buddies and began a downward, deteriorating skid. He last endeavored to become a lapidarian—a rock hound. With his drinking buddies in tow, Dad would take long trips out into the Nevada desert and collect rock specimens, placing them in white canvas bags. Nothing came of the effort except mounds of white canvas bags stacked in the backyard.

My emotional well-being began to resemble the landscape of the post-flood years: barren, disharmonious, isolated, and uprooted. Vanished were the lush orchards of Township. Gone were the Larkin Ranch and the exotic harvest times with mountains of peach boxes to be used to build forts. Absent was the feeling that my father was in control and orchestrating a beautiful dance that brought financial stability, happiness, and love to our family. The exotic people who helped work on the ranch had exited. Dad's participation in my

upbringing began to disappear. Filling the void was the notion that life was unfair. My expectations dropped by the wayside, replaced by unhurried decline and the erosion of self-esteem. I began developing a self-assured compensation mechanism and advanced a new way of preserving my pride and dignity by cultivating a desire to prove I had something extraordinary inside me.

As a family we endured many dirt-poor years. This part of the memoir explores for me the most difficult and stressful segment of my life. It was during these slow-moving years, which took place from fourth grade to my junior year in high school, that I began developing a self-contained and unconventional personality.

Phil and I were great playmates. We were hardy and tried to make the most of our post-flood situation. We both liked adventure and were continually building interesting projects. The new medium of television became a great source of inspiration in our creative ventures.

Phillip and I settled close to the TV in the living room on a typical school night in 1957. It was early winter and a little chilly. I had just lit the centralized propane heater, a three-foot-high, four-foot-wide construction of sheet metal coated with brown enamel. I struck a match and placed it on a long row of propane burners and then rotated a four-inch handle. A wide blue flame lit and then flowed across the inside of the heater. The smell of burning dust momentarily filled the air. Four minutes later there was a crisp *bonging* sound as the brown enamel exterior of the heater expanded. Robert, who was in the running to become the high school valedictorian, was in his bedroom diligently doing his homework.

The best way for us to quickly warm up was to lean our butts up against the newly lit heater. As soon as I could take no more heat on my behind, I slid across the floor—with the help of my slippery socks—away from the heater and toward our light blue couch, where Phillip sat watching TV. We owned a 1950s furniture-style black-and-white TV set, currently tuned to *The Jack Benny Program*. The comedy show was almost over, and Phil and I were hoping we could keep the TV on the same channel. *Have Gun—Will Travel*, a popular cowboy show, was scheduled to air next. Unfortunately, the dreaded *Lawrence*

Welk Show was about to start on another station. Phil and I thought Lawrence Welk was dorky and couldn't stomach all the singing and dancing. It was Mom's favorite program, however. Dad had been away for a couple of weeks, so Mom would probably get her way. We'd have to endure polka songs, Doris Day, Tiny Bubbles, and who knew what other torture. If Dad had been home we'd have been able to watch the cowboy show starring Paladin, the cool, incorruptible, pockmarked rebel cowboy dressed in black who bagged the bad guy every time. Richard Boone, the movie star who played Paladin, occasionally stayed at the local historic Hotel Marysville, a landmark from the gold-rush days only twelve miles from our home. I assume he stayed there because he liked the "Old West" ambience; I was sure it helped him stay in character as well. Phillip and I were interested in making a replica of his notorious gun. We also wanted to craft a copy of his black holster, right down to the flat silver medallion in the shape of a knight chess piece riveted to the side.

Phillip was a terrific builder and craftsman and had a taste for adventure. Later in life his building and construction abilities would serve him well as an engineer. He worked building roads for Caltrans for thirty years as a soil specialist.

We had already built a great project inspired by *The Silent Service*, a TV show based on the World War II exploits of a submarine and its crew. The program led Phillip—with my eager assistance—to build a one-quarter-scale model replica of a submarine. He built the submarine as though it had just surfaced from the water. The sub faced in the direction of the empty twenty acres as though it was patrolling on the open seas protecting the newly planted trees as they grew up. Pallets were laid out on the ground and covered with wood to simulate the deck. We built a sub conning tower big enough to hold two people, complete with a ladder and escape hatch. Phillip's building prowess really blew my mind when he fashioned an ingenious workable periscope out of a holdover project that Dad had shut down.

Robert and Phillip also enjoyed building and firing homemade rockets, a national rage at the time. They would dig a large hole in the

ground and use the periscope to watch the launch. Dad put a halt to the young rocketeers' activity after one of the pipe rockets blew up. The periscope was now used as a makeshift submarine periscope.

The conning tower contained an improvised steering wheel and assorted depth gauges and firing gadgets made from old car parts. The deck gun, my favorite innovation, was constructed from wood and resembled the shape and structure of a submarine deck gun. Phillip drilled a large hole meant to function as a breach in the barrel of the wooden gun. He then made stacks of artillery shells on his homemade wood lathe. The shells fit perfectly, sliding into the breach until they hit the wooden lip of the shells.

Phillip gave orders from the conning tower. "Now hear this. Now hear this," he would boom. "All hands on deck. Lock and load the deck gun. Prepare to fire."

I'd pick up a shell, push it into the breach, and pretend to lock it in place with an invisible latch.

"This is the captain speaking. One shot across the bow," Phil would order.

"Yes, sir," I would respond and pretend to fire a shot.

"Fire at will. Fire for effect," he would bark.

We played this game only once or twice. I think Phillip simply liked the act of building. After a project was finished he moved on quickly. Years later, after he graduated from high school, he began rebuilding classic cars, turning them into hot rods with souped-up engines. A '48 Mercury coupe with a V8 hemi engine was his first street rod. Later, when he worked in Reno, he bought a Corvette and with loving devotion transformed it into a street drag-racing machine, drilled for lightness and stroked and bored with headers, duel quads, and a roll bar.

Back in the living room Phillip and I were waiting for the end of *The Jack Benney Show*. Mom was writing in her diary—a daily routine she continued throughout her life. She would record the first freeze, the temperature, the last flower to die, the time the bus arrived in the morning, what flowers she planned to plant next year and at what location, and phone calls from her sisters regarding the health of a

child. She was anticipating the start of *The Lawrence Welk Show* and set down her diary.

Mom was relaxing in her favorite position: leaned back with her feet up on the couch. The couch was part of a light-blue, three-piece ensemble with a carpet-like finish. The ensemble had been placed in the living room after the flood but never seemed to fit the simple décor of a ranch house. Attached to Mom's couch was a built-in, highly polished table. On its surface and in easy arm's reach was an assortment of items used to keep a ranch family with three sons healthy and functioning. A vertical container on the table held a pair of scissors, a magnifying glass, tweezers screwdriver pencils, and pens. Lotion, alcohol, iodine, Band-Aids, and a tape measure were in another container in easy reach.

Katie was a gifted, brassy original, a one-of-a-kind renegade with wide-ranging abilities and interests. She adored innovative projects that revolved around her one true passion: growing plants. Mom never cared for housekeeping. She kept things clean and hygienic, but that was the extent of her housekeeping efforts. Scattered across the room were baskets of laundry and stacks of clothes. After Mom mopped the floors, she would lay down newspaper for us kids to walk on, extending the mop job a few extra days.

The Jack Benny Show ended, followed by a Chesterfield cigarettes commercial. The ad featured a three-foot-high pack of Chesterfield cigarettes with human legs extending through the bottom of the pack. The nimble legs with the pack of Chesterfields riding on top danced to a cheery tune, skipping across our TV screen.

"Danny, change the channel to 10, and let's see if we can get *The Lawrence Welk Show*," Mom said in a forceful voice. In those days you got three channels on a good day and maybe one on a bad day. We were one of the first families in the area to own a TV, having purchased ours back in the good old days. Installed on the roof was a twenty-five-foot-high metal antenna with support wires running to all corners of the roof. Mom knew she had better get the channel changed prior to the cowboy show or Phillip and I would start complaining.

My brother and I had discussed a plan of action to ensure access to

our favorite program. I was the designated TV adjuster. My part in the conspiracy was to foul up the reception of Mom's favorite program. Then, by default, we'd have to switch back to the honorable visage of Paladin, since he would be on the only channel watchable.

I obligingly flipped the channel to *The Lawrence Welk Show*. The program came in with only a slight amount of vertical interference in the form of a one-inch black line that started at the top of the screen and slowly moved toward the bottom of the set. In the background you could hear Lawrence Welk saying, "Let's hear the latest rendition from the Clark Sisters." You couldn't miss their boring matching costumes.

"Great, the channel's coming in pretty clear," Mom said before turning to me. "Danny, can you fix the vertical?"

There were only three adjustments on the TV to control the picture. I grabbed a knob and turned it until snow dotted the screen to mess it up a bit.

"Not that way!" Mom yelled.

I could tell from the intensity of her voice that there was to be no messing around on this evening. I fixed the picture.

The reception was good for those days. The Clark Sisters were dressed in the same corny outfits as always, complete with matching dopey feathered hats. Phil and I sat on the couch, bored and itching for trouble. We got into a footsie fight, which Mom had to break up. I slid past Mom and over to get a glass of milk.

"Sit still," Mom demanded. "I can't concentrate on the program."

Phillip pulled a coin from his pocket, and we fought over it.

"I warned you guys. Now it's off to your rooms." Mom pointed to the hallway.

"Mom, please let us sit here and watch," Phillip pleaded.

"Then sit still and watch the program," Mom reprimanded.

Lawrence Welk spoke to the audience. "Next up, we have a sweet couple singing their rendition of 'Old Susanna,' but first we have a station identification."

This was our chance; the moment Phillip and I had been anticipating.

As Mom got up for a bathroom break Phillip whispered in my ear. "Wait until she's in the bathroom, then change the channel."

As soon as Mom shut the bathroom door I turned down the sound and quickly flipped over to the other channel. There was Paladin with his gun drawn. We might've gotten away with a quick channel change, but Phillip and I so were immersed in studying the pistol and holster with the silver medallion that I was slow on the draw. Mom returned to the room just as I was changing back to *The Lawrence Welk Show*.

"What the hell are you guys doing?" Mom demanded.

I was nervous and having a hard time getting the program properly tuned. The screen was a mess of diagonals and snow.

"You kids have been asking for it all night long," Mom scolded. "You couldn't let me watch my favorite program in peace. Danny, go pick a switch. Phillip, go to your room," mom ordered, her eyes covered with an icy glaze.

I tried to get out of the whipping by ratting out Phillip. "He was in on it too!" I informed her, all but crying.

"Yes, but you changed the channel," Mom reprimanded. "Phillip, I said go to your room. The only program on TV I really like, and you guys had to ruin it for me," she continued, psyching herself up for the ensuing whipping.

Pick your switch was the most dreaded of all possible punishments. Mom had started using whippings more frequently, especially when Dad wasn't home. Dad never allowed us to be touched. Phillip was especially traumatized by the whippings. He was an easygoing guy and cried sometimes when I was getting one. I was becoming less afraid of that punishment since I'd devised an effective strategy against the pain. The first thing I learned was: Don't pick a long, limber switch. They wrap around you and sting and sometimes leave welts. Pick a short, stubby one, and make sure you pull off all the small branches flush to the main switch. The real secret for not feeling pain was to add an extra cushion between your pants and your butt. I had discovered the perfect cushion system six months earlier in a creative flash while on the way back from picking a switch. I was walking across the porch when I spied a pile of newspapers. A lightbulb flashed above my head,

and I tore off a section of the papers and began stuffing them into my pants. To my amazement it worked like a charm.

As time went on I enhanced my technique. Hidden in the back porch now was a stash of specialized newspapers which fit my butt perfectly. I used scissors to cut out pieces of newspaper until I had a pile tailor-made to fit the contours of my behind. A four-sheet-thick stack provided great protection. I practiced over and over again, getting the motions of opening my pants and sliding the paper into position down to ten to fifteen seconds.

I returned that day with a two-foot hedge switch and my fanny shield in place.

Mom was impatiently waiting and agitated. "What took so long?" she chided.

I handed over the switch.

She grabbed me under my armpit. "Turn around," she ordered.

I faced the TV with its three vertical stripes moving from top to bottom.

"This is going to hurt me more than it's going to hurt you," Mom assured me in a resolute voice.

I had learned another secret by then: Don't struggle. Let her flail away at her mark. If she missed you might get hit on the legs, and that really stung. The first whack didn't hurt at all. The noise the switch made against my rear reminded me of the sound of a rug being beaten. I figured I had better start acting the part soon. On the second stroke Mom upped the power, and I grimaced and let out a convincing "uhhh." On the third stroke I moaned out a blood-curdling "oh-ehh-ahhh." On the fourth stroke I let out the same three-syllabled cry but at a higher register.

It was too much for poor Phillip. He emerged from his room and stood in the hallway. "Mom, please. Mom, please," he begged, eyes welling up.

"Get back in your room, or you'll get one too," Mom threatened.

As much as I loved brother Phil, I never let him in on my newspaper-butt-protector secret.

I don't know what Mom's thoughts were when she punished us, but

I imagine that it probably went something like this: "By God, these kids are going to learn discipline and behave one way or the other."

Corporal punishment was a very effective way of keeping us in line, but if I could change one thing about our upbringing it would be to be get rid of the whippings. I loved many of my mother's qualities. She was an exciting teacher, and we had a lot of good times. Katie buttressed and reinforced me in my long struggle to become an artist. She believed in me when everybody else gave up. However, I wished the whippings never happened.

Looking back on those days, I think those punishments were an expression of Mom's frustrations and disappointments. She had unachieved life expectations. I believe she wanted to finish college and become a professional, something that would showcase her skills, maybe a botanist. Her difficult, truncated childhood added to her aggravation. Katie's best friend, Dorothy, a weathered-faced lady with moist brown eyes, told me on her deathbed that my grandmother, Jelena, died as a result of a fight with a neighbor. The neighbor threw a rock, which struck Jelena in the leg. Grandmother later died of complications from that simple injury. Katie was only fourteen when it happened. As tragic and unbelievable as that may sound, it helped me understand my mother's unusual behavior and helped explain her outbreaks of anger and animosity toward our neighbors.

Mom possessed many clear-cut academic skills. She believed that the Leko clan inherited a superior set of genes and was industrious, efficient, original, and perfectionists by nature. There was no doubt that my mother demonstrated unique abilities and was intelligent, a nonstop worker, and owned an unstoppable will. However, her people skills needed work. Mom had no patience for ignorant people. She believed that if you did something stupid it was your own fault, and she didn't mind telling you so. In her opinion the best way to get ahead was to be smart, work hard, and get educated. She struggled to get along with folks, especially our neighbors. They could be decent people and Mom would still find something to hold against them. If I received a bad grade, she'd drive to school and tell off the teacher. She would find something wrong with one of my friend's parents.

You can't imagine how weird that would make me feel. If I received a bad grade, it was probably because I deserved it. On the flip side, my mother could be very generous and loyal to those she loved. There wasn't anything she wouldn't do for her closest friends. As a child I never really understood Mom's behavior, but I ultimately came to believe that it was caused by unresolved childhood anger issues.

Being surrounded by head cases was probably an asset to my art career. I found ways of working around self-absorbed, unreasonable, and egotistical people. My childhood was great training for grasping the neurotic psychology of some art dealers who years later became such an important part of my art career. By that point in my childhood Mom and Dad's marital problems were coming to a head. One night my brothers and I were out of the house attending Boy Scout meetings and other functions. Dad came home for a quick visit and got into a row with Mom, tearing up the living room, throwing things around, and overturning furniture. The next day Mom approached me as I was playing with Sammy on the driveway and asked, "If Dad and I were to separate, who'd you want to live with?"

I thought about it for a couple of seconds. "Dad," I declared, wounded. A few days afterward I began to put together a plan to run away. Sammy and I would escape together. Somehow we'd travel ten miles, cross over the Marysville Bridge, and then make our way to the unpopulated foothills. Once there Sammy and I could live off the land. I thought about it for a couple of days but couldn't figure out how the heck we could travel the first ten miles to the bridge. Figuratively speaking, it's as though I took a selfie on that day, and it was placed on the backs of milk cartons. I was lost and wouldn't find my transcendental home for another twenty-five years.

The middle part of grade school and my high school years were the most difficult for me emotionally and scholastically. Unmet goals and lack of success damaged my self-esteem, resulting in a slow, burning angst and eventually molding my socially isolate and nonconformist persona. I was a late bloomer and didn't do well in school until I entered college much later in life on the GI bill. I worked my way through grade school, receiving average grades. I was a lazy student.

Occasionally I'd do well in a subject such as history, receiving the best grade in the class on a single test, only to fall back to average on the next one.

During grade school, teachers singled me out as possibly having art talent. I've concluded that maybe one in twenty people have the inherent talent to become an artist. For the exceptional artists the ratio is maybe one in a thousand. Beyond talent, it all comes down to tempering, education, and whether the Art Gods favor you. In my case, I was born with an appreciation for art, understood it as well as it could be understood, and had a fair ability to learn history and art techniques.

My fifth grade teacher, Mr. Robison, who later became the superintendent of the school district, took an interest in me, no doubt for two reasons: I looked Irish and was the only kid in the class with more freckles on his nose than he had. Mr. Robison admired my fiery quality, which had caught his attention a year earlier on the playground. Jared, a blond, blue-eyed kid, was emotionally challenged and one grade above me. His father's heart-wrenching suicide left Jared mentally adrift. One day we were playing a baseball game called "workups" during lunch recess. Jared hit a screaming liner with his bat. I made a lucky jumping catch, snatching the ball in midair.

Jared ran out to second base where I was standing and started shoving me. "Why did you catch it? Why did you catch it?" He kept repeating as he pushed me.

I got him in a headlock, dropped him to the ground, and rubbed his face in the dirt. I remember the look on his face. Tears were running down his cheeks, and debris from the ball field stuck to his wet lips. I did it because I was tired of being pushed around.

Mr. Robison grabbed my shoulder, pulled me back, and said, "That's enough. Enough, Danny." Mr. Robison later told my mother about the incident, telling her, "Danny is as tough as wire."

That was my first fight. Later in life I developed a fondness for fighting. It relieved my frustration and made me feel alive and in control. Brawling ended disputes quickly and allowed me to take what

I perceived to be mine. Scrapping became problematic as an adult, as I began to overuse it as a means to resolve problems.

Mr. Robison pulled me aside during an art class and handed me a landscape pencil drawing. It was a typical scene of our region and depicted mountains, pine trees, and a meadow.

"Danny, try to copy this drawing," he instructed.

It was quite an honor. I was the only student ever to be released from one of his class assignments to work on a special art project.

The last year we received a major harvest from the Larkin Ranch was in 1958, three years after the flood. The harvest season started well. Phil and I camped out in a small yellow trailer parked under a large walnut tree. I was twelve years old and now had a gap between my two front teeth. In summers past we had stayed in the house located on the ranch, but now it was rented out to friends to bring in extra income. Phillip and I didn't mind the trailer. In fact, we liked the freedom it gave us. On the radio Bobby Darren blared out his latest tune, "Mack the Knife."

Oh, that shark, babe . . . has such teeth, dear . . . and he keeps them . . . pearly white.

Inside the trailer we began making unusual discoveries such as old brown bottles of prescription pills and small, blue, stripped pill boxes in the drawers. Two years earlier an old friend of Dad's had lived out his last days in the trailer before passing away in the hospital. Phillip and I should have taken that as a sign and ran off and hid in the river bottoms.

Phillip, now seventeen, had been given a new job and was now allowed to swamp with the adult farmhands. Phil had a pleasant smile and was as strong as a horse, sporting a six-foot frame with powerful legs. In the old days Dad raised us kids to be gentleman farmers; the only job we performed was driving the farm equipment. But this was a cost-cutting measure Dad was now implementing to hold on financially. After the morning harvest, we'd go for a swim to cool down in the canals. To finish the day, we'd hike down a country road an eighth of a mile and enter the back of Christensen's private fruit orchard. We picked bunches of grapes and then strolled home in

the cool evening, eating the fruit, spitting out seeds, and enjoying the end of the day.

I believe those seeds were what brought about Phillip's appendicitis. Phillip woke up two mornings later complaining about not feeling well. His illness was a startling development, since we had been taught to keep ourselves healthy. We simply could not afford doctor visits. I only visited a doctor twice as a kid. My first doctor visit was a result of almost putting my eye out with a homemade Argentine bolo copied from a TV cowboy show. The second time I saw a doctor was after a hallucinogenic reaction to a diphtheria shot. The evening after that shot I had staggered into my parents' bedroom and hallucinated two-foot wasps flying in a linear formation just under the ceiling. I then wandered into the bedroom Phillip and I shared and spotted a black panther sitting on top of my dresser. I implored Phillip to find Dad and "get the .30-30 rifle and kill the panther."

"Where is it?" Phillip had asked.

"On top of my dresser," I whispered. On my dresser was a folded pair of black jeans, which, in my delirious state, clearly looked like a panther.

Phillip walked over and picked up the jeans, letting them unfold.

I then looked out the bedroom window. On that wintry night the moon was full and the wind ruffled through the branches of a tall black walnut tree outside our bedroom. The high bare branches shimmered and shined like white water in the moonlight. I gazed at the flickering reflection of the moon glaring through our bedroom window, pointed to the walnut tree, and stated, "There's a giant waterfall outside our window." Later that night they dashed me to the hospital.

At the Larkin Ranch, Dad gave Phillip the day off. Phil lounged about and complained about a pain in his side, saying he didn't feel well. He wouldn't eat. Dad called Mom and asked what she thought.

"Try to feed him ice cream," Mom suggested. "If he won't eat I'll pick him up and take him to the hospital." Later that day, Mom rushed Phillip to the emergency room. His appendix had already burst, and bile had spilled into his abdomen. The doctor gave him a fifty-fifty chance of survival. When the heavily built doctor tried to

help Phillip onto a gurney, he snarled, "Get your fuckin' hands off me, Robert."

I was not allowed to see Phil until three weeks after the operation. When I visited him at the hospital he was a ghostly sight and didn't resemble the brother I knew. He had lost forty pounds, and his eyes had sunk into discolored eye sockets. You could see the outline of his skull. A transparent tube ran from his abdomen, and a tiny pump propelled green, slimy stuff from his stomach along a six-foot transparent tube into a glass receptacle. His hospital stay lasted two and a half months.

Finally, he came home to convalesce, and I became his nurse for a couple of months. Mom instructed me to keep Phillip away from ice cream. Of course, Phillip begged me to bring him ice cream.

"No ice cream. Mom will kill me," I told him staunchly before quietly adding, "but we have pink lemonade in the freezer."

"Let's make some and not tell Mom," Phillip suggested. Phillip drank glass after glass of the sweet lemonade. He finally lied down and said, "I'm not feeling well." In about five minutes all that pink lemonade came gushing out of him in a solid stream, like a three-inch water faucet turned all the way open. The regurgitation was the same color as the pink lemonade but with a slightly greenish tint. He moaned and groaned on his bed until I called Mom, who picked him up and returned him to the hospital. I didn't get in trouble, but Phillip's operation and long stay in the hospital was probably the last straw in our depressed financial situation. After that season, we had problems paying the taxes and began selling off parts of the Larkin Ranch. At that point we were officially through as farmers.

A few years of stark poverty were all Mom could take. She attended a local junior college for two years, received a degree in accounting, and began keeping the books for an auto parts store in town.

In the latter part of grade school my unconventional personality was becoming more pronounced. My seventh grade teacher, Mr. Bentley, was tall and gangly, a straight-laced guy, a cleanliness freak, and a bit of a highbrow. He never really cared for me, the scruffy-looking, spotty academic achiever. I even wore a greased-back duck

cut, short on top and long on the sides. Mom cut our hair, and this was one of her better styles. I used abundant amounts of grease squeezed from a tube, and with the help of a comb I would plaster the sides straight back. Staying in character, I befriended a number of ostracized foreign students and other eccentrics in my class.

During this fateful year in school I showed the Art Gods my artistic potential, and they bestowed upon me encouragement. I made my first sculpture in seventh grade; it was the epitome of my resourcefulness.

Mr. Bentley had announced to the class that we were going to carve a sculpture. We were instructed to bring from home a half-gallon milk carton filled halfway with solid plaster of paris. Then, as a class, we would carve a sculpture out of the plaster block at school. Our family was dirt-poor at the time and didn't have enough money for the necessities. There was no way I could ask Mom to drive ten miles into town just to purchase a bag of plaster. I scoured through our supplies around the ranch and found a cup of clumpy, dried-up plaster of paris in the bottom of an old bag. To get enough materials for the project I mixed in a cup of equally old, dried-up cement from another bag. I broke up the lumps as best as I could, added some water, and stirred in circles with the same frenzied passion as two dogs fighting.

The cured block revealed an interesting texture as a result of air pockets and bits of cement exposed on the surface. It was a grayish color, the right size, and seemed moldable. I had studied primitive sculpture from our encyclopedia the previous night and had a plan on how to give the sculpture relief, line, and contrast. In the classroom, I accentuated the given shape of the block and carved a primitive square head with eyes, nose, and lips. Then I carved in lines to represent stylized hair. Inserting another design element, I rubbed a chalky black color onto the head for its hair.

When the class project was completed the students lined up the creations on a large table and voted on the best. I won unanimously. Fellow students wanted to know how I did it. Mr. Bentley, who had issues with my inconsistent academic achievements and uncommon

behavior, had to admit that the head was remarkable. He spoke about my sculpture in front of the class, saying, "It's really very noteworthy and different. However, it may not be fair to the kids who followed the instructions."

That sculpture was the epitome of my original style and offered a revealing insight into my disposition. I was born to do things differently. Looking back on that incident, I really haven't changed all that much. Over the years I've added experience, knowledge, and skill to my artistic persona. However, the attributes shown in my seventh grade class exposed my qualities as an artist and divulged my atypical temperament. If the Art Gods were watching that day they gave me a thumbs-up. They sent out their beacon, and I was receptive. I was one of the lucky ones—or one of the ill-fated ones, depending upon your viewpoint.

This might be a good point in the memoir to clarify my beliefs concerning the Art Gods. I view the Art Gods as guardians of humanity. Their job is to use art as superglue, bonding together culture and civilization. They embrace art and artists as enablers and agents of peaceful transformation. I see the Art Gods as a natural force of social evolution and change.

The world seems to be divided into two kingdoms, one made up of those who have faith in divine creation and the other of free thinkers who believe in science and technology. My spiritual beliefs are an eclectic blend and reside someplace in between these two vast realms. If such big questions are not confusing enough, add art to the mix. Art is an example of a human mystery that defies explanation. I believe art is a manifestation of spirituality, cloaked in mysticism. Another way of thinking about art might be as follows: Art is the nearest thing we have for getting it right and keeping it real. However, after forty years of trying to figure art out I have come to simply attribute it to a higher power: the Art Gods.

I don't imagine the Art Gods as bearded deities in the sky, such as the ancient Greek god Hephaestus, who was the patron god for sculptors, the god of fire, and the deity who bequeathed creative skills to artists. I see the Art Gods more in genetic Darwinian terms. I

believe these gods reside in our bodies, in our minds, or in our DNA as agents of cultural progress, social bonding, and peaceful change.

Where else could the Art Gods dwell? Possibly they exist in another dimension that only interacts with ours in the form of art. Perhaps they are trying to communicate from another part of the universe; only art can travel the vast distance, and we can only hear them knocking when inspired music is played. Maybe art is the residue of an advanced civilization's collective scream, released when they were sucked into a black hole and shot out into space. Possibly art is a universal truth, a measuring rod, placed here to gauge the height we achieve as a species. Who knows?

The only holdover from the ancient Greek and Roman gods that I think is relevant today is faith and belief in the unknowable and the role artists play in the ongoing cultural endeavor of art. I do believe artists carry the flame of change, similar to the art cult rituals from ancient Greece. When one artist is through, he or she passes on the art torch to the next capable artist.

Don't mistake or confuse the Art Gods with Mother Teresa. The Art Gods recruit talented and driven individuals for this demanding job. Many of the artistic recruits, who accept the challenge, have flaws in their weave. It doesn't matter to the Art Gods if the recruits are social misfits, deviants, drug abusers, sexually maladjusted, mentally erratic, or lousy mothers and fathers, or live short, depraved, miserable lives and die of cancer. The Art Gods' only concern is the artist's ability to carry the art torch in order to keep society stitched and joined together. If an artist catches on fire while carrying the art flame, the Art Gods are willing to sacrifice that individual for the sake of the greater good.

FLOWER GARDENS OF BOZRAH

INDIRECTLY, MY MOTHER taught me the most about being an artist. From her I learned how to be dedicated, persistent, preoccupied, innovative, and experimental. Katie taught me how to think and conduct myself like an artist at an early age. She was an artist in her own right, and cut flowers were her medium. Ever the perfectionist, Mom was a musician when it came to growing flowers. Money was short after the flood, and her obsession with growing flowers evolved into a dubious moneymaking scheme. That endeavor continued in earnest for ten years and even went on while she was employed first as a bookkeeper and then later as a state of California employee for the Department of Transportation.

The California County Fair coffers were full as a result of horse track racing. A percentage of the gambling earnings was allotted to all county fair districts. Each fair had a cut flower division. The county fairs offered 150 to 250 different categories for cut flower entries. The prize money was three dollars for first place, two dollars for second, and one dollar for third. Mom entered cut flowers in three surrounding counties. Many times she won first and second sweepstakes for exhibition flowers under her name, as well as under Phillip's. In the lean years after the flood and until she went back to work full-time, she earned more money exhibiting cut flowers than we made as farmers. I was her intrepid helper, especially during exhibition season.

To make room for Mom's new daring enterprise, she enlisted

Phillip and me to tear out the front lawn and—to my Dad's utter exasperation—to cut down and burn the hedges as well. Phillip especially enjoyed demolishing the eight-foot prickly hedges that had produced so many switches over the years. Both of us gleefully burned the bushes. Later Phillip disked the roots under the ground with a tractor. Where once our lawn had grown now stood rows of dahlias, marigolds, gladiolas, fox tales, coxcombs, daisies, delphiniums, asters, coleus, cosmos, digitalis, alyssums, and other vibrant varieties of cut flowers. Any suitable growing area around the house was utilized. Begonias and geraniums grew on the shady side of the barn. The four-foot-high earthen loading dock, used to unload heavy tractors in the old days, now sported rows of colorful petunias.

It took Mom a couple of years to get on a good roll. She learned how to grow and then specialized in dahlias, the grandest of all flowers in the cut flower division of the county fairs. That was a considerable achievement, considering how difficult it was to grow dahlias in the valley heat. The best dahlia bulbs came from Holland, packed in boxes filled with vermiculite. The boxes would arrive by post with ten or fifteen exotic Dutch stamps attached. We would open the boxes and vermiculite would spill onto the kitchen table. Ten to fifteen light brown bulbs, which looked like sweet potato bulbs but were longer and skinnier, would emerge from the spilled sea of minerals. Dahlias came in more colors than any of the other cut flowers in the divisions: pink, salmon, red, peach, lavender, purple, white, yellow, rose, and variegated. Miniature pompon dahlias were sized and shaped like golf balls. The next size up, comparable to large baseballs, was the three- to five-inch pompon. Cactus dahlias were in another category and were shaped like pinwheels, with each individual flower petal ending in a sharp point. But the grandest of all were the formal dahlias, which could reach fourteen inches in diameter. The categories and colors of that flower seemed endless. In later years Katie hybridized and exhibited her own varieties of dahlias.

Mom was sustained in life by her desire and ability to grow beautiful flowers. She was profoundly devoted and made every sacrifice to grow a better dahlia. Phillip rototilled the soil, which we then sterilized by

spraying on a stinky fungicide, Vapam. Phillip and I then covered the ground with large, black pieces of plastic, fumigating the underground nematodes. We drove supporting posts into the ground, providing a buttress for the flimsy dahlia stalks. We laid irrigation pipes and flooded the areas designated for growing new flowers. Bulbs and tubers were planted in the springtime and dug up in the fall. The flowers had to be sprayed, fertilized, irrigated, and babied beyond all reason. In the shop I redesigned plywood peach boxes to make seed-starting flats. With Phillip's guidance, we remodeled the back porch into a greenhouse.

When Katie would tiptoe down a row of dahlias, the largest of which reached over her head, she would vanish into the green foliage, only to reappear twenty feet later at the end of the row, her face emerging from behind large dahlia blooms. A typical large dahlia plant had seven blooms in different stages of maturity. On the ground and in between the plants grew thick clumps of Bermuda grass, knotted around the dahlia stalks as a result of overwatering—the only way to keep dahlias alive in the valley heat.

In the daytime, if you drove past our place on Township Road, the ranch looked like a rundown botanical garden run by a nutcase. Everything was haphazard and out of alignment. Flowers were grown in areas where the soil and lighting conditions were ideal for a particular plant but never in a symmetrical format. A mound of one-gallon cans lay here, a heap of black plastic against a walnut tree there. Unruly piles of stakes bordered the garden. An old kitchen table placed in the middle of the garden functioned as a workbench. Katie used pink nylon hosiery that she bought at junk shops to tie the dahlias against the tall support stakes. Dozens of nylon stockings blew in the wind like tiny flags. As muddled as it all appeared, there was a method to Mom's madness. She used nylon stockings because they were flexible and soft on the dahlias' stalks, especially when the north wind blew. In Katie's mind all the clutter was acceptable. Her only concern was growing the best possible cut flower.

Clutter and randomness seem like two common traits to creative people, and I've displayed both throughout my artistic career. It never

occurred to me until years later, when my older brother Robert visited my art studio in Hawaii and made the observation: "The way you have the place laid out reminds me of how Mom did things."

My indispensable job throughout the years was helping Mom during flower exhibition season, which took place during the hot summer months. One time Dad came home for a surprise visit ahead of exhibition week. It was afternoon; Mom, Dad, and I were in the kitchen. Dad opened the refrigerator and pretended he was looking for something to eat. The fridge was packed full of stored cut flowers wrapped in cellophane.

"What's the big deal with posies? You can't eat them," Dad said to me playfully within earshot of Mom. "Danny, go out in the flower garden and find a coffee cup. There doesn't seem to be any left in the kitchen," Dad instructed me with playful eyes, laying down a frisky blanket of harassment.

"Son of a bitch . . . bastard . . . fucker," Mom said, eyes ablaze. "You can't let me do this, can you? Crazy and mad both. Why don't you find some hooch and get lost in the desert with your rummy friends? Maybe we'll get lucky this time and the whiskey heads will stumble into a ravine of glowing uranium and burst into flames," Mom growled, just getting warming up. That day Mom threw a far-reaching cussing fit so masterfully composed and delivered that Dad cleared out for a month.

A trip to the county fair began at four-thirty in the morning. We started out in the predawn coolness; however, the day would eventually progress into a baking hot valley afternoon. Mom woke up early, having decided which flowers to pick the previous night. With a flashlight in one hand and a paring knife in the other she carefully traversed the flower garden, picking only the freshest flowers well before the sun rose. The flowers had to be transported and exhibited by eleven o'clock in the morning. Then, the entries were professionally judged.

She picked the flowers and placed them in one-gallon tin cans, organized by type, color, and size. It was my job to load the car. I pulled the backseat out of the Chevy for more space. Then, I delicately

packed every square inch of the car with flowers, placing makeshift packing materials between the gallon cans so they wouldn't spill. The last flowers to be loaded came from the refrigerator. Mom used our family fridge to store the cut flowers, prolonging the life and freshness of the hard-to-grow exotic varieties. If you opened our refrigerator door during flower exhibition season you wouldn't find milk, just dahlias wrapped in cellophane—or my favorite: large red cocks combs, which had few blooms during the season but kept for weeks when refrigerated. When the day's entries of cut flowers were packed I would take my position in the front seat. Between my legs would be cans of zinnias or pompons. I hand-held the most delicate flowers, mainly the gladiolas wrapped in cellophane. They were so fragile that if they brushed up against something hard the pedals would bruise.

We drove through the predawn hours to the adjacent Colusa County fairgrounds, arriving when it was just light enough to see. There was always an overall calm and quiet around the grounds. Abundant open spaces with lush green lawns grew in between the exhibition halls. It was quite a contrast to the frenzy of flashing lights, noise, movement, and uproar of the fair crowds that had ruled the fairground just seven hours earlier. The section of the fairgrounds containing the rides would be packed. At night time the carnival grounds were so overflowing you could not walk five paces without bumping into someone else's shoulder or colliding with a kid blind and dazed with excitement. There were twenty rides, which included the Ferris wheel, the octopus, bumper cars, a house of mirrors, flying swings, the carousel, the crazy snake, and, for the brave, the hammer. Screams slung out of the diabolical spinning hammer, echoing the shrieks pouring out of the ride below: the whirling, ululating octopus. From the half-sphere of the motorcycle cage, unmuffled engine noise tore through the surrounding howls as a daring young man rode his motorcycle at such a blazing speed that he could be kept upside down and aloft at the top of the steel meshed cage by centrifugal force. The sticky sweet aroma of cotton candy, taffy, lollipops, and fruit-flavored ice cones enhanced the nighttime jubilee of extravagance. But in the

first light of morning, all was quiet except for a small cleanup crew and a few carnies recharging on coffee and using the bathrooms.

The flower exhibitors competed passionately over the limited resources at the fair, and my first task upon arriving at the exhibition hall was to secure worktables, stack them with exhibition containers, and fill those containers with water. My second task was to unload the fragile flowers and place them in the shade.

After that, the intense part of the job began. I stuck close to Katie, functioning as her second pair of hands. She'd tag sixty individual flower entries, which I would then run to the exhibition hall two at a time with one in each hand. Exhibiting flowers was a tough act owing to the hall closing at exactly eleven o'clock in the morning. Then, the doors would lock, and no more entries would be received.

It was ten-forty on one particular morning, and I was anticipating Mom's every move, knowing we had only twenty minutes remaining to tag and deliver the remaining entries.

Mom was keyed up. Every movement she made was well orchestrated. She turned to me with a glove on one hand and a pair of flower clippers in the other. "Danny, I need containers for the large formal dahlias," she anxiously requested.

I returned with eight large display containers, placing two containers within easy reach of her hands.

"Good," she said. Katie was pluming a large, fourteen-inch formal dahlia. She cut off excess vegetation on the stalk, turned the dahlia around, and pulled out a couple of older discolored petals from the back of the flower. She then placed the prepared flower in one of the containers and reached for an equally beautiful flower to place in a container next to it. "Danny, come around here and take a look at these two flowers. Which one is best?" she asked.

I swung around the table so I could see the front side of the two flowers. "What color is it supposed to be?" I asked.

"Salmon," Mom replied.

I had an instantaneous feel for the better flower based on its shape, the freshness of the bloom, the supporting foliage, the angle and hardiness of the stem, and the brilliance and correctness of the color.

With just a glance I soaked up every element and sized up the overall impression given by each flower. "This one," I said, pointing to one flower.

"I think you might be right," Mom agreed as she placed an entry stub at the base of each of the two containers. "One of these has a chance to be the flower of the day," she told me, making sure I realized the importance of these potential winners. "Double-check the section when you get inside," she instructed, then quickly moved on to other flowers. The entry stub was about the size of a playing card and read: Class 103, Section: Formal Dahlia, Color: Salmon. I folded the entry card in half and slid it under a rubber band bound around the tall display container. I picked up two containers, one in each hand, danced around the other exhibitors, and moved quickly toward the flower hall.

Upon entering the exhibition hall there was a transition from disorder to order and from hot to cool. Outside, the early morning freshness had begun to subside, and the initial signs of a blistering one-hundred-degree day were becoming apparent. However, the morning freshness still prevailed inside the flower hall. The concrete walkways had been recently squirted with a hose, and a garden-fresh, moisture-laden aroma permeated the entryway. A composed, long, willowy, gray-haired lady greeted me as I strode past the hanging-plant section. Large green ferns and potted begonias hung on hooks; underneath them the ground was covered with gray, pea-sized gravel.

She was raking the gravel Japanese-style as I entered the building. "Dahlias are all the way back and to the right," she directed me.

"Thank you. How much time do we have left?" I asked.

"Fifteen more minutes," she replied.

A mixed vegetative fragrance saturated the flower hall. I passed through various sections of exhibited flowers. The sections were most notable for their uniformity of color, making it easy to locate subdivisions. There were eight colors of petunias, including lavender, purple, pink, white, and variegated red. I hurried through that division. Zinnias populated the next section, their psychedelic colors electrifying the whole building. I arrived at the formal dahlia section

and spotted the salmon-colored subdivision. My task was to display my containers amongst the seven other entries. I positioned the container in a spot where the judge could advantageously view the flower. My last act was to lift the flower up a couple of inches in the air, adjust the supporting foliage, and set it back into the container, facing the judge. This activity taught me a valued art lesson at an early age: presentation.

There were other indispensable art-related lessons to be learned as Katie's helper. Most importantly, I learned objective observation skills. One of the hardest things for an artist to learn and apply is the ability to look at their work objectively—to see his work as it actually appears. Not the way you visualize it, mind you, but the way it actual *looks*, as though you are standing back and observing your own artwork for the first time. When Mom asked me my opinion on which flower looked best she was helping me develop critical observational skills based on objectivity, knowledge, and instinct. Looking back, I didn't mind helping Mom exhibit flowers. Mom respected my working abilities and she always rewarded me for a job well done. Besides, she was so passionate about her plants, it was a small amount of effort on my part to bring so much joy into her life.

Mike Hummel transferred from a downtown school into my country school's seventh grade classroom. Soon we became close friends. That friendship filled the void of me losing my brothers' camaraderie. Robert went off to college in Reno and Phil would soon follow. Mike's friendship ended my monotonous, dreary social isolation, and filled my life with companionship and adventure. Mike was handsome, well mannered, and at the time an all-American boy. He looked like a surfer with his blond hair, light-blue eyes, and mouth full of perfect white teeth. His father John stout and rugged, belonged to a sheet metal workers union and was an avid outdoorsman. Mike's family had purchased a twenty-acre almond ranch and moved in, embracing their new country lifestyle. Their ranch, only two miles away from my house, was an easy bicycle ride away and became my second home. We had many things in common, but mainly we were both mechanically inclined and liked sports.

We attended Boy Scout meetings, loved the outdoors, and became inseparable hunting buddies. Only war outranks the hunt in building men's brotherhood. The best hunting grounds began west of my place, in the spread-out expanse of the rice fields. I introduced Mike to my hunting grounds, and he introduced me to his pleasant, hospitable family. Mike's father, John, a well-portioned large man with light blue German eyes, enjoyed taking us out on late-night catfishing trips and overnight duck hunts. We would ride to the Sutter National Wildlife Refuge in a van and spend the night preparing for the early morning duck hunt. Mike and I stayed up most nights playing cards and loading our own shotgun shells. One of our specialty shotgun loads was called "the skyscraper." We loaded the shells with extra black powder and 00 buckshot. The skyscraper load was designed to bring down high-flying ducks. We would wake up early, and in the predawn darkness trek to the hunting grounds, generally bagging a couple of ducks each in the morning shoot. Our close friendship lasted another six years, until we were both drafted into the U.S. Army. Mike served in Vietnam. He was never the same afterward, just as I was never the same after my Army hitch.

DRAWERS FULL OF SILT

I HAVE TRACED MY nonconformist rebel stance and underdog view of life to an incident that occurred on the ranch when I was in eighth grade. After a twenty-minute bus ride from school, the bus dropped me off at a crossroads where Sammy was patiently waiting. We hoofed it the eighth of a mile to the ranch. The house was empty when we arrived. I deposited my schoolbooks, which were not touched again until I woke in the morning and caught the school bus. I changed into work clothes and set about the day's chores. It was a spring day in May 1960, and my first task was to grease the centrifugal pumps, which ran day and night irrigating the peach trees. I grabbed a shovel, threw it over my shoulder, and headed toward the wooden pump house. Sammy escorted me as I rambled along, jumping from ridge top to ridge top. The trees leafed out in the springtime and now were more rounded. When we arrived at the wooden pump house, I entered the small building and descended two steps down, arriving at a platform that held the large electric motor and the centrifugal pump. There was another eight feet of damp, empty darkness below the platform prior to hitting the dirt bottom. That additional space was needed on drought years to lower the pumps. The interior was noticeably cooler and filled with a high-pitched humming sound. The belt-driven system vibrated the platform I stood on. I always carried a special stick when entering the pump house to avoid the many black widow spiders that inhabited the moist, dark, musty interior. I twisted the grease caps a couple of firm turns, forcing grease into the bearings

of the humming electric motor. Then, I turned more grease into the bearings of the centrifugal pump.

Upon exiting the pump house I'd stride the few steps necessary to a faucet for a drink of fresh water. The faucet was attached to an eight-inch steel pipe containing the water pumped from underground. Sometimes I'd take five minutes of pleasure for myself. I'd lay down with my back up against the water pipe, which was made cool and moist by the freshly pumped water. As soon as my back touched the moist pipe my arousal began. I would then open up my pants and pull out an erect Mr. Johnson. To my right was a water tap, which I would open slightly, using the pristine water for lubrication.

That day, after a dozen euphoric power strokes, my young prostate blasted out a tightly wound luminous load that would arch through the air, splattering on the dusty ground and setting a new record. It had been a few days since I'd choked the chicken, and pressure had accumulated. I cleaned up with fresh water, and five minutes later I was back at my job irrigating the trees.

My task was to monitor the water, making sure the trees were sufficiently irrigated. Two-foot-high ridges ran in between the tree rows. As soon as one row of trees was flooded I'd switch the water over to another row. Upon finishing my chore in the orchard Sammy and I hiked toward the dirt road that separated our place from our neighbor's. As I walked along the ridges it became obvious to me that our orchard was not being properly maintained. There was an abundance of hog weeds growing along the crests of the ridges, and Johnson grass had sprung up around the young peach trees. Only Dad knew how to properly grow trees, and he had lost interest in farming.

When we reached the dirt access road I noticed our neighbor, Mr. Petrovic, driving toward us. He pulled up alongside me and stopped his white pickup, kicking up a cloud of dust in the process that drifted by me and Sammy. His name was written on the door in classical lettering. I remember that he was short and affected by a noticeable limp. Mr. Petrovic, who had achieved financial success developing properties in the Bay Area, cashed out and decided to get into farming

orchards. Ranch land was cheap and plentiful in our area after the flood. Mom called him a "modern-day carpetbagger." He may have indeed been a carpetbagger, but when it came to ranching he was modernized and up-to-date. He hired a bilingual Mexican American foreman to oversee his large operation and was no slouch when it came to politics. He was one of the elite ranchers who used Mexican nationals (braceros), contract laborers from Mexico, as field hands. That exclusive program brought increased wealth to growers such as Mr. Petrovic but poverty to the hard-working Mexican labors. He housed the field workers in a building separate and distant from his lavish ranch house, which included a main house with courtyards, professional landscaping, and a swimming pool. The building that housed the Mexican farmhands was our former fourth grade elementary school room. Politically astute, Mr. Petrovic had acquired the building from the school district, transported the large, self-contained building three miles, and placed it on his property.

My mother detested him and called him "a mean Serb son of a bitch." Mr. Petrovic was a second-generation Serbian. My mother was a second-generation Croatian. If it wasn't enough for those two Yugoslavian minorities to fight it out in the old country, they had to carry on their tribal fighting in a different country half a world away and in a brand new language. Mom's yelling and cussing always made me feel uncomfortable, especially since Petrovic's well-groomed son Matt was in the same grade as me.

Looking through the window of his stopped pickup, Mr. Petrovic greeted me the same way he always did. "Dangerous Dan. How are you doing?" he inquired.

My standard reply was "Fine." I continued that tradition as I leaned on the shovel.

"If your parents want to sell, I'd be willing to buy your place," he casually revealed, then made some idle chitchat and continued on his dusty drive.

I'm not going to tell anybody about this, and why in the hell is he talking to me about this sort of thing? I thought to myself. *Can you imagine the fit Mom would throw? She'd go on for days. Mom*

had initially cussed out Mr. Petrovic for cutting back the shade trees next to our house in an effort to give his prune trees more sunlight. Now, Mom started cussing every time she thought about the tree incident.

I rid myself of such thoughts and continued my trek to the house with Sammy. I was two hundred yards from home when I noticed a strange vehicle parked on the dirt road. Two strangers carrying work tools were moving about. Stealthily I worked my way toward them, using peach trees for cover. I got about a hundred yards closer and spotted a truck with a large trailer parked along our property line. Two men were busy working on our Ford tractor, trying to get it started. I knew something wasn't right, but I didn't think they were trying to steal the machine. I heard one of them say, "Get it started before someone shows up."

I revealed myself and asked, "You guys trying to get it running?"

The stocky man in charge looked up and said in an authoritarian voice, "We are taking it back to the dealer. Your dad can fill you in on the details. We will be out of here shortly."

I realized that something awful was happening. They were repo men. We were in such bad shape financially that we could no longer afford the small monthly payment on our used Ford tractor.

That is the kind of thing that gets pushed way down inside you, injuring the heart. I don't think the incident affected the rhythm or cadence of my heart; however, I do think the episode affected the way I interacted with society for years to come. My self-esteem may have taken a hit, but my foolish pride definitely shot up to compensate, morphing me into a socially rebellious, emotionally alienated teenager with moderate juvenile delinquent tendencies, a social rebel who began fostering a desire to prove himself as something different and unusual.

The incident seemed unfair, and I knew it would push my proud father further down the stepladder of despondency. In some mixed-up way the event made me feel weak, but it also made me stronger. The compensating behavior I developed during my teenage years eventually evolved into endurance skills, sustaining me as an

artist in the years to come. If the Art Gods were watching, they most likely said, "This could work for us."

Two months later, in the midst of my drifting social malaise during the eighth grade, I experienced my most unforgettable childhood moment. Yo-yo season was coming up and was very popular. I had a natural kinetic ability for things that required coordination, and for me spinning a yo-yo was cooler than academics. The problem was I didn't have a yo-yo for the approaching season. Since I was unreasonably proud and knew we were broke I refused to ask Mom for one. Instead I scrounged around the ranch and found an old Duncan yo-yo that had belonged to one of my brothers in our dilapidated and neglected little house. Farmworkers had stayed in that house prior to the flood. Now, the home was overgrown with weeds and left a derelict, with warped floors and busted-out windows. I discovered the yo-yo in one of the cabinet drawers still full of flood silt. I decided to rehabilitate the device. The paint was chipping off, something I could easily fix, but there was also structural damage to deal with. The wood dowel that held the two wooden spheres together was rotten and ready to break. I fixed the structural problem by carefully driving a finish nail through the center of the yo-yo to give the wooden core steel support. Carefully, I placed the yo-yo in a vice, cut off the end of the nail that extended out one side of it with a hacksaw, and used a file to smooth out the metal. I sanded and then painted the yo-yo with harvester-red enamel. Then, I found some broken, discarded yo-yo strings on the playground and tied them together with a square knot. They worked well enough for me.

The annual yo-yo competition at our country grade school was held in the auditorium. This large, multipurpose room had a stage built into the back of the building and hosted various social functions such as speeches, Boy Scout meetings, folk dancing, band rehearsals, assemblies, and school plays. The yo-yo competition was a big deal for the kids, and the auditorium was packed with people. An official from Duncan even came in to oversee the contest. The participants lined up in rows. Then, the judge progressed from student to student, asking each one to perform one of the ten mandatory tricks. "Around

the World" and "Rock the Baby" were two of the more difficult tricks. Of all the contestants only two completed the ten compulsory tricks perfectly: me and Matt, my neighbor's son.

Matt was a short kid with a narrow head and eyes who wore a crew cut and dressed in fashionable clothes purchased in San Francisco. We were cordial but totally different people. I was an on inward, horizontal journey of discovery, and he was on a vertical social ascent. We had competed head-to-head for the same coveted prize a number of times, and each time Matt had gotten the best of me. The first time we had competed for class president in the fifth grade. The whole class was new to the concept of electing a president. I was a popular kid at the time, and one of my friends nominated me. Matt was also nominated. During class our teacher announced, "Now, the candidates need to give a speech on why they want to be class president."

I had to go first, was not prepared, and quite frankly stunk at public speaking. Matt was second and went on and on about "school pride" and "more fruit in the cafeteria." Even though I didn't really desire the position, the election loss hurt me more than I anticipated. My classmates made the right choice, however. Matt was a talented class president and shined under all the attention. The second event we competed for was the marble championship. He was a terrific marble player and excelled at ringsie, a game where you knock all the marbles out of a circle. He beat me and every other kid in the school for the marble championship.

The third competition was over the position of pitcher for the varsity softball team. Mr. Bentley was a recently hired teacher, and part of his responsibilities was to coach varsity baseball. He fulfilled his duties as coach but was more of an academic sort than a jock. I developed a 360-degree, windup, fast-paced softball pitch that I could get over the plate and was practically unhittable. I learned that pitch by studying an opposing pitcher from a team that had slaughtered us the previous year. Mr. Bentley, our new team coach, announced Matt as the team's pitcher without considering me as a prospect. That really stung, since I knew I was the better athlete. Thus began

my introduction into politics. To me, Mr. Bentley's choice stank of favoritism.

I held an upbeat mood about the yo-yo competition since it was judged by an official from Duncan. The judge decided to break the tie between Matt and me with the customary loop-to-loop competition. To perform the trick, you must throw the yo-yo out, and as it comes back you flip your wrist and redirect it out once again. You continue this looping motion as long as possible without the yo-yo faltering. The official took us to one corner of the auditorium, flipped a coin, and said, "Matt, you're first. The most loop-to-loops wins the contest."

Matt looked very confident. He was always the best-dressed kid in school and wore the latest style: a short-sleeved plaid shirt with button-down lapels. On that day designer tennis shoes even graced his feet. I was wearing my worn-out Converse tennis shoes, which were fashionable enough and of the latest design. The snag was that they were tinged pink. Mom bought them at a discount closeout. No boy in his right mind wore pink tennis shoes to school. As soon as I got the shoes I put them on, ran out into the orchards, stained them with grass, and jumped into a muddy irrigation ditch. I then brought them back to the porch and washed them twice in the washing machine, adding bleach in the hopes of eradicating all traces of pink.

Matt possessed the latest Duncan yo-yo model. It was painted a glossy yellow and had a gold Duncan yo-yo emblem embossed on the side. The contest began. He started out in a good rhythm, but his string wasn't wound tight enough. When he reached thirty-seven loops the yo-yo didn't come back.

The judge faced me. "Danny, it's your turn. Thirty-eight loop-to-loops wins the school championship."

I was feeling confident at this point as long as the string didn't break. This well-kept city kid, with his namby-pamby political ways, wasn't going to impede me this time, I thought. I spun the yo-yo, tightened the string, and then placed the yo-yo in my right hand, making sure that the slack in the string was three-quarters of an inch long and that the yo-yo was gripped at the proper angle. I threw the first forward pass, turned the yo-yo back with a flick of my wrist, and

settled into my rhythm, and it felt like I could have pumped the yo-yo until the sun went down.

The Duncan yo-yo master dutifully counted each loop. When I reached thirty-eight he said, "That's enough, Danny. You're the winner."

I caught the yo-yo in my right hand and held it tightly, hoping they wouldn't notice its beat-up condition.

Matt must have found my action suspicious. He looked at the yo-yo master and pointed to my hand. "Is that a regulation Duncan yo-yo?" he asked.

The master held out his hand. "Let me see it."

I untied the yo-yo and handed it to him.

The master slowly examined the device, looking at it from every possible angle. "Did you put a coat of paint on it?"

"Yes," I nervously said.

He studied it again. "It's regulation," he concluded. "An oldie but a goodie. It seems to work well." He returned it to me.

I wore an unseen smile on my face for days. My victory encouraged my belief in myself. Eventually, and with enough perseverance, I was going to get my due. The competition reinforced the idea that I had unique abilities, but what were they exactly?

The transition from grade school to high school was a near-insurmountable and overwhelming social and academic ordeal for me. I transferred from a small country grade school to Yuba City High School, which at the time held 1,400 students. I was developing an antisocial, nonconformist personality. I couldn't shake the feeling of being isolated and out of place, as though I was born one hundred years too late. I determined that I should have been born in a pioneer wagon bouncing over the Donner Pass.

My first writing assignment in my high school English class was to answer the question: What do you want to be when you grow up? In response, I wrote, "I want to be a wildlife bounty hunter, hunting wolves for a living." I can't remember if I was joking, serious, or just being a smartass. My parents enrolled me in college prep classes. It was cruel treatment to keep me in algebra and Spanish for the entire

year. I was lost after the first two weeks. I was academically lazy and used chores as an excuse to seldom do my homework. I'd bring a big stack of books home with every intention of studying them, but the next morning I'd collect up my stack and jump on the school bus without having even cracked one open. The only class I excelled in was P.E. Since I was a decent athlete I managed to retain some of my dignity amongst my fellow male students.

Out of necessity, I wore my brother's hand-me-down, rust-colored suede jacket to school. During Spanish class, a classmate who sat behind me wrote a blunt note directly on the back of the jacket in red pen: "Suede is very uncool. It's like something someone on *Leave It to Beaver* would wear."

I never wore the jacket again and vowed I wouldn't be embarrassed by laughable clothing in the future. Being cool was later to become one of my anthems. Even at that early date, and like so many other teenagers, I was sensitive and couldn't tolerate embarrassment or humiliation.

After school I often hung out at Mike's house. Sometimes I shared in the family dinners and occasionally slept over on weekends. It became my second home. There were a few other kids our age who lived nearby, and there were always games to be played. We rebuilt hunting boats, planned complex hunting and fishing trips, and invented original games, bicycle polo being one of our favorites. After dark we played hearts and chess and watched *Star Trek*.

We started a four-member gun club called the "Thunder Busters." The name was derived from the explosions our shotguns made when we blasted upland game from the sky. During the winter months Mike and I would place our guns across the handlebars of our bicycles and ride three miles through the cold, foggy darkness, water dripping from our gun barrels, to the outskirts of the Sutter National Wildlife Refuge. Once there we would hide ourselves high on the level banks waiting for the geese to fly out of the foggy refuge. Then, we would blast away at them with our twelve-gauge pump shotguns.

In the late summer months pheasant hunting was our obsession. After such a hunt on a hot autumn day we'd ride our bikes with

dead pheasants strapped to our backs, shotguns supported on the handlebars, and dogs following behind with their tongues hanging out, to the local country store. Upon arrival we gorged ourselves on berry pies and the latest pop-top sodas.

At home on the farm my dysfunctional home life remained in the doldrums of deterioration for seven unnerving and slow-moving years. Over time I capitulated to my indifference. Tedium was the only thing I had, so I clung to it. It was as if I had been given an empty box to be filled with dreary days of boring, monotonous work such as disking, ridging, shoveling, irrigating, fertilizing, and wiring. As much as I disliked the task-mastering and the self-motivated, improvised, process-orientated work, it was great training for becoming a sculptor, like painstakingly learning all the scales for a musical. Looking back now I believe those hard-learned work habits allowed me to endure many years of unproductive art struggles before getting it right.

THE COMICAL SMILE OF THE WHISKEY MAN

IT WAS DURING this time that my father fell headfirst into the depths. Dad had an assortment of eccentric friends, none of them mainstream. Some I liked; others I avoided. Bob Jones, in his thirties, was of medium height and kept his black curly hair neatly combed. He survived the Korean War. Bob was a local boy and a good mechanic. We got along well, and I helped him work on our International tractor. One day the radiator began to leak, and the tractor began belching steam as I drove through the orchards. The radiator part needed for the repair arrived, and Dad sent me to Bob's house to let him know. He wasn't there, but his wife Ide was, along with her sleeping baby.

Ide was built top heavy on a slim frame. She had a gap between her front teeth that always seemed funny to me. She answered the door in a loose-fitting night robe. I relayed the information at the door, but she insisted I join her inside. "Bob's not here. He made a run to the store. Why don't you wait inside a while, I'll make some tea," she urged, waving me in with her hand. I was seated at the kitchen table. She returned with a sugar container and walked behind me and intentionally brushed my shoulder with her breast as she placed the container on the table. She then sat across the table from me. Ide placed an elbow on the table, leaned forward, and rested her chin on it. One of her round, fleshy breasts burst out of the robe into

sight. "You really have beautiful eyes," she cooed, staring at me with a playful smile. I was stimulated and panicked at the same time. Bob will kill me, I thought.

Just then the baby started to cry and I jumped to my feet. "I'll flood the neighbors if I don't get back to irrigating," I announced, lying, and then ran out the front door. I'm not having anything to do with crazy drunks, I thought. Living up to her reputation as a barroom hussy, Ide had found an untamed man at the local bar not too long after and ran off to Reno with him. She came back pregnant with another man's child. Bob, a tenderfoot in love, thought he could marry Ide, provide a home, and break her of her errant ways. His best efforts went by the wayside. Bob couldn't deal with the situation for long. After six months of working on the tractor with us, he walked from his house into a prune orchard, sat down, leaned against a tree, and shot himself in the head. I liked Bob and the news numbed and chilled my insides. How am I going to survive these strange people, I wondered?

During this period in my life Dad would stay away for months at a time, hanging out with his creepy new whiskey-drinking friends. My advice: Keep Irishmen away from whiskey if they're on their way to the bottom. In the old days Dad knew weird people and had a taste for eccentrics but never developed friendships with them and always came home to the family. He had always done the right thing, had always taken the high road. Now he had slipped and fallen into the ditches. I'd see him home in the middle of the day, red-faced, stumbling around nonviolent but sloppy drunk. One time I slapped him across the face. "What's happened to you? Why are you like this?" I shouted, wanting him to come out of it, wishing he could be like he used to be.

I didn't take sides concerning my parents' marital problems. I liked them equally for their good qualities and disliked them equally for their bad ones.

Here, I must introduce Al Hopkins, whose mesmerizing whiskey spell tragically bewitched my father. Al Hopkins' personality was a peculiar blend of social sweetness and comical aversion. Physically he was hard to look at. His highly arched forehead and long neck

with its protruding Adam's apple weren't particularly eye-pleasing, but his most striking facial feature was his mouth. His upper lip was malformed and a different shade of red than his lower one. A few front teeth were visible when his mouth was shut, which to me was reminiscent of one of those funny-looking breeds of dog that always have some of its teeth showing in a comical smile.

When Al Hopkins spoke he was syrupy sweet, and over the top with compassion. I only saw Al in our house once, while I was in the living room reattaching the copper antenna wire to our TV set. It was afternoon, and Hopkins stood next to the blue couch chatting with my parents. He complimented Mom at length over how beautiful her flowers were.

"My greatest admiration is for people like yourself who has the blessings of a green thumb and brings flowers and prettiness to the world, enough beauty to save the cursed city of Bozrah. You brings the Lord's dance into this hard-cheddar world we all live in," Al praised with his hands spread wide.

Mom then grabbed Dad and jerked him out of the living room and into the kitchen. "Don't ever bring that creepy bastard to this house again," Mom barked loud enough for Al and me to hear in the living room. She then slammed the kitchen door on her way out of the house. Mom had no patience for religious hypocrites. Mom absolutely hated the man and believed Al Hopkins had killed his former wife with Dad's .30-30 hunting rifle. Me, I didn't want to know about these creepy episodes and pretended I never heard them.

Dad and Al again showed up at the barn on a summer day while Mom was at work. Al pulled me aside and showed me a photograph of a slightly chubby girl about four years younger than me. He told me this was my half-sister and that he wouldn't tell anybody. "Nobody's ears but yours knows this secret. I'll keep it between you and me as long as the Lord allows the sun to shine," he declared with Bible-thumper sincerity.

I was frozen on the inside, unable to think or act. I shoved that one down inside me and buried it, not to resurface until I wrote this book. Later that day, after my Dad and Al powered down a few shots of Jack

Daniel's, Al asked me if they could borrow my single-shot .22 rifle to go on a grey squirrel hunting trip. My rifle was an old hand-me-down single-shot that sometimes didn't fire because the firing pin was worn out. But it was *my* rifle. I had saved money for it. I had a scope mounted on it and could hit rabid skunks in the head at a distance of one hundred yards with that gun. I let Al borrow it.

I never saw my cherished rifle again. Everything in my life seemed to be going awry.

A month later, in the late afternoon, I returned home from high school. Dad was unexpectedly in the house. He was sitting at the kitchen table practicing writing Mom's signature. The problem was that he was left-handed and his writing slanted in the wrong direction. Mom's name was barely legible at its best. "Danny, I'm having a hard time writing Mom's signature. Can you help me out? Try to make it look right," he directed, handing me a piece of paper and a pen. "Practice it a couple of times. Yes, that looks good." He slid a check in front of me. "Sign Mom's name on this line."

I wrote Mom's signature on the back of the check.

Dad picked it up, folded it in half, and put it in his breast pocket. I knew there was something suspicious going on, but I could never say no to Dad's needs. He was probably taking one of Mom's paychecks that he had intercepted at the mailbox. Most likely he used that money for a rock-hunting and drinking excursion with his buddies in the Nevada desert.

I reached my lowest point at the beginning of my sophomore year and soon slipped into juvenile delinquency. I no longer wanted to be a part of school or society. My first year of high school had been so traumatizing and embarrassing. I decided that I wasn't going to attend another class without decent clothes and devised a shoplifting scheme. I worked in the neighbor's orchards at that time driving a tractor, striving to earn enough for my school clothes, but there was never enough money to buy shirts and shotgun shells.

It was afternoon on a hot September day in Marysville, and the streets were full of high school students shopping in department stores for school garments. Mom had begun her downtown bookkeeper's

job at an auto parts store, so I decided to use our parked Chevrolet as a base of operations. I entered the front door of a large department store carrying armfuls of elegant, colorful paper sacks containing school clothing I'd purchased earlier in the day.

A tall lady attendant wearing a short dress held the door open so I could squeeze in. "Looks like you've been busy," she commented, glancing at the packages I was carrying.

"A few more items and I'll be done," I told her.

"Take your time. Find something that fits," she encouraged me.

I passed her by and surveyed the store. When I was sure nobody was looking I selected three or four shirts and made my way to the fitting room. Once inside I found a shirt I wanted and rolled it up tight so it would squeeze into the empty shoebox I was carrying. Tied around the shoebox in a complex decorative fashion was a piece of white string. I untied it, opened the box, and placed the shirt inside. I then retied the string decoratively, capped off with a nice square knot on the back of the box. Then I carried the box in plain sight, along with the paper sacks, and exited the store. That became my routine. Sometimes I would purchase a second item; other times I placed the remaining items I had grabbed back on a rack and left the store with just one heisted shirt. Returning to the car I would empty out the shoebox, retie the string, and be ready for the next store.

As I exited the car that September day, by coincidence walking towards me were my Thunder Buster hunting buddies, Mike and Harry. Harry was a tall, skinny East Indian kid with a full head of black hair and a rib-tickling smile. His parents were divorced and he was now being raised by his grandparents, who lived across the road from Mike's place. My friends were also engaged in pre-school shopping and came walking toward me. As they approached I was still carrying those stupid packages under my arms and getting out of the car. The empty shoebox with the string tied around it fell to the cement sidewalk. Harry quickly reached down and retrieved the box. Upon picking up the box he realized it was empty, shook it a few times, and then looked at me kind of funny.

I quickly snatched the box back. "You have to look good when you

go shopping," I misdirected him, placing the box under my arm along with the other packages I was carrying.

I'm sure my friends were never the wiser. They really didn't know that side of me, and I wasn't sure I recognized it either. I simply didn't care if I got caught. The risk was worth the reward. I was going to look good around other kids or I wasn't going back to school. I stopped shoplifting after that fall; it was a one and done situation—I had lifted a nice wardrobe for the school year and was satisfied. With Mom back to work our financial situation finally began to stabilize.

THE BACKBEAT OF FREEDOM

I FOUND MY STRIDE in my junior year of high school. I never took an official art class before I served in the military; however, during my high school junior year I enrolled in two classes that provided an outlet for my pent-up creative impulses. I had a craving to draw, which was satisfied via my mechanical drawing class. The most fascinating aspect of that class was my assigned task of making lines with a pencil and a T-square. Mechanical drawing is based on symmetry, and I believe that linear quality found its way into my mature sculpture and painting styles.

The second creative class I attended was an English class that focused on literature. We read the standard pieces of fiction for my age group. I credit *Catcher in the Rye* by J. D. Salinger as one of the books that triggered my artistic awakening. I identified with Holden's antagonistic relationship with society. Literature unlocked a new panorama of adventure, a way to fight back, and an expressive outlet. Literature allowed me to break free of the constraints I felt toward life.

Mr. Moreash was my English literature teacher. He had an unusual balding pattern. The first inch into his forehead was bald; after that his full, black hair shot straight up in the air from his massive, oval-shaped head. His clothes were always clean but rumpled. He never wore a shirt that didn't look in need of a robust ironing. Mr. Moreash looked and acted every bit the part of the brilliant eccentric English instructor and became one of my favorite teachers of all time. I was floundering when I started his class. Mr. Moreash showed me a way

to grapple and tussle my way through those difficult adolescent years. For our essay assignments he instructed us to write about things we knew. Mr. Moreash read a couple of my essays out loud in class as examples of how it should be done.

"It's hard for me to believe a student has written this, but here it is," Mr. Moreash once said.

He read aloud my essay depicting Grover Pelican's rustic historical house. I described Grover's broken nose jutting out of his head at an obtuse angle, the pepper-sized, entrenched blackheads in his forehead, and his purple-tinged lips. I spoke of the World War I military rifles mounted on white wooden-planked walls in his dark house and the thick coat of dust covering the carbines. I described a shaft of light that emanated from the only window in the dim living room. Within that light you could see large dust particles floating. Stacked on the windowsill from which the light shaft emanated was a collection of World War I memorabilia. There, positioned upright and lined up as though each piece was in military formation were six rifle cartridges with large, pointed metal tips. Next to the tarnished ammunition rounds were four bronze military medals with faded colored ribbons attached. I ended the essay with questions and theories. I wondered if Grover earned the medals in combat at the Battle of Verdun and if the lined-up cartridges were a tribute to dead enemy soldiers he had killed in combat.

From literature I developed my personal viewpoint, which gave me fortitude for the years ahead. In quiet moments I'd contemplate my new chorus: Adventure is the journey. I will not live an ordinary life. Chance and circumstance will dictate my new life. I'll embrace the unknown and lift off and fly with the migrating geese. I'll abandon the familiar and reach for the hand of fate, believing that searching would bring me the unconventional life I craved. Life might rip me from end to end, but I was not going to be torn along the dotted line. "With risk comes reward" was my mantra.

As soon as we received our driver's license the Thunder Busters' activities evolved from bike rides to car rides. We found a new passion: pool halls. Eight ball and snooker were our games of choice.

The Thunder Busters didn't involve themselves in typical high school extracurricular activities; we preferred alternative pursuits. Mike received a hand-me-down convertible, and the first thing we did was cruise the local Foster Freeze on Saturday nights. There, the cars lined up ten deep as they drove through the popular establishment. We soon tired of this cliquish activity. Car cruising seemed to be an extension of a high school pep rally. More group bonding was the last thing I wanted.

We preferred pool halls, with its interesting cast of characters. Among them were the coolest oddball musician kids from school, the bad boys from high school who had problems with the principal, and the high school jocks. The pool halls also attracted provocative girls who dressed in suggestive outfits—a stark contrast to what they wore to school every day.

Back on the ranch times were changing. From the bottle of my boring farm life emerged the rock-and-roll gene of freedom. Music became my new liberating companion and proved a great buddy during the long hours on the ranch. Those were the last days of the folk era, and rock was just emerging as a social catalyst. I purchased one of the first inexpensive portable pocket-sized plastic radios and kept it with me while working in the orchards. I like listening to Bob Dylan, but found another new and equally talented artist: Bo Diddley. The local radio station kept a rotating playlist and played a Bo Diddley song every forty-five minutes. My recharged transistor radio batteries only lasted for thirty minutes. After hearing a Bo Diddley song I would turn the radio off, wait forty minutes, and then turn the radio quickly on and off to conserve the batteries while probing for another Bo Diddley song until I found my prize. Through a circle of small holes on my green plastic radio came a screaming electric guitar and pounding-out rock and roll with a throbbing backbeat. *I walked forty-seven miles of barbwire. I got a cobra snake for a necktie. Who do you love? Who do you love?*

As the Thunder Busters grew older our cravings became more juvenile and adolescent. On a fall afternoon in my senior year of high

school the Thunder Busters devised a plan to get our hands on a bottle of booze.

"I'll do it," Mike volunteered, his face determined.

We drove to the local liquor store. Mike walked in, picked up a bottle of Wild Turkey, returned to the counter, and sat it down. The guy behind the counter must have started laughing. Mike was the youngest-looking seventeen-year-old in all of California. He asked for Mike's ID, and that ended the plan.

The next idea we came up with was to wait around in front of the liquor store, locate a sympathetic customer, give him five bucks, and ask him to by us some liquor. So, we chose our night and waited at the designated spot. Eventually a military guy with a short haircut and mustache came strutting up. We stated our proposition.

"What's your pleasure?" he inquired.

"Some beer" was our answer.

"Wait around the corner," he instructed. "I'll bring it to you." He then took our money and headed toward the liquor store. We never saw him again.

We were not about to give up so easily. One evening at Mike's house, our latest brainstorming session started to move in an interesting direction.

"If I just didn't look so damn young it would've worked," Mike complained.

Suddenly an idea struck me. "How about me?" I suggested. "I can grow a beard."

"How's that going to help?" Mike asked, his forehead wrinkled.

"Dress me up like a wino. We could try the skid row liquor store in Marysville."

We agreed to give the idea a try the following weekend—in order to give my beard sufficient time to get good and scruffy-looking.

So, the next weekend we assembled my wardrobe from the oldest and the dirtiest duck hunting gear we could find. I donned a worn-out pair of Levi's, ripped at the crotch and stained with engine grease. My boots were encrusted with mud and straw remnants from a long-ago goose hunt. To complete the wardrobe we selected a worn and torn

duck hunting jacket, made more authentic-looking by mimicking food stains, a splash of ketchup here and there. For the final touch the guys smeared some duck-hunting black grease on my face, giving me an appropriately dirty look. My friends evaluated the wardrobe. I looked in the mirror and deemed the transformation to be pretty impressive. "Do I look like a wino that needs a drink?" I asked.

"Your hair doesn't look right," Harry decided. "It's too healthy looking."

"It could be a little grayer," Mike added.

"We could put some foot powder in it," Harry suggested, laughing at his own thought.

"I have some talc—we could use that," Mike offered.

My friends rubbed talc into my hair, and my skid row/bum look was complete.

Now came time to put the plan into action. We waited until dark and then drove to the skid row liquor store. I had cased the store beforehand and was ready for my part. Shuffling and stumbling to the store's entrance, I pretended to have a hard time opening the glass door. Once inside I turned in one direction, then the other, and then with one finger I pointed down the aisle that had bottles of wine on display. Wordlessly I began tottering in that direction.

Mike entered the store on the pretense of buying gum, but he was really there to watch me in action.

I picked up a gallon jug of Red Mountain Wine, spun around, and zigzagged up to the clerk, placing the bottle of wine on the counter The clerk was a heavyset man with short red hair and thick glasses. He watched in disbelief as I fumbled through all my pockets until I located a crumpled-up ten-dollar bill. I opened the bill up with my fingers and then laid it flat on the counter, stroking the bill with the palm of my hand to smooth out the wrinkles. I then presented the bill to the clerk with my dirty, twitching hand, then grabbed a bag of potato chips and dropped them on the counter as my final action.

The clerk, not missing a beat, gave me the change, then placed the gallon bottle of wine in a paper sack and rested the potato chips on top. I took the bag and stumbled out of the front door.

Mike and I jumped into the convertible laughing our heads off. As Mike drove us to the river bottom, he asked, "Did you see the look on the clerk's face?"

Harry, who had been waiting in the car the whole time in the backseat, probed for more info. "What kind of a look?"

Mike shook his head while driving, trying to get the words out, "Like . . . like . . . like . . . ," he stammered.

Harry poked his head forward into the front seat area, swiveling his head, looking at Mike and then me with his wacky smile. "Like what, like what?" Harry prodded.

"Like he couldn't believe someone could be so fucked up," Mike declared, wagging his head.

It was an easy acting job. I'd seen my share of messed-up winos and drunks over the years so I had plenty of inspiration to draw from. In future years I performed in a number of college plays. However, this was my best acting job ever. During the whole performance I never once spoke, only issued a grunt here and there. It was about staying in character, about movement and picking my moments. Later that evening at the river bottoms we drank Red Mountain rotgut until we were country bumpkin, red wine blind drunk.

LINGERING DRONE OF
THE COLD WAR SIREN

URING OUR HIGH school days the nation was rife with the stress and paranoia of the cold war. The world's political climate seemed to echo my unsettled family situation. In my sophomore year came the Cuban missile crisis. Our high school was located only seven miles from Beale Air Force Base, the North America strategic command center and home base for the intercontinental-range B-52 bombers. There was a heightened cold war paranoia at my school. Air sirens were mounted on top of the school buildings, and at designated times the student body would perform test rehearsals. We memorized our response to a nuclear attack. The student body would load up into buses and be taken ten miles behind the Sutter Buttes, a small mountain range in the middle of the Sacramento Valley, to seek shelter. The idea was ludicrous, since the Sutter Buttes contained newly constructed, fully loaded ballistic missile silos pointed toward Russia with first-strike intercontinental nuclear capabilities.

President John F. Kennedy was assassinated my junior year. I can't emphasize enough the effect this had on our generation's confidence in society. I believe much of the radical social upheaval culminating in the late 1960s began with that assassination. In my senior year Johnson was elected to his own term as president. With Robert McNamara, the logistics genius, at his side, the Vietnam War was now advancing on full-tilt boogie.

That year, my world history class professor brought up a subject that would overshadow the next eight years of our lives: the Vietnam War. The class was taught by Mr. Obi in an auditorium that held fifty students. He was wiry trim with light brown hair, and wore a white shirt and black tie as his trademark. Mr. Obi was very astute, matter-of-fact, and to the point. His face still showed the residue of large scars from a head-on automobile accident he had been in as a teenager. The accident had been so horrific that the ambulance drivers thought everybody involved was dead. Later they discovered he was still alive and brought him back to life at the hospital.

Mr. Obi kept his finger on the pulse of the nation and tried his best to wake us up concerning the realities of our 1965 graduating year. In a free-flowing moment during a lecture with the whole auditorium in attendance, he said, "All of you graduating men have a job set aside for you after graduating from high school. Do you know what it is?"

I raised my hand, and he called on me. "Working in a gas station?" I clowned. I received a chuckle from the professor but had missed the point.

"The bigger job is working for Uncle Sam," he informed us.

His insights were prophetic. Ten months later I was a draftee in the U.S. Army.

Overall, my senior year of high school was probably my best year. I began gaining momentum on both social and academic fronts. The financial stress on our family began to subside. Mom had switched to a better job working at the California Department of Transportation and was now making a sustainable wage. We also received a modest flood settlement during the latter part of my senior year. The levee had broken at the location where the Army Corps of Engineers replaced a section of the level. They were held culpable for not building a fifteen-foot-high rock core inside the replaced earthen level. The settlement money sadly didn't arrive in time to relieve my family's stress. Mom and Dad's relationship was all but over by then. They stayed together simply out of apathy and familiarity, but years later would divorce.

In my senior year we discovered the adult pool hall in Marysville. The establishment served alcohol; however, as a minor you could

enter the joint if you played pool in the dry section. I was happy to discover that their jukebox played the latest hip music. I first heard the Righteous Brothers in that dark, smoky pool hall. *You've lost that loving feeling, whoa that loving feeling. You've lost that loving feeling, now it's gone, gone, gone, woh.*

For me it was an exciting place to hang out. The joint was mostly occupied by servicemen from Beale Air Force Base accompanied by their dates. If there were any high school kids in attendance they were the coolest ones at school. Dollar bets on a game of eight ball would raise the tension and excitement in a room already filled with high levels of testosterone. That atmosphere fit into my idea of a cool lifestyle. The way you broke a rack of pool balls spoke volumes about who you were, more real than any ride through a Foster Freeze or a bunch of rah-rah stuff at a football rally.

Back on the farm, water, my stern instructor who had hardened my willpower, now became my emancipator. It was a hot July afternoon at the Township Ranch. The orchard had finally grown to the point where a small harvest could be picked from the young peach trees. That day an unusual sight appeared in the skies over our ranch. Dark rain clouds began to form and through them streaked lightning, piercing the sound barrier. Rolling thunder could be heard bouncing off the Sierra Nevada Mountains. It rained for half an hour. After it stopped a sweltering humidity hung in the air. It seldom or never rained during the summer months in California. Peaches are very fragile, and a few raindrops on one causes brown rot. After two days a quarter of the peaches on each tree were affected. The first sign of trouble on such an ailing peach is a brown spot about the size of pea. The small blemish then grows to a dime-sized spot, which extends from the surface all the way to the pit of the peach. Ten days later, a third of the peach is brown and mushy. The stem lets go, and the peach falls to the ground.

Two days after the rain, the pickers frantically picked a load of peaches, which I drove to the station. The station's grader rejected the load, so I turned around and pulled the load back to the ranch.

Upon returning, Dad met me. "What's the problem?" he asked.

"The grader rejected the load. Brown rot," I replied.

Dad thought about it for a couple of seconds, his face calm. Then, in a matter-of-fact finality, he said, "That's it."

The rain put an end to Dad's unrealistic ranch dream, and the downpour dissolved my marriage to boring labor. Later that day Dad decided it was time to sell the ranch. Within six months it was sold, and we moved into a new house on the outskirts of town. I graduated from high school that summer, and my long ordeal on the farm was over.

The next sign that a new age was beginning for me was the death of Sammy, my beloved dog. He was my best friend, spiritual guardian, custodian of my desires, and companion of my hopes on many lonely daydreaming afternoons. He helped me make it through grade school and high school. Now, with his mission successfully completed, he was moving on, emboldening me to do the same.

Looking back, my early life was rough and fun at the same time. I've forgiven my mother's shortcomings and now appreciate the many sacrifices my parents made. I understood and forgive Dad for his shyness, lack of confidence, and inability to remake his life. On the night I graduated from high school he wore his expensive mail-order clothes, bought from the flood settlement money. Dad went overboard with that money, purchasing outlandish items such as ten pairs of exotic mail-order shoes and ten exotic expensive hats. When we arrived at my outdoor nighttime high school graduation ceremony he was too shy and reserved to get out of the car. He just sat in the driver's seat wearing his kangaroo-skinned boots and his L.L. Bean elk hunting pants held up with a silver-buckled belt, all topped off with a Texas ten-gallon hat.

The unsettling aspects of my youth probably seeded personal problems that would ultimately grow into lifelong challenges. However, my parents raised three boys, one who became attorney, one an engineer, and one an artist. They must have done something right. My mother loved me and taught me the best way she knew how. Dad never abused me and was proud of my modest successes. He gave me a great deal of freedom. If his plan for me was to learn

about life starting at the clay deck and to achieve my victories the hardscrabble way, it certainly worked. I understood Dad and loved the crazy bastard until the day he died.

I viewed my stint on the farm as an empty cubical of domestic duty, which I filled with arduous labor carried out on long dusty roads. I met my family responsibilities and at age eighteen was now seeking my own path. I enrolled at the local junior college, held my own at academics, dated, and finished one semester. At that point I finally decided to drop out. The draft and the Vietnam War hung over all the young men of my age. To be truthful, I didn't get the Vietnam War and basically thought it was none of our business. I briefly considered becoming a conscientious objector for a day or two, but ultimately dropped the idea upon concluding that there was no way I could pull it off. I gave in and decided I'd let the draft take me. Phillip had already been drafted, and I figured I'd let the same thing happen to me and pick up my life where it had left off after I returned home. Serving my country seemed like another obligation I needed to fulfill. During that period of my life I was probably more inclined to trust the government's judgment than not.

At age eighteen my youthful beliefs and ideals were going by the wayside. A large reservoir of pent-up energy was welling up in me, seeking an escape. I wanted to get out on my own. In my youthful exuberance, I believed there was something extraordinary out there waiting for me, and I'd find it and make it mine.

Robert, who later became an attorney, came to my aid. Robert had now filled into his large frame and suddenly was buff. He was the first person I'd heard of who lifted weights, starting eons before it became fashionable. During my long passage to become an artist he was an angel on my wings, helping me out of tough situations and providing advice and assistance during my long, grueling crossing to fulfill my dream. He was attending the University of Nevada at the Reno campus, and working part-time at the casinos to help pay tuition. He landed me a job as a bus boy at the Harris Casino.

I left for Reno on a cold December day and got on a Greyhound bus, the first of ten Greyhound departures I would make over the

years. My bus depot departures brought out a wacky peculiarity in my character. I was usually broke, in upheaval, and couldn't wait to get on the bus to escape my present circumstance. However, once the bus started moving I would replay my uncertain station in life over and over again in my mind. I seemed to be in sync with the other passengers. We all had the same empty stare, anxious to travel to a more promising location.

A PAIR OF ACES IN RENO

I F YOU HAD been there to see me arrive in Reno on that cold day in December 1965 you'd have witnessed an energetic young man adorned with a full red beard and longish hair and dressed in a green down jacket walking along a typical old-town Reno street. I've never figured out if I was the last of the beatniks or the first of the hippies, but there was no doubt that I was unconventional. The streets were lined with older, two-story brick buildings, and in this part of town I was seeking a barbershop. The remnants of dirty snow still remained on the sides of the streets. What really impressed me as being different in Nevada was the topography, the vast amount of light in the atmosphere and the desert vistas. Distant, warm-colored mountains dotted with green scrub bushes seemed to outline all directions.

I spotted a red-and-white circular barber pole stationed in front of a glass entry door. The barbershop obviously catered to an older local cliental. The decor consisted of mining paraphernalia, picks, scales, shovels, and rodeo posters. The aroma of old leather and aftershave added to the ambiance. I received another signpost, a reminder of my youthful station in life, from the barber. He was busy cutting hair, so I grabbed a seat and waited my turn. The barber was adorned with a unique black-and-white peppered goatee and a waxed handlebar mustache. I waited as an older gentleman's gray beard got a trim. After he was done I slid into the vacated barber chair and glanced at my beard one last time. The barber asked me what I wanted.

I told him I was getting a job in food service and needed to be clean-cut.

During this period of my life I was an observant, know-it-all smartass. The barber was giving me a razor shave and, being very proud of my ability to grow a full beard at such an early age, I asked the barber in full seriousness, "How does my beard compare to the last guy's, I mean in terms of toughness?" I asked seriously.

I could tell by the expression on the barber's face that there was no comparison. "About the same," he said in an easygoing manner. He proceeded to make me busboy-presentable.

After the haircut I journeyed back to my newly rented room near the University of Nevada. I walked along Virginia Street, the main street of Reno, which skirted the university campus. Looking further south, you could see the famous sign arching over the street proclaiming Reno as "The Biggest Little City in the World." Even further south began the blinking and flashing neon lights of the casino mile.

My new adventure began at the gambling casinos. I had a new look, freedom, a full tank of boundless energy, and a shoebox full of naïveté. I was ready to test my wings. That was the first time I had lived on my own. My room was a hole-in-the-wall rental room in the college housing area. It was more than adequate. I worked two jobs, one as a busboy and the other as a doorman at a movie theater. I quickly moved from the busboy job to a room service waiter, aiding hotel room guests at the casino. I was presentable, hard-working, and a curious type, and people seemed to enjoy my company.

I liked the atypical and alternative atmosphere of the gambling industry, especially the entertainment portion. People were on the hustle, and there was money to be made. It fit in with my newfound sense of adventure. In Reno I experienced two memorable events that propelled me along in my path of life. My job as a room service waiter required me to sit in a little office that contained a telephone. I was dressed in a red waiter's uniform bearing the insignia of the casino. To my amazement I began seeing major stars walking around the facility. Jimmy Durante played a piano next to the swimming pool.

Michael Landon, the star of *Bonanza*, lodged at the casino. Given that I was new to the job, I worked the morning shift. The senior waiters worked in the evening, when the tips where better. I was capable and more than willing to do a good job. I wasn't handsome, but girls told me that I was cute. My most unique feature was my green eyes, and somehow I had inherited long eyelashes. A girlfriend once told me I had "Tom Jones sex appeal. You're a guy with a big hairy chest and a big butt."

One of my fondest memories as a room service waiter came early one morning. It was nine o'clock when I received a call from room 207. I was alerted to the room because Al Hirt, the famous jazz trumpeter, and Pete Fontaine, the equally famous jazz clarinetist, were performing at the casino and staying in that room.

I knocked at the door and announced, "Room service."

Al Hirt, the man with the widest head in North America, answered the door. He was a big man, with a full beard and smiling eyes. "Hey, how you doing? Come on in," he said.

I entered the room and spotted Pete Fontaine sitting in a chair by one of the windows. His face was adorned with a unique wide, black goatee, and he was dressed in a long-sleeved striped shirt. They had been up all night and hadn't yet come down for the last evening's performance.

"What's your name?" Al asked.

"Danny," I replied.

"Danny, I have a job for you." He handed me a pair of black loafers. "I scuffed them up a bit last night moving around. Can you take them to the shoe shiners? Say they are Al Hirt's. They know how I like 'em. As soon as they're done bring them back to the room. I'm going to need them for tonight."

I took the shoes from his hand and said, "Will do."

At that moment Pet Fontaine, still in the chair, started scat singing: "Get them shoes bahoo-a-la-a-ba-ta, get them shoes, bahoo-a-la-a-ba-ta."

To my amazement Al Hirt joined in on the improvised vocal scat. "Bring them back, bata-bata-ba-ta."

They went on for two minutes, alternating between call and repeat, putting everything together with a syncopated backbeat.

If they were trying to blow me away over how talented and gifted they were or how interesting life could be, they were successful. It was the coolest spontaneous act of creativity I've ever experienced in my life. I returned the shoes later that day, and Al Hirt gave me a four-dollar tip. Looking back today, the famous musicians probably saw a sparkle in my young eyes, read me like a book, and decided to give this energetic country boy an insight into their world of creativity and entertainment, and for that I say, Thanks, guys. During my artist life and career, I've had a kindred relationship with music and musicians. Years later Elton John would buy two of my sculptures, helping sell out an Atlanta show at Fay Golds Gallery.

A couple of weeks later I received my induction notice from the United States government. The induction notice began as follows: "Greetings from the president of the United States of America." It went on to say that I had been given the opportunity to serve my country and that I must report to the Oakland induction center on April 6, 1966. I contemplated the news for a couple of days while I conducted business as usual. I wanted to work as long as possible.

It was during this time that I experienced my most fortuitous slip in life. Guests who stayed at the casino's hotel could call room service and order from a limited menu. I worked out of a small office where I would take their food orders over the phone and then call up a cook at the casino restaurant, place the order, pick it up when it was ready, and then quickly deliver the meal to the room. On that March morning I had to deliver a breakfast. I exited the elevator on the second floor, carrying the tray high over my head using one hand while carrying a scissors easel in the other. My destination—the room I needed to deliver the breakfast to—was located at the end of the hall. In front of me and blocking the hallway were two plastered women probably in their late twenties or early thirties. Professionally dressed in suit tops and skirts—one was a brunette, the other blonde—they looked like they had just departed a banker's convention. They were trying to unlock the room door but were having a challenging time, laughing

and stumbling about in their attempts. As I approached, one of the ladies held up the key and asked, "How do you get this to work?"

I quickly set the tray down on the scissors easel to give them help.

The dark-haired lady held out the key to me. I looked into her eyes; they were brown, female mysterious, and slanted at the same angle as her eyebrows. She was medium height and her suit accentuated mature female curves. "Why don't you give it a try?" she suggested playfully, jingling the key in front of me.

I took the key from her hand in a way that ensured we made physical contact. Looking at her I said, "You have to insert the key properly." I opened the door and gave the key back.

She followed her friend into the room, then turned back and asked, "Are you room service?"

"Yes," I replied. "See if there's something on the menu you might want. It takes twenty minutes."

"This could be fun," she flirted.

"Could be," I responded, giving her goo-goo eyes. I went on my way thinking, I have nothing to lose here. I'll be in the Army in a couple of weeks.

Thirty minutes later I received a call from the same room. "I'm in room 238. Could you bring me an omelet? I'm quite hungry," she toyed.

I recognized the dark-haired woman's voice. As I wrote down the order I was already becoming aroused. I thought to myself, I'll make her in the room if she wants, but I need a sign.

I picked the omelet up from a downstairs kitchen and headed to room 238. I knocked on the door and said, "Room service."

The dark-haired lady answered the door wearing only a black negligee, black panties, and black dress shoes. I was blown away and turned on by her bewitching audacity.

I thought, this has to be the sign. "Come in," she smiled, holding the door open wide so I could pass through. I caught a glimpse of her body: a curvaceous figure, with laden tactile breasts pressed against the negligee. I set the easel down and put the tray on it. Positioning myself on one side of the easel, I grabbed the tablecloth covering the

tray and pulled it off in one fluid motion. Just as gracefully I lifted the cover off the stainless steel delivery dish, exposing the omelet for her approval.

"Should do fine. Looks yummy." She gazed at me coyly.

From my red waiter coat pocket I pulled out a bill. "Do you want to sign for it?" I asked.

"No, I'll pay cash," she replied.

The room was dimly lit. The curtains were drawn. One light was on next to the bed. Standing with easy confidence, she swiveled in a half circle, flounced toward the bed, bent over it, and pulled a bill from her purse. At that moment excitability paralyzed my thinking.

She returned and handed me a twenty-dollar bill. "This should cover it," she said.

"Thanks," I replied, then, while nervously switching my weight from one leg to the other, I added, "Anything else you might want?"

"There's one other thing you can do for me," she enticed.

I swallowed. "Anything you want as long as I can have my way with you," I replied and was suddenly embarrassed by my Freudian slip. Quickly I added, "I mean, I mean anything you want as long as I don't get fired."

She studied me closely. I had the distinct feeling that she could see right through my daring facade. Everything about her was mischievous: her half-closed eyes, her parted lips, the way she stood. "In that case . . . ," she began, ". . . I'd like to have my way with you."

I managed to get out, "As long as I can . . . get back to my desk in twenty minutes."

There was a slight change in her expression. She pushed her lips forward as though thinking hard about it. "Okeydokey," she finally decided.

Quick and hard were the way things were done in that room. I doubt if I made it to the ten-minute mark. In those days I didn't have much control. I just came early. On the stroll back to my office, I noticed my red waiter vest had been smeared with jelly juice. I sensed something breaking loose in me, an ecstatic sensation of gratification, endorsing my impulses. With risk, I realized, came reward.

What I took away from the experience was the realization of how mysterious women are as a gender and how different ladies are individually. I couldn't get over how nervous I was in the beginning and, as things progressed, how much influence I gained.

Looking back on the interlude, I don't know why she covered me in a coat of heifer dust or what had inspired her to seduce me. Perhaps it was too much booze, or simply fantasy, lust, encouragement from a friend, or the desire to put distance between herself and an old lover.

For me it was about uncovering my life force and being overtaken by passion. I desperately wanted to expand on my sexual experiences after that seduction. Most of my experiences with women around that time were aided by alcohol.

I had two days off from my room service waiter job, although I still had to work my second job as a doorman at a movie theater. I greeted people at the door, took their tickets, and welcomed them to the theater. *The Sound of Music* was the only movie shown during the three months I worked there. Teenage boys are sperm-producing factories. Throughout the next two days, as I listened to Julie Andrews sing *Doe, a deer, a female deer, ray, a drop of golden sun . . .* , Mr. Johnson was moving about and dripping fluid.

Upon returning to my waiter's job two days later, I relieved my fellow coworker, Kevin. He was a thin, rangy, long armed, straight-laced family man, slightly religious and born in Reno.

"You won't believe what I saw in room 238," he blurted out when he saw me.

"Elvis Presley?" I shot back, confused.

He went on to explain how this hot chick ordered up an omelet in room 238. "She answered the door in a negligee," he went on wide-eyed and grinning. "Did you get some?" I countered, trying to figure out what was going on.

"Heck, no. I'm a married man with a kid," he answered self-righteously. A sense of relief came over me that I wasn't getting caught in a twisted affair. I thought I had something special with the dark-

haired lady. She had now checked out. Maybe she had a thing for waiters, or maybe she thought I was working that day. I was grateful for the memories she gave me, but the day's kooky events caused me to give the boss a two-week notice. I had to move on and prepare myself for the Army. Reno had dealt me a pair of aces, stimulating my imagination and rousing my desire for travel and adventure. I was convinced in my teenage enthusiasm that there was something special out there intended for me, and I'd find it, avoiding all of life's pitfalls in the process.

I boarded a Greyhound bus with my possessions in an expensive travel bag I'd picked up from a pawn shop. My final destination was the Army induction center in Oakland, California. The bus left early on a cold and crisp morning. It had not snowed in a couple of days, and the roads were clear as the bus snaked into the high reaches of the Sierra Nevada Mountains. Deep snowdrifts aligned the roads on either side due to frequent visits from the snowplow. Sticking out of the pure white snow were red metal pole markers—guides for the snowplow drivers. We reached six thousand feet and arrived at Donner Summit. The only mountain surfaces not covered with snow at that elevation were the sheer, vertical cliffs of gray granite in the distance. Those cliffs were polished by glaciers, places where snow couldn't stick. The view from my bus window revealed the tops of the mighty pine trees that grew in the summit. On a calm day the vast, elevated wilderness of mountains and greenery and snow was eerily quiet, but on a blustery day the wind howled. I couldn't help but think about the fortitude and tenacity the Donner party showed in their ordeal of survival. It gave me inspiration in my present situation. If they could survive outdoors in this inhospitable place, surely I could tolerate two years in the U.S. Army.

My mind rehashed those strenuous years I had endured on the farm, as the bus descended into the Sacramento Valley via a long, downhill grade. Every now and then I caught glimpses of the entire valley in all its grandeur. Vast and green, it ran from the snow-covered Mount Shasta at the north end of the state to Mt. Diablo in the East Bay region. The bus traversed the valley and climbed the slow-rolling

green hills of the coastal mountain range, closing in on the San Francisco Bay. My mind was full, awash in anticipation of what the future might bring.

The Greyhound sped over the Carquinez Straits Bridge. Long and towering, it spanned the confluence of the Sacramento and San Joaquin rivers. Eons ago those colossal rivers had merged, carving and gouging a gigantic outlet to the sea and giving shape and vitality to the San Francisco Bay. Outside of my bus I watched the jarring transformation from rural life to urban life. On the right-hand side of the bus, oil refineries a mile long appeared, belching smoke. I passed by huge, silver-painted holding tanks lined up in formation. The sprawling oil-refining complex was tucked next to the San Pablo Bay. Through a crack in the bus window you could smell the acidic odors released from all those refining facilities.

From there we traveled through a sprawling, hilly, urban environment that boasted a population of two million people and that encompassed the East Bay cities, which edged the huge bay. It was a typical cold, foggy, gray day as I zoomed along Interstate 80 through the smaller cities of Vallejo, Hercules, San Pablo, Richmond, El Cerrito, Berkeley, Emeryville, and finally the Port of Oakland.

I distinctly remember driving past the industrial section of West Berkeley. To my right lay the depressing mudflats of the Berkeley Bay front. Derelict wooden docks with timbers askew stuck out of the mud. Tidal flow debris was scattered about the surface of the nasty flats. When I looked out of the bus to the left I was met by a string of depressing West Berkeley factories: ugly, black and brown edifices that spewed and belched smoke into the air, which was quickly dissipated by winds whipping in off the bay. I passed a steel factory, a mattress factory, a paint factory, and who knows what other kinds of factories. The place looked unhealthy and polluted. I remember wondering who could possibly live in such a depressing, unnatural place. Ironically, twelve years later I moved to that very section of Berkeley and lived one block away from the paint factory. During my five years in the Bay Area I would endure the most stringent struggles of my artistic life, giving up everything to achieve my dream. But

those fateful events were yet to come. For now, I had to submit to the military.

My bus arrived at the main terminal in Oakland. There to greet us was a military shuttle intended to assemble all the potential inductees and transport them to the military induction center. The draftees came from all the small West Coast towns and cities. We had all been swept up in the Vietnam military buildup. The domino theory was now about to be challenged by the might of the U.S. military.

We arrived at the Army induction center at midday. I had been riding in the bus with Harvey, a fellow draftee who had boarded the bus in Auburn, California. He was athletic, with a strong build, freckled face, blue eyes, and wavy red hair. He was also very provincial. We decided to buddy up and figure out this process together. In time Harvey and I would endure the rigors and toils of basic training in the same platoon.

We departed the bus carrying our small travel bags and walked along submerged railroad tracks that ran in every direction along the chaotic port. The induction center, our destination, was an older building composed of a gigantic auditorium connected to smaller adjacent rooms. The last time those older buildings had been used for such activities was probably during the Korean War.

A contingent of military police greeted us as we departed the buses. Their black-and-white armbands, which sported the letters "MP," helped them stand out from the rest of the soldiers. They were also large men who carried long clubs and dressed in white steel helmets, olive drab fatigues, bloused pants, and spit-shined boots. They guided us to the starting point of the procedure, which involved paperwork and a basic medical exam. Harvey and I filled out our papers and were then moved to a medical room for a blood-pressure check. After that we were escorted to another room for a very basic dental exam. Lastly, we had to complete the eye exam, which required a long walk through the main auditorium in order to reach the proper station. Judging by the tensed bodies of the MPs guarding the auditorium door, I could tell that something out of the ordinary was happening.

The MPs gathered up fifty inductees, then opened the door and

guided us inside the auditorium along the edge of the vast room. Sitting on the cement floor in the middle of the auditorium was an inductee in civilian clothes surrounded by an officer and three MPs. He had assumed the lotus position and sat motionless with his arms extended and resting on his knees, his thumbs and forefingers forming a circle. The officer and MPs just stood there looking at him.

I noticed a group of recruits heading toward us from the other direction. "What gives?" I asked one inductee as he drew near.

"The guy's been there for over an hour," the recruit replied. "Hasn't moved. He's protesting the war or trying to get out of the service."

"Why don't they take him away?" Harvey asked.

Another nearby recruit said, "I don't think they can touch him."

Two MPs strode aggressively toward us. "Keep moving," one of them ordered.

An hour later I experienced one more memorable event at the induction center, a stroke of luck that probably changed my life. The war protester had been removed from the main auditorium. Four hundred recruits had passed the pre-induction physical and were now assembled in the auditorium to officially become members of the U.S. military. A speaker's podium was positioned on top of a raised stage that overlooked the huge auditorium. Painted on the floor in front of the stage was a 150-foot-long green line, meant to straighten up the ranks of new recruits facing the podium. Fifty recruits were lined up on the first line. The spacing between each soldier was determined by raising your hand and placing it on your fellow inductee's shoulder. Eight feet behind the first line of soldiers was a second line, and eight feet behind that was a third, and so on. Ultimately the file was eight rows deep. I was in the third file back. Harvey and I were separated but in the same line.

In five minutes all the soldiers were in military formation.

"Attennn-hut!" a massive, stiff-backed sergeant ordered in a commanding voice.

Eight hundred coordinated feet slapped together in unison, sending out a rumbling noise that reverberated through the hall.

In the silence that ensued, a well-decorated major with combat

ribbons and patches adorning his dress uniform ascended the steps of the stage and positioned himself behind the podium. "Good afternoon, gentlemen," the major began, and then gave an order: "Count out by twos."

The first solider in the first row said, "One." The soldier next to him said, "Two," and so on. The process wound its way through every rank and file in the building. Three minutes later every soldier in the building was a one or a two.

"All of you ones, take one step forward," the major commanded.

His order was quickly followed by the echo of four hundred feet taking a step forward. The guys on both sides of me moved up. I was a number two and stayed put.

"Welcome, all of you ones. You are now proud members of the United States Marine Corps," the major informed them.

The guys in front of and in back of me murmured under their breath. One guy said, "Shiiit." Another guy said, "Jesus." A third said, "That's fucked."

The new Marine recruits right-faced and marched into the Marine Corps.

As a two, I was drafted into the U.S. Army. I've had great luck in my life, but that definitely stood out as one of my luckiest days. My line of soldiers marched out of the hall and into a waiting bus in a five-bus convoy. I reconnected with Harvey, and we shared a seat on the two-hour drive to the Army training facility in Monterey. Finally, we passed through the main gates, where an overhead sign read, "Welcome to Fort Ord."

By the time we arrived darkness was setting in. Our bus parked in front of a processing center.

Drill sergeants greeted us by positioning themselves outside the bus two feet from our heads and shouting, "Get out of that civilian bus. You're in the Army now. I wanta see you guys moving. Outta the bus. Get in line over there, soldier. Is that the fastest you can move, fat-ass? You gunna have to lose some weight to be in this man's army." The drill sergeants had already found a guy to pick on.

I learned a lot about myself and my commitment to my beliefs that

day. I had nothing against the Vietnamese and didn't think what was going on in their country was our business. In some ways I admired their natural, centuries-old, self-sustaining existence in the bush. However, I wasn't ready to make a commitment and take a stand. I had just been a passive observer. But that night I became a clog in the military system, joined the collective, lost my freedom, and stopped thinking. My unconventional and nonconformist beliefs seemed phony to me as I started this new phase in my life.

cog

U.S. ARMY

THE FORT ORD military installation was a sprawling complex covering three square miles of sand dunes and rolling hills nestled next to California's beautiful Monterey Bay. Hill-sized sand dunes next to the ocean functioned as a rifle-firing range. I trained for a total of five months at this aged, rustic facility comprised of older wood barracks built back in 1917 and once used for the World War II push. I became convinced that the physical location of the Army base was selected because the weather there was the lousiest in the Monterey Bay region. It was always cold, wet, and foggy. Three miles away in Carmel the sun would come out, yet the fort area remained so endlessly damp that long, green moss hung from the limbs of the small oak trees that populated the complex.

The damp weather had become a problem for the earlier draftees. A meningitis outbreak shut down the entire fort for six months prior to my arrival in 1966. We were the first bunch of recruits allowed back into the facility, just in time for the Vietnam buildup. To safeguard us against a reoccurrence of meningitis all the windows in the barracks were locked open, keeping foggy ventilation constantly flowing through the barracks. During the first month of basic training I suffered from a raw sore throat and experienced the sensation of swallowing razor blades every time I ate in the mess hall.

As messed up and flawed as the Army is, some of its methods made perfect sense. The military performed two days of testing on each soldier to evaluate his strengths before assigning them to basic and

advanced training units. In the barber shop getting my head shaved, a talkative, chubby civilian barber with long sideburns was filling me in on the ropes of basic training. He led me to the cash register. I gave him a good tip. He leaned over and spoke in my ear. "Make sure you fail the infantry test," he whispered.

The testing began early the next morning and lasted two full days. Most questions were multiple choice. Two hours into the testing, there it was. In front of me lay the infantry test. It asked combat-related questions.

The bazooka is used for:

A. Preparing mashed potatoes
B. Engine repair
C. Blowing up tanks
D. Living outdoors

One of the tests I excelled at was on Morse code, a two-hour-long recorded sound test. Over the speakers it slowly began:

A. Dit Dau
B. Dau Dit Dit Dit
C. Dau Dit Dau Dit

I had a decent memory, liked the rhythmic quality of Morse code, and did well on the test. My ultimate job, or "MOS" in Army nomenclature, was a 52B20—a radio teletype operator. My job training lasted six months, one of the longest training cycles in the Army. Considerable time and resources were spent on training us operators, and the Army took steps to ensure we wouldn't get killed quickly. Most well-trained teletype operators were sent to companies at headquarters, away from the action and potential death. That was their plan, anyway.

Well, if any of you have been in the military, you know things don't always go as planned.

The day after testing I was called out with ten other soldiers by a first lieutenant. We were sequestered in a private room and

informed that we were the select few who had passed the threshold and were qualified to attend O.C.S. (officers candidate school), or in common jargon, the school of sixty-day wonders. After sixty days of training you could become a second lieutenant. I declined the offer. The commission meant I had to extend my enlistment for another six months, and it was common knowledge by then that second lieutenants were being killed in Vietnam faster than they could be commissioned. I had no desire to go to Vietnam and lead a platoon. I was only willing to give my country two years as a draftee. For some peculiar reason I thought of myself as an equal member of society and could not see myself as an officer, giving other people orders. I simply wanted to do my own thing and let other people do theirs.

"Corbin has a negative, self-destructive, pre-conditioned need to rebel and disregard authority," my rivals would later declare.

My basic training experience was similar to those of the other millions of soldiers who endured the Vietnam military era. The psychological aspect of basic training was the least desirable for me. Mentally, the Army wants to break you down, changing individual priorities to a collective way of thinking and preparing you to make the ultimate sacrifice later on. The physical training was tolerable for me, since I was a natural at most of the physical tasks the Army demanded of its recruits such as PT, hand-to-hand combat, marching, and rifle range. I enjoyed the camaraderie of the great guys I met, though the assholes I could have done without.

Our drill sergeants exercised curious judgment in picking out who they thought the company leaders should be. Of the fifty men in our platoon the drill sergeant picked out the two biggest dickheads and made them assistant platoon sergeants. The drill sergeant's first pick was an integrity-deficient guy who confided in me that he wanted to become an MP because of the graft associated with the position. Not exactly what you'd consider leadership qualities or the right moral character to be a platoon leader. He lasted one month before the drill sergeants dismissed him for stumbling around during one morning formation, too drunk to organize the fifty-man platoon. The drill sergeants chose as his replacement the most egotistical, arrogant,

self-absorbed jerk and easily the most despised guy in the platoon. That always struck me as curious, since drill sergeants have perfect pitch when it comes to evaluating the strengths and weaknesses of the trainees. Looking back on it now, I think it was a piece of the Army's brilliant plan and an integral part of their chain of command. At the lowest end of the chain you need a guy who will follow orders and be just big enough of a chicken shit to force his fellow soldiers to charge up Hamburger Hill.

A sobering revelation dawned on me during my second week in the platoon. I concluded that the real enemies in the world were organizations such as the Army. It would be a few more years before I put power-hungry politicians into the same category.

My journey to become an artist began at the basement level; I had to work my way up from there, learning about life by hitting every pothole in the road. What I took away from my first two months in the military was my ability to weather extreme situations and my capacity to hold my own. Five months later I was on my way to Fort Gordon, Georgia. I had completed my basic training, along with an additional three months of preliminary radio and Morse code training at Fort Ord.

I was finally sent to Fort Gordon to complete advanced radio teletype training. This training, which took another three months, entailed listening to Morse code for four hours in the morning and then learning radio teletype for the remaining four hours in the afternoon.

It finally happened to me one day—a result of my total immersion in Morse code. Other soldiers had warned me about "Morse code override," as they called it. One morning I turned on the shower in the barracks and heard Morse code blasting out of the showerhead.

We arrived in Georgia during the humid summer months. While stationed at Fort Gordon most of the trainees in my company of 250 men were housed in big green canvas army tents. The massive Vietnam War buildup had resulted in a lack of wooden barracks to shelter all of the incoming trainees. Our company had only two wooden barracks. I was one of the remaining 150 trainees who were housed in twelve

large army tents, which had no running water; you had to walk a hundred yards to use the bathrooms. I would soon experience my first southern summertime thunderous downpour. On any given summer day in Augusta, Georgia, along the horizon, dark, ominous clouds could quickly amass. Within an hour the sky would turn a silky moist charcoal-black color. Lightning would unleash a torrential downpour lasting two hours, after which the sun would come out, and humid steam would rise in between the green canvas tents.

Our class completed and graduated from radio teletype training. Winter was approaching by then, and I waited for the orders that would send me to my permanent duty station. Within three days of graduation every other member of my class had gone to the first sergeant's bulletin board, learned of their individual deployments, and were packing up to go home for a short leave prior to shipping off to places such as Saigon, Greece, Rome, England, and Istanbul. My orders never came. One week later I was assigned to a holdover company. Not a single soldier there had orders; we were all in limbo. It was just another Army SNAFU, Army slang for: Situation Normal: All Fucked Up. There were a total of ten holdovers in our company. We were assigned to a tent that was segregated from the newly arriving trainees.

The next three months were spent in a demoralizing limbo, a cuckoo's nest, the makings of a Will Ferrell comedy. Every morning we stood in roll call formation in our little holdover squad, separated from the rest of the new trainees. Then a sergeant marched our squad to a Fort Gordon location, where we joined up with holdovers from all the other companies stationed there. Two hundred men strong, we'd spread out and police cigarette butts until noon. After lunch they sent us back to our own company, where we policed the cigarette butts lying around our company's parade grounds.

The only way out of the long-term holdover situation was to volunteer for Vietnam. If you volunteered, the Army cut a new set of records, and you could be on your way. I didn't volunteer.

Eventually I became friends with a fellow holdover named Jeb. He had straight red hair and narrow hazel eyes and was slightly built.

Jeb had already been in holdover limbo for six months. He was an ingenious, self-reliant kid from the Tennessee mountain country. In the evenings he showed me how to play the guitar, which we would sign out from the recreational center.

One night, while sitting at the end of his bunk after a song, he rolled the guitar over to admire the woodwork. "I think I'll take one of these when I go," he announced.

"Go?" I repeated, puzzled.

"I've had it with this place. Can't take it anymore," Jeb revealed, his face a stoic mask.

"You going on leave?" I asked.

He shook his head. "No, I'm going AWOL," he resolutely divulged, followed by a quirky half smile.

"They'll track you down in Tennessee and lock you up tight," I threatened, hoping to change his mind.

"No! I'll get so lost in the mountains they'll never find me." He half smiled again, resigned to his fate." He continued, "I'm taking this guitar because the Army owes me much more than one lousy guitar. I've been in the Army over a year, and I'm still a buck private. No chance of advancement. Stuck in this hole after all the schooling, picking up cigarette butts. They can't do right by me, and I can't do right by them."

"I know what you mean," I said, supporting his situation.

"Have you ever seen anything as miserable as this part of Georgia?" Jeb asked.

"No. There's nothing like this in California," I reinforced.

"Have you seen the tin and cardboard shacks surrounding the base? We're poor in the mountains, but at least we're healthy, got something to do," Jeb went on, resolved in his decision.

That was the last time I saw Jeb. A few days later a sergeant I hadn't seen before came poking around in the tent and asked me if I'd seen Jeb. "No," I answered. I really liked Jeb and there was no chance I'd rat him out.

After two months of picking up cigarette butts I caught a break. It was after lunch on a Saturday during a freezing ice storm. Private

Jones, a light-skinned Afro-American with kinky red hair and unusual light-colored eyes, a holdover who grew up in New Jersey, was standing in front of me, holding the tent door flap open and admiring the ice storm in progress.

I was sitting on my bunk, which was positioned next to the entrance of the tent. "Jones, can you get inside? I'm freezing to death here," I complained, zipping my field jacket all the way up.

"I'm digging on this beautiful storm. Corbin, did you know this is your lucky day?" Jones said as he closed the tent flap and then leaned on a tent pole, watching me with those rare amber eyes and a big smirk on his face.

"My lucky day?" I repeated skeptically. "I've been picking up cigarette butts for two months and living in a tent. And now ice is falling out of the sky."

"See? There's the problem, Corbin. You think the world revolves around you. Today, the world revolves around my black ass," Jones quipped, followed by a toothy smile. A moment of truthful resolution came over me. "Jones, I don't know if you know this or not, but your ass isn't really that black," I bantered with him.

"And it's not going to get any blacker, 'cause I'm not shoveling any more coal. I'm giving my fireman's job to you, and I'm taking my black ass to Istanbul," Jones rhymed and then began strutting about.

"Jones, you lousy fuck. You're not leaving me here in this shithole," I snapped, and bemoaned, shaking off the cold.

"Corbin, I'm giving you my fireman's job. The first sergeant asked for a recommendation. I said, 'Corbin can do it.' Take the fuckin' job. Stoke the furnaces. Read books. Whack it all night long. I'm telling you, picking up cigarette butts will drive your ass crazy," Jones said, and then resumed strutting. "Istanbul meets Mr. Cool—doesn't that sound good to you, Corbin?" Jones goaded, laughing.

A night later I was the new fireman. All of the surrounding wooden barracks had coal-burning furnaces. I loved stoking them, watching the coal turn from black to orange. I worked my own hours, mostly at night and in the early morning. It was an easy job and a bitchin' way to keep warm. The best part was that I had time to read. Next

to my cozy companion fire I read the entire James Bond series, then branched out into other popular novels.

On a cold January morning, while working in the orderly room—also known as the company office—I saw the infamous runner close-up. Rumor had it that he was a holdover. I was stoking the company commander's stove when a soldier opened an inside secure door and then ran through the orderly room around a desk and past me. He had blazing blue eyes and a very agile body. He continued in a blur, running onto the parade field during morning formation while two hundred men stood at attention for roll call. The runner weaved his way through the ranks and was hilariously pursued by two lumbering, overweight sergeants.

In every station of my army experience I witnessed soldiers trying various tactics to get out of the service. Some were indeed crazy; others were crazy like a fox. That guy was a runner. The military police locked him up for a week in the stockade and then returned him to our company. As soon as he got back, he took off sprinting again.

My holdover ordeal ended simply on a January morning. After stoking the company commander's stove as usual, I was called to the first sergeant's office.

I entered and found him sitting behind a well-organized desk. He was an older soldier but still muscular with an angular build and had a probing stare. "Private Corbin, report to records at 0900 hours," he ordered.

"Will do, First Sergeant," I replied, then reported straight to records, where a hefty clerk gave me the good news: They had found my files. He also informed me that I was being assigned to a permanent duty station in Frankfurt, Germany.

I thanked the clerk for the great news and asked him what happened to my records.

"Follow me," the clerk said. He showed me a row of four-foot-high file cabinets. "We found your records behind the cabinets yesterday." I left the office with a bounce in my step and a smile wider than Jones'. In life, it seems some things are a matter of perseverance and others are a matter of chance.

THEATRE OF THE KAISERSTRASSE

I ARRIVED IN FRANKFURT, Germany, in the dead of winter in February 1967, twenty-two years after Germany's defeat in the Second World War. The city of Frankfurt, nestled next to the Rhine River, had been totally rebuilt. Few if any signs remained of the devastating Allied bombing. What remained, however, was an uneasy pall, masking the still recovering psyche of the German people.

My deployment in Germany lasted a year. Five hundred thousand American soldiers were stationed in Germany during my deployment. Four hundred thousand American troops were stationed in Vietnam during that same time period—which is one example of why LBJ's slogan, "You can have guns and butter at the same time," was nonsensical political B.S. The U.S. Armed Forces had too many unnecessary guns and soldiers stationed around the world to have prosperity in all realms. It's my opinion that our overextended military helped bring the country down a couple of notches during the Vietnam era. It takes a generation to get over such blunders. We may have repeated history once again with George W. Bush's campaign in Iraq. We started a war on trumped-up reasons, and when it didn't go well we began torturing people. It's my viewpoint that this kind of divergent leadership trickles down a moral erosion, descending onto and influencing the general population.

During my tour the American Army in Germany was an occupational force, keeping an eye on the Germans and helping them

back on their feet as a democracy. More importantly, however, we were there to make sure the big, bad bear, communist Russia, wouldn't scoop up West Germany. The cold war Iron Curtain ran through Germany, dividing east from west.

I was assigned to Headquarters Company of the Seventh Engineers, stationed in downtown Frankfurt. The engineer battalions had helped defeat Germany, and then after the war helped rebuild German roads. The Seventh Engineers' main job now was maintenance of American military instillations. We wore the sword of freedom insignia—a flaming sword on a blue triangular background—high on our shoulders above our rank insignia on our green fatigues. The majority of our company was comprised of officers, along with a few enlisted men such as me. Most enlisted men worked in communications; some served as clerks or drivers for the officers. Our headquarters' command building was located in one of Hitler's infamous military buildings, which had only been partially destroyed during the Allied bombing. My job, along with that of twelve other communications counterparts, was to set up field radio communications in the event of war. Under our command were six outlying engineer divisions spread throughout West Germany.

That was where the regal-sounding part of my assignment ended and the fantasy began. The truth of the matter was that we were not prepared for war with Russia, and the generals didn't anticipate a conflict. It was all political posturing, perception, and theater; it was a big ruse, part of the political cold war propaganda. The soldiers who were stationed in Germany did nothing. Idle time, poor attitudes, and bad morale were our constant companions. It's my opinion that the occupation of Germany in the late 1960s was a big political pork barrel of waste. There was no political will to reduce our bloated presence in West Germany, and too much money was being made off of lucrative military contracts to change that status quo.

During the entire year I worked as a radio operator, we established contact with all of our six outlying divisions spread throughout West Germany only once or twice. Only one division was diligent about returning my daily Morse code signal of "How do you read me?"

quickly and efficiently, and that was a West German unit under our command. Their reply was always, "Loud and clear."

I arrived at Germany's Rhein-Main International Airport on an ice-cold February evening. Two GIs from our company drove out to the airport to pick me up. Nelson, who became my roommate, was medium height and handsome with a pale complexion, dark hair, and brown eyes. He wore a sharp uniform, fatigues well-pressed and a perfect fit. He was accompanied by another communications worker, SP4 Miller, who worked in crypto. Miller had the lean physique of a runner with blond hair, and his blue eyes revealed smarts. They welcomed me to Germany, and on the drive back Nelson said, "Let's drive through the city so you can see some of the sites."

Nelson knew the city well and turned onto the main downtown thoroughfare, the Kaiserstrasse. Once we were on the main drag it was like someone had flipped on the master switch, for the atmosphere completely changed. The bright lights were radiant, and the streets filled with animated people bundled up against the cold striding two and three abreast with red cheeks and steam puffing from their mouths. Recreation was their destination. We drove through the lively hub of cosmopolitan downtown Frankfurt, a cultural and entertainment center. I was riding shotgun and rolled my window down as we turned onto the Kaiserstrasse. The blast of freezing air in my face, intermingled with the aromas of the street vendors, was my quintessential memory of Frankfurt and has lasted throughout my life.

When the traffic slowed we came to a stop, which afforded me the opportunity to check out the street corner vendors. Once again it was German efficiency and adeptness at its best. The venders stood inside large, fifteen-foot-long carts that resembled portable kitchens or the grommet selection of an upscale supermarket, offering pickled herrings and a spicy array of exotic seafood. Hot items were also prepared. The signature food dish was a steaming bratwurst served with sauerkraut, mustard, and a German lager beer. For me, this iconic German vinegary dish remains unsurpassed. Its memory touches all my senses and brings back my experiences of youth and travel. Taste-

wise, the dish was the most unique and agreeable combination of tastes and textures ever to grace my pallet, which is seemingly always consumed in exotic surroundings.

Nelson navigated the four-lane, highly congested Kaiserstrasse skillfully and pulled in behind a white Mercedes-Benz 230 SL. I stared at the ultra-modern sports car, a masterpiece of German engineering.

"I'm going to pull up on the right side. Take a look and tell me what the driver looks like, Private Corbin," Nelson instructed.

As soon as we pulled even, I looked inside the Mercedes and spotted a lady behind the wheel. "A suicide blonde wrapped in furs. Lots of rings. Pink scarf," I reported to Nelson.

He nodded, then said more to Miller than to me, "Mustang Sally, the sweetest lollipop of them all."

It had been a long day for me and at the time I didn't comprehend his meaning.

Once we left the Kaiserstrasse and started winding our way through the smaller suburban streets, I began to realize how large the city of Frankfurt was and how different European living conditions were compared to that of Americans. The historically inspired architecture, the cobblestone streets laid out in circular patterns, and the oddly constructed gingerbread houses were strikingly different than anything I had seen back home in the States. I particularly admired the engineering skills that graced not only the sports cars in that country but the edifices as well. German architects intentionally exposed steel construction as part of the finished appearance of their building projects. Back then the Germans didn't seem to abide by the concept of four-by-eight sheets of plywood or houses built with studs and plasterboard lined up in housing grids. Instead, German buildings seemed to be integrated into the natural topography of the landscape, held together by a network of narrow, winding cobblestone streets.

Later that night we arrived at the *Kaserne*, or barracks—my new home. It was sixteen klicks from downtown and situated in a Frankfurt suburb. The *Kaserne* housed only enlisted men and was a large, two-story enclosed quadrangle with ample space for morning formations. The facility was constructed out of large quarry stones

and built like a fortress. It came equipped with a large motor pool and a huge front gate. Two hundred and fifty Army soldiers from various units were housed in the barracks there. Our company included only forty enlisted men, and we were segregated from the other units. The other soldiers housed at the *Kaserne* worked in different command groups, or in artillery units or transportation and medical outfits, spread throughout Frankfurt.

The enlisted men in our unit were a close-knit bunch of guys. We developed strong friendships and looked after each other. Two weeks into my stay at Frankfurt the guys decided to initiate me into German culture. Nelson asked me if I wanted to go with a couple of guys into Frankfurt on Friday night. I found Nelson to be one of those guys you had a hard time not liking. His good looks and well-manicured presence were deceiving; he was a guy capable of doing bonehead things. Even so, his self-effacing character and ability to laugh at himself made it hard to hold anything against him. Nelson never talked about where he came from, but I had the feeling he really liked his present position in life. That night, being a ladies man, Nelson was eager to throw away his pay on the German nightlife.

He suggested I buy German civilian clothing. Then, he'd talk to the guys in the orderly room and get me a pass so I could visit downtown Frankfurt on a Friday night. Since I was one of the new guys, I chalked this up to part of the male initiation process. Male bonding rituals were one of my favorite social rites, and I looked forward to giving the guys a good show. Searching through the German shops, I bought a pair of fully lined, ankle high-top, German-made suede shoes, along with a pair of comfortable brown slacks and a warm German coat. To my surprise the price of German clothing at the time was rather expensive.

After work on Friday I showered and dressed in my new civies, then waited in my room for the other guys to arrive. Four men were assigned to each room, all of which were large with high ceilings and wooden floors. Each man had a double-sided wall locker to keep his positions secure and organized. Our rooms were on the second story and came equipped with large, steam radiator heaters and huge

windows—surrounded and incased by massive steel bars—which opened for ventilation. Beyond those windows was a scenic view of the surrounding German community.

Specialist Fourth Class Nelson, SP4 Miller, and SP4 Bennie, all dressed in civies, entered the room.

"How do I look?" I asked, pointing to my new clothes.

Nelson looked me over. "Not bad. Just like a Kraut. So, you ready to hit the nightlife of Frankfurt, Corbin?"

I nodded yes.

"You have your ID, pass, and some spending money?" he asked.

I patted my wallet in the back of my new tan slacks. "Got it right here."

"Have any marks?"

"A couple of bucks' worth," I told him.

"No problem to get more," Nelson reassured. "You can get money exchanged almost everywhere in town. Most everybody will take dollar bills. They like the green stuff." Giving me the basics, he continued, "A dollar is worth four marks exactly. Just like quarters. Don't pay over two marks for a beer and never pay, I impress upon you, *never pay* more than fifteen bucks for a prostitute. You want to buy a beer, you say, '*Ein beer bitter.*' You buy something, say, '*Danke schoen.*' Means thanks. Be polite to the Germans. It's a good deal we have here. We don't want to mess it up." Nelson ran a comb through his hair.

The other two guys, Miller and Benny, were clearly bored listening to Nelson's basic chatter and were antsy to get on the move.

"We better get going or we'll miss the tram," Miller emphasized.

As we were getting ready to leave, I eyed the massive steel bars on our windows and asked, "What's with the bars on the windows? Are they afraid we're going to jump?"

"No, they just left them there. This was an Allied prisoner of war camp," Miller explained. "During the war Nazis interned downed fliers here. Most of the fliers were shot down making runs on the Messerschmitt factory."

"Really? No wonder it's built like a prison," I engaged. "There is

an underground complex beneath the *Kaserne*," Miller continued. "That's where the Nazis interrogated the fliers. It's off-limits. Every now and then some big brass tour it. Now, we better get a move on or we'll miss the seven o'clock tram."

We showed our passes, exited the main gate, and walked as a group along the narrow cobblestone streets. Benny, the fourth person in our group, was an Eskimo kid from Alaska who came from a family of fishermen. Benny had a round face, sparkling dark eyes, and a boyish manner. His grandfather taught him how to hunt seals in a kayak. He was drafted into the Army just like the rest of us and was doing his best to assimilate into mainline American culture. Miller hailed from Wisconsin, was a specialist fourth class, and worked in crypto. Capable and efficient, he had one of the highest security clearances and wasn't allowed to talk to anyone about his work. We caught a yellow tram at a stop denoted by a blue, bird-like emblem embossed on a yellow sign. Twenty-five minutes later we entered the center of Frankfurt.

We arrived at a busy streetcar terminal in downtown. "Let's get a couple of German beers," Nelson suggested, swinging out of the tram by one arm. He led us down a busy street and then through a courtyard and into a German beer garden occupied by noisy jubilant Germans. They didn't seem to mind us Americans; in fact, they liked sharing that aspect of their culture. The beer gardens were one of the few places Germans let their hair down. I never saw a stumbling drunk German. They maintained their poise; however, when they left the garden they were a shade redder around the cheeks than they were when they had entered.

The interior of the beer garden was welcoming and had a spacious lobby kept boisterous by the sixty or so people who were mingling, jumping from table to table, and coming and going. The decor was simple, consisting of wooden tables and benches. A glossy varnish brought out the qualities of the woodwork. Some tables were adorned with red-and-white checkered tablecloths. This type of decor carried over from beer garden to beer garden. Cuckoo clocks hung on the walls. Multiple cases filled with small, kitschy knickknack items were

placed on walls around the guesthouses. The waitresses were healthy-looking, robust German girls dressed in white blouses and short red skirts. As I entered one guesthouse I noticed an intriguing aroma that hung in the air. Cooking smells from the kitchen intermingled with beer and European cigarette smoke, creating the unique fragrance. The kitchen worked from a small convenient menu of substance, mostly meat pies, fish, bratwurst, and sauerkraut. Such robust cooking gave ballast to their customers' high consumption of beer.

One of our guys approached the waitresses near the beer taps and brought back a pitcher of warm German beer. The Germans served their beer at room temperature. It's an acquired taste, but once immersed in this facet of their culture you soon came to accept warm beer as normal. We were in the beer garden for two hours, had a bite to eat, and then worked our way through three pitchers of beer. Benny the Eskimo and I were pretty drunk by then. I've always been an easy drunk, but I arrived there in particularly rapid fashion on that evening, largely due to the fact that I hadn't realized the kick-ass power of German beer. It contained point-nine percent alcohol and was three times stronger than the beer served stateside at the enlisted men's club. To top off the evening we were also smoking Kool menthol cigarettes.

Benny lit a new cigarette, then stood up and put it out in an ashtray. "I don't know why I smoke these things anyway." He took the pack of cigarettes out of his pocket, tossed them into the middle of the table, and said, "You guys can have them. I'm going outside to get some fresk air." He mispronounced the word as he staggered toward the entrance, bumping into several tables along the way.

"Bennie's pretty drunk," Nelson observed.

Miller got out of his chair and followed Bennie. "I'll make sure he catches the tram home," Miller called back to us on his way out.

Nelson picked up the pack of cigarettes and said to me, "Corbin, let's go for a walk. It'll sober you up a bit. German beer has some getting used to." He rose, navigating his way toward the exit.

I followed. I wasn't quite seeing double, but I was pretty drunk.

We explored the Kaiserstrasse together. Nelson was in his element. Germans were out taking in entertainment, along with a never-ending spectacle of GIs dressed in civies, young men alive with excess patrolling the streets looking for action.

Nelson pointed out the different hot spots and told me which places to avoid and where to buy inexpensive beer. It was cold outside that night, but I wasn't feeling a thing. Nelson then marched me to one of his favorite parts of Frankfurt. We turned down a darkened side street and walked for a block. Two-story dwellings aligned the street and appeared to be living quarters or apartments. We stopped walking.

"You see that gal over there in the doorway?" Nelson eyed a nearby building. "She's turning tricks."

I followed his gaze. Sure enough, there was a tall, blond lady, wearing intriguing makeup, standing alone next to a stairwell, wrapped in a stylish coat.

Nelson put his arm around my shoulder, turning me down the street. "Let's see what's available this evening on Hooker Strasse," he said and began eagerly walking.

We strode along the street. At every third house was a single female simply standing alone next to a doorway. We walked a little further.

"You see that one there?" Nelson indicated one woman in particular. "That's good German pussy." "You mean you can buy them?" I quizzed, trying to clear my mind. "More like rent them. They're professionals. Each one's different." "How do you approach them?" I asked, desire stirring in me. I attempted to straighten my clothes.

Nelson took a hit from his cigarette. "Simple. Ask them how much, but never go over fifteen. If they say twenty, you counter by saying fifteen."

"How do you say fifteen in German?" I asked, vague about how to communicate.

"They all speak English," Nelson assured me.

As we were talking, a well-dressed man approached the lady of the evening that Nelson had approved of. They spoke briefly, then strode upstairs together and disappeared into a room.

"The beekeeper has arrived. He'll be harvesting honey soon," Nelson grinned. I didn't catch Nelson's drift.

Nelson noticed my confusion and clarified, "He'll be giving that sweet German pussy some bone in a couple of minutes."

Throwing caution aside I thought to myself, I'm going upstairs with one of these babes. The next lady we spotted look good to me. "I'm going upstairs with this one," I announced to Nelson. Nelson emphasized, "No more than fifteen bucks. I'll wait for you at the square." Nelson pointed to a miniature park a block back toward the main drag.

I took a long look at my lady of choice. She was in her mid-twenties, blond hair, an innocent-looking face. Her deep-set blue eyes were overly made up with mascara. That's all I can remember about the way she looked. I remember more about the way she acted. Approaching her, I asked, "How much?"

"Twenty dollars," she replied, businesslike.

"Fifteen," I countered.

"Fifteen, only one cum," she told me.

I said, "Yes." We walked up the stairwell to the second floor, then stopped at the entrance. "Money now," she demanded.

I discreetly handed her fifteen dollars. She opened the door, and we entered the room. It was a makeshift attic space with a sink and a bed. You could see the rafters and the steep pitch of the roof. I couldn't get over how professional she acted. She had a set way of doing things and led me through them step by step. Even the ladies of the evening exercised German efficiency. She walked me to a porcelain sink, which I noticed had been altered. It was lower than the normal height—about even to my genital area.

"Take off your pants," she ordered.

I was excited and Mr. Johnson was ready.

She examined and then washed the entire gizmo area, then pulled a rubber over Mr. Johnson. She started undressing and told me to do the same.

I was instructed to lie down on the bed on my back. She then mounted me. After five to ten rhythmic thrusts I was ready to cum. I

tried with all my might to hold it, and for the first time I overrode the unstoppable urge, sending it back down into the depths and thinking, now I can have some fun. I reached up to touch her bouncing breasts. She pushed my hands away. They were off limits.

Ten minutes into it she started pretending to have a good time—or was actually having a good time, I don't know which for sure. When she started to "uhh" and "ahh," I tried again to touch her breasts. Finally she gave in, letting me hold them as she bounced up and down.

After twenty minutes of action a clock went off in her head. She had apparently exerted enough effort on me and slipped off. She then started a monologue out loud in German while gazing at me. It didn't sound demeaning or malicious or aimed at me personally. It actually sounded kind of funny, even though I couldn't understand a word of it. She probably said something to the effect of: "These American guys get so drunk you can fuck a rubber off them and they still won't cum." The rubber she had placed on me had split open. "All done," she said as she pulled the rubber off.

"One cum," I countered.

She shook her head. "All done," she repeated.

I pointed to Mr. Johnson and said, "One cum."

She began another long German monologue. The translation probably went something like this: "I really have to find another job. Plan number two: Now I'm going to introduce you to some of my friends." To my amazement she quickly grabbed my pants and shoes and exited the door, locking me inside. I dressed in my coat and boxer shorts—my only remaining clothing—and began contemplating my situation. Five minutes later I heard the distinct sound of military police sirens getting closer. I thought, I have to get out of here. Nelson later told me that he had waited for me with Miller, but when the MPs arrived at the door downstairs they skedaddled.

Inside the apartment I searched the room for a way out and found a small latched door that opened onto the roof. I climbed out of the attic room and was standing on the steep, tiled roof in my coat and boxer shorts. Every time I tried to climb up the steep roof, I started slipping down the slope. The MPs arrived and had me cold—there

was no getting away. The MP on the ground shone his flashlight on me, and the other MP inside the attic room stuck his head out the roof door and directed his flashlight on me as well. My mind was racing and my judgment was impaired. *I can't get away. I really screwed this up and I'm going to the stockade* I envisioned. They finally talked me down off the roof and back into the attic.

The MP in charge was a sergeant. He was a large man with distinct overreaching dark eyebrows that moved around as he spoke. He handed me my pants. "Check your wallet. See if anything is missing," he instructed. His eyebrows and lips took on a playful expression. This particular lady of the evening was very professional; everything was still in my wallet.

The other MP was also a tall man but thinner. He was a trainee and mostly observed. The sergeant placed me in the back of a patrol unit behind a steel cage. He keep the door open as I sat and he gawked at me. "We can take you in, and you can cool your heels in lockup, or you can tell us what happened and we'll give you a ride back to the *Kaserne*," he said glaring, his eyebrows locked in a serious expression.

I chose the latter. The sergeant drove and did most of the questioning.

"How long have you been in Germany?" he asked.

"Two weeks," I replied. The trainee requested I bring my head closer so the sergeant could hear better as he drove. I rode all the way back to the *Kaserne* with my head and hands planted on the steel cage, close to the sergeant.

"You've been in the Army for a while. Why are you still a buck private?" The sergeant inquired.

"I was a holdover in Georgia, picking up cigarette butts for three months before I came here," I replied.

A chuckle came from the front. "You have anything to drink?"
Less than a pitcher," I said.

"What happened to your buddies?" he asked, trying not to laugh.

"Bugged out, I guess," I replied.

They started laughing. "What were you going to do up on the roof in your skivvies?" the trainee asked.

"I hadn't figured that out yet," I frankly answered.

That busted them up. They guffawed and snorted, breaking into spontaneous laughter. They asked to hear the story again so I could fill in all the missing sections. They chuckled right up to the moment they dropped me off at the front gate of the *Kaserne*.

"*Guten tag,*" the sergeant said before the unit spun around and headed into the night. I was upbeat, relieved, and thankful as I strode through the front gate a free man, thinking, Now we're getting somewhere, and what a memorable night that was.

My situation probably presented an easy night for the MPs and helped restore the relationship between the American Armed Forces and the German civilians. No disorderly conduct or fighting, and certainly no mayhem. I was just another drunken private cutting loose in Germany for the first time.

Back at the *Kaserne* I became a controversial folk hero for a couple weeks. I was perceived as fighting for my rights against the expensive ladies of the evening. The perception among us enlisted men was that the MPs were overly protective toward the working gals. You have to remember, as a buck private my pay was only three dollars a day. Other straight-laced types questioned my actions and how it reflected on the unit.

Jackson, my new roommate, put an end to the controversy. An Afro-American who had grown up in Watts, Jackson was one of the coolest guys to ever walk the face of the earth. He was streetwise, six feet and two inches tall, handsome, and had the respect of his fellow black soldiers. He would eventually introduce me to black culture. At this crucial moment, Jackson articulately spoke up for me and supported my case. I heard him say to another soldier, "Fuck, cut Corbin some slack. He just arrived. He went kipper-shoppin' and bought some honey. Let the man chomp some German honeycomb. What's the big fuckin' deal anyway?"

With my pride, overconfidence, and high opinion of myself I went out and tried to out-drink the guys and became roaring drunk. Then I tried to out-fuck the guys and was brought home by the MPs. My careless, messed-up behavior was not only acceptable but also

admired by some of my fellow enlisted men. I passed my initiation into the all-men's club with flying colors.

I had begun learning about life in the basement and was working my way up. Were all these sociological research projects necessary for me to become an artist? In my case, they probably were. It's my viewpoint that in order to uncover a common trait of humanity in people you must live a little bit. I probably could have made a faster ascent in the art world with a privileged cosmopolitan upbringing, but by doing it the hard way I was able to intimately understand the ground I had to transverse. In my creative journey, the uniqueness of my art vision has been formed and shaped by the body grinder of my life experiences.

A typical day in the Army began with me getting up at six in the morning, putting on green fatigues, standing in roll call formation, eating breakfast in the mess hall, making my bunk, and then falling out once again for eight o'clock formation in the quadrangle. After that, I'd report to motor pool and find a sidekick. We'd then sign out a two-and-a-half-ton truck mounted with a self-enclosed radio rig seven feet high by fifteen feet long by eight feet wide. A portable generator mounted on a trailer attached to the back of the truck by trailer hitch. With my copilot at my side we'd drive the radio unit ten miles into downtown Frankfurt. The first portion of the route wove through narrow cobblestone streets where buildings jammed both sides of the roadway. We then merged onto the ultra-modern Autobahn.

There was no speed limit on the Autobahn, and the fastest German drivers drove Mercedes, flashing their lights as they sped by us doing sixty, seventy, even eighty miles an hour. Every time I drove that road it was an interesting adventure. The top speed of our truck was fifty mph. Driving that vehicle was similar in concept to driving a load of peaches on the ranch. You were pulling a trailer and couldn't accelerate, couldn't stop, couldn't steer, and couldn't see very well. My fellow radiomen liked riding with me for they saw no joy in driving an unruly truck in a foreign country.

Once we arrived at the downtown central command building the

real theater of the absurd began. The biggest issue of the day was always parking. We would eventually park the radio rig between two wings of a large, military, two-story command building. The problem was that the whole complex was surrounded by parked German cars. That happened every time we drove to headquarters; we would have to move a parked car in order to reach the stationary antenna. We'd find a specific U.S. Army captain, who would jot down the license plate number of the German worker, track them down, and request that they move their car. I'd then back the radio rig with the trailer attached between two parallel-parked cars over a curb and in between two buildings to the location of a stationary radio antenna.

A defining Army moment happened one morning after the radio rig was up and running. Sitting in chairs inside the tightly enclosed radio compartment was Specialist Fourth Class McAfee, SP4 Miller, and myself. McAfee, a tall, six-foot-two, divorced, red-faced, hard-drinking Irishman from New York, was knowledgeable, blunt, an iconoclast, and absolutely brilliant. His father owned a bar in New York. Also joining us in the fully enclosed radio rig was a newly reassigned incoming noncommissioned officer, Sergeant E-7 Baylor. He was the new man in charge of the radiomen and communications specialists. Being a new replacement rotating in, he wanted to get acquainted with his new men and had entered the radio rig through the secure door. His military appearance was well maintained. Sergeant Baylor's hair was cut so short on the sides you could make out the shape of his skull. The hair on top of his head was an inch long but always covered with a neatly boxed green Army cap. He came equipped with the compulsory noncommissioned officer beer gut.

We were seated in rolling chairs as he spoke. "You guys have radio communications with the lower divisions?" Sergeant Baylor inquired, standing and looking down at us.

"Only the Germans are answering today," I replied.

"Maybe you need to recalibrate the radio," Baylor suggested in a show of authority. The radio was a very sensitive and sophisticated piece of equipment. It could send a radio signal around the world and pick up the same signal six minutes later. "Let me recalibrate

it," Baylor mandated. In a whirlwind of misguided and ill-advised twisting of dials, cranking of cranks, and erratic movements of levers, smoke began streaming from the back of the four-foot-high radio. Next came a popping sound, and all the lights on the front of the radio went out.

"Well, we'll have to requisition another," Sergeant Baylor said as though he had only broken a stapler. Self-assured, he exited the security door.

SP4 McAfee, with his immaculate timing, said, "Can you believe how fucked up that was? You just saw a great example of why the American Empire is going to fall. Dumbass NCOs. Throw in a mobile and motivated guerrilla fighting force. We're screwed in Vietnam. We're going to get our butts kicked." McAfee looked at Miller and then at me. "You guys don't get it either," he exclaimed while exiting the radio compartment, shaking his head.

Miller switched on a ventilation fan. "If McAfee doesn't tone it down, we're all going to get court-marshaled," he grumbled.

McAfee's insights were new to me. "What does he mean by guerrilla force?" I asked. "They only have monkeys in Vietnam," I flipped off a switch on the radio.

"Beats the shit out of me." Miller grabbed the fire extinguisher off the wall. "I'll tell you what McAfee doesn't know: How to keep his mouth shut." Miller sat back in his chair, hands around the extinguisher.

"You think the radio might catch on fire?" I asked.

"Did you notice those other assholes left?" Miller asked, now holding the fire extinguisher in the ready position between his boots. That was the day I realized the Army was broken.

Going downtown and getting bombed with the guys got old in a hurry. My whole life has been a character study in duality. On the one hand I liked all the man stuff, hanging out with the guys, getting drunk, doing the tough male competitive thing. The other side of my nature seemed inquisitive and wanted more. To help quench this thirst I began taking art classes at the USO clubs. My official entrance into exploration of the field of art began with a painting and

a photography class at the local USO club. The facilities were located three blocks from our *Kaserne*. The USO club offered painting classes and maintained a well-equipped photo darkroom—and gave soldiers several options and alternatives as to how best to get smashed every night. They also helped the German people get back on their feet by providing jobs. Our club was staffed by talented German artists. My German painting instructor, Hans, spoke English, had greased-back brown hair, slate-blue eyes, and the residue of a serious burn scar on his left arm. He was the only laid-back German I ever met and ran the painting class informally. One day I checked out a book from the library that contained impressionistic paintings and a colorful yellow nude painting by Bonnard.

"Could you show me how to paint like this?" I asked Hans.

"The best way is to try and copy it. I'll help you out," Hans offered.

This was my introduction to drawing, color, composition, and the figure.

I bought a 35mm Konica camera at the PX and began shooting photographs. In those days exposed film was kept in an aluminum metal canister with a nifty screw top. After work I'd walk to the USO club, develop the film, cut it into strips, and select three or four negatives to enlarge in the darkroom. Any reader who came into this world during the digital age has missed out on the exciting but labor-intensive process necessary back then to obtain a photo image. The darkroom contained an enlarger and three trays of chemicals. You had to place a negative into the enlarger and a piece of photo-sensitive paper underneath the lens. The process began by shooting light through the negative onto the photo-sensitive paper for ten seconds. Then came the magical part. With a pair of tongs, you dipped the exposed paper into trays of chemicals and waited for an image to appear. It reminded me of dawn, but in reverse. Out of the totally white tray an image would slowly begin to magically appear on the white photo paper.

This introductory class led to my love of photography, which proved invaluable to me as an artist and became the one consistent activity to follow the many twists and turns of my long, meandering

career. Those eight-by-ten, black-and-white glossies were crucial in promoting my work and helping me get published.

In the motor pool, not long after the MP hooker incident, my roommate Jackson introduced me to black street culture. Jackson was a social innovator, and as a cultural leader he was contagious. I credit him with starting the expression "to the max."

One morning after breakfast I asked Jackson how was it going.

"To the max," he answered. Jackson then walked down the hall, and another soldier asked him, "Jackson, you driving today?"

"I'll be driving to the max," Jackson answered.

Pretty soon everybody in our company started saying "to the max." Two months later, in downtown Frankfurt, I heard soldiers from different outfits using the jargon. Three years later, while I was enrolled in college at UCSB, "to the max" was circling through the student body.

Jackson and I had the West Coast vibe in common. I always liked cool, and he was the essence of it. We shared mutual interests, getting along fairly well for this period of time. I remember one Saturday in the motor pool on a cold March morning. The sky was high but the sun not vigorous enough to penetrate the cloud cover. We had dressed in our heaviest winter clothing: gloves, wool socks, and lined field jackets to ward off the Baltic cold snap. We only worked half-days on Saturdays and kept busy in the motor pool, doing routine maintenance on the trucks. There were perhaps fifteen to twenty vehicles in the pool, comprised of jeeps, half-ton trucks, three-quarter-ton trucks, and pickups, most of which were painted green or olive drab. On the bumpers white-painted letters and numbers denoted the command level assigned to each vehicle. That particular morning, I was striding through the motor pool and passed a two-and-a-half-ton truck.

Suddenly the door opened. "Jump in," Jackson invited.

We sat inside bullshitting about how cold it was. The front windows of the truck were obscured with a coat of ice. The steel springs beneath the fabric of the green front seats were frozen stiff, and you could see your breath when you spoke. The temperature had recently dropped to six degrees below zero, but the truck's interior seemed even colder.

Private Dixon, a huge muscular black soldier from our unit who had grown up in Harlem, opened the door and slid in beside me. Now I was flanked between these two brothers, one from Watts and the other from Harlem. Dixon was a little surprised to see me, and I was definitely more than a little surprised to see him. We were in a headquarters company and short on personal, so the orderly room had requisitioned a GI from one of the lower units. The lower units sent up Dixon to rid themselves of a difficult soldier.

Private Dixon had powerful shoulders and my first impression: he was a bad ass brother. Blacks and whites alike gave the man a lot of space. I had no understanding of black culture and only saw a man surrounded by a swirling cloud of dilemma, his exterior persona seeming to reflect an inner turbulent world. He was hard to understand owing to his heavy Harlem slang. Dixon had been busted to private and spent time in the stockade, but they still hadn't broken his brio.

Dixon and Jackson exchanged looks, temporarily ignoring the white man squeezed between them. Dixon was probably thinking, What in the fuck is Corbin doing here?

Jackson eased the tension. "Corbin's cool."

Dixon nodded, deferring to Jackson's judgment.

"Want to get high?" Jackson invited.

"Sure," I agreed. For me the decision was as much about trust as it was about curiosity and experimentation. It was an opportunity for me to gain respect from a man who had defended me and whom I admired. I trusted Jackson and saw him as a highly evolved spiritual person.

Hashish is a concentrated form of marijuana and was the drug smoked by soldiers in Germany. Ten to fifteen percent of the GIs in Germany smoked it recreationally. Dixon pulled a half-inch cube of brown hash, which looked like chocolate but had the consistency of soft resin, from his field jacket. Hash could be rolled up into tiny balls the size of a pencil head or large grains of black pepper. Jackson retrieved a cigarette from his pack of Kools, dumped half the tobacco out, and loaded the partially empty cigarette with four or five tiny balls

of hash. He twisted the end of the cigarette so the contents wouldn't fall out and to make the cigarette easier to light. We passed the lit cigarette back and forth, taking tokes and occasionally coughing it all out. It was an honor to share with those two. I felt a bond with them, although it helped that Jackson was running interference between me and the unpredictable Private Dixon. You must realize this was an exercise in trust and social graces as well as getting high. It was 1967, and race relationships between black and white soldiers were occasionally strained.

That was my introduction to a recreational social convention I indulged in for the next twenty years. For me, pot was never a problem and was my recreational drug of choice. In my case alcohol seemed more destructive. My whole life has been about moderation. I was a health-food nut and watched my diet for most of my life. I treated Mary Jane with a lot of reverence. Although not for everybody, I had tremendous respect for its properties. I considered pot to be a gift or a privilege and felt it should be treated as such. In the 1960s it became an anthem for the baby boomers and a core issue for the cultural revolution. Sex, drugs, and rock and roll were tools used for social bonding at the time. Pot united a rebellious idealistic generation against our perceived and real disdain of the state; it bolstered our "us against them" mentality. If they'd only smoke a joint, everything would be all right. Of course, since it was illegal you had to choose the friends you shared alternative states with wisely. My favorite pastimes were the recreational use of pot, smoking with friends, playing music, and lovemaking.

When it comes to the actual construction of a sculpture, weed is a hindrance. Pot is great for unrealistic ideas, but the process for making sculptures is precise and requires power tools. You have to be a top athlete mentally and physically to be a good sculptor, and pot tends to make you stupid and clumsy. I kept it out of the shop. Mary Jane's biggest advantage in my case came in the form of endurance. It helped me tolerate the long journey through the woods. I thought of pot as a friend or as part of a special relationship. When the relationship was no longer beneficial, I gave it up.

I assimilated certain black cultural and social conventions into my impressionable and developing personality while in the Army. From black culture I learned how to add an easygoing humor of the moment while trying to get my point across in social situations. There is a lot of idle time in the Army, and much of it is spent smoking and joking. I began looking forward to sharing some harmless banter with Dixon. Dixon's room was four rooms down from mine. It was June now, and the first warm air of the coming summer, loaded with the enticing smells of flowering vegetation, drifted through the open windows of the barracks. One weekend, well past midnight, I was strutting down the hall to the latrine looking for Dixon, making sure my bodyguard Jackson was present before entering. None of the rooms had doors, and whoever was still up this late probably had a buzz on. I discovered six guys already present in Dixon's room; among them were a couple of new Afro-American faces. Everybody seemed to be in a good mood. Dixon had his back to me while I stood in the entryway and was adjusting his heavy wall locker. He habitually engaged in feats of strength to subtly show off his muscular physique.

I entered and in a loud voice said, "Damn, Dixon. You're a strong man." Having captured everybody's attention, I taunted, "You're going to need everything you have and a little bit more."

Dixon turned to face me, his eyes bloodshot and one eyebrow slightly raised higher than the other. His mustache had recently been trimmed, and he was wearing the kind of loud maroon shirt only a black guy could get away with.

Dixon let out a grunting laugh. "What the fuck you talking about, Corbin?" he asked.

"I heard you been talking about me," I accused.

The two white guys in the room started looking at each other.

"Just what in the fuck you think you heard I said?" Dixon grunted, annoyed.

"You said you don't think I can make it Harlem," I madcapped.

Dixon was proud of his Harlem roots and loved it when I brought up the subject. The two new black guys in the room started snickering.

Dixon let out a controlled laugh. "Shit, Corbin. They kick your mother fuckin' ass in Harlem for walking down the street."

"I don't think so. Not going to happen. See, I go to Harlem, I go with you. You look after me, show me around. Check this out. We walk into the Apollo side by side and take in a James Brown show," I said, eyeing Dixon, who had an incredulous look on his face.

"You out of your fuckin' mind, Corbin. I show up in Harlem with your mixed-up, green-eyed shit, they kick my ass too. They pull this nigger's legs right off me."

"Nobody going to fuck with you, Dixon. Nobody. And I'm not going with anybody else," I declared.

"Corbin, find some-fucking-body else to go on your motherfuckin' sightseeing tour of Harlem with," Dixon said, finalizing the conversation.

I shot a disbelieving look toward Jackson.

"I'm sure the fuck not going to Harlem with you," Jackson affirmed, blowing smoke from his cigarette.

I looked at the other guys in the room. "Then I say fuck all you guys." I turned on my heels, pointed my thumbs toward my butt, and slowly left the room.

I learned something profound from those two black brothers, and a novel expansion of my mental awareness began to occur. Through that opening ran a tiny river that nourished a neglected part of my soul, allowing my psyche to contemplate the wonder and unlimited capacity of the human spirit in a new way.

I came to realize that, though unpredictable, Dixon was not a danger to me personally, and trying to get over on him was exhilarating, like playing with fire. You never knew what was going to happen, but you knew it was going to be exciting. Although he was erratic, he was probably more dangerous to himself. Dixon was problematic for the sergeants, however. Some mornings he didn't want to get up or be told what to do. Finally, he was shipped out to a lower unit. It was one of the first acts of our new company commander, Lieutenant Anderson.

There's a rule in the Army. Your life is only as good as the chain of command above you. If your commander is a dickhead, your life

in the Army is going to be miserable. When I arrived we had a great company commander at the *Kaserne*. He was in the first sergeant's office every day, knew all the enlisted men, and fully understood our mission. Then, the old company commander rotated out and a newly minted commissioned officer rotated in. His name was Anderson, and his most distinguishing feature was his lack of height. He couldn't have been taller than five feet, three inches. Anderson liked being an officer and did things by the book. Two steps up, one step back. By the numbers. Spit and polish.

Lieutenant Anderson showed the confident behavior of a purposeful man who never questioned himself. His admiration for power seemed, in his mind, to justify his willingness to make other men's lives needlessly miserable. Our mission was to occupy Germany and burn up as much of the taxpayers' money as humanly possible, but Anderson ran the company as though it were his personal fiefdom, his ticket to advancement in the military. He projected Nixonian illusion, as though our unit was willing and ready to fight it out with the Russia army. Pride, country, duty, honor, obligation, and sacrifice were his favorite words, and he savored them all as they slid from his tongue during motivational speeches he gave to our company.

After one such speech McAfee whispered to a bunch of us, "This guy is fucking dangerous."

I assumed that McAfee acquired his considerable life knowledge from his unique New York perspective. He gave me piercing insights into some of my confidence issues, which I was to later work out. I admired his chutzpah and uncompromising attitude toward the truth as he saw it. The tall draftee set the intellectual tone of our small company and figured he ran things by default. In his mind, the new company commander needed straightening out, and he was the right man for the job.

One morning, in the orderly room, a mixed group of enlisted men of various rank and Lieutenant Anderson were all engaged in casual chitchat—a holdover social convention from the days of our last easygoing company commander. McAfee was present and sensed his moment. He began engaging in witty conversation, and in the middle

of one clever analogy said something to the effect of, "The headless horseman doesn't have a Napoleonic complex."

All Anderson needed to hear were the words "Napoleonic complex." It was a subtly delivered New York mindfuck that backfired on McAfee. Two weeks later, the new company commander uncovered a conduct violation, alcohol in the barracks, and used the infraction to bust McAfee down to a PFC (private first class) using Article Fifteen.

Lieutenant Anderson was on a roll and cleaning house. The Army was trying to straighten itself up before it eventually fell apart. Nelson was the next person in our unit busted to private first class. He had acquired a German girlfriend and was therefore not getting much sleep. He would often show up in the middle of the night, change out of his civilian clothes and into his military uniform, and then lay on top of his covers so as not to mess up his bunk and sleep as long as possible before roll call formation.

Nelson would fall asleep during the middle of the workday anywhere and everywhere. You could walk into a latrine and find Nelson, asleep while sitting on the john. The situation finally caught up to the soldier when he dropped a colonel off at the command building and fell asleep in the driver's seat while waiting for his return. Sleeping on duty is an automatic bust. The pitiful thing was that Nelson liked the Army and was a natural lifer. He had just re-upped, and they had promised him sergeant's stripes.

The next one to receive Anderson's punishment was Jackson after he knocked up a German jazz singer. Jackson was very taken with her and decided to reenlist, with the hope of using the substantial cash incentive he would receive to marry his German *Fräulein*. He needed one more routine document from the new company commander before the reenlistment could be finalized and he could collect his reenlistment cash bonus. The new company commander, Anderson was out of the office on a three-day leave. Jackson was impulsive and couldn't wait. He forged Anderson's signature on a routine form and turned in the paperwork, speeding the process up by a week.

Lieutenant Anderson learned of the transgression and informed

military justice of the forgery. Jackson was prosecuted, busted to private, and sent to the stockade for four months.

Racism was probably a factor in Jackson's harsh punishment and incarceration; however, there was clear wrongdoing on both sides. I have a big enough task figuring out how to make an interesting sculpture—I'd let someone else figure out race relations. I do know this: Jackson was never the same after he came back from the stockade. Two of the men who received the brunt of Lieutenant Anderson's disciplinary action were tall men with superior natural leadership abilities. A yellow warning message appeared on my screen, and I lowered my profile.

Looking back on those events now, my life up to that point had been spent in the capacity of observer. I laid back, watched, and studied. People trusted me since I didn't seem judgmental. I was a pretty "live and let live" kind of a person. Later, when I was in college, a girlfriend told me that I had a real ability to blend in, as if I was a human chameleon. Relationships were more important to me than overriding social dogmas and causes. I think that nonjudgmental part of my being allowed me to get close to people and eventually helped me realize my dream of becoming an artist.

However, I was also wishy-washy, noncommittal, and suffered from an undying naïveté. Some part of me couldn't be satisfied with the complexities of life—I wanted something even grander. The outlook I created was unrealistic and unachievable, my goals were nonexistent, and to top it all off, everything had to be done my way. It was probably a compensating mechanism from my stressed childhood, or perhaps it was just natural-born naïveté. Whatever the reason, it would be another six years before I finally made a commitment to something in life: art.

The communal situation at the barracks was going downhill. I became close friends with a Canadian from Montreal by the name of Greg Hoyle. He had a dimpled chin and red checks and was constantly smiling. Greg had joined the Army to become an American citizen. His civilian ambition was to become a disc jockey. During the off hours he would practice his shtick on anyone who would listen. "This

is CKGM *rocking* you from Montréal, bringing you Wicket Pickets in the midnight hour," Greg would slam in his pumped-up radio voice. Other times he delivered his disc jockey pitch in French.

We were great friends and considered ourselves the Captains of Cool. We improved our dance moves to songs such as "Mustang Sally" by Wilson Picket next to the NCO club's jukebox. We would then dress up, don our 1950s Fonda hats, and head to Storyville, a club in downtown Frankfurt. Once there we'd dance a while with the local girls. Greg was soon 1049ed, transferred out of our unit, and reassigned to Vietnam. When he left, the real fun left the barracks with him.

I began spending more time at the USO club working on my art projects. Doing creative work boosted my appreciation of life and gave me a sense of direction. Plus, the classes reaffirmed that I had natural talent. The fantasy of becoming an artist merged with my long-smoldering belief that I was someone special with an unusual gift. Psychologically it fit in with my desire to do something extraordinary. Maybe art was my calling, I thought as an uplifting sensation flowed through me.

Those first art classes taught me how to progress as an artist. I was learning a system, the same system I had used during college and expanded upon during my long years of struggle. You make a painting and use what you have learned to make the next one. Every work you finish ignites an idea for the succeeding one. In the discipline of art you realize that subtle changes can make a huge difference. A reservoir of procedural learning becomes stored someplace in your brain. The more you do, the more you learn. As time passes your knowledge builds and becomes part of your being. When I work on a sculpture now, all these years later, the answer to a problem may not be immediate, but there is an intuitive answer to most of my art-related issues.

There was no great epiphany from the Art Gods at that point to give me guidance. They took no interest. I was a smartass kid from the country who just now was acquiring a taste for culture. Millions of people out there were also exploring the possibility of becoming an

artist. The Art Gods had more talented and committed individuals to endorse to carry the art torch of social change.

A three-day pass to Amsterdam ignited my desire to see Europe. Miller and I traveled to Amsterdam by train. As we checked into a hotel the pleasant, outgoing, buxom lady maître d' asked, "Do you want ladies to spend the night with you? They are clean and friendly." She made the offer with an enduring smile. Miller and I turned down her proposition. We preferred the better selection offered by nighttime window shopping in the red light district. Amsterdam was a relaxing break from the fastidious German psyche, and we enjoyed ourselves.

The former crossroads of civilization, Amsterdam was open and exotic with an international flavor. Exciting my senses of travel and discovery were the tall, narrow, multicolored buildings crammed together, overlooking an extensive system of canals and bridges. Narrow cobblestone streets were clogged with bustling folk riding by on bicycles. Displayed throughout the city were large movie posters in English announcing the arrival of the American movie *Doctor Dolittle*. Cold, salty ocean breezes blew in over the low, manmade earthen dikes. I found the Dutch to be tall, skinny, good-natured Nordic people who loved eating pickled herring. I would watch them turn their heads up and with one hand lower the herring into their mouths. In Amsterdam, I saw raw red meat consumed as a snack food and washed down with a Heineken beer. I ask you, who in his right mind eats raw meat? Outlandish Amsterdam stirred my imagination and sold me on European travel.

I received a European discharge from the Army and traveled the continent for three months using a motorcycle as my mode of transportation, prior to my return to the States. I learned of the European discharge from a former U.S. soldier who had acquired a job working for the U.S. government as an intelligence officer. He also spoke fluent German, was married to a German woman, and held dual citizenship. I asked him how he had managed it all.

"It all began with a European discharge seven years earlier," he told me.

I asked my heavily built company clerk if he had ever heard of

a European discharge. He said he hadn't but would look into it. A week later I had my hands on the extensive paperwork needed to receive a discharge in Europe. One of the sticking points was that I needed a recommendation from a German national concerning my character. I met Hans in his classroom and asked if he'd mind giving me a character reference so I could get discharged in Germany.

Hans paused and with a straight face said, "Deutschland? My homeland? It's my pleasure, an honor. I approve. You like the arts. You have an open mind, inquisitive. However, you might think about it, to reconsider. Germany, my homeland, put guys like you in jail twenty years ago." It was an awkward moment, an attempt at a joke.

My initial reaction was to don a poker face. Then I broke into a spontaneous chuckle. That was the only time I heard Hans or any German joke about Germany's painful past. I took it as a compliment that he trusted me enough to make an effort at a joke.

In the Army there is an expression called "short-timer." Officially, short time begins sixty days before the date of your discharge. Every soldier who is short knows exactly how many days he has left. I woke up on April 6, 1968, put on my civilian clothes, organized my remaining possessions in a backpack, and swaggered out the front gate during morning formation a free man. I made sure everybody in the *Kaserne* saw my exit, especially my buddies. I was over-the-top exuberant with my recently obtained freedom and liberty.

Catching a tram I rode through this section of Frankfurt for the last time, making my way to the Bahnhof, Frankfurt's main railway station. There, I bought a one-way train ticket to Barcelona, Spain.

All of my ill feelings toward the Army were now put aside. Being stationed in the European theater was a fortuitous event in my life. The tour in Germany facilitated my exposure to European art. I also have to credit the Army's USO clubs for introducing me to art classes. Those combined experiences helped trigger my cultural emergence, setting me on the path to becoming an artist. A big thanks goes out to the studio extras—all the unnamed people I passed along the way— who rounded out my spiritual essence and who helped further season my impressionable personality.

RESTLESS AMBITIONS

MY ADVENTURE IN Europe furthered my pattern of self-sufficiency and self-reliance, one of my strengths in life and probably also one of my biggest weaknesses. The three months I traveled that country became a journey of discovery and awakened me to the vastness of foreign cultures. On a map of Europe, I planned my itinerary, during which I would cross nine European countries. I stayed in Spain a couple of weeks, where I decompressed, visited art museums, ate paella, and took in the warmth there—my only respite from the cold that currently plagued western Europe. I loved the laid-back, international charm of Spain, and after college I would return there and set up an art studio.

From a Spanish man in a black beret I bought a two-cycle Ossa 160cc motorcycle. It had enough power to hold its own on the larger highways and demonstrated great scaling ability in the mountain regions. Two bungee cords allowed me to strap a backpack to the back of my vehicle. In one pocket of my Levi's I carried my passport and travelers checks, and in the other pocket my switchblade knife. The journey began along the warmer sections of the Mediterranean.

I left Barcelona and toured along the Mediterranean Sea, arriving at the French Riviera and stopping in Cannes and Monte Carlo along the way. Most days I motored a comfortable four to six hours and then would stop at a hotel, pension, or youth hostel. If the area was interesting, I'd stay a couple of days. In the late 1960s Europe was relatively inexpensive for travelers. I slept out under the stars or in

barns only four times. I preferred staying in roadhouses due to the endless parade of interesting travelers and the information they would pass along regarding places I was preparing to visit. I crossed Italy, sped through Milan, and ascended into the Italian Alps, finally arriving in Switzerland via the Swiss mountain tunnel. The only time I had trouble on the road was in that long tunnel. Keeping your balance on a motorcycle in a tunnel is difficult because you can't use the horizon line as a point of reference. Lake Geneva was beautiful; I spent a couple of days taking in the sights there before motoring down the Swiss Alps and riding through France, ultimately arriving in Paris.

Paris 1968 That was the spring of 1968, and Paris was wracked by political unrest. Parts of the city broke out in riots and demonstrations. One night I decided to venture into the riot scene with French students, who were enthralled to have an American behind their cause. The French girls were unbelievably cute, which was the real reason I came along. The political upheaval was beyond my comprehension. I had no idea what it was about and certainly didn't want to become involved. That was my first exposure to mass civil disobedience. The chaos and destruction surrounding political riots has always unsettled me. Years later when I was a college student protesting against the Vietnam War I only did so in a steadfast fashion and never joined in on senseless mob destruction.

That spring it seemed the whole world was involved in political unrest. Martin Luther King Jr. was shot during my motorcycle trip. Riots broke out in U.S. cities, and prior to my arrival in the States presidential hopeful Robert Kennedy was assassinated. In the Army we were intentionally isolated from politics. Only then did I begin to understand the full brunt of world opinion concerning our involvement in the ambiguous and ill-conceived Vietnam War.

I crossed the English Channel by ferry and motored into London. *London* Texting while driving—that's not so hard. Try riding a motorcycle through the busy motorways of London on the left-hand side of the street. London agreed with me, and I took in multiple cultural events, live theater, museums, and body art at the London strip clubs.

From there I motored up to Scotland and visited Edinburgh, one of my favorite European cities. Afterward, I drove back down the east coast of England. I loaded my motorcycle onto a ferry and landed in Rotterdam. From there I drove back to Germany, finally ending my travels at the Rhein-Main International Airport. With me I carried papers that allowed me to catch a military flight back to California. There was only one catch. A staunch, chunky military official said he would not let me board unless I shaved off my full red beard. So, I reluctantly took down my freak flag. I was slightly peeved. The beard seemed to represent my newfound freedom. However, I shaved it off and caught a flight back to California.

I discovered something about people and about myself during my travels, which I later applied in my artwork. Humans are curious beings. One part of the mind loves change and craves different experiences, while the other part likes familiarity. Traveling gave me confidence and belief in my life positions. There's not just one way of viewing things; there are multiple ways of perceiving the world.

Upon arriving back home in Northern California, I worked, saved money, and enrolled at the local junior college on the GI bill. I was twenty-one years old, excited, confident, and full of life. I grew my hair long, not quite shoulder length, and experimented with beards and mustaches during my college days. I was never a hippie and didn't act or dress like one. My clothing consisted of old leather jackets, Levi's, and unusual shirts purchased at second hand shops. To my amazement I became a decent student. During my first week of school I met my future girlfriend, Susan, in a beginning chemistry class. I'd taken notice of her in the campus library days earlier and was struck by her intriguing appearance. A unique life force seemed to emanate from her being, most notably in in her movements and in the radiance of her skin, which glowed like honey. Susan had a large smile, blue eyes, and a trim figure, and was one-eighth American Indian. She wore her light brown hair medium length and brushed straight. Susan dressed California casual, a wardrobe based around blue jeans, blouses, shirts, and a practical coat.

College classes began in September. It was still baking hot in

California. I entered the beginning chemistry class and saw Susan sitting on a stool next to a laboratory work counter. I quickly occupied the stool next to her and introduced myself, landing a handshake. The white-haired, red-cheeked chemistry professor welcomed us to the class and began going through the class schedule. It felt good touching her, I thought. He wrote the names of the chapters we were required to read on the chalkboard and gave out handouts that were passed around, indicating the required reading materials. This is going to be a hard science class, I visualized. Then he pulled down a roll-up display of a large periodical table showing all the elements. On the left-hand side of the chart in purple, he informed us, were the alkaline earth metals; on the far right of the chart were the nonmetals. I was taking in what the professor said but was stealing glances in Susan's direction. "In a month's time you can answer anybody's questions concerning the periodical table," the professor said. He finished by explaining how the class was structured and how the grading system worked. At the end of his forty-five-minute spiel he said, "Next week, you'll need a lab partner. Okay, that's enough for today. Familiarize yourselves with your surroundings."

Susan swiveled on her stool and faced me. "You have a girlfriend?" she asked, to my utter astonishment.

"Well, kind of. You see, you're my secret girlfriend," I replied, unstoppable and high on life.

We walked out of the chemistry class as lab partners, and within three months we were living together. It was a beautiful once-in-a-lifetime romance. In the beginning Susan left an anonymous note on the front seat of my treasured MGA Morgan convertible parked at the college. "The devoted canine awaits the master's return," the note read. It was a simple note written on a torn piece of paper sack. However, the note touched my deepest sensation of intrigue, friendship, loyalty, and romance. I felt whoever wrote the note understood me. I remember thinking, I could learn to like this person and hoped it was Susan. We were meant for each other. I thought she was the most interesting girl I'd seen on campus, and later she told me she viewed me as the most intriguing guy. At this point in my life, it felt like I had an unfair

advantage on other students; more grown-up and worldly. I was a late bloomer, and now that the bloom had finally opened, it was as though I was ahead of the curve, especially in understanding people and zest for living. Susan was rebounding from a brief affair with a married student athlete. The married star athlete was picking cherries. His wife found out and dramatically confronted Susan. I believe Susan's ill-fated fling helped accelerate our fast-moving mutual infatuation.

We moved into an apartment one mile from the campus. It was typical college housing, an older apartment catering to students. We lived on the second story; there were two additional units on our floor and three more downstairs. The other inhabitants were students or alternative types, all working part-time jobs and going to school. A train ran by the low-density property five times a day, and you literally *trains* could not hear a single word anyone said in that apartment until the train completely passed. For me the older complex was a sanctuary, a place where I could be myself and Susan and I could be together.

One afternoon, on a clear December sunny day, Susan and I were sharing a simple sandwich of cold cuts, cheese, fresh lettuce, and a glass of milk in our apartment after a day of classes. Susan was preparing to return to college to complete a class assignment. I walked her to the door and put my hand on the knob.

She pulled a lock of hair from her face, gave me a kiss, and said, "I'll see you later."

I opened the door and let her out. It was the smallest of gestures; however, the moment my hand came off the doorknob a realization overcame me. "I'm in love with her," I said out loud to myself.

We enjoyed lovemaking, and she seemed to be more exploratory—in an honest and wholesome way—than myself. Her straightforward curiosity began the night we relocated to the apartment. We moved in during the evening hours. Partially opened cardboard boxes were scattered about the studio apartment. Ambient light passed through our second-story window, casting soft shadows. We were lying together on our sheet-covered mattress, which still lay on the apartment floor. Self-possessed, interlinked, making love. I was surging into her, not thinking about protection, carried away with

the act and ready to climax. At the last moment I pulled out and ejaculated onto her abdomen.

What you have done now? I thought. "Sorry," I whispered.

To my amazement, with one hand she touched my semen and with her forefinger and thumb examined the fluid's texture and viscosity. I remember thinking that our sexual thing is a shared experience, and it's going to be all right.

For me love was a real phenomenon, like entering a different dimension where everything was more intense, interesting, and complete. There was no groping for the meaning of life; it was about the here and now. Susan was the daring train conductor of my emotions. She entered my being, flagged my self-reliant train, and switched my track to the destination of love.

The formula for falling in love seemed easy to me at the time. Find someone you really like, make sure they like you, tell them you love them, and let go. The overall closest moments for me in my relationship with Susan occurred when we slept together. At night I would let her fall asleep first. When I sensed the first involuntary jerks of her legs or arms, I would know she was asleep and would drift off, feeling contented.

Whether it was first love or Mother Nature's means to assure procreation that created that chemistry between us, it seemed as though it was meant to happen. I got a taste of how exciting and exhilarating life could be. In my opinion, Mother Nature gives us a one-time gift, imparted to our impressionable hormonal youth, that fuels enough optimism and idealism to propel us for the rest of our lives.

Susan encouraged me to take art classes. "If that's what you really like, do it," she said. She could draw and brought home a Picasso painting from the school library. It was a simple linear drawing of a guitar and a face.

After staring at it at length, I declared, "I don't get it."

"It's how it makes you feel," she explained.

All of a sudden I understood the Picasso. I was ready. I openly embraced exploitation of the art field and enrolled in drawing and

acting classes. The love I experienced during that time period was a seminal point in my development. I got in touch with my emotions, embracing them. They made me confident and smarter.

Susan was the first woman I completely shared myself with, and I soon discovered that I enjoyed her company more than a man's. Physically I relished the softness and sensuality of her female essence. Her mind and her body made me feel good. We bought old bicycles and road over and around the river. We adopted a long-mustached mutt named Rufus from the local pound. We went on trips to San Francisco, Clearlake, and her parents' house. Unsuccessfully I pleaded with Susan to let her father, Joe, a trim man with course black hair, know we were sleeping together. "Joe's a psychologist. He will understand. Let's find a way to tell him. Better that than finding out on his own. Let's not deceive him," I implored. Susan would clam up, implying it was not my territory and that there was no way her father would understand.

As a student I blossomed. Psychology classes were interesting and helped me get a handle on my own mind. I held my own in English and in public speaking. I started taking drawing classes and loved them. My most satisfying achievements were in acting classes. In drama, I found I had an ability to put myself into character and create. In the college production of *Antigone* I played the messenger, and it was exhilarating. The drawback of theater for me was the vast amount of people needed to put on a production. I preferred a form of creative expression that was more unilateral, a venue that allowed me to rely more on myself than others.

Susan and I dwelled in our apartment through the winter and into the spring before Joe found out we were cohabitating. Dramatically he separated us, and Susan moved to the dorms. A wave of disappointment flowed over me. There was a father and daughter dynamic at play, and I wasn't a part of it. I believe the outcome might have been different if we would have told him. Things between Susan and I were never the same after that. She suggested I'd make a great attorney and told me how much her mother liked babies. The subject of marriage came up, but I still entertained a youthful restless ambition and was not ready

to jump into another commitment. As good as our relationship was, freedom and adventure were still my chant. I tried my best to break things off with kindness, but I don't think that's possible. Before I left town Susan was dating one of my acquaintances. The breakup hit me much harder than I expected. The experience changed me, however; I now preferred relationship to casual encounters.

With fifty dollars in my pocket I piled my sleeping bag and shaving kit into the front seat of my MGA Morgan and drove to Santa Barbara. Thus began my six-year, on and off again relationship with that exclusive Southern California beach town. Santa Barbara's nurturing, beautiful, natural environment allowed me to develop and heal. Once again I was broke, on my own, and forced to be self-reliant in a brand new environment. I landed a job working at a dental supply store where I prepared supplies for dentists and then delivered them to dental offices throughout the different regions of Santa Barbara. Looking back, I've come to notice reoccurring themes and patterns to my life. I would move to a new place, work my tail off getting settled in, learn the ropes, and have a brief moment at the top before giving it all up, moving someplace new, and starting all over again.

I fell in love with Santa Barbara's year-round mild climate, beautiful ocean, palm trees, eucalyptus trees, bougainvillea bushes, and scenic mountains. Even in those days Santa Barbara was an exclusive, expensive place, which always put my survival skills to the test. The great thing about beautiful environments such as Santa Barbara, especially when you're young, is that you don't need much in the way of housing or material possessions to be happy. Just being alive in such an environment seems reward enough.

BURNING THE BANK OF AMERICA

AT THE BEGINNING of the school year I enrolled at Santa Barbara City College, since it had one of the best art curriculums at the junior college level in the nation. The fact that it was situated on a cliff overlooking picturesque Santa Barbara Harbor was a bonus. I enrolled in a life drawing class—my introduction to a lifelong study of the human figure.

I remember feeling nervous while walking along a palm-tree-lined sidewalk to my drawing classroom on my first day. I simply couldn't draw well. My art education had been unstructured, and I had not acquired sufficient drawing expertise. Under my arm I carried an eighteen-by-twenty-four-inch drawing board; attached to it were several pieces of drawing paper held tightly in place by metal clips. In a plastic container I carried an assortment of drawing supplies— mostly graphite pencils of various weight, erasers, and smugglers.

We started drawing from live models on our first day. I entered the classroom and was greeted by the drawing instructor. He was casually dressed, long bleach blond hair hung to the tops of his shoulders. He was in his early forties, and he exuded an easygoing demeanor. Most of the instructors were part-time; they worked to support their art careers.

"Morning," the instructor greeted. "Find an empty easel."

I examined the large, naturally lit room. Twenty-five easels were dispersed in a semicircle surrounding an eighteen-inch-high modeling platform. Ten students had arrived ahead of me, filling the

room with chaotic shuffling and scratching sounds as they dragged easels and wooden chairs across the floor. Others were fumbling with paper or rummaging through and organizing their art supplies. I chose an easel located toward the back of the room and waited.

When the class had fully assembled the instructor started speaking, and the room became silent. "Today, we are going to start out by doing one-minute gesture drawings. Molly is our model." In a slightly lowered voice, and looking at no one in particular, he asked, "Molly are you ready?"

Molly exited the changing area and disrobed as she stepped on the modeling platform.

"We are going to do one-minute gesture drawings for the first ten minutes to give you time to get warmed up. Afterward we will do some longer poses," the teacher informed.

Molly was lean and elongated and had her hair tied up above her head. Her neck was completely visible, and she was totally at ease. She assumed a contrapposto action pose. One arm was outstretched overhead and pointed toward the ceiling, and most of her body weight was on one leg. Her body twisted in one direction, and her head twisted toward me. She was looking my way, but her eyes were focused on a point over my line of sight. Even though I couldn't draw well, on that day I discovered my life's passion, the study of the human figure. Representing the human form in art gave an outlet for my reserved objective interest in humanity.

At the time I could only draw around the outside of the figure—a contoured drawing, in other words. I required eight more years of drawing practice before I could fill inside the lines with structure and anatomical detail, applying the concepts of proportion, direction, and chiaroscuro (light and shade). I can't emphasize enough how important it is for artists to learn to draw. Drawing is an applied science with artistic intent, a fundamental prerequisite to art. After receiving my AA degree from the city college I attended one semester at California Polytechnic State University in San Luis Obispo and soon discovered I didn't care for their academic direction. The college didn't have an art department and the ratio of boys to girls was three to one. Finally,

I was accepted to my dream college, the University of California at Santa Barbara, in the fall quarter of 1970. I was determined to go to UCSB after visiting the campus the first time in 1969. It appeared to be an idyllic place with a world-class art department.

The UCSB campus was breathtakingly beautiful, nestled on a promontory protruding into the Santa Barbara Channel and overlooking a pristine beach. The textures, the colors, the feel of the place would all make into to my essence as an artist. The campus embraced a mile of untouched landscape along the Pacific Ocean. The campus grounds were a unique ecological environment containing indigenous wildlife. It even came furnished with its own private lagoon, stocked with herrings, egrets, cranes, and various shorebirds.

The recently constructed two-story art department complex of five two-story buildings was located next to the lagoon and stands only 250 yards from the Pacific Ocean. After classes commenced, I began walking home along the provocative, awe-inspiring ocean. I began my walk at the art department and then journeyed past the lagoon along a ravine, which cut through a thirty-foot-high sandstone bluff, bringing me to the beach. Once on the beach the vast horizon line of the ocean invigorated my sense of being alive. There I contemplated the tantalizing possibilities of what my undiscovered future might bring.

The beach extended forty yards during low tide. The sand was tan-toned and fine in texture, eroded from the soft, sandstone bluffs that occupied the length of the mile-long campus property. I used the time on these long walks to get centered, thinking about how small we are in the scheme of things and how far-flung the universe is. These infinite philosophical thoughts actually stimulated my desire and passion for living in the moment. During high tide I had to hustle because the beach gets swallowed up by waves breaking and running toward the thirty-foot-high vertical cliffs, eroding them a few centimeters a year. The incoming tides drew long-beaked shorebirds that skirted along the waves as they flattened out over the sand. The shorebirds would do a stop-and-dive maneuver, picking off sand insects fleeing

the incoming waters. Seagulls could often be heard making a ruckus in the background.

On a sunny day the ocean appeared blue. If overcast, the ocean reflected the sky's deep gray. On a clear day, when the conditions were right, I would hide amongst the sand stone outcroppings next to the cliffs and watch small flocks of pelicans fly in a straight, synchronized formation level to the height of the cliffs, gliding along and then hitting a couple flaps of their wings. Watching the birds made me feel interconnected with everything, my place in the world. Their long beaks jutted out in front as they soared, the bulk of their bodies and weight below wing level, similar to the design of B-24 Liberator bombers. If you were close enough and stayed hidden and still, you could see their eyes scan the ocean for fish as their heads turned. Upon spotting their prey they would circle, collapse their wings, and dive twenty feet into the ocean. If successful, they would pop back up to the surface, point their beak toward the sky, and gulp down the fish headfirst.

I loved walking barefooted on the beach, feeling the sensation of the sand pressing against the pleasure sensors on the bottoms of my feet. I'd run on the wet sand and grab long strands of kelp as it was washed onto the shore. Occasionally I'd take a bite out of the salty gelatin kelp leafs. It tasted intriguingly wild, like the aftertaste of intimate contact with females. I felt intertwined with all things and was overjoyed to be immersed in this beautiful circle of life. Another place I liked to contemplate the wonders of nature was the small eucalyptus groves, growing on the bluffs. Upon entering them I felt a sensation of enclosure, of being completely immersed in a peaceful setting. A walk through these groves stimulated my sense of smell. Eucalyptus trees emitted an aromatic fragrance that adds a spicy scent to the relaxing, mesmerizing atmosphere of the Santa Barbara area. In the constant offshore breezes, eucalyptus leaves vibrated, rippled, and brushed against each other, creating a soothing background sound that added to Santa Barbara's gentile ambiance. Looking back now I'm convinced the natural environment of the campus grounds assisted in my cultural, artistic, and personal growth during this time period.

I soon discovered my new home, Isla Vista (Spanish for "island view"), the student community next to UCSB. Looking seaward from Isla Vista, a string of small, secretive islands rested mysteriously in the Santa Barbara Channel. Situated on the bluffs next to the ocean, Isla Vista was comprised of a dense community of white stucco apartments hastily fabricated by speculators and investors, running a mile in one direction and a half mile in the other. These apartments, which I came to know so well, housed 12,000 students during the school year. Situated between the campus and the apartments, Isla Vista's downtown area was populated by pizza parlors, fast food outlets, hamburger joints, bicycle shops, pinball arcades, and the Magic Lantern theater. They all became well-known niches of my extended living room.

The centerpiece of Isla Vista was its small community park, called Perfect Park, located one block from the ocean, where I spent leisurely afternoons throwing Frisbees with my shirtless, long-haired friends. Counterculture is what I have always been drawn to, and Perfect Park was full of alternative, uncompromising, totally bitchin' young people. The area became a mecca for my rebel, idealistic yearnings. On weekends rock bands played at the park for free. The awesome aroma of Ganges smoke, carried by gentle breezes, would drift through the dancing crowds. There would always be a contingent of female dancers who understood that they danced better bare-breasted. A year earlier I had been told by a lady friend that I viewed the world through rose-colored glasses. Now, residing in my Isla Vista nirvana, a rosy shade of pink had truly become my reality.

Forty yards from Perfect Park stood the infamous Bank of America, which would be set on fire and burned to the ground during the February riots of 1970. Only one student was shot and killed during the riots. I was living in Isla Vista at the time, wrapping up my AA degree at City College; my apartment was only a quarter of a mile from the bank's location. By coincidence I witnessed the confusing incident that ignited the riots. I must tell you my firsthand account of the events, differs greatly from the urban legend.

On the afternoon of February 25, 1970, the day the bank burned,

William Kunstler, a defense lawyer for antiwar activists, gave an inflammatory speech at the UCSB football stadium on campus. After the speech, hundreds of fired-up students streamed back to the apartment community of Isla Vista, many of whom had already had bloody confrontations with the riot police. There was an ongoing violent history between the students and cops there. A popular college professor who was against the war had been fired and a staff member killed in a campus bombing. During a separate incident three hundred students were arrested, during which brutality allegations were aimed at the riot police and their swinging batons.

It was a cool, coastal February afternoon and I was walking with Sandra, a coed majoring in political science. She was slender with a narrow face and had a small, sensitive smile. She had blond hair and wore it long and she looked unreal in tight jeans. Sandra was born into a wealthy L.A. family. We met on the dance floor of the Stork Club, a live rock and roll venue, and now we were dating. We liked to have a few beers and then annihilate the dance floor, flipping our hair, shaking our hips, until we were drenched in sweat. She liked to cut loose and slum it with me. On her birthday, after a night of frenzied dancing, I took her back to my apartment and locked the door. We got nude and smoked some Acapulco gold. I rubbed her down with Crisco and then we rejoiced in celebratory, slippery, sweaty sex. We were more like buddies than lovers. On the afternoon of the riot, we left my apartment on Segovia Street and were walking toward the business area of downtown Isla Vista, looking for a meal. The apartment-lined streets were vacant; only a few students were out and about. Both sides of the street were lined with parked cars. We approached the small downtown business area. On the street corner of Embarcadero Del Norte and directly in front of us stood an out-of-town, ill-advised police officer frisking Joshua, a long-haired hippie burnout.

I'd see Joshua most ever day I toured downtown. He was a street person and a fixture on the streets of Isla Vista, renowned for selling low-grade Mexican pot to the students for ten bucks a lid. Joshua's romance with street drugs showed on his sunken face. His hair was

long and stringy, and he was always seen in the same red flowered shirt. We watched as the police officer riffled through Joshua's backpack and then handcuffed him. The officer then led Joshua toward his police car, parked next to the street. At that moment, by coincidence, forty agitated students returning from the antiwar speech spewed into the intersection across the street from the police car. Another four hundred students followed close behind.

Sandra and I stood on the curb in disbelief and, in super slow motion, watched the fiasco unfold.

"Doesn't the cop see all of those angry students?" Sandra asked, bewildered.

"Where are they coming from?" I asked as more and people poured into the street.

"They're coming back from Kunstler's antiwar speech. They're looking for a reason," Sandra said tersely, as one of her hands lifted to her clenched mouth.

The officer opened the back door of his police car and guided Joshua towards the backseat. Protesters surged forward, kicked the door shut, and ripped Joshua away from the officer. Now surrounded by protesters, the officer finally awoke from his "protect and serve" daydream and ran for his life.

Acting as one, a cluster of students lifted one side of the police car, overturned it onto its roof, and then set it on fire. Dancing around the flaming vehicle, the crowd whooped and hollered, celebrating their small victory in the revolution.

"Pigs know how to run. Pigs know how to run," protestors chanted.

On that afternoon Sandra and I were only anthropological observers. We watched as political frustration, mixed with fervent social activism, ignited madness and anarchy. Of all my memories this one ranks as the most striking and traumatizing, illustrating the wacked-out behavior of the apex predator: man.

We continued watching, knowing something big was happening. Thirty minutes later a yellow school bus arrived, parked eighty yards from the smoldering overturned police unit, and unloaded twenty sheriff's deputies from L.A. County. They were Reagan's kickass

riot squad and had banged heads in Isla Vista just months earlier. Considering their quick response time they must have been on standby alert. The riot police disembarked from the bus and lined up on Embarcadero del Mar equipped with Plexiglas shields, helmets, and riot batons, fully prepared to retake the burned-out police unit. The officers arranged themselves in a phalanx formation and began marching toward the overturned police car. Vocal, abusive students lined both sides of the street and crowded on the sidewalks and beyond. Shoulder to shoulder, with their forces stretched out curb to curb, the riot police slowly marched. Halfway to the car one or two students began throwing large, white, one-by-two-inch rocks. Soon more students picked up rocks and hurled them at the cops. The decorative white rocks were conveniently placed by the thousands between the street and the sidewalk in a recessed strip that functioned as landscaping. A volley of six rocks came from one side of the street. Then, ten rocks were launched from the other side. Soon a crossfire of dangerous missiles descended on the officers, flying through the air in a curved, linear formation and then crashing down and shattering the Plexiglas shields, seriously injuring a half dozen officers. The deputies retreated, boarded the bus, and drove away. The rioters' blood was high. Isla Vista was exuberant and free. "We chased out the pigs" was the overwhelming sentiment. It was all beyond my threshold of reason.

Sandra was shaken up by the violence, and I escorted her to her ritzy oceanfront apartment. Two of her female roommates were in the apartment and offered comfort and companionship by nestling up next to her as she sat on the couch, her head in her hands. The roommates were twins. They were both full-figured ladies and both were dressed in pink and wore white tennis shoes, the official color scheme of the affluent coed. Standing in the luxurious apartment taking it in, I felt I was in an in-between zone of not belonging. I returned to the streets, thinking I was out of place in her privileged world and out of place in Isla Vista.

The riot officers returned later that evening in a domineering show of force. Choking teargas and stinging pepper gas permeated the

whole of Isla Vista that evening. At some point during the night I left the security of my apartment and ventured into the streets. Billowing smoke and tear gas emanated from the direction of the bank. Our internal pyro of retribution and injustice had set the bank on fire. It was still burning; I could see the flames.

I avoided that area and headed in another direction to see if the other icon of corporate greed, the Union 76 gas station, was on fire. One year earlier a Union 76 offshore oil platform was found responsible for a major oil spill, devastating Santa Barbara's beaches. I was sure there would be a skirmish at the station, but when I arrived there it was, dark and eerily quiet. All the lights were out. Nobody was close by. I just saw a few people across the street looking at the remnants of a property management office. Rioters had broken out the windows and ransacked the interior. File cabinets and papers were thrown into the street, some still smoldering. I was still standing near the gas pumps in the creepy darkness when a mob of forty ragtag rioters, wild-eyed, high on destruction—and possibly blotter acid—and looking for action rushed straight toward me from the direction of the burning bank. Amongst the disheveled rioters were men with short hair and straight clothing taking pictures of the protesters.

As they approached running, a thought jumped into my mind to shout out, "Burn 76 for the oil slick!" The mob mentality of my primal self was urging me to action. I kicked that thought out of my mind and stood silently instead. The mob ran through the gas station past me and I hid my head, not wanting to be photographed. The chaos was epidemic. Occasionally police vehicles would screech to a stop in the area, then cops would jump out and disperse the crowds with swinging batons. I was against the war but hadn't experienced this kind of violence from a local community before. To me it was mass insanity.

During the night a large garbage Dumpster on wheels was ignited and rammed into the Bank of America, burning it to the ground. Cars were moved into place, overturned, and set on fire, barricading the main entrances and thoroughfares leading into Isla Vista in an attempt to keep the police out. Riots went on all night long. After the

sun came up and things had quieted down I walked through Isla Vista. In the aftermath of the riots Irish confetti was everywhere. Rocks, bottles, bricks, limbs, trashcans, and other debris covered the streets in random patterns. There was an overwhelming police presence. The place looked like a war zone, with burnt-out, flipped cars partially blocking intersections.

I despised the war, but considered indiscriminate mob violence to be nuts. There is a baffling schism that exists in my mind. For me, it's okay to take out bloody, punch-thrown revenge on another person whom I believe to have wronged me, but mob rioting is beyond my acceptable scope of violence. I had been accepted to Cal Poly San Luis Obispo and decided to go there for a semester, getting out of Isla Vista. I spoke to Sandra and we agreed to visit one another. Soon she found another dance partner. We were not in love—only two people who met and were having a fling. I got over our split relatively unscathed.

Later that day Ronald Reagan, then governor of California, gave a speech condemning the protesters as bums. Reagan rode to power denouncing student protesters, and the latest riots seemed to play into his hands. Was the student who was inadvertently killed by a police sniper a bum? Was the dumb cop who helped initiate the riots a bum? Was the Gulf of Tonkin incident started by a bum? There were enough bums to go around for everybody during the Vietnam era.

I was accepted and returned to UCSB seven months later, after most of the political violence had settled down. I worked hard to get accepted and was humbled, apprehensive, and motivated by the opportunity. It was an extraordinary time to be a student. The atmosphere was rife with a feeling of idealism, and we sensed change was possible. The art department attracted some of the best minds in the student body. We had valid convictions and thought there was a social revolution coming, and by working together our generation, the baby boomers, could pull it off. We were against the war, pro-environmentalism, pro-transcendentalism, pro-sexual freedom, and believed that somehow art was the instrument for the ensuing social revolution.

A MEASURED DIPLOMA

MY FALL QUARTER classes began on a blue-skied September day in 1970. The temperatures reached eighty degrees, a slight shore breeze blew in from the ocean, and riding on the wind was the salty aroma of the Santa Barbara Channel mixed with the effervescent fragrance of the eucalyptus trees. I sported longish hair and was fashionably dressed in blue, skin-tight, bell-bottomed jeans that covered my twelve-inch-high leather boots. I rode a bike from my apartment in Isla Vista and followed along with many other students down the bike paths to my destination: an introductory ceramics class, located on the bottom floor of a two-story art department building. I walked past the lagoon, through the courtyard of the ceramics department, and into the cavernous kiln room. There I saw four kilns ranging in dimension from small to walk-in size comprised of soft brick on the inside, backed up by hard brick on the outside, and held together by expandable metal frames. That was the beginning of my fascination with kilns and the firing process.

The kiln room contained a ten-foot-long pug mill—a machine specially designed to compact and formulate clay bodies. The classroom contained five kick-wheels for turning pots and five long wooden tables covered with canvas and specifically designed for the hand building technique. The walls were lined with wooden shelving, providing storage for the classroom projects.

In that class I found my power as an artist. Clay allowed me to

visualize an idea and then make it. As I began to build simple forms, an awareness overtook me: I possessed a naturally ability for the clay process. Years later clay would allow me to build life-sized figurative sculptures.

I opened a plastic sack of formulated clay for the first time in that class, although it was not the first time I'd worked with clay. During my upbringing on the farm I used clay in every way imaginable. Clay is a pure form of silica earth, the same as soil but without all the organic contaminants.

Our professor, Mr. Arntz, was young and powerfully built and possessed a keen intellectual capacity. He instructed us on the seven states of clay, the first state having a portable soup-like consistency, the next state being sticky mud, and so on. Of course, there was the type most people are familiar with: the very workable and malleable clay-like state. In the drying-out process, clay proceeds to a leathery hard state and finally reaches the bone-dry state, bereft of any water. Intuitively I understood those seven states, having worked with hundreds of tons of the stuff.

Driving tractor on the farm, I had disked clay in the orchards, rolled it flat with a one-ton roller, and used a rigger to make two-foot-high irrigation ridges around and through the orchards. I drove a ridge breaker behind a tractor, leveling out the ridges. I shoveled clay by the tons and watered it by the acre. I had worked with clay in each of its states, but now I had the chance to use it to create.

This might be a little technical for most people, but the reason clay is so malleable and such a superior modeling media is because of its integrity at the microscopic level. Clay is full of platelets, similar in appearance to little guitar picks, which slide against each other, lubricated by water. When you stop modeling, clay holds its shape due to the structural qualities of the platelets. When clay dries out to the bone-dry state, it can then be fired to a temperature of 2,000 degrees in a ceramic kiln, heating it to a low-grade glass. That's the ceramic process in a nutshell. I'd use clay as my main medium for the next twenty years and would remain fascinated by its plasticity and the magic of the firing process. As much as

clay became a strength to me, it was also to be my undoing, my Achilles' heel.

Conceptualism and videos were overtaking the academia art world in the beginning of the 1970s, and a couple of weeks into class Professor Arntz introduced the students to conceptual art by including us as participants in his art video.

The video began with shots of students retrieving twenty-five pounds of clay extruded from the pug machine. Next, the students were filmed building vegetables out of clay. Arntz instructed us to build two-foot-high vegetables of our choice using the hand building technique: the oldest method of clay construction using coils and slabs of clay to build objects. I built a thirty-inch hollow mushroom. My fellow students created tomatoes, peppers, squash string beans, carrots, etc. The next sequence of video presented the finished, bone-dry vegetables lined up in rows on the cement courtyard as though part of a garden. A sprinkler was then positioned to soak the vegetables for an entire day; the vegetables were filmed over an eight-hour period as they melted down to a heap of nondescript gooey clay stuck to the concrete courtyard. The final shot of the video showed students scraping the clay off the cement and returning the goo to the pug mill. The exact title of the video presently eludes me. I believe it was something like "Endless Cycles."

As a class we really didn't get or appreciate conceptualism. The essence of conceptual art is the "ah-ha!" moment when the idea hits the mind. It took me another twenty years to appreciate conceptualism. At that point in time I simply wanted my mushroom back.

I met my future live-in girlfriend, voluptuous Megan, during the first day of a modern dance class. She was also an art studio major. The campus layout was immense and new to me, and as I recall I had a difficult time finding the dance building and was late for my first class. Megan, who was dealing with the same problem, arrived minutes after me. Since we were both late the teacher assigned us as partners. We spoke after class while standing outside the new glass and cement studio. That was the sunny spot, the place where new, uninhibited,

raw emotions emerged that would soon overrun my life. Nearby, a large cement planter containing bougainvillea plants grew in the sun. Long, thorny vines outstretched in wild, uncultivated directions. At the ends of the vines were a dozen small, angular, intensely vibrating purple blossoms. Megan's shadow fell over the box. Megan's short, dark hair snugly framed her face, accentuating her high cheekbones. From there, dark, spirted eyes gazed out, examining the world. Her full body radiated sensuality.

"Why are you taking a modern dance class?" Megan asked me, her eyebrows lowered in a thoughtful expression.

"I like to dance, was curious about it. And I thought it'd be a good way to meet girls," I truthfully said, hoping this beauty would enjoy my sense of humor and honesty. A smile momentarily appeared on Megan's lips.

Megan and I shared common sensibilities. We were both from Northern California, although she had been raised in a middle-class, large family. Her father Lyle, was a tall World War II veteran, seriously wounded in the Pacific campaign. He was a decent, down-to-earth guy who managed a gas station in San Jose. Megan and I were both on a course to discover ourselves as artists and loved the beautiful atmosphere of Santa Barbara. A friend told me that Megan ". . . has wide-ranging talents. She could be a Supreme Court justice or a backup singer for the Pointer Sisters." I thought this was an accurate and amusing summation of Megan's charms.

I remember the unique sway in her walk and that she was a curious person with beautiful, talented hands that knew how to caress your back after a long day. We found a new home in Santa Barbara and lived together off and on for two years.

We were together mostly during the peaceful idyllic summers. She went to summer school, and I worked a summer job at the beautiful Refugio State Beach Park. We had a loving, unbridled, windswept relationship that didn't last. It was mostly my doing. I had fallen in love once again and didn't want to go deeper and deeper into an all-encompassing partnership. I wanted to slow things down and have a little more space.

There is truth to an old saying, "Two artists under one roof doesn't work very well." If there was jealousy toward the other person's abilities in our relationship, it came from my side. Megan was more advanced as an artist and made incredible strides in printmaking. She left me behind in her ability to find her direction so quickly, creating sophisticated inked etchings developed around the human figure. She produced incredible accomplished artwork as an undergraduate while I was floundering about trying to learn the basics. We'd break up, date other people, and then reunite. Over the years we got back together again, but ultimately becoming just friends, and continue to be to this day.

I tried to enroll in a traditional sculpture class, but none were available at the university. Experimentation was king in the art world at that time, and if you wanted to learn traditional techniques this was not the age, nor the institution, in which to learn them. Sculpture had formally been taken off the pedestal; there now seemed an official indifference for traditional techniques.

The tenured sculptor professor was on sabbatical. Mr. Lindsay, a lofty, trim, blond-haired, blue-eyed, pale-complexed man was his substitute and was a cutting-edge video sculptor from London. Mr. Lindsay let his students make up their individual assignments based on the class project: to contrive scenarios involving the public. Our projects would be videotaped by a discrete Mr. Lindsay. I decided to include unaware students in my project, using the campus center as the location. The campus center, a large, two-story building housing the cafeteria and bookstore with ample space for lounging, possessed a mind-blowing view of the ocean. It was perfect for my purposes.

Professor Lindsay stationed himself and the camera on the second floor. Below him, I ran through the campus center lobby carrying a one-quart coffee can full of marbles. I pretended to stumble, then opened the can of marbles, which scattered in every direction upon hitting the slick floor. Rising to my feet, I announced to the crowd, "I've lost my marbles—it's my class project."

Helpful students began gathering my marbles and putting them

back into the container. A couple of students discovered they were being filmed on the second floor by Mr. Lindsay. Two guys threw marbles at the professor, who stood behind the video camera. Mr. Lindsay found them hilarious and thought it greatly improved the video. He liked my work so much he invited me on a sail outside the Santa Barbara Harbor in his private sailboat.

To be truthful I didn't get video as an art form. I simply did the projects for the grade. From my point of view it seemed more like psychology, social commentary, or acting rather than sculpture. But I acquiesced to the art curriculum, kept my mind open, and went with the flow to chase my diploma.

In order to meet the graduation requirements for a BA degree in art, you had to take a lot of art history classes. Half of my required classes fell under this subject. Art history can be very esoteric—and sleep-provoking. Some of my Renaissance art history classes were more boring than watching an electricity-generating windmill on a calm day. I remember one Renaissance class in particular that was very specific and difficult. The final exam was given in a large lecture hall with maybe sixty students in attendance. All of us brought blue books to record our answers. Art history professor Chad Pennington, athletic and as handsome as a Greek god, wrote the names of ten Renaissance Italian painters on the chalkboard and then asked us to write in our blue books the names of the Italian cities in which they were born.

The winds of interest began to pick up, however, when Pennington lectured on modern art. He proselytized and preached the predominant art theory of the day: linear progression. One "-ism" is followed by another "-ism" in a straight line to the new avant-garde art. Impressionism is followed by cubism, which is then followed by post-cubism, then by modernism and finally by conceptualism. Pennington believed that the only contemporary art quest worth undertaking was the search for the next "-ism," based on cutting-edge experimentation in association with intellectualism. He assumed this discipline would bring about the next art revolution.

Chad Pennington threw Greek dress-up parties at his home

in Santa Barbara. He was well built and possessed the intellect and curiosity of the great philosophers, and, though in his forties, had a reputation for tremendous stamina. Initially I thought he was gay. There were two social fault lines that ran through the art faculty. One was the clash between the gays and the straights, and the other was derived from a more philosophical conflict: traditional art versus experimental. Mr. Pennington was at the center of both skirmishes.

I later found out that he slept with women, or so I heard from an Orange County coed named Kelley, full figured, red-headed, and sensuous who majored in art history and complained how difficult Pennington's program had become. "I had to sleep with the scumbag to get an A," she told me, referring to Mr. Pennington's fringe benefits, her lips turned down, distastefully.

Bedding students was an unauthorized but well-maintained perk for the art professors. Larry Rivers was a guest painter at the university and caused a much-deserved ruckus in the art department by sleeping with a laid-back coed named Freddie. She came from a moneyed family, had long red hair, painted her fingernails black, and wore black clothing before Goth became fashionable. She ran in my circle of art friends.

Rivers was long and lean and had wavy dark hair that called attention to his large forehead. His angular cheeks were gaunt and his alert gaze was hawk-like. Rivers always wore a leather jacket with a big red capital "A" flagrantly painted across the entire back. I assumed the "A" stood for artist; however, others thought it signified "asshole." I was intimidated by his presence and his artistic ability and was too insecure over my insufficient painting skills to ever take a class from him.

My girlfriend Megan did, however. One day they engaged in friendly conversation after a class. "You're interesting. I'd like to meet your boyfriend sometime," he told her. It had to have been a pickup line. Megan told me about the incident. I don't think she was tempted, but I think she liked the attention from a famous artist and was letting me know how lucky I was to be her boyfriend. Rivers was a celebrity

and created quite a stir amongst the students who craved painting skills.

Chad Pennington and Larry Rivers were from two opposing philosophical camps. Friction ensued between the two social titans until the day Rivers threw Mr. Pennington through a plate glass window on campus. I asked Freddie what happened. Four of us students were standing in her apartment. Freddie was dressed in a black leather coat, dark eye shadow above her eyes. "Pennington tried to tell Rivers what his paintings were about," Freddie said, defiantly holding her hands on her hips, her black fingernails twitching to an unheard beat.

Our art experience at the university coincided with the ongoing political unrest accompanying the Vietnam War. The largest spontaneous student antiwar demonstration I attended occurred on a late afternoon in the fall of 1972 and took place at the Santa Barbara municipal airport. Our civil disobedience was ignited by the evening news. Walter Cronkite had informed the nation of the renewed bombings in Cambodia.

Nixon became tough on communism once again and ordered that Cambodia be attacked by B-52 bombers. After hearing the news we spontaneously spewed from our apartments in Isla Vista and congregated in Perfect Park. Student leaders with megaphones came up with the idea of marching two miles to the Santa Barbara Municipal Airport and occupying the runway. Five hundred students marched en masse to the airport. We opened a gate, poured out onto the tarmac, and sat down, causing the airport to come to a virtual standstill.

Within minutes law enforcement authorities arrived and tried to negotiate with student leaders. In a show of force, military buses drove up in preparation for the ensuing arrests. The authorities issued an ultimatum: Clear the tarmac or be arrested. The student leaders decided to clear the airport, but anybody who wanted to be arrested could stay. I considered sticking it out, but I simply didn't have the conviction to see it through. I left with the other students.

In the fall of 1972 I had accumulated enough units for my BA degree and was wrapping up the remaining requirements for my diploma. My paper chase at the university was finally reaching its end. I had gained considerable knowledge and laid down the foundation for an art career, but had not yet acquired the kind of accomplished skillset necessary to survive in the competitive art industry. I still lacked an understanding of color theory, the theory of light, the major concepts of drawing, and basic sculpture technique. It was primarily my doing. Insecurities prevented me from seeking out professors who could have filled in those gaps. I was more of a professional student seeking good grades than a committed artist. On the positive side, I acquired a tremendous amount of art information, met and interacted with remarkable minds, and gained some lifelong art friends. In the long run my studies at UCSB were undoubtedly a bonus. I was able to sift through all the different art sensibilities and come up with my own brand of figurative sculpture.

I received my college diploma; however, the accomplishment instilled in me an audacity based on overconfidence, self-importance, and a false bravado. I believed that I could handle anything life threw my way. What I didn't know at the time was that it would take twenty more strenuous years of development before I would reach my goal of becoming a self-sufficient artist with a mature style who would be shown in museums and in New York and who would ultimately sell my entire production to collectors.

The Art Gods had no interest in me at this time. I was just another noncommitted, promising student who got stuck in the advancement of his art career. It's not the Art Gods' job to motivate a potential artist or to help artists find themselves. Once you have discovered and developed your art, that's when the Art Gods take an interest and start facilitating connections.

Like most undergraduates, I was oversaturated with academia and wanted to start working on my own. A game plan crystalized in my mind. I'd return to Europe and set up a studio in Spain. The flame of adventure burned in my core, and the travel bug kept buzzing my restless soul. I also entertained an idealistic exuberance

of righteousness and decided to leave the country and not come back until my great nemesis, Nixon, the power-hungry paranoid, was impeached and thrown out of office. I would set up a studio in Europe, where I would feel even more invigorated, and then invite Megan to come for a visit. Unfortunately, some plans don't have an extended shelf life and evaporate prior to becoming fully realized.

Building my bank account, I worked for six months, sold my MG, surfboard, guitar, and other possessions, and bought a one-way plane ticket to London. With my ticket in hand, my updated passport, a pocket full of travelers checks, and a well-packed travel bag, I was ready to revisit Spain. I needed to touch base with my parents prior to flying out of San Francisco. I rode north on a Greyhound bus and Mom picked me up at the bus depot. She looked great, was now dyeing her hair black, was animated, and looked ten years younger than her real age. She had been working for the state for seven years, and enjoyed the larger social network. The biggest drag on Mom was Dad. I was hoping their relationship dynamics might have changed but Dad continued to lose ground socially, slipping further into reclusive and paranoid controlling behavior of Mom. He accused her of having lovers, jumping into jealous tirades before leaving on trips with his buddies. They would soon separate and Mom would get a divorce.

Later that evening Mom was in the kitchen and Dad and I were in the living room watching TV. Dad was sitting on his throne, the recliner. At sixty-two he was still a bear of a man, now growing heavier around the midsection, and had lost more teeth. There was money for dentistry, but Dad didn't want a dentist messing around with him. I was sitting in a chair next to him. "You staying for Christmas?" Dad cajoled in a manner meant to persuade me. "I'll be in London for Christmas," I replied, poker-faced. "It's bad luck to travel in winter." Dad decoyed, using games to persuade me. "I've already bought the ticket," I informed him. "You can cash tickets in. We can put a heater in the garage and cut some cabochons," Dad coaxed. He was referring to finished gem stones intended for jewelry. Over the years Dad

placed lapidary equipment in the garage, and this was his last attempt to get me into a partnership with him. "Rocks are interesting, but it's not my thing. I want to do some traveling," I said, having a hard time saying no to him, but there was no chance I would say yes. I'd fought too hard to put my past behind me. Later that night as I laid in bed I heard my old friends, the Canadian geese, squawking overhead, my signal to lift off for an unknown adventure.

THE LIGHTEST LIGHT AND
THE DARKEST DARK

UPON LANDING IN London I bought a VW van from another traveler and drove to Barcelona, Spain. I secured painting supplies in Barcelona and began exploring the Costa Brava highway. Altea, a small town situated next to the Mediterranean Sea that housed an international art colony, became my home for the next nine months. I rented a small apartment, broke out my art supplies, and started painting. I chose painting over sculpture because sculpture requires more space more tools and is an all-around harder exercise.

A typical day in Spain began with me waking up in the morning and preparing eggs in a simple kitchen. That was the beginning of my solitary art lifestyle. Artists need a quiet environment to contemplate their work. My disciplined work routine began in Spain, but I upheld it throughout my art career.

After breakfast I would hike to the town center through narrow cobblestone streets packed with small white stucco houses with potted geraniums hanging from second-story balconies. My destination would be a small, outdoor café.

"Café con leche, por favor," I said each morning, pulling up a stool. Behind the bar a slightly built, olive-skinned Spaniard dressed in a waiter's top tended to me with precision movements, first filling a utensil that looked like an ice cream scoop with ground beans, then scraping the excess off the top until the contents was perfectly level.

With a twist of his wrist he inserted the scoop into the main section of the shop's espresso machine. Volumes of steam would begin spurting out, accompanied by a high whistling sound. A small cup of coffee placed on the base of the machine caught the trickling coffee. The waiter steamed the milk and poured it into the coffee cup. A saucer was finally placed underneath the cup, which was slid across the counter toward me. What I really enjoyed about the morning ritual was the professionalism of the proprietors. Every move was choreographed and precise, executed with purpose and character. This was his occupation, and he took pleasure in bringing proficiency to the job. I handed him forty pesetas and was then ready to jump-start my day in Spain.

After my morning coffee I'd head to the Postal Correos to see if I had received mail. I was writing bundles of letters at the time. My goal was to get settled in and then invite Megan to Spain for a visit as soon as she graduated. Standing guard and patrolling the post office was a member of the Guardia Civil. Franco the dictator used a police force to watch the civilian population. I was told never to look the Guardia Civil in the eyes. With that in mind, I made an observation that day that summed up my understanding of the Spanish psyche. The Guardia Civil's uniform was gray and included an unusual triangular hat and white gloves. As he marched past me I averted my eyes, but I caught a glance of him as he strode by and noticed that his white gloves had tiny holes in them. I could see the pink of his fingers through those holes. What impressed me the most was the pride and dignity in which he wore those tattered gloves.

Next, I'd head to the daily market a few times a week and buy fresh octopus, fresh fruit, olives, and vegetables—enough to last me a day or two. After returning home I worked a four-hour painting day. In the evening I usually stopped by Claus' bar, a great place to meet fellow artists. Claus was a bulky but graceful man, with a wide forehead and uncrowded blue eyes. He was a German-speaking American ex-patriot. Claus called his place a bar, but it had the atmosphere of a European cafe. You could sit at a table, finish your beer, and throw the empty bottle and hit the Mediterranean Sea. The water lapped

up against the bar's outer patio. The interior of his establishment had large walls, which Claus used for painters shows. I brought in two completed paintings for his inspection.

Claus decided that he liked my paintings. "Make a half dozen. Let's put them on the walls, get some feedback. If nothing else you'll get free beer," he encouraged, handing me back a painting. My goal was to finish six good paintings and have a show at Claus' bar.

Altea was a viable ex-patriot and international art colony. I met an American writer there who had recently sold a script to Hollywood. He kept a small place in town to continue his writing. The writer compared himself to Marlon Brando and thought of me as more of a James Dean type. There was an older Spanish painter named Padero. He was gangly, long, and raw-boned and had a deeply furrowed brow. His teeth and fingers were tobacco stained. Padero was currently showing paintings at Claus' bar. During his younger days he had become entwined with the cubist movement in Paris. I felt comfortable in that atmosphere. The people there showed me what it was like to be an artist. They reaffirmed that my different way of doing things was actually an attribute for becoming an artist.

I had been in Spain for six months and had moved my small painting studio twice in that time, still looking for the ideal situation. The studio I now inhabited was a new apartment in a recently constructed small complex owned by a British fellow with a full head of flawlessly groomed black hair. He was confined to a wheelchair and his wispy-thin Irish wife wheeled him around place to place. I was his first tenant and my rent was free; my only responsibility was to keep the swimming pool clean. Initially I liked the situation and stayed there for three months, but more people moved in, and I couldn't make a big enough mess, and didn't want to foul the apartment with oil paints.

At Claus' bar I met an older American who offered me the ideal studio set-up in exchange for me house-sitting his property. He owned a simple cottage a mile from town that bordered a cumquat orchard. A few days prior to moving out of the Brit's apartment I woke up with

a stiff neck. It went away after a couple of days and I didn't think much of it.

I had been in Europe for six months. Now, summer was beginning. The new place I moved into was owned by an ex-patriot, an American World War I veteran named Walter. His lively blue eyes took in an unglazed view of the world. His full head of unruly gray hair seemed to confirm his obstinate temperament. He carried a black cane and had a hitch in his giddy-up. Walter entrusted me to look after the cottage. He lived in Chicago and occasionally visited Spain. Walter's claim to fame was his work on the editorial staff of *The Chicago Tribune*. He had been a member of the infamous newspaper staff who erroneously declared, "Dewey Defeats Truman." The local cab drivers wouldn't pick Walter up. He had a reputation. They called him *periodista loco* (crazy journalist). He received the nickname late one evening while riding home in a cab after a heavy night of drinking. In Walter's version of the story, the Spanish cab driver was going on and on about what a great man Franco the dictator was and how he'd saved Spain. "The guy wouldn't shut up. So I pissed in his cab," Walter told me unapologetically, holding a pose, leaning against his cane, his shadow stretching long towards his cottage.

The cottage had a large open room on the bottom floor, which served as my studio. The place also came with a friendly dog. I had lived there a week when Walter said good-bye and flew back to Chicago.

The night he left I congratulated myself on my life so far, on finally having done it. I allowed myself to be happy and revel in my accomplishments. I had fulfilled my obligations to my family by helping on the ranch. I had served my country, worked my way through college, and now had the time, resources, and finally the studio necessary to become an artist.

There is a concept in drawing called the lightest light and darkest dark. This technique is used to give dramatic contrast to a drawing. You place the lightest highlight next to the darkest shadow, giving the drawing an intense focal point. The lightest light and darkest dark became a metaphor for what happened to me next. The lightest light

came at the point when I allowed myself to be happy and congratulated myself on my accomplishments. The darkest dark came next: I awoke in the morning and could not walk.

I greeted the morning with unbearable pain in my hips. I couldn't stand. It felt as though my ball joints had been pulled from their sockets. I crawled and dragged myself to the VW van. Somehow I managed to open the door, and by using leverage was able to get inside the cab and start the engine. I put the van in first gear and babied it one mile into town, parking at the local hospital.

An attendant from the hospital greeted me as I arrived. My hips hurt so badly I couldn't get out of the van. I said to him in my best Spanish, *"Ayúdame por favor." Help me, please.*

"¿Que es problema?" he asked. *What is the problem?*

"No puedo caminar." I can't walk.

He returned with an assistant and a wheelchair, and they wheeled me into the hospital.

The hallucinations began immediately and lasted three days. The first time I met my doctor he seemed competent but agitated and nervous. He was a thin man with greased-down, meticulously combed, jet-black hair, an olive complexion, and a pencil mustache. Soon, I began viewing my doctor as a man with evil intentions; his mustache became the focal point of my delusions. The hair beneath his lip grew more elongated in my mind, as though he was a malevolent cartoon character. I grew convinced that he was trying to keep me in the hospital on trumped-up reasons.

The disease I contracted shouldn't be called typhoid fervor. It's not a suitable term. A more graphic descriptive name is needed here. Perhaps it should be called: *Burn your ass to a crisp and then kick it fever.* Every afternoon at around three o'clock the fever picked up to and sometimes exceeded 103 degrees. My fever roller-coasted up and down and lasted two months. I lingered in the hospital for four days before emerging from the hallucinations. In a moment of clarity, I realized I was really sick and had not gone to the bathroom since I'd been admitted. I wasn't able to gain the nurse's attention or communicate my predicament. Either they couldn't understand my

Castilian Spanish, as they spoke only regional Spanish, or they simply chalked up what I said to nonsensical hallucinations.

In the evening of the fourth day the shift changed, and a new nurse entered my private room and greeted me. She was good-natured, short, and well-fed. She put the old-fashioned mercury thermometer under my tongue and walked out of the room. As soon as she left the room I removed the thermometer, noted at what temperature it was registering, and began aggressively rubbing it back and forth against the bed sheet to elevate the temperature reading by a few degrees. I returned the instrument to my mouth and awaited her return. When she retrieved the thermometer from my mouth and read my temperature her jaw dropped. She hurriedly left the room, holding the thermometer out in front of her as proof. She returned with a new doctor, and I said to him in my best Castilian Spanish, *"No puede ir toleta por cinco dias." I haven't gone to the bathroom in five days.*

It registered this time, and the new doctor brought back a hypodermic needle and gave me an injection of opiates. My statement, a suppository, and the shot of morphine probably saved my life. All of that hard-learned high school and college Spanish finally came in handy.

The nurse returned with a bullet-shaped suppository and said, "Take this."

I began to put the suppository in my mouth, but she stopped me and explained by gesture the proper orifice to insert it into. In about thirty minutes I had the urge to go, and to my amazement got out of bed with no pain and walked fifteen feet to the toilet. That was the last time I would walk for two months. It was the best bowel movement of my life. It doesn't seem possible that the human body could contain the volume of excrement I flushed down the toilet that evening. I filled the toilet bowl up twice and flushed it twice.

I was no longer hallucinating, but I believed there was some kind of conspiracy brewing. Something fishy was going on, some undisclosed secret. The hospital kept me in the dark about my illness. I asked to call the American Consulate, but there was no response from the staff. I asked to talk to someone who could speak English.

There was no reply. My best guess is that they were trying to cover up my illness. Franco the dictator was still in power, and the country was locked down tight. Altea was on the popular Costa Brava highway, and tourist season was just beginning. They didn't want to scare away precious foreigner tourist money. After I stayed at the local hospital for three weeks they planned to transfer me to another hospital. I signed over my travelers checks, worth 700 dollars, to the hospital. Still hidden in my van was one last hundred dollar travelers check.

The hospital transferred me to an isolated infectious disease hospital. My relocation began in the afternoon. I was placed in the back of an older, round-shaped ambulance that looked like something out of a 1940s movie. The ambulance driver turned on his revolving red light and continuous siren. Culturally the Spanish do love their processions, clamor, hubbub, and uproar. My transfer became the driver's badge of honor. Every second saved was a victory for the cause. Horns were honking and brakes were screeching as he swerved in and out of traffic. The Europeans have a lot of things going for them, but their proclivity for passing on two-lane mountain roads is one of the nuttiest things I've ever seen. We arrived an hour later at a secluded, rustic, tree-lined, antiquated charity infectious disease hospital, run by nuns.

Upon reaching the end of that harrowing trip, I was left in the ambulance with the door swung open for at least an hour before I was transferred to inside the hospital. My room was large and sparse with a dynamic view overlooking the cholera pit. Yes, I said cholera pit. That's a sight you don't forget for a long time. In former days I believe my room was the official viewing and monitoring area of the entire pit. It was constructed from buff-colored concrete, and its bottom lay a good eighteen feet below my room. The yawning pit stretched sixty feet in diameter, with fourteen-foot-deep vertical walls. Obviously it hadn't been used for decades; nonetheless, it was well maintained. My room was off a hallway with ten other private rooms. I never saw a female patient during my two-month stay there.

The room next to mine revolved patients in and out. I'd see new folk being wheeled in on a gurney who would cough most of the day and

into the night. Two weeks later they would succumb to their disease and be wheeled out on another gurney to the morgue. Two months later, when I learned to walk again, Sergio, a dark-haired and dark-complexed Spanish buddy, showed me the morgue. I had a hard time understanding him, but with hand gesturing Sergio led me through the tree-shaded grounds to the morgue. It was too straightforward to believe. The inside of the room was constructed out of bare wood with a high roof, buttressed by three side walls. The fourth side was open to the elements. Inside was a simply built, two-story wooden racking system, designed to store the corpses. The floor was graveled. In the height of an epidemic it could easily house fifty to one hundred bodies. I remember that it was dark, shady, and cool in the morgue that day. Sergio showed me the one body contained there—that of the patient who had died earlier that morning. There was no attendant in the room. The body was positioned on the top story of the storage unit and still lying on a canvas stretcher. His face was covered. He was bundled for the shift of man to matter in a simple dark blanket. What hit me was the fact that there seemed so little emotion shed on a destitute man who had died in a charity hospital. Maybe it was because he was indigent, or maybe the Spanish don't have the same outlook on death. I didn't know the man. I had no feelings. It was only a strange, lonesome occurrence to me.

It took an eight-week stay at that hospital for me to learn how to walk again. I was simply too weak to stand on my legs. All the muscles there had atrophied, and I had no muscle memory to compensate, nor did I have any coordination or balance. With help I could walk two or three steps, but then I'd have a setback and lay in bed for another three days. The symptoms of typhoid fever are lethargy, weakness, and a long recovery time. Maria, a thick-set nurse with gray hair and wide-set, kindly brown eyes, wore a white uniform and looked after me. Maria gave me a goal. I wanted to call the U.S. Consulate. There was a red phone twenty feet away. This was my lowest point. I was deathly sick. I had lost control over my life. My mind and body were both useless. Daily bedpans were my routine. I developed bedsores on my back for lying in bed all day. I wanted reassurance from someone

on my side who spoke English telling me I was going to be OK. Maria told me that as soon as I could walk to the phone it was mine to use. It still took another month of effort before I could walk on my own.

The red phone was another ruse. It didn't work. I never did contact the U.S. Consulate, and after a while it seemed pointless to try. It was similar to when I was a kid and use to dive into the river and hold my breath and see how far I could swim underwater, beyond normal endurance, submerged in the blurred darkness, stroking with everything I had before coming up for air. It seemed as though I had completed the murky underwater swim and now, above water, I was going to make it to the other side. Walter, bless his heart, somehow got word of my situation, tracked me down, and visited me at the hospital. I think it was his sense of camaraderie; don't leave a buddy on the battlefield. He asked if there was anything he could do. I told him he had done enough. He picked up my spirts, brought me reading material, and sent other visitors.

In a current *Time* magazine that Walter left for me, an article featured Andrew Wyeth's latest paintings, one of which depicted a realistic nude. The other male patients were quite taken with my magazine. When I was finally discharged there was a considerable skirmish amongst my Spanish friends as to who'd be the recipient of the prized magazine. There was stringent censorship in Spain at the time, and I don't think my fellow patients had ever seen a published nude picture of a female.

After many starts, stops, and setbacks I learned to walk again and spent my days pacing around the grounds and watching televised soccer games with the Spanish guys. I didn't write a letter home while in the hospital. My nemesis of mislaid ego, my pride, showed his tricky spinning head. He suggested I could save face and maintain a good appearance by recovering on my own. I followed his advice, embarrassed that I'd gotten myself into such a messed-up predicament.

On the day I was discharged two memorable things happened. Maria told me they were going to dismiss me and give me a ride back to Altea, where my van was parked. Trying to find the right words in Spanish, I asked her what I owed.

Maria put her hands to her lips, kissed them, and then blew the kiss away. Later on she informed me the ride was ready. Before leaving the hospital room I removed the piece of paper attached to my bed chart, folded it, and placed it in my pocket. Then, I left the room for the last time. Later, with the help of a Spanish-English dictionary, I learned the nature of my disease.

Still weak and recovering, I drove my van to Barcelona, sold it, and bought an inexpensive plane ticket that was about to expire from another American traveler. We walked into Barcelona International Airport, where he checked in my bags and gave me his boarding pass. I boarded the airplane and flew back to the U.S. using his name. Things were a little different back in those days.

Finally, my false bravado and invincible feeling of being able to conquer the world and do anything I set my mind to had come to a halt. With typhoid, I had met my match, and it had kicked my tail. Typhoid crashed my most precious gift: my temple. My Red Bull protein machine was put on hold. I had in essence downloaded a Trojan virus, spilled my coffee, and forgotten my password, all in one setting. The damage was done. My memory wasn't ruined, but it wasn't as good as it used to be. In college I simply worked my way through courses by remembering lectures and reconstructing sound bites for the final exams. But now I was shaken, and it'd take more time and patience to get my body back on track than it would take to harvest sea salt. Getting my mojo, stamina, and confidence back to normal levels would take years. The illness affected my development as an artist by hardening my will and core. Glad to be alive, I felt every day after I got out of the hospital was a present, a gift to be opened and used as I chose. However, I never believed in my lucky star again, and from that point forward I didn't trust being happy, knowing it could vanish in an instant.

I returned to Santa Barbara and more bad news arrived. Megan and I spent a couple of days together but it was obvious I was a sick man. Megan then told me she had fallen in love with the bartender at a popular restaurant where she worked as a waitress. That hurt like hell. I have no memory of the event. My mind is a totally blank as

to what was said and where. I had been staying at a friend's house sleeping on his couch. The night Megan dumped me I slept outdoors in a stranger's backyard cuddled up against a big friendly Labrador I met that evening. The Labrador kept me warm and comfortable and I made it through the night. In the next couple of days my sideburns suddenly had a touch of gray in them. I guess I had it coming. Megan's words fractured my love vessel. My dissolved emotion dripped out the porous bottom. My fall was complete. I was broke and weak, lost my confidence, and went into an emotional deep freeze, lasting years. I still had friends and hunkered down working in a Santa Barbara restaurant for a year as a waiter, intent on getting my health and finances back in order.

One day I drove north to retouch with my mother, arriving in the afternoon. Katie was working in her treasured flower garden, which encompassed the entire front and back yard of the newer suburban home. I was happy to see here and basked in the warmth of a mother's adulation. Dad wasn't there; he had had moved out. They would soon divorce. She greeted me with beaming enthusiasm, her dark eyes radiant. She was dressed in a wide-brimmed sun hat and comfortable polyester slacks hung loose on her body. "I have something special I want to show you," she said, leading me down a garden path while tenderly pushing blooms aside. She stopped at a huge dahlia plant and gently turned a large bloom in my direction. "Don't you think it's beautiful?" she asked. "It's one of my hybrids. I grew it from seed." "Simply gorgeous," I affirmed. "I named it after you," she said. "It's called *Favorite Son.*" She glowed with an exclusive smile only reserved for me. I wasn't up to the moment. "I've really enjoyed you as my mother," I awkwardly said, not telling her I loved her, not seizing the moment. It was difficult for me to tell Mom I loved her, even though I did.

Later that afternoon I jaunted out to retrieve the paper. There's something about my mind and how I approach things: it's all or nothing. I had been following the Watergate hearings and was anxious to know if Nixon would be impeached. I edged past Katie's large garden of zinnias. The brilliantly colored psychedelic flowers

were at the height of their bloom cycle and cast bluish shadows on the tan concrete driveway. Suddenly the power light in my brain switched on. The day's events lifted my essence and rebooted my craving to pursue art.

Once again I became obsessed with the art journey, convinced I needed a new start. Formulating a plan for my new adventure I decided a flight to Australia was in order. Exploration of the unknown was still calling me. I applied in person for a work visa at the Australian Consulate in downtown L.A. The country of Australia, not needing another long-haired art teacher in Sydney, denied my request. Undaunted, I decided to visit Australia on a travel visa. The most economical way of flying there was by island hopping, first to Hawaii, then to American Samoa, and finally on to Australia.

The day I landed at the international airport in Honolulu was a typical eighty-degree day in paradise. It was midmorning, and a slight five- to ten-mph trade wind was blowing. The passengers disembarked from the 747 directly onto the tarmac. We walked along the runway toward the terminals. Before reaching them something inside me, no doubt my love for nature, was telling me that this place was special. The fresh scent of tropical flowers carried by the gentle winds closed the deal for me. I fell in love with Hawaii and would stay there for the next four years.

The heat in Hawaii, which only varies from seventy-two degrees in the winter to ninety degrees in the summer, seems to permeate your body from the inside out. Everything on the island—the rocks, plants, and water—all feel like similar matter, almost interchangeable and constantly at eighty degrees. If it rains, it's eighty degrees. If the wind blows, it's eighty degrees. Wake up in the middle of the night, it's eighty degrees. Go for a swim in the ocean, it's eighty degrees. The comfort zone induced by the heat reminded me of when I was a child and slept under electric blankets; I always felt so comfortable and toasty.

The visual impact of tropical colors slung my world off its axis. I needed a whole new operating system to make sense of it. It was as if somebody had messed around in Photoshop, pushing the slide bar

all the way to the right and giving the colors in Hawaii the maximum intensity and saturation. When God made colors for the tropics he must have thrown out all the monochromatic grays and dull tones and used only iridescent, Day-Glo, vibrant colors of pure pigment, concentrating on cadmium yellow, alizarin crimson reds, and cobalt blue pigments. In his masterpiece of contrast, he put colors together from the opposite ends of the color wheel, purples next to yellows and violets next to iridescent greens. Colors in Hawaii seem to vibrate. Focus on them, and you'll almost hurt your eyes. Who cares if it's garish or gaudy? Colors have to be vivacious in the tropics. The flora and fauna try to outdo each other. The insects are colorful, the wild parrots are vibrant, and the flowers are pulsating. Insects as well as the fish under the sea have blue stripes next to orange. Even the people who walk the streets of Honolulu are colorful, adorned in vibrant Hawaiian shirts that would get you a profile stop in some Midwestern cities. The only thing I can figure is that latitude affects color. The closer to the sun you are, the more radiant colors become.

My understanding of Mother Nature fell to the wayside as well. Forget about camouflage. Apparently, the more the flora and fauna stick out, the better their chances of survival. That doesn't figure or compute—unless outrageous colors attract mates in the tropics.

I decided to stay in Honolulu for a couple of days and visit the University of Hawaii's Manoa campus. I toured the art department and requested application forms for their graduate school. Being obsessed with pristine, unspoiled nature, I decided to explore the less-populated outer islands and chose the Big Island as my starting point. Australia could wait.

THE LOST COAST OF KONA

Y OU HAVE TO endure a tropical downpour most every day in the city of Hilo, located on the big island of Hawaii. Hilo is surrounded by a tropical rainforest and is on the windward side of the island, receiving two hundred inches of rain during the year. Moss grows on buildings, walls, cars, trees, and the mandatory corrugated tin roofs so prevalent in the tropics. It rains so hard in that city that moss grows on the underbellies of flying seagulls who soar across the clear-blue humid skies after a downpour. Rain and wet weather depress me. I need sunshine.

On my second day in Hilo I met Floyd, a retired former military man, along with his easygoing wife, Jean. Floyd, in his late fifties, had an athletic, lean body. His hair was gray and styled in a crew cut, flat on top. Jean shared her husband's athleticism; however, she was a short lady who wore flower-patterned dresses. They invited me to visit the leeward (desert) side of the island. Our destination was the deep sea fishing and tourist port of Kona, ninety miles to the west. Kona, as I was later to find out, is a modern-day land of Oz.

Actually, there were probably a dozen different mini-Ozes residing in Kona, all willing to dispense advice for your personal maladies. Pagan worship, drugs, meditation, diet, political extremism, cult Christianity, exercise regiments, sexual experimentation, etc. . . . If you're wacked out, crave followers, and can't find a home for your alternative social experiment, bring it to the lost coast of Kona. I soon became one of the lost souls on the coast of Kona, wandering the

water front beaches, digging through my pockets looking for answers. Floyd and his wife's hobby was collecting souvenir railroad spikes from the defunct, small-gauged, sugarcane railroad on the distant side of the island. Floyd agreed to take me along, and he, his wife, and I left in the morning with a full itinerary. He had served in the Pacific during World War II, was very astute, and seemed to have a clairvoyant sense of observation—no doubt survival skills developed during the war.

On the drive Floyd filled me in on the local culture and gave friendly advice. "Dan, Hawaii is full of people from the mainland who are running, some away from bad experiences, others toward a dream. I'm not for sure, but I think you're the latter. Anyway, Hawaii's a great place to sort things out. Let my wife and I show you some of our favorite spots." Floyd drove the car with one firm arm planted on the steering wheel and all the windows rolled down.

I gave his insights into my situation some thought as we drove. We drove through the island's unique, ever-changing terrains. The untouched environment soothed and enticed me. The landscape reminded me of a magical fantasyland, like we were lost in a modern-day fairytale. The dense vegetation of a rain forest soon gave way to long, descending green slopes flowing down the side of Mona Kea. I noticed that cattle ranches occupied those lush green areas. The landscape changed again, and soon we caught the first glimpse of Hawaii's primal, mystical crust. A desert composed of black lava both new and ancient spread out before us, lasting twenty miles. Now in the background the majestic volcano Mana Loa could be seen, looming high, overlooking, dwarfing the island, and casting its mysterious spell on me. When we arrived on the west coast the soil grew fertile again, dominated by dense sugarcane fields. The island was sparsely populated; we probably didn't see another human being for two hours, and that was just fine with me.

We began searching along the easement of the defunct sugarcane railroad, which cut through eight-foot-high sugarcane fields, peaceful and totally impregnable. The sugarcane fields swayed in the gentle breezes, blowing away anxiety and calming my unsettled psyche. All

that afternoon we scoured the railroad tracks, filling a bucket with small, rusted railroad spikes.

"Now I have a treat for you," Floyd divulged with a smile. "Let's drive into Kona and watch the sunset." He loaded the bucket into the trunk, and we arrived at the quaint tourist destination of Kona in the late afternoon. The western sky was already showing signs of yellow. Floyd parked the car next to a three-foot-high, magnificently constructed black lava rock wall, which wound its way along the undeveloped oceanfront. We stood on the wall, and Floyd acted as a tour guide. "That's the deep sea sport fishing wharf there." Floyd pointed with his arm extended. "Anglers from all over the world fish these waters. Record blue marlin are caught here. See, they are weighing one now." I looked in that direction 150 yards away and could see large sport fishing boats, secured to the docks and gently bobbing. Next to one was a long fish suspended by its U-shaped tail. It hung above the dock, high in the air, by a wench. People were standing around taking pictures of the dark blue fish with the long sword bill. Floyd continued, "The hotel to the right is the Royal Kona Hotel." He turned and pointed behind us. "There's a half dozen shops in the mall over there. That road is the only road around the island. Maybe three thousand people live spread out in this area." My own private getaway spot, I envisioned.

We then sat on the wall with a dozen other people and prepared to watch the melting colors of a breathtaking sunset. Before it began, we dined on Jean's packed dinner of sandwiches, fresh mangoes, and papayas. She brought a small cutting board for the fruit and sliced it for us. That was the first time I enjoyed a fresh mango. She showed me how to remove the stringy pit by slicing the mango in half. She then picked up one of the halves, diced the meat into little squares, and pushed from the back side of the fruit, forcing up the sugary, cube-like squares. Holding the rind in your hand, you could easily bite into the individual squares of juicy mango. She sliced into a papaya to open it. The cavernous interior was a salmon color and contained twenty little black seeds, which she scraped out before slicing the papaya lengthwise like a cantaloupe.

The light show began in earnest and continued for forty-five minutes. It was out of this world and seemed designed specifically for the emerald city of Kona. Solar winds blew in an aurora borealis comprised of charged particles of plasma. Ionized gasses shot from the far side of universe at the speed of light and hurled toward Earth, traveling through eons of time until caught by the Earth's magnetic field. They dispersed in the sky and thunderclouds in a time sequence, beginning with yellow, then orange, and finally pink. That extraterrestrial crown of hot, changing colors descended upon the emerald city of Kona. For the climax, the fiery sun dove into the ocean, surrounded by thunderclouds with their edges ablaze.

After the meal I jumped down from the wall and ambled around a bit to stretch out. The tropical heat was beginning to work its magic on my recovering, stiff lower back, and I felt better than I had in a year. I've always loved nature, and that was the sweetest unadulterated place imaginable. With Kona, I found my revival temple. My body was starting to heal, and I decided to employ the solace of nature's treatment and let the Big Island cure me.

The next day I packed my bags, caught a bus to Kona, and rented a studio apartment no further than 150 yards from where Floyd, Jean, and I had watched the sunset. For transportation, I bought an Opel station wagon from a young gay couple who operated a telephone-booth-sized live pearl kiosk in the shopping mall.

I hadn't attempted an art project since contracting typhoid fever, but I was ready to start again. The only problem was that I had no idea how. In my studio apartment I opened a large sketchbook to the first page and wrote the word *enigma*. Then I rewrote it ten different ways. I wrote in large letters, small letters, and in descending letters. I wrote the word in one-point perspective. I contemplated the word and came up with more emptiness that a meditating monk. In college I had used that exercise to jolt my mind and jumpstart ideas, but that day I came up with zilch and began seriously doubting whether I had it in me to start again. Artistically, I was uninhabited. Should I just call it quits and get it over with? Was Floyd's assessment wrong? Was I running away from something

instead of trying to find myself? Exasperated, I asked: What am I really good at?

I decided to try a different avenue. Locating a pottery store I bought bags of clay and decided I'd make simple forms out of that medium. I began by making a bowl of fruit that held an apple, a banana, and a pear. That was my humble new art beginning. Six grueling years later I secured a one-man show in San Francisco.

I would work on sculpture during the morning hours. Evenings I waited tables at the main dining room of the Keauhou Beach Hotel. Our signature entrée was locally caught mahi mahi, once a delicacy reserved for Hawaiian kings. It is still my favorite-tasting fish. Typically, mahi mahi is served with a side of poi made from the taro root. The tourists seldom ate poi; its bitter taste made it more of a curiosity item than anything else. My favorite entrée to serve as a waiter, however, was flambé pepper steak seared in flaming brandy. I loved bringing out the little cart with the portable gas range and steak skillet. At the tourist's table I would pour brandy into the sizzling skillet of pepper steak. When the brandy began to fume I tilted the edge of the skillet toward the burner, watching the pepper stake erupt into blue and orange flames.

Other nights I'd work the luau with the local Hawaiian men and women. They liked me because I could handle the white tourist crowds and were as wild as they were. We also shared a fondness for homegrown weed. The Hawaiians liked to roast a whole pig in the ground traditional style, surrounded by banana leaves and hot lava rocks. When the pig was removed from the ground, succulent meat fell from the bones.

After dinner, the local Hawaiians changed outfits and redressed in flimsy Polynesian attire. Hawaiians are naturally gifted artists. The men pounded high-pitched indigenous drums, and the women shook their rears, undulating up and down and around in circles in an exotic, erotic dance. Based on its stimulation factor the act could have been R-rated. No wonder early Christians banned those traditional dances. However, my favorite act was performed by a Hawaiian man who twirled fire on a four-foot stick.

I remained on the Big Island for a year; my stay there was significant because I may not have gone back to art had I never visited Hawaii. Even though I wasn't very committed at the time, I think that the most courageous decision I made in my long and difficult career was to give art another chance. It would've been so easy for me to pump the brakes and slide to a halt. But like a driver tailgating you through narrow mountain curves, the art muse stayed on my tail and wouldn't go away.

The traditional Art Gods had given up on me; however, Pele, the Hawaiian goddess of volcanos, did pay me a visit. Some nights while working the dinner shift I could sense the ground shaking. The land was experiencing small earthquakes, signaling the impending eruption of Mana Loa. Late one evening, after I finished work and was driving home, I saw the majestic goddess Pele for the first time as her red head towered above the volcano. The illusion was caused by red hot molten lava in the crater's center reflecting light off of linear clouds that blew over the volcano. It didn't take much of an imagination to see her glowing red head soaring over the volcano and her elongated arms sweeping down and guarding the sides of the mountain. Accompanying the visuals was a windswept woodsy smell of burning vegetation produced by molten lava as it scorched and blackened everything on its march to the sea.

Hawaii also offered an abundance of calm, adventurous moments. I spent my leisure time body surfing and snorkeling in the warm ocean. A diver's knife was essential upon entering the sea. The phenomenal underwater postcard world came to life the moment you entered the crystal-clear waters and descended amongst the lava rocks. Once submerged, you couldn't help but get the distinct impression that you were participating in a National Geographic special featuring colorful tropical fish. My scariest moments came when I swam through a grove of Moray eels. They were positioned vertically, like stakes in the ground, and stretched three feet long each, swaying back and forth. Their tails were locked into the crevasses of lava rock. Their camouflaged flat-like bodies ended in ghoulish heads filled with razor-sharp teeth. As you swam by, their beady eyes tracked you, and their

jaws were constantly opening and closing. That particular grove of eels was spaced five feet apart in eight feet of water. According to their reputation, Moray eels liked to bite and lock on until you drowned. The only effective escape tactic was to slice off their heads. I saw the eels as weird temperamental friends. They were scary but predicable.

I often made excursions into the jungle to harvest wild avocados. The fruit was stringy, as big as grapefruits, and hung from forty-foot-high trees. Underneath those trees, razor grass covered the ground. Traversing twenty feet through the ground cover to reach the avocado trees was difficult. Mangoes and papayas were plentiful if you were willing to work at it—and if you remembered to carry a six-pack of rubbing alcohol for the cuts.

The biggest challenge for me on the Big Island was finding suitable female companionship. Women were in short supply and simply didn't stay on the wild remote island for more than three or four days; most were on tours. The ladies who lived there seemed to have unusual elliptical orbits. Maybe I just saw myself in their eyes: a person who was a little off kilter.

I applied to the University of Hawaii's graduate school using my undergraduate slides, but was turned down. The official notice implied that the work was interesting and recommended a reapplication the following year. My new plan was to move to the island of Maui, make new sculptures, and reapply to graduate school. Maui was a more developed island, a larger social network with a community college and upgraded art resources.

THE MAKING OF A COMMITMENT

UPON LANDING ON Maui I immediately secured a waiter's job at a ritzy exotic restaurant in fashionable Lahaina that specialized in wild African big game. It was the most extravagant restaurant I ever set foot in. I was a waiter-in-training and worked in tandem with a more experienced one. We served only one or two tables a night. It was the ultimate in excess and decadence. We pampered our clients as though they were the kings and queens of industry—which they were. The clients feasted on four-course meals that came with two spoons and two forks for every course. One couple would soil enough silverware during a meal to fill up a dishwasher. The restaurant catered to affluent clientele, many from the L.A. movie industry. The main course included antelope, gazelle, zebra, water buffalo, and other big African game.

The ambience of the restaurant was against my sensibilities. On an especially taxing evening I received an important bit of advice that helped restart my fledgling art career. We had a full house—which was only four tables. In the mix were Hollywood movie executives. The table we served was occupied by a fat cat and his trophy wife. They wore matching gold bracelets. He was drunk, self-righteous, and arrogant and smoked a big cigar—a walking cliché, in other words. I was ready to quit on the spot. To my amazement, after the crass couple left the restaurant a tall, skinny, polite, middle-aged, casually dressed man approached me. He had been dining at an adjacent table and apologized for the behavior of the couple who had just left the

restaurant. He seemed to be genuinely embarrassed for the other man's conduct and insensitivities.

The stranger seemed very astute and had read my mind perfectly. He stayed in the restaurant after the front doors were locked, and we chatted a bit. Little did I know he was about to become my biggest mentor.

"What's your passion?" he asked in a sincere way.

"Sculpture," I revealed.

"You should pursue it," he told me, and then followed up with a piece of advice that would last me a lifetime. "I'm a writer. I can tell you one thing for sure. Every artist who has done something worthwhile has made a total commitment to their craft." After he left, I was told that man had written the screenplay for a movie. I didn't realize until I began writing this memoir and researched him on the Internet that he was Stirling Silliphant, the talented and prolific Hollywood writer who penned the screenplay adaptation for the academy award winning movie; *In the Heat of the Night*. He has since passed on.

His words shoved me over the safe boundary line and into a bohemian quest to become an artist—the all-out, balls to the wall, every food stamp in, cut down the safety net pursuit of an art career, which meant total immersion and total commitment. Get rid of gluten-free and nonfat products and bring in the juicy red zebra steak. Become an artist or die trying. The first act was to find a place that could function as a small sculpture studio. The second act, which lasted twenty years, was swallowing my pride and downsizing my social regime.

Housing in Hawaii was scarce, and the best an artist on Maui could hope for was a small room in a flophouse. I'd become accustomed to having my own private space and control over the people I lived around. Now, I joined a community in a house with shared bathrooms and kitchen facilities, similar to being in college, except these tenants came from all corners of the earth. They were eccentrics of every kind, characters out of Stirling's movie scripts, the dispossessed, the seekers, and the voyagers. Most were underemployed, and all had a taste for Maui Wowi.

Julie Melbourne was in her late thirties, with an actress's face featuring big, opulent lips. She was short and possessed amazing body curves. Julie owned a house located near the Maui Fish House, a restaurant that overlooked the ocean on an isolated beach in the Paia district of Maui. Julie was a kind-hearted former movie actress who had enjoyed limited success as an extra in a number of movies. She unsuccessfully ran for the mayor of Maui at one point. Julie rented out three rooms and kept the interior portion of the house for herself. A swing had been mounted to the ceiling of her large living room, where she'd sway back and forth, watching the beautiful Maui day pass. During the night the swing doubled as a sexual prop, captivating her lovers. Julie was proud of her sexual powers and shared tidbits of her exploits.

In the mornings tenants liked to gather around Julie's coffee machine to wait for their cup of Kona coffee and to chat. One morning I met Sam, another ex-Hollywood type hanging out in Maui. Sam's most memorable characteristic was his enormous phallus. He was dressed in a Hawaiian shirt and loose-fitting shorts, waiting for his turn at the coffee machine. People were talking and getting acquainted when all of a sudden his schlong started falling out of his shorts and just kept unfolding like a fire hose, falling to his knee. "Excuse me," he said, having the hardest time getting it all back into his shorts.

I didn't think it was physically possible for a man to have a unit that big. You'd need two horses' hearts to pump his gismo full of blood. Later that afternoon I brought up the incident with Julie.

"It's a staged act he does to entice the new ladies. How do you think he did?" Julie asked with a coy smile.

"Pretty impressive," I replied, believing this bunch was nuttier than me.

After moving in and setting up I decided to get my body and mind in shape. I read every book in the library on the lives of artists. I joined a yoga class at the local junior college and began meditating. I devised a strategy, set my compass, and began my voyage to become a sculptor. Out in another realm in the control room of the Art Gods, a distant radar blip appeared on their screen of potential artists. I had made

the commitment, and unrelated art mechanisms and undercurrents throughout the universe began lining up for me. Later that night the ghost of Jackson Pollock toasted my commitment to art with a shot of whiskey as he flew by in his green Oldsmobile.

One of my new roommates was Brad, an Alaskan pipeline worker from Texas. He was chilling in Hawaii for a couple months before returning to the pipeline project. If the universe had central casting, it had sent the right body type for a Texas redneck construction worker. However, the universe made a mistake and sent a man with the wrong political outlook to be a redneck. Brad had a Texas sun-cured face, as though he'd been outdoors for too much of his life. Garnishing his rugged face were cerulean blue eyes surrounded by deep wrinkles. However, when he spoke, he revealed himself as a left-leaning radical intellectual type, exposing a socialist progressive ideology. Brad was a Berkeley radical wedged into a redneck's body, rallying against the corporate elite.

"Money is what they want. Sex, superstition, and power are what they worship. They're not into finding a common humanity," Brad often preached. He took an interest in me and started giving friendly advice. He suggested I apply for unemployment insurance.

"I'm on it," he informed me. "Half of Hawaii is on one sort of supplement or another. That's the only way people can make it here. You qualify. You deserve it. Waiting tables for two years . . . Christ's sake, man. That's bondage, present-day servitude." Sensing my resistance, he changed tact. "Then think of it as a scholarship. You've earned it."

Two weeks later I enrolled for unemployment insurance and was registered for the food stamp program. The supplements were not enough to get by on, but in combination with my savings it was enough to afford me six months of concentrated effort.

Formally, I always had a job, carried my own weight, and never thought of myself as a slacker or a welfare recipient. I justified it in my mind and swallowed my pride, but this wouldn't be the last time I lowered my expectations. In the coming years I'd experience many more downward turns on my lifestyle's screw. My plan was to make

new sculptures, document them, and reapply to the University of Hawaii's graduate school.

My Buddhist monk art routine began with a bowl of granola in the morning. Then, I'd walk a short distance to a cliff overlooking an isolated beach and begin a thirty-minute yoga and exercise regimen. When finished I'd return to my small room, which also served as my clay studio. In the morning I covered my bed with a piece of plywood, which I used as my main work area. My studio's atmosphere was comparable to the single-mindedness of a doctor's office. It was dedicated to one activity: the making of clay sculptures. My area was cramped but neatly organized, similar to space in a submarine. Everything was folded and tightly packed like a Swiss Army knife. A huge bookcase lined one wall and was stacked with clay projects wrapped in plastic and slowly drying. I'd place a project on the piece of plywood, unwrap the plastic, spray it with water, and begin working. The sculptures began with drawings from my sketchbook. My first projects were satirical portrait busts of presidents completed in porcelain clay. Nixon with his prominent nose. Ford with his "win button." Jimmy Carter with his huge smile. The finished sculptures were fired at a local pottery.

Six months later, when my savings were used up and the unemployment insurance stopped coming, I landed another waiter's job at the newly constructed Intercontinental Hotel located in Kaanapali, Maui. Over the years I had become a fairly competent waiter. However, when we opened the hotel on inauguration night, it was a chaotic disaster from the dining room to the kitchen.

By coincidence, the distinguished looking, gray-headed architect who had designed the magnificent hotel was seated in my section of the main dining room. I spent the evening making apologies to that decent and patient man. It took at least two hours for him to receive his dinner.

"I really want to apologize for the slow service. Can I bring you a complimentary drink from the bar?" I kept asking. I served him and his blond, impeccably dressed, younger wife multiple complimentary drinks. They ultimately became smashed, crabby, and judgmental.

"This is the first job she's ever had," I overheard him whisper to his wife, assessing my fellow waitress's performance. By the time they received their dinners the couple was sensationally drunk, starving, disheartened, dismayed, and obnoxious—and who could have blamed them? I've forgiven him for his behavior. He conceived a beautiful site-specific piece of architecture and deserved better than he received on what should have been a night of celebration on a job well done.

The main dining room was a stunning piece of architecture. Half of the large, arched space was open to the ocean. My fellow staff members and I watched many unbelievable tropical sunsets while guests dined on world-class cuisine. Occasionally, in the late afternoons, we observed whales breaching no more than a quarter-mile away. In the middle of the dining room on a platform was a white harp, played by a female musician dressed in a flowing white evening gown. As her angelic music carried along the aromatic sea breezes, it was as though we were participants in a Botticelli painting.

My fellow workers were a mix of mainland haloes [whites] and locals who had grown up on the islands. We were all young and alive. The benefits of that job included an instant social circle of fellow waiters and waitresses, a free meal a day, and in this case good tips. My liaisons with women were intimate but friendly. We enjoyed each other's company, but everyone seemed to be in transition or on an adventure. Most people didn't want to get into serious partnerships, and I was certainly one of them. I continued working in the studio, saving money, and waited to see if I would be accepted at the University of Hawaii.

Cosmic indifference was delivered by the postman. He rang twice, because twice I was turned down by the University of Hawaii's graduate art department. The rejection didn't deter me; actually it fired me up to work harder and reinforced my desire to move to Honolulu. I decided to use the Honolulu campus facilities, even though I hadn't been accepted. I simply needed access to specialized art knowledge.

My health and swagger had returned. The slight tremor in my hands, a leftover remnant from typhoid, had finally gone away. Nurtured by Maui's beautiful extinct volcano Haleakala, the abundance of wild

mushrooms in Hona, the nude beach where we body surfed in the raw, the cast of distinctive characters who were drawn to this location, and my daily regimen of yoga and meditation, I became healthy once again. Maui was my spiritual retreat for a full year, and I will forever be thankful for the healing powers of that transcendent place, which allowed me to reclaim my body and mind.

I packed my studio possessions into the back of my Opel station wagon, which was then loaded onto a cargo ship destined for the city of Honolulu on the island of Oahu, the smaller of the Hawaiian Islands but the most populated, and also the location of historic Pearl Harbor.

Each Hawaiian island was unique and represented different states of my reemergence. On the Big Island, I attempted to heal and recommit to art in a remote setting using solitude as my approach. Maui was more of a spiritual and upscale cool society scene. Honolulu, a large metropolitan city, exhibited the attributes that came with urbanization and a large condensed population. Upon landing on the island of Oahu I searched for a suitable rooming situation that could double as a studio.

The Chans' rooming house, located a quarter-mile from the University of Hawaii's Manoa campus, was perfect. We called the cramped quarters in back of the Chans' house, situated on a steep hill and surrounded by a manicured jungle, the "Tarzan Compound." David Chan, the oldest son in the Chan family, managed and maintained the ramshackle rental rooms. David was not tall but sported enormously wide and powerfully built shoulders, attached to two muscular arms that ended rather oddly into smallish hands, almost as if they were an afterthought during the development of his body. He had medium-length black hair and a classic Chinese male face with almond eyes, and he was all-American, culturally speaking.

There was a rumor at the Chans' rooming house that Edgar Rice Burroughs, who wrote the Tarzan series, once lived in the main house. Burroughs did live in Honolulu during the war, witnessed the bombing of Pearl Harbor, and was a war correspondent, so the story might very well be true. The Manoa Valley has the natural beauty a

writer would love. It rains for half an hour and then the sun comes out. White, puffy clouds float through the sky in front of towering cliffs covered with lush green jungle. The moistness in the air brings out the sweet fragrances of plumeria and other scented flowers. The Manoa Valley flirts with all your senses in an irresistible way.

One week after moving in, I began to walk past David Chan through the garage on route to my room in back of the house. He was shaping a surfboard in his garage.

David stopped working when he saw me coming and stood with his legs apart, blocking my path. "I was bitten by a shark," he oddly informed me.

I stopped walking and stared at him, not comprehending a hint of what he was talking about.

"Don't believe me? Let me show you." He pulled up his Hawaiian shorts. Above his knee and wrapped around his leg was a nasty scar. David had a reputation as a twenty-two-year-old surfer who could ride the monstrous waves of the North Shore. David was intelligent, but his mental wiring was comparable to a jury-rigged third-world telephone pole. You never had a clue what was going on in his head. He was certainly unique, though he conveyed a typical homegrown mindset. Initially, I thought he didn't get it. His localized behavior was actually a clever cultural survival technique, no doubt a result of Hawaii's turbulent history. That calm, unhurried, cultural norm adopted by the indigenous population was their way of coping with Hawaii's culturally diverse and cramped island society.

David's only job was to manage and maintain the Tarzan rooming compound, a daunting task. The ramshackle quarters built behind the Chans' main house had probably started out as a garage and then been added onto again and again. The last addition was fastened to a steep hill; the supporting timbers stretched eight feet through the jungle prior to reaching the floor of the rental room.

David had recently completed an eight-by-twenty-five-foot wooden deck, which attached to the front of the rooming quarters. Five rooms opened up onto the deck, which made for a terrific common area, extending the living space of the diverse tenants. Some

of the rooms were as small as six by twelve feet. A green easy chair was the most coveted object on the deck. On a flat, terraced section below the deck stood a camper shell, which had formally been attached to the back of a pickup truck but was now situated in its own private, entangled jungle. The camper shell housed two mainland surfers. As crowded as the compound was it still had privacy. Large, leafed jungle plants grew around everything, giving our living quarters a secluded feel.

I moved into a large, dark, gloomy room and began remodeling. My plan was to make it into a suitable clay studio by letting in light. David thought it was a good idea and paid for the materials. Together we put in a large screen window, flooding the room with natural light while maintaining privacy. I appreciated David's support and felt that he had allowed himself to get as close to me as possible, considering I was one of his wacky hawole tenants.

I liked the company of the area's surfers. Having been a body surfer since the college days, I respected their laid-back, tubular attitude, their respect for nature, and their reverence for the ocean. I also admired the awesome athleticism it took to ride the big, gnarly waves.

Two month later David finished his fiberglass, nine-foot-long board. I started to walk through the garage and once again he stopped me. "The waves are breaking on the North Shore. You want to go for a ride?" David asked.

"Yeah, sounds good," I replied.

He loaded the newly completed fiberglass board in the back of his purple pickup. Seated in the truck bed next to the surfboard were three bikini-clad local surfer girls who needed a ride to the beach. I jumped in the front, and we drove around the island to the North Shore. When we arrived at the beach, the surfer girls giggled and scattered, finding other friends and other places to watch the surfers. David grabbed his board.

The surf was huge and breaking that day. The waves looked like rolling hills as they rapidly approached the shore. Suddenly they would transform into recognizable waves as they neared and broke in a thunderous cascade of crashing whitewater. David placed the

newly constructed long board in the ocean, got up on his knees, and used his tiny little hands as paddles. He entered the water using a safe, roundabout route. It took twenty-five minutes for him to reach a take-off position two hundred yards out. No one else there dared attempt to catch any of those monsters.

A long-haired, blond surfer wearing a wetsuit and carrying a short board approached me. "Does that guy have a death wish?" he asked, echoing my thoughts.

To my utter astonishment David caught a treacherous wave, rode down a near vertical slope, and then surfed it all the way to the beach. Back on his feet and beaming with understated surfer cool, he put the long board under one arm and trotted along the wet beach until he reached the pickup and tossed the board in back.

We jumped in the truck and drove off, making the perfect surfer exit. On the way back not a word was spoken. It was as though any conversation might have taken away from the magic of the day. We took in the sights and let the awesome day speak for itself. When we arrived back home David finally spoke.

"You have to do that at least once a year," he informed me with only the slightest trace of a smile.

Settling into my studio I continued with the same zealous effort I had applied in Maui. Only now, I had a bigger and more comprehensive clay studio. I built an outdoor working area with a cement table, where I could wedge and prepare clay. Clay almost works itself in Hawaii. The temperature and humidity there seem perfect. At the end of a workday I'd cover my progress with a thin piece of plastic sheeting, allowing the clay to dry slowly and firm up overnight so it would be stiff and ready for the next day's addition.

The university's libraries offered not only public access but an extensive art collection, and I set my sights on looking at every art book they had. It took two years to complete that manic, preoccupied goal, but ultimately my investigation into historical art began to bear fruit. From the ancient Cambodian Buda sculptures I discovered a surface quality of textures that produced shadows, softening the form and giving the figure spiritual and lifelike attributes. From

the primitive arts of the Eskimos and the Dogon African tribes I synthesized enigmatic, potent, and powerful abstract motifs into my style. That was the beginning of my eclectic borrowing from other cultural perspectives. Later, those attributes would evolve into my mature figurative style.

A fortuitous circumstance provided me with free clay. The university had just completed a brand new, ultra-modern, two-story studio arts building and moved the ceramics department into the newly completed complex. The old and remote ceramics department's building was abandoned and overrun with jungle growth. That proved a bonus for me, because tons of dried-out clay in old plastic bags was left lying around the old building. I had become quite the streetwise opportunist by then, always scrounging for art materials. I attached a utility box to the back of my motorbike and drove down to the jungle location, where I loaded up fifty pounds of dried-out clay, then motored back to the studio and recycled it into sculptures.

From the surfers I learned how to work with fiberglass and began to make primitive, two-part structural matrix molds. The mother mold was constructed out of fiberglass, and the insert mold was fabricated out of latex rubber. I drove my motorbike to the airport and picked up resin, latex rubber, and fiberglass from industrial suppliers and then drove back to the Manoa Valley with the unruly supplies strapped to the back of my motorbike.

My daily routine still started with a bowl of granola in the morning. After breakfast I'd unwrap yesterday's clay project and begin work. My goal was to complete five physical jobs during the day. I believed I could out-work anybody, and with brute strength and perseverance I'd mold myself into a self-supporting artist. In the morning hours when I was the freshest I'd add on to the clay sculpture, paddling and scraping the pieces of clay until it became one with the overall structure. One sculpture I completed during this period earned me a third-place cash prize in an island-wide juried competition. George Neubert, the curator of the Oakland Museum, gave me the cash award. Another sculpture I completed during this period was one of the first that I sold through Harcourt's Gallery in San Francisco.

I would work all morning and into the afternoon. A couple of times during the week I'd take a bus to the Alamona shopping center and restock on supplies. It wasn't long until I discovered that Safeway Market discounted bleu cheese to half price. They did so in order to rid their shelves of the moldy-looking but still perfectly good cheese. My dinner usually consisted of bleu cheese and peas mixed together and cooked on a hot plate. With the addition of a piece of bread and a mango or a papaya I devised a nutritious, inexpensive dinner. I was on food stamps, money was tight, and it was necessary to stretch a buck to survive. In the evenings I'd trek to the library and browse art books. I had been an aspiring musician since my Army days and sometimes I took along an old silver flute and played a blues riff in a Jethro Tull style to add another layer to the ambience of the incredible Hawaiian evenings. Looking back, I've often thought that anonymous music was the best art I ever created.

The Tarzan complex became my sanctuary. Nobody questioned my actions. We were all living an underground existence, and I had become entrenched, making it by surviving off food stamps, unemployment insurance, and my meager savings. It was as though society existed on two levels, one in which everyday people lived their lives and the other in which our culture resided, an underground society of dreamers, surfers, lost souls, dopers, drunks, mentally ill or damaged individuals, and alternate types all seeking asylum and a place where they could live. We seemed to hold on to the same misconceived notion that at some point we'd pop to the surface and once again be productive normal citizens. In my case it'd take another ten years of underground struggles eating away at my self-image, and when I did finally decide to give up on my dream and attempt to rejoin society I was impaired, scratched, and dented. My hard drive had become infected; I was no longer able to function in a conventional social setting.

The cast of unusual characters I met in Hawaii continued to grow. There was the medical student who lived in the smallest room whom I only spoke to three times. He was a small man with thick glasses and constantly studying. Often when I came home late at night I'd see

his car parked under a bread fruit tree not far from the house, where he discretely made love with his Oriental girlfriend. Another guy, Steve, was a Vietnam veteran with shaky hands, remote and serene blue eyes, and worry lines entrenched into his forehead. He seemed to be misplaced and dwelled somewhere in the past. A nice guy, but severely damaged by the war. One evening on the deck, he confided in me.

"I was on point. I couldn't take it any longer. In a firefight I shot myself in the leg and just rolled down the hill," he said with a distant look in his eyes. When Steve awoke the next morning he doused himself in copious amounts of aftershave. It was as though he thought he could conceal his troubles with a pleasant fragrance. He only lasted a month. One day Steve was gone and nobody knew what happened to him. I found his driver's license in his room.

A short time later Steve's replacement, Henry, arrived and took the room. Henry was pale in complexion, somewhat handsome, and very innocent. His mother came with him when he moved in. She was considerate and nice. He did well for the first three weeks, but then his complexion started to change, and he developed dark bags under his eyes. I was to later learn that he had stopped taking his medication.

"Where you headed today?" I asked him one morning as we lounged on the deck.

He explained to me that he was going to the park. "I like going there. The ducks talk to me," Henry said as though he was lost in a child's fantasy. One night he failed to return. That was my first disturbing encounter with the shadowy mental affliction schizophrenia.

The next person to occupy the room was Jerry, a tall, narrow-shouldered intellectual type. His faced revealed the residue blemishes of a bad case of acne. He was the first Oregonian I met. They were my favorite group of people hiding out in the islands. It turned out that Oregon had a tough drunk driving law, and if you wanted to beat the rap you had to leave the state for a year. Jerry was smart and educated but also impulsive and exhibited little self-control, especially when it came to excess.

Rooming in the second terrace below in the camper shell was

Kenneth Abernathy. He was fair-skinned with freckles and wore a close-cropper red beard. Ken was the son of an Army colonel, and also was an incredible alcoholic. He was a decent enough guy during the day but would withdraw into himself every evening. Ken would sit in the green easy chair at night and power down a pint of whiskey in three gulps. He would quickly pass out and lie back in the chair with his mouth open. Sometimes the Tarzan compound felt like a fraternity of adventurous friends and other times it seemed a dead-end flophouse. After dwelling there for eight months, my stay at the compound was about to make a menacing U-turn toward the tenderloin, Honolulu's underbelly.

After Mr. Philadelphia moved in, the atmosphere changed quickly. The compound began to resemble an inner-city crack house or a shooting gallery. There was a high amount of traffic in and out of Mr. Philadelphia's end room. He would stand at the entrance of his doorway like a door bouncer at a hip inner-city disco, orchestrating events. Mr. Philadelphia was a six-foot-one, 220-pound, out-of-shape slob. He hadn't assimilated to the island's way of dressing and preferred to wear dark pants and long-sleeved, dark, striped shirts, gaudy jewelry, and copious amounts of men's cologne. An unpleasant acidic smell emitted from him and trailed him as he walked by. There was also an aggressive, intimidating quality about him. His eyes darted around but never met your gaze head-on. Those devious eyes didn't emit light. They were made of dark matter, nothing behind them, only black holes sucking up energy.

Mr. Philadelphia may have had some redeeming qualities, but I don't know what they were, nor do I really care. I had no way of knowing what he was thinking or what his motivations were, but my best guess goes something like this: Mr. Philadelphia, after contemplating his present situation, said to himself at one point, "I was lucky to get out of that sideways shit in Philly alive. But that's the nature when you ride the red horse. Heroin is fucking unpredictable. This time I'm doing it right. Start right here. Use my experience. Look at me now. I've been in Honolulu for a month and have already made an Oriental connection. Soon, I'll be getting supplied directly from

the triangle. I'm going to be big. This time I'm not going to use the stuff. I'll be a guru and teach others. These guys in Hawaii are a bunch of sissies. I give them one little taste, and they're in my pocket. They can be my delivery boys. David is a junkie; he just doesn't know it yet. He's been on the horse, but he doesn't know how to ride. If I load him up right I'll be in the main house in a couple of months. His Chink cousins will be stoned on their asses and taking turns sucking my big, hairy cock. In the meantime I need more space, a legitimate shooting gallery. I'll chase out the faggot Corbin and get the big room. Then, I'll control the whole pad. I'll use a little Philly scam on him. Sorry you had to leave, Corbin. Here he comes now. Look at the yellow shirt, shorts, and sandals; he's definitely queer bait."

It was afternoon when I arrived at the compound carrying a paper sack full of groceries and began unlocking my door. Lounging on the deck in that big, green easy chair watching me was Mr. Philadelphia. Nearby was Kenneth, who was already drunk. In another chair on the deck sat Jerry, so stoned he could barely hold his head up. Jerry had tasted the beast and come under Mr. Philadelphia's spell. Heroin had its allure on the islands.

"Hey, there. Hey, hey," Mr. Philadelphia called out to get my attention. "What do you do in the room all day?" His red lips wore a weird expression.

"A little of this, a little of that," I said. I had been anticipating this day, and now it had finally arrived.

"You know, I might want your room. What do you think of that?" Mr. Philadelphia asked as he looked at the other two deadbeats with a wry smile on his face.

His intentions were clear. I set my groceries down. A red-hot volatile plume of fury rose from the mantel of my being. The Slavic subhuman in me joined with my primordial Viking, and we wanted blood. In a controlled fashion, sensing I had a tactical advantage, I slowly walked over to his chair, planted my feet, and looked down at him. "You want my room?" I asked.

He nodded at me.

"I don't think so," I said. I noticed his zipper wasn't all the way

up. His shirt was only halfway buttoned, and unruly black chest hair grew around a gaudy piece of neck jewelry. The chair sagged under his weight.

Mr. Philadelphia placed his hands on the arms of the chair and pushed himself up to confront me.

I readjusted my footing, leaving most of my weight on my left foot, and threw an uppercut, keeping the momentum rising vertically. My fist landed on his chin just as he stood. I felt the energy of the punch enter his head and short-circuit his brain. His neck went limp, and his head began to fall.

I remember two things: his feet losing contact with the ground, and the loud, reverberating drum sound his crumpled body made as he hit the deck. Smack and boom, a split-second of activity.

I backed up to see if he was going to try to rise, but he just laid there in a heap. His mouth opened and closed as he gasped for air like a land-stranded catfish. White snot oozed out of one nostril. A perfectly placed punch had blue-screened him.

I stared at Jerry and Kenneth. "What about you guys?" I asked dangerously. "You want my room too?" My blood was high and I was in an ass-kicking mood. I literally saw red during the event.

No more than fifteen seconds later David arrived on the deck, all pumped up for action. "What's going on?" David assessed the situation, his face locked in battle mode.

"A minor misunderstanding," I replied, backing up and then entering my room. I let David deal with the aftermath. He was top alpha dog, and I wasn't going in that direction. I had made my point.

On that day, I learned a great deal about why men engage in violence. I had suddenly gained instantaneous respect amongst my Tarzan compound peers. Mr. Philadelphia moved out in a couple of weeks. His demeanor around me completely changed. He cowered upon sight of me, and I kind of enjoyed it.

"Now, we have someone to protect us," Jerry pandered, laying it on thick, flowed by a nauseating smile.

I just want to do my own thing, I thought to myself.

"What are you, some kind of a gnarly ass?" Kenneth grilled me soon

afterward, half-drunk with his head dropping from side to side. Then, managing to temporarily keep his head vertical, he added, "He was going to cut us in on the action." Kenneth grumbled, disheartened, as though he just missed his big chance in life.

Not long afterward we had a new surfer on board. It was like putting the right cream on a fungal infection.

Looking back, I realize those were very difficult years. No doubt I was frustrated. However, Mr. Philadelphia deserved the Sunday punch, and I had been more than willing to give him one. For the past two years I had slipped into an aggressive posture of physical fighting to resolve disputes. I loved the exciting feel of violence, the spontaneity of the fight, and the finality of its outcome. That attitude continued for the next eight years. I had my ribs, nose, and knuckles broken, my face scratched and bruised, was given facials by beer bottles, had my shirts torn off, broke my share of pool cues, had the cops called on me, and on certain occasions was forced to run for my life. My behavior didn't change until I beat up an art dealer for nonpayment, but that would happen eight years in the future.

FOOTSTEPS ON THE ROOF

IT WAS NOW the fall of 1977, and Jimmy Carter as president extended veterans' benefits for an additional year. That was the best gift I ever received, and I'd like to publicly thank Jimmy Carter for his humanity, insightfulness, and loving heart. I enrolled at the University of Hawaii and began officially taking classes in the art department. At the time I pretended I didn't care that I'd been rejected twice by the graduate department and set my goals on learning art expertise.

In need of more studio space I moved from the Tarzan compound into a beautifully lit, second-story Manoa apartment, which would become my power spot. I had gained momentum the whole time I was in Hawaii. Now I reached the magical apex. Everything lined up for me, and the world became my personal blowout sale. Door-buster items were ten cents on the dollar. The articles I desired—missing art technique and knowledge—were there for me on the shelves. Female companionship lined the end caps, some free for the asking, others two for the price of one. I filled my shopping cart with needed art knowledge and other long-desired items. When I checked out at the register my spirit began to soar. I suffered no buyer's remorse. I only wished that I had organized my shopping cart better so I could have gotten more items aboard. To help pay for my shopping cart of goodies I began a part-time job working for the university as a groundskeeper after classes. The main tool I used in that position was a bush knife, commonly known as a machete.

My goal upon entering the university was to gain skill by seeking out professors who could fill in the gaps of my art education, specifically drawing and sculpture. Two professors who helped me obtain missing proficiency were Richard Fooman in drawing and Frank Beavor in ceramics.

Richard Fooman, a tall, long-legged man with delicate hands who had studied at the Art Institute of Chicago, was a rigorous academic instructor, and he became the perfect drawing teacher for me. He was the right person at the right time. His figure drawing class was held in a naturally lit, second-story classroom. I came in the morning of the first working day of class. The model was holding a thirty-minute standing pose. Eighteen students stood behind their easels and worked diligently. Mr. Frooman began monitoring each student's progress, walking behind them to take in their drawings. We had been working from life for twenty minutes when Mr. Frooman appeared behind me.

"Yeah, that's it. You got it. Keep it up," he muttered in spontaneous approval. Mr. Frooman was a very talented artist. His paintings were prominently displayed on the cover of the Hawaiian telephone book. He was a no-nonsense art educator who knew what he was doing, knew where every student was in their development, knew what they didn't know, and in my case could effectively communicate how to improve my skillset. He helped me understand and apply the concepts of proportion, form, structure, direction, and light. With the application of those concepts I was able to draw the figure, but more importantly those concepts allowed me to sculpt life-sized hollow figures in clay. I began firing them in the art department's kilns.

Hawaii has a strong ceramics tradition owing to the huge Oriental population. The ceramics department was headed by a youngish and knowledgeable Frank Beaver. He was stocky and powerfully built, wore glasses, and sported a sizable red mustache. Frank taught me how to formulate clay bodies using additives such as coffee grounds, lava rock, and ground-up firebrick, which all provided a unique texture to my finished ceramic figures. Frank taught me the intricacies of the firing process and the technical way to fire a kiln. I was fascinated by the firing process. In notebooks I kept firing schedules, noting

the times when the physical water and then the chemical water were driven from the clay.

Watching the temperatures rise from zero to 2,000 degrees was mesmerizing. The first thing you see through the round spy hole is a cherry-red glowing circle. Four hours later it becomes a circle of orange translucent heat; fourteen hours after that it reaches the white-hot vibrating termination point. The process captivated me, and unfortunately evolved into my albatross, a bad artistic addiction. I became dependent upon the firing process and would not be able to free myself from its magnificent grasp for another ten years.

With my newly obtained knowledge and my beautiful clay studio, I was free from restraints and began an artistic ascension. My consciousness was in sync with the art molecules around me, and my spirit began to climb. Students and professors could hear my footsteps as I sprang across the rooftops of the university art department, taking off on my soaring artistic ascent. The sculptures I made during this period began my career in Honolulu and in several San Francisco art galleries.

There was a seamless coupling of my street skills and my academic skills. I loaded the fragile, bone-dry sculptures from my Manoa studio into the back of my Opel station wagon and drove them to the university's locked gate, which had to be passed to reach the art department kilns. The automated car gate required a pass to unlock. I waited until a car in front of me triggered the gate and then quickly followed it through. I breathed a sigh of relief as the gate slammed shut behind my car.

I was not the only streetwise adventurer on the streets of Honolulu. I had been following the antics of a pudgy, mixed-race, strikingly handsome, and shy teenager who would become the forty-fourth president of the United States: Barry Obama. Barry was a mall rat who hung out with his posse at the Ala Moana shopping center. You couldn't miss him. Early on, Barry appointed himself mayor of the mall. The mall functioned as his living room. I had met Barry's mother, Ann, who was smart, slender, and plain-looking and wore colorful flower dresses, at the university campus and had also chatted

with Barry and his crew at the mall, not knowing they were related. When I saw Barry and his mother together in the supermarket, I put it together and started talking. Barry was shy and naïve, and his mother considerate and knowledgeable. As we checked out at the cash register, I noticed they used food stamps, the same method of payment I used to purchase my foodstuffs. Food stamps were no big deal in Hawaii. Soon Barry's mother left Hawaii on an anthropological assignment to Indonesia, and occasionally returned to the Islands. Barry was being raised at that time by his grandparents and his extended family: the residents of Oahu. After Barry's teenage growth spurt, a transformation occurred. He became possibly the most overt human being ever to walk the face of the earth, requiring everybody's attention all the time.

I believe Barry was already practicing to be president, similar to other kids practicing to be a pitcher or a shortstop for the New York Yankees. Most of his preparation occurred at the mall. He instinctively understood there was power and protection in large crowds. Barry hung out at his favorite, centrally located bench next to the main double doors of the Ala Moana shopping center, where passengers from buses that came in from all over the island would disembark. From that vantage point, Barry continued to expand his posse and fan base. Barry exerted a covert "gumbah" style of leadership over his followers. He organized games of tag and brainstormed ways of getting into concerts without tickets. His posse at the mall was often seen running fervently amok through the mostly Oriental shoppers while playing a bizarre game of tag.

Barry ramped up his conspicuous, attention-getting teenage behavior by growing an Afro hairdo. I watched with reservations as Barry stood in front of the main double doors at the shopping mall and greeted people as they entered and chatted them up as they left, imitating the way Jimmy Carter "pressed the flesh" after one of his speeches. Barry would just stand and smile by those doors, patting people on the back, shaking hands, and greeting complete strangers, all the while gauging their reactions to his Afro. Like many other people on the island I befriended Barry early on, but eventually

found myself sidestepping him. To me his behavior was silly and out of place, particularly in an Orient-influenced culture. Even taking Obama's early age into consideration, you'd shake your head at his antics and say, "Who is this guy, and what's his trip?"

One day, my art mentor Richard Frooman pulled me aside and gave me advice. "Dan, you have to move to a larger art market if you want to sell artwork for a living."

With my GI bill running out and feeling as if I was now ready, I crated my best artwork and prepared to return to the mainland. The San Francisco Bay Area became my destination.

Each island had been a steppingstone, culminating in my last magical two years in the Manoa Valley. Although my technique was not totally worked out, I had found a direction for my figurative sculptures. My style had begun to emerge in the islands, but it'd be a long maturation process, demanding all my strength and many more years of labor, toil, and grinding before my final style would emerge.

And what about the Art Gods? Where were they? I believe they were curious at this point and taking notice. However, it's not their job to help you on technique. The Art Gods are a big tease. They turn the lights on in the all-encompassing art room and show you the art treasures, but they expect you to learn everything and make it to the other side of the room on your own. Once you do that, and pass through the gate meant for all accomplished artists, the Art Gods begin facilitating your career.

Upon leaving Hawaii I reset my art compass to San Francisco and began my voyage of discovery. Christopher Columbus had a better idea of his journey's outcome than I did of mine. So, riding on a raft constructed of ambition and dreams, held together with zeal, sparks, and idealism, I set sail on my artistic quest in unchartered waters. Above me colorful shorebirds flew in the direction of San Francisco, and I followed. The only life-sustaining provisions I had on board were my buoyant disposition and an unflappable belief in my capabilities.

DISORIENTATED IN THE FOG

IN THE FALL of 1978 I left the warm, nourishing arms of Hawaii and relocated to the cold, inhospitable factory area of West Berkeley. My lifestyle and fortunes changed with the new environment. Hidden in the incoming gray fog banks of Berkeley was a storm of madness and gruesome violence. News of an exiled San Francisco unhinged killer preacher, Jim Jones, found my ears as I searched for a studio in town. Then, I caught wind of the headline from Guyana: "Over 800 Temple Members Die in Mass Suicide." I should have taken that grisly calamity as a sign and said catch you later to the Bay Area.

No sooner had I settled into my Berkeley studio than another surreal tragedy visited that Baghdad by the bay. George Moscone, the presiding mayor of San Francisco, and Supervisor Harvey Milk were murdered in their offices in Civic Hall by an ex-cop city councilman who was reportedly high on Hostess Twinkies. It was a bizarre, ominous Bay Area greeting; however, nothing could have slowed down my zealous mission of discovery.

My aunts and uncles assisted my relocation to the Bay Area. Uncle Gerard tuned up an old family station wagon, and Aunt Rosie and Uncle Vic, schoolteachers, gave me a place to stay in the East Bay while I searched for a new studio. I found a small, dilapidated room above a garage in the gritty industrial section of West Berkeley a block from the paint factory, two blocks from the tidal bay lands, and four blocks from the world-famous Spenger's Fresh Fish Grotto, a

landmark, multiplexed restaurant where I could get a cup of coffee in the morning and use the restrooms.

My room above the storage garage hadn't been occupied for fifteen years. It took two days to clean it up, after which I broke out in a rash that lasted a week. I transformed the space into a rudimentary studio and awaited the arrival of my crated sculptures from Hawaii. Once they were back in my possession I decided to revisit Harcourt's Gallery on Powell Street, located in downtown San Francisco two blocks from Union Plaza and up a steep hill via a cable car line. The gallery director, Fred Banks, always an immaculately dressed man in his fifties with a stylized trimmed beard, had expressed interest in my work during an earlier visit, and I considered this to be the perfect opportunity to reconnect with him. In the morning I rode beneath the San Francisco Bay from Berkeley on the BART transit system, disembarked at the Powell Street station, and hiked up Powell Street toward the gallery, my updated eight-by-ten portfolio in hand. It was overcast and chilly. Cable cars rumbled past me, clanking, banging, and ringing their bells. In those days in advance of entering a gallery, I'd stop and do ten push-ups. It was all part of my messianic-like zeal to make it as a sculptor.

Harcourts Gallery was a mixture of international blue-chip artists, such as Miro, Zuniga, Hundertwasser, Picasso, and a sprinkling of local contemporary artists. The gallery was more accomplished and acclaimed than ninety percent of San Francisco galleries; however, it was not considered avant-garde like the Post Street Gallery, which represented San Francisco's famous figurative contemporary artists. Harcourts fit in fine with my goals, which were to do my own thing and support myself as an artist. In addition, they fully understood the prima donna demands of sculpture.

I entered and reintroduced myself to James, a gallery assistant. A red Van Dyke emphasized his narrow, long face. He wore a business suit and stood ramrod erect. "Hi, my name is Dan Corbin. I met Fred Banks a couple of months ago, and he said the next time I was in town I should stop by. Here are some photographs of my new work." I placed my portfolio on an immaculate black granite countertop,

opened it, and then spun it around so James could view my eight-by-ten, black-and-white, glossy photographs.

James studied the photographs a moment, then took my portfolio to Fred Banks' private office.

Fred owned the gallery, was the boss, and, as a person who understood artwork, made all the decisions. As Fred walked me to his private office past incredible sculptures I thought that I could fit into this place. The man ran a classy professional gallery; every piece was world-class and well presented. "Why don't you bring in a couple of sculptures for a trial run?" he encouraged after viewing my photographs.

On the designated day I loaded two of my best Hawaiian ceramic sculptures in the back of my '64 Ford station wagon, drove over the Bay Bridge, parked, and then dollied the sculptures into Harcourts Gallery. I used my landlord's telephone as a business phone. Three weeks later I received a call. They had sold both sculptures. My instructions were to bring in two more sculptures and pick up a check.

Sold sculptures

When the Art Gods are working for you it's that simple. One of their unpleasant chores is keeping money in the pockets of artists whom they favor. The Art Gods, as guardians of humanity, constantly watch out for artists who have discovered the universal art superglue that can bind together and unite society. When they're excited about an artist, they work behind the scenes. Art Gods are the divine managers of seemingly random connections. Those were the first sculptures I sold through commercial means (via an art dealer, agent, or gallery). Over the next thirty years I'd sell over 350 sculptures through gallery representation, yet I wouldn't come into my own as a sculptor for another decade. The Art Gods were giving me encouragement, even as they withheld endorsement.

I settled into my Berkeley studio and began making ceramic sculptures. Unfortunately, I drifted off course immediately and spent my energy in the wrong art direction. Berkeley was an unfriendly, daunting, and scary social environment, putting a cramp in my laid-back lifestyle. My studio was not warm enough and was too small, making it inadequate for models—who were expensive to

procure anyway. Soon, I gave up my strength working from live models and stopped making significant progress toward my ultimate contemporary figurative style. I chose a misguided course adjustment, attempting to compete as a ceramic artist in the highly competitive Bay Area ceramic market.

My career sputtered along for six more years. Much of my ceramic work found collectors; however, I was still years away from my mature figurative style. During this period, I was like a wasp, trapped inside a house, disoriented, and flying up against a glass window while trying to get to the other side. No matter how hard I worked, I couldn't find my way through the invisible barrier. In Hawaii two professors told me my technical problem point blank, but I could not hear or accept their advice.

Headstrong and not willing to give up ceramics I ran into the open arms of my nemesis by moving into a ceramic studio. There, I grew even more addicted to the firing process. The Bay Area was a hotbed of ceramic art, espoused by Stephen De Staebler, David Price, Richard Shaw, and Peter Voulkos. Once again I overestimated my abilities and got caught up in the competition, assuming that my raw talent would win the day. In hindsight, I now realize that talent isn't everything.

I used the kilns of the Front Yard Pottery, the quintessential cooperative studio artist complex, to fire my sculptures. The complex was called the Front Yard Pottery owing to the beautiful courtyard leading to the entryway. A garden of exotic shrubs and flowering bushes were enclosed in the courtyard and greeted people as they approached the front door. The two-story-high, red, majestic, industrial structure was a grandiose 1940s former tombstone factory, built from massive wood beams. The building was naturally divided into small workrooms and had a high ceiling. Natural light glowed through the many windows. It was a Berkeley landmark, one of the last holdovers from the hippie days, and the perfect building to resurrect as an artist's studio.

In the back of the complex, a large, outdoor, fenced-in area housed three ceramic kilns, along with a number of chickens who ran wild

in between five-foot-high, unruly licorice plants. Over time I became friendly with the artists and craftsmen in the complex.

Next door to the Front Yard Pottery on San Pablo Avenue, and sharing its huge parking lot, was the Pick and Pack Liquor Store. It was a mixed, rough, working-man section of town. Sundays were the horse racing days at Golden Gate Fields. The oval racetrack was only four blocks down from the pottery complex and planted next to the bay. Next to our studio, in a secluded corner of the parking lot, Afro-American men bet on the horses each Sunday afternoon. They would listen anxiously to the radio, drink, and hoot it up as the ponies strode to the finish line. The parking lot was nonstop free entertainment. It was as though *Divorce Court* and *The Jerry Springer Show* were live and acted out daily in the parking lot. Social fracases were constantly breaking out, and the large parking lot was well patrolled by the Berkeley police.

One of the affectionate names for Berkeley back in those days was "Berserk-ley." While driving around Berkeley on my way to the campus to use their photography facilities I'd see people and situations so far out of the ordinary that I'd just shake my head and mutter to myself "Berserk-ley." It was 1979, and Berkeley was still an attraction. Starting in the late 1960s the country was turned on its side and shaken really hard. Adventures, seekers, dreamers, kooks, runaways, and alterative types came tumbling out and landed in the outstretched, welcoming arms of the San Francisco Bay Area. For the outliers of society, Berkeley was still a top attraction on the exotic erotic tour. Included in my top ten vignettes of strange sights witnessed in that town is a wedding that took place on the medium strip of bustling Shattuck Avenue, a main boulevard running the length of Berkeley toward the university. It was a warm, sunlit afternoon, and in attendance, standing on that five-foot medium divider, were the bride in her beautiful white dress, the groom, the minister, maids of honor, and friends as four lanes of brisk city traffic zoomed by.

Harcourts Gallery continued to find collectors for my sculptures. Fred Banks decided my artwork would be perfect to help initiate the opening of his new gallery devoted to contemporary art, Harcourts

Contemporary Gallery, which stood across the street from the main gallery. We had a one-man show of my work in May 1980. Some work in the show was influenced by Stephen De Staebler and Deborah Butterfield, two prominent Bay Area artists who used nontraditional images and nontraditional materials. I felt good about the show. It offered a variety of drawings and heavily textured ceramic sculptures. Visitors and artists especially liked work influenced by primitive arts and anthropological artifacts.

Further good news soon arrived; I was selected for an artist profile in *Southwest Magazine*, a national art publication. We eventually sold five sculptures from the exhibition. You can't ask much more from an inaugural sculpture show of an unknown artist. I used the income to join the Front Yard Pottery Cooperative. I now had a studio next to the kilns.

There were officially eight co-op members and another unofficial dozen hangers-on. Doug Crawford became my closest friend at the pottery. He had long hair tied back in a ponytail with a full beard, was long and trim, and had an engaging smile that seemed to highlight his outgoing social personality. Doug was a potter who specialized in large ceramic vessels. He had two dogs named Zoie and Lather, which he dutifully hauled around in a Dodge van with me and whoever else wanted to go on a Doug adventure. Unique people passed through the doors of the pottery, and Doug kept in touch. Doug kept the social calendar, and his connections seemed endless.

One of the remarkable things about Berkeley during that era was its jumbling and intermingling of the social classes. One day we'd be roughing it, showering at the marina, and the next day we'd be enjoying a sauna courtesy of the manager of the Record Plant, a Sausalito recording studio with gold records hanging on the walls. Interesting stories were told about famous musicians who recorded at the studios. While we were taking a steaming sauna, a tale about Van Morrison stuck in my mind. Between his recording sessions for the album *The Philosopher's Stone*, Morrison drove around in circles in the parking lot trying to get his thoughts together before the next session. The next weekend Doug and I and two other friends attended

an informal dinner at an eminent nuclear scientist's house in Berkeley. The week after that we attended an Oakland A's baseball game.

My work sold in starts and stops, just enough to keep me going financially but not enough to make me comfortable. The Eugene Performing Arts Center in Oregon commissioned me to create a five-piece ceramic freeze for the interior of their new arts center. I picked up two agents, one from L.A. and another from Palm Springs. It was a gritty, tough, artist's existence. After years of being a potter Doug tired of the poverty-level lifestyle and moved to L.A. With his vast connections he landed a job as a set designer in the movie industry, a perfect fit for him. It was a big loss after Doug moved on, but I continued on my artistic quest. There was already a Lady Raku potter living at the corporative, sleeping in her studio. Meanwhile, I started living in the fenced-in backyard portion of the cooperative in a camper shell mounted on blocks. Does that sound familiar?

At times I felt like a modern-day Spartan art warrior, born and reared in a disciplined world with the single-minded purpose to be an art combatant and taught not to fear overwhelming odds. If you can't steal enough food to eat, cram your belly on happy hour bar snacks. Learn to make your bed from a bundle of wild tulles. Learn to love the unknown, being alone, and the darkness. You can't have a wife until you're thirty. Life is a contest of endurance, and giving up is the ultimate disgrace. Become an artist or die trying—that's the only way to fulfill your duty.

During the winter I witnessed an event in the liquor store parking lot that epitomized my hardest days in Berkeley. It was one o'clock on a foggy morning, and the streets were very quiet; no one was around. A cold breeze gusted in off the bay, scattering plastic bags around the parking lot. Fog silhouetted the street lamps of nearby San Pablo Avenue, and shimmering fog surrounded the high-security lights of our parking lot. That fog was so dense and heavy it seemed to drift by in waves near the ground.

I was firing a kiln and had recently turned up the volume of natural gas to the burners. I happened to look through the gate and saw something unusual in the liquor store parking lot. A homeless

man, scruffy and skinny, was walking along, pushing his small mobile home. It was a wooden box, constructed much like a coffin with a latched door on the top designed for easy access. Four bicycle wheels were ingeniously attached to the box, rendering it mobile. For security purposes he had fastened a fifteen-foot leash to his home, at one end of which was a medium-sized Doberman pinscher crossbreed with pointy ears. The man was taking in the cold, mysterious night much the way I was. A Berkeley police unit raced into the parking lot. The tortoise man quickly slid inside the coffin and sealed the hatch. Two policemen jumped out of their patrol unit with batons drawn. One of them began pounding his nightstick on the end of the coffin. The Doberman bared its teeth and lunged, jerking the wooden box five feet toward the retreating officer.

The second officer then banged at the other end of the wooden box and yelled, "Anybody home? Anybody in there?"

In response, the dog leapt at the second officer, jerking the coffin in an entirely different direction. After a couple more tries by each officer they tired of the game. Sadistically laughing and chuckling as though this was a nightly ritual, they jumped back into their unit and sped off into the night. The tortoise man triumphantly opened his hatch and stood up. Hysterically laughing and gesturing, he shouted, "Fuck you guys! You can't stop me! You can't get to me!" He then jumped to the ground and nonchalantly continued his stroll across the liquor store parking lot.

That event seemed to define the darkest hours of my artistic struggles, my seclusion, and my frustrations. I identified with the strange man's social isolation. That was the beginning of the '80s, and a new word had entered the American vocabulary: homelessness. The Reagan era had begun, and there were newfound freedoms and liberties for all citizens. If people wanted to live in boxes in the streets, they could now give it a shot. Little did I know at the time that I'd receive a similar rousting by police in the not-so-distant future.

Occasionally I'd visit Trevor Herd's glass studio, located four blocks from mine. Trevor was six feet tall with black hair and looked like a young Tom Cruise. He was talented, knowledgeable, animated,

hard-working, and zany. He also became my business mentor. He was full of himself; however, egotism to me was not an offensive character trait. Trevor could back up his talk with action. He was financially successful, making him a rare bird in the art industry. On one Berkeley afternoon Trevor was at his usual working position in front of the red-hot glory hole, making a glass art vase. There was a constant roar emanating from the three fired-up, hot glass furnaces. Trevor's shop was noticeably more elaborate and organized than my studio, a necessity due to the exact nature of the glass process.

There is an egotistical and self-centered competition among artists, a give-and-take that is simply part of the artistic turf. Most such one-upmanship is based on who is more successful financially; the rest is based on that contested immeasurable component: who the better artist is. I entered Trevor's studio and stood behind an invisible line. He glanced my way.

"Stopped by to see if you were still in business," I bantered.

He pulled the blowpipe out of the glory hole and began stylishly whirling it with a blob of red-hot glass stuck to the end. After a few twirls he casually plunged the blowpipe into the white-hot hole, then rotated the blowpipe with one hand as his head turned my way.

"I won't be if I don't get this order out," he bragged. "Twenty vases to Paris."

"You learn how to make the vase yet?" I countered.

Trevor pulled the blowpipe out of the glory hole, put his lips to the pipe, blew a large glass bubble, then returned the pipe to the hole and said, "I've been trying to tell you, repetition is where it's at. One right after the other. Just like layering. Multiply each one by three hundred dollars and you have something: layers. Layers of money." He ended his declaration with a long, curious, high laugh. He then ordered his assistant to take over the vase-making, picked up a towel, and wiped the sweat from his brow. "I have something for you," he added, waggling his index finger at me in a come-here style.

I crossed the nonvisible line into his personal studio space.

Trevor continued, "I'm throwing a party at my grandmother's

place." He handed me a formal party invitation. A large, intricate, gold ring was noticeable on the middle finger of his left hand.

"What's the occasion?" I asked.

"You don't need an occasion. Nothing else to do but have a party. Liven things up," Trevor said loudly, then belted out another madcap laugh. "This is an experiment," he explained. "My girlfriend is inviting her real estate friends, and I am inviting my art friends. This is going to be verrry interesting." Trevor tossed his sweat-dampened towel onto a table and nodded to his assistant, indicating he was ready to resume the glass blowing duties. With a loud-mouthed order to his assistant—"Use more finesse!"—Trevor indicated it was time for me to leave.

I admired Trevor. He was a one-of-a-kind character, a doer, an alternative success story to the idol-like art professors who dominated the Bay Area art scene.

A typical cold Berkeley evening found me in my clay studio dressed in warm clothing that consisted of a blue navy pea coat, clay-stained Levi's, work boots, and a watch cap pulled down tight over my head. Since I only shaved occasionally, two days of fungus on my face completed my winter wardrobe. I now occupied a large room with a cement floor and a twenty-five-foot-high ceiling, supported with massive wood columns that towered above me. The air was chilled. The room contained a maze of worktables covered with partly completed clay body parts cushioned on foam rubber mats. These sections would later be assembled into finished sculptures. Clay tools and bags of clay were scattered about. The whole scene was chaotic, cluttered, and seemingly disorganized, with plastic sheeting strewn everywhere.

In the corner of the room covered with plastic sheeting was my latest clay figure in progress, balanced on a sculpture stand that could be turned 360 degrees. Surrounding it was an assortment of clay tools and bags of clay. Stapled onto the wooden wall behind the project were drawings, art announcements, articles, photographs of sculptures, illustrations, and anything else that caught my visual fancy. Artists call it: the wall of fame.

The day's sculptural activities had ended, and now I had my feet propped up on a worktable while making a simple evening meal. The end of the table had been cleared off to make room for a makeshift kitchen. My cooking stove was a hot plate, on top of which was a pot full of six eggs boiling in water. Steam evaporated into the cool evening air.

The double doors leading into my studio swung open, and Ted Bauer entered the expanse of my large studio. "Greetings from the working class," he announced. Neatly tucked under his arm was a brown paper sack containing a six-pack of bottled Miller Lights. Quickly he freed a cold one and handed it to me.

Ted, a tall, well-built, balding man always seen in a stylish Panama hat, had served in Vietnam and was a man of many skills and life experiences. He taught art at a Florida college and had maintained a studio in the Florida Keys called the Sea Breeze prior to moving to California, where he currently works construction and remodeling jobs on houses, specializing in kitchens and decks. At that time he kept his hands in the arts by maintaining a small studio at the pottery complex. Ted came equipped with a dazzling smile. The sun shone through it, and it could cheer up any friend who had just received a non-deserved speeding ticket or worse. Ted had a natural gift with people and an aptitude and propensity for seeking out and finding extreme social situations. Later, Ted would become a master of the dawn patrol. He rented a room next to mine and showed up every other evening to work on his three-foot-tall porcelain ceramic pots.

Ted had split with his wife a month earlier and was a little down, off his usual enthusiastic self. He looked at the pot. "What's on the menu?" He pushed back his red-rimmed glasses and examined my boiling eggs. "I see you haven't received your check yet," he jested.

"I have to wait till Friday for it to clear," I revealed.

"Who sold them, Mr. L.A.?" Tom searched.

"No, Harcourts." I held back, not caring to give too much away. My nickname back then was the "Mystery Man." Later it became "Fort Knox."

"They sold two?" Ted questioned, still probing.

"Yeah. I haven't seen the money yet, but supposedly some guy liked the way they look together," I disclosed.

We continued chatting about different subjects. I asked him about how his separation was going and then remembered the party invitation from Trevor.

"Hey, I think I have just the ticket for the both of us." I pulled down the party invitation from the wall and handed it to Ted. "My glassblower friend Trevor is throwing a bash. He's inviting artists," I said.

The next weekend we rode in Ted's car to Trevor's party, located in the upscale community of Piedmont, deep in the Oakland Hills. We arrived at a white-column mansion in the midst of an extravagant party. Spilling out of the cartouche entryways where immaculately dressed guests with drinks in hand, engaging in polite conversation. We sat in Ted's customized pickup taking in the sights. I'd received my check and was decked out in new clothes.

"We're in a time warp," Ted said, breathing out the words, shaking his lowered head. "This is the great Gatsby's residence."

"Look at all those women," I remarked. "Not a guy in sight."

"Is this Trevor's place?" Ted asked, changing the subject.

"No, it's his grandmother's place," I replied.

"You can bet she's loaded. Well, let's go mingle," Ted said, listless. He opened the car door, and we joined the party. Chilled wine was served by bow-tied waiters, and hors d'oeuvres were lavishly displayed on linen-draped tables. A four-piece jazz band played, and a few couples danced. I was in a groovy mood. Ted tuned me up prior to our arrival. I was trying to find a dance partner and asked a well-dressed, fashionable socialite if she wanted to dance.

"I'd love to, but I'm looking for a friend," she responded, then turned and glided away.

Now was the ideal moment for me to try the hors d'oeuvres. As I was about to reach for one, I heard a female voice ask, "Wanta dance?"

Surprised but not missing a beat, I turned and answered, "I was looking for a friend, but sure."

I led Diane Gates to the dance floor. She had hazel eyes, highlighted

with eye shadow and light brown hair styled into a page boy bob. Diane was medium height, with distinct female curves and somewhat wide shoulders, which on this evening were accentuated by a padded-shouldered, stylish light gray business suit. Medium heels completed her wardrobe. As we were dancing I said, "Let me guess . . . you're part of the real estate crowd?"

"Sort of," Diane replied. "I'm an attorney. I have business associates here."

"I don't think I've ever danced with an attorney before. Feels good, though," I offered.

"I gather you don't sell commercial real estate," she surmised with a twinkle in her half-closed eyes.

"No, no. I sell a different kind of property," I told her.

"That being?" she asked.

"Spiritual property. Sculpture," I replied, dipping my shoulders with the jazz beat.

We didn't have a chance to taste the hors d'oeuvres that evening. It was love at first sight. Ten minutes later I was riding in her BMW to her Victorian house in the upscale neighborhood of Piedmont. We spent the night together.

A day later, back in the studio, Ted and I got together to discuss the previous evening. "Did she take you home?" Ted asked probingly.

"Yeah. It was only a few blocks away," I reluctantly revealed.

"You like her?" Ted inquired.

"I do, but I don't see how this is going to work."

"She's probably bored. Think of her as a groupie. Take her to an art opening," Ted suggested.

"That's a good idea, but I can't tell her I live here," I emphasized, looking around the studio.

"Tell her you live at my house," Ted offered.

On our first date I took Diane to my dealer's art opening in San Francisco. We drove in her BMW over the Bay Bridge. It was an evening art opening at Harcourts, featuring originals from Spanish artists, current and deceased. Diane and I entered the gallery just as the opening was gaining momentum. The space was already half-filled

with people talking and looking at artwork. We picked up two glasses of Spanish champagne from a stylishly dressed Asian waiter and began viewing the paintings. A man and woman, dressed in matching tuxedoes, played a Rodrigo flute and cello duet. We began following and listening to two knowledgeable, elegantly dressed socialites as they critiqued various artwork. The elderly ladies discussed an incomprehensible Picasso.

"The judicious indication of his work is divine," one of them said.

"Simply caudex energy," the other added.

We tailed the ladies as they worked their way to the corner of the gallery, where one of my sculptures was displayed. They began their critique.

The tallest and most slender aficionado of the two commented, "Archaeologically inspired with—"

The other lady completed her thought. "—with an anthropomorphic African representation and a realistic matrilineal enactment."

Embarrassed at what was to me absurd nonsense, I took Diane's arm and began retreating in another direction. "I can't listen to this," I whispered.

"But I wanted to listen," Diane said, playfully disappointed.

"Let's find something with a little more caudex energy," I said, looking around. "I can't introduce you to Picasso, but over there is the gallery director. The hard part is getting his attention."

"Fine," Diane said, ready for any circumstance.

I steered my date over to Fred Banks. When I caught the director's eye, I began. "Fred, I'd like to introduce you to a friend of mine. Diane Gates, this is Fred Banks, owner of the gallery."

Fred, looking very distinguished, said, "Pleasure to make your acquaintance. Are you enjoying the opening?"

"Very much so," Diane answered, then added, "I'd like to compliment you on your choice of champagne. Picasso being a Spaniard, it seems only most appropriate to follow that up with a Rodrigo concerto."

"Dan, you have discovered a cultured woman," Fred said, gazing at Diane. "You may have the ultimate challenge before you," he added, having some fun at my expense.

"With persistence and hard work, wonders can be accomplished," Diane said, picking up on Fred's lead.

"I wish you the best of luck. Please do enjoy the show. There is more upstairs," Fred said, moving on to other people who wanted his attention.

That little exchange between Diane and my art dealer showed just how lacking I was in business and social graces. Lawyers are quick on their feet. Art dealers, since they don't have to follow the law, are even faster on their feet. But I have the quickest feet of all when I'm delivering a right cross to the face of a fucked-up art dealer. It took four more years for me to get pissed off enough to punch one, but we'll work up to those events. Fred Banks, however, was a decent and innovative kind of art dealer. An agent of hope. He gave me a chance. I just didn't have the total package at the time.

Sorry, Fred. Thanks for giving me the opportunity.

Diane and I seemed perfectly matched and began an exciting relationship. We were from totally different backgrounds, yet had the same temperament and shared similar values and beliefs. We had met on a corridor that spanned the gap between two large provinces. I was an educated, streetwise art survivor, and she a cultured urbanite business professional. Diane was a graduate from Bolt, Berkeley's law school. I thought she was brilliant. I hadn't been in a loving relationship since Hawaii and was ready to come in from the cold. I was tired of being a one-dimensional art drone, renouncing all worldly pleasures and flying solo. I was attracted by her intelligence and liked her instincts.

As we all know, the lunch date is one of those compulsory social trials and public rituals in the beginning of a relationship. So, on our second date, we met for lunch at the swanky Chez Panisse in Berkeley, a restaurant that in later years would become a trendsetter for the California culinary scene, serving organic vegetables and free-range beef. Back then, however, it was pretending to be French. The pinnacle of East Bay society dined at Chez Panisse. Diane wanted a couple of her friends to see me; she also wanted to let her former attorney husband know that she was moving on. For me, the restaurant was

a mind-numbing bore. I've never understood why people stand in line twenty minutes at lunchtime just to be seen in a trendy hoity-toity restaurant offering sluggish service and expensive fair. In my opinion, the small portions of sweet breads and veal kidneys, sautéed with black mushrooms and served with a spicy brown wine sauce, were over-the-top pretentious, only to be matched by the boring clientele lounging around in the restaurant. However, I passed the social ritual because I was at ease in restaurants and understood their special dynamics. Dining out was a social convention I relished and, as a former waiter, a scene in which I felt empowered. I commanded this battlefield.

We hit it off, and our relationship continued to grow. It was as though we were destined to come together. Like analogous colors, we complemented and enriched each other. Diane was urbane, soft on the outside and tough on the inside. She adorned herself in angora, chiffon, silk, and business suits and knew about society from the top down. She was also curious, attractive, and quirky-conventional, an urbanite who knew the Bay Area, the culture, the people, and all the good restaurants. But her roots still recognized only one location: Oakland. Born and raised there, she knew the judges, the mayor, and the newscasters. Her father owned an Oakland drugstore. She had insights into the workings of power finance and politics. Her providence was her brilliant mind. Her humanity revealed compassion for the human spirit. Her vices were expensive perfume, chardonnay, and the occasional ride on the Peruvian snow train. Her dreaded antagonist was a genetic link to Huntington's chorea. Her older sister had already been sent to a care facility. Dianne didn't know then but in ten years, she would begin experiencing symptoms.

As Dianne's complement, I was hard on the outside and soft on the inside. I wore Pennington shirts, weather-beaten leather jackets, and Levi's. I knew humanity from the basement up based on hardscrabble knowledge. My life seemed to be founded on taking risks, playing without a safety net. Fire was my lust, travel and discovering the unknown my nucleus.

I familiarized her with the art world, and she exposed me to

cosmopolitan Bay Area culture. I shook hands with opera, the symphony, and traveling museum shows. In exchange, I familiarized her with the blues and jazz clubs in the heart of West Oakland's ghetto. We ventured into musical festivals at the Russian River, where I taught her how to swim. We visited archaeological museums in Mexico City and toured Mexican art studios in Tlaquepaque, Mexico.

One day I suggested we take a drive in the country.

"That's an intriguing idea we might be able to expand upon," Diane quipped, her face gleaming with the prospects of entertainment and adventure.

We began exploring the Napa wine country, where she familiarized me with all the varieties of California wine.

Soon after, Diane gave me keys and invited me to move in and share her spacious beautiful Victorian house. Our relationship blossomed. We liked dining out and explored restaurants all over the Bay Area. We ventured into the ethnic neighborhoods of Oakland and discovered hole-in-the-wall eateries that served authentic Thai and Vietnamese cuisine. Fresh spring rolls dipped in vinaigrette sauce stands out as one of my favorite appetizers, and who could forget the incredible heat generated by pho soup or other spicy Vietnamese foods on a cold, foggy Oakland night?

In San Francisco we once dined at Diane's old favorite: the House of Prime Rib. The restaurant's decor was a reminder of older San Francisco's ornamental wood interiors. The light from the afternoon sun reflected off the highly polished wooden floors and lit up columns of decorative arabesque woodwork. After being seated at a table and served a salad with a chilled fork, we waited for a unique silver bullet canister, pushed by a tuxedoed waiter and containing prime rib, to reach our table. The waiter worked his way around the large restaurant, winding around one table after the next. By the time he got to ours he was greeted by two ravenous appetites. The waiter slid the door of the three-foot-long canister open so we could choose our personal cuts. I was immediately attracted to the end cut of meat, which always seems to be well done. Our plates were set: a light covering of the natural juices over the meat, a serving of horseradish,

and for my pallet, a bottle of pinot noir to complete the meal. In terms of taste and ambiance, that casual dining experience was hard to top.

We began eating at Spengler's world-famous fresh fish grotto, not far from the Berkeley Marina or my first primitive Berkeley studio. In the old days I had a cup of coffee in the morning and used the restrooms during my daily constitution. The restaurant was divided up into four unique dining rooms. When we arrived, I requested the dining room with the view of the Bay Bridge. Diane and I ordered our favorite: baked crab. I chose a dish baked in a stainless steel container filled with large pieces of crab, smothered in butter and a touch of spices. To complete the dining experience, we ordered fresh sourdough bread and two chilled Anchor Steam beers.

Our favorite hangout was the Blackfish Restaurant, a hip underground diner tucked away in the Oakland Hills not far from Diane's Piedmont home that featured Cajun cuisine and live jazz acts. It was a cool, spontaneous scene where we met up with other couples. We were friendly with the owners and became acquainted with the musicians and followed their careers. The restaurant was a steppingstone for upwardly mobile jazz acts coming to the Bay Area. Ted and his new wife frequented the restaurant as well. Out of the pages of a fairy tale, Ted had met a stunning New Zealand lady, brought her to the Bay Area, and married her. The musicians loved Ted because of his unusual lifestyle and his ability to give direction to the coke-craving caravan. That was the middle of the Reagan era. A cultural free-for-all in epidemic proportions had infected the nation, and Ted was everybody's Bogota tour guide. Upon leaving the restaurant Diane would pick up the tab and I'd pay the tip. If I was selling artwork at the time, I'd carry more of the load; if not, Diane took care of things.

By that time, I had been in the Bay Area for six years and had laid the foundation of my understanding of the sculpture business. I had been in and out of six different galleries in the Bay Area and beyond. Sculptures have always been difficult to sell. A painting can be hung on a wall. Sculptures demand more space, a pedestal, and lighting to

be properly presented. One gallery dealer joked about the difficulties involved with selling sculptures.

"You know those infrequent funny little shaking sensations we have in California? Most people think those are earthquakes. Actually, the ground begins shaking when a gallery sells a sculpture," he deadpanned.

I hustled my tail off getting nationally reviewed and was in multiple shows, but I still only brought in enough money to sporadically hold up my end of the financial bargain with Diane. After three abundantly happy years our relationship began to drift. I loved her but was now unhappy with my life and the direction of our relationship. I didn't feel like I was contributing and was drifting and becoming swallowed up by her lifestyle. It was a romance started in a house filled with colorful balloons. Now, most of the passion had leaked from those balloons, and the last ones left were blown away by the winds of indifference. The diversity that made our relationship so interesting in the beginning was now pulling us apart. Our two worlds had been bridged by a delicate catwalk; now it was withdrawing. Diane retreated to her side, and me to mine.

My art career was lackluster, and my creative bubble had burst. I became more concerned with making money than making innovative art. To receive the Art God's blessing you have to give one hundred percent. I had chosen creature comforts with Diane, a conventional life, being kissed, having a phone, a car, and going out. I squandered time that should have been spent on my art on trivial pursuits. No new revelations came. No timely ideas. I stopped working on the weekends and was home every night by six o'clock, switching off my creative urges. I began putting on weight. My passion and enthusiasm for life waned. I'd walked over the thin, uneven section and was headed towards the transparent cusp, the place where if you stopped believing in yourself you ceased to exist, spiritually the point of no return.

After work one evening we were lounging on Diane's white leather couch watching a PBS special on the new man of the year: the computer. Off-white walls and light-colored wooden floors set off

the interior of Diane's spacious house. Natural light filled the open space during the day. A huge indoor weeping fig plant dominated one corner of the living room, and a large, arid marginata plant that would have looked at home in a desert occupied another. Next to the couch stood Diane's glass coffee table. Diane's Samoan housekeeper had recently tidied up the house, and the books and magazines on the table were well organized.

"Maybe find a part-time job," Diane suggested as she stroked her Siamese cat, who stood on her lap, gazing with sleepy affectionate eyes toward Dianne. "You'd be good at managing rental properties."

I listened and didn't say anything, but struggled silently with an internal wince. She is trying to change me, I thought.

"If you want mindless employment get a part-time job at a gas station," she continued, giving the cat a long stroke all the way down to the end of its tail.

I didn't care for her suggestions. It felt like applied pressure, screw tightening, and made me realize she didn't know who I really was. Just watch, I'll show her, I thought.

Diane had seen firsthand how difficult the art world could be. She wanted me to phase out art and find another means of support, a trade demanding less dedication and commitment, an occupation with rules, something that revolved more around her known world. If I compromised, she could be totally happy with me. In her mind it was the only sensible thing for me to do. She was absolutely right, but artist desires are not sensible and don't respond to rational thinking. During the height of communist rule in Russia, the Politburo dealt with unruly artists by declaring them mentally insane and incurable. The Russian leadership banished artists off to Siberian gulags to make them disappear. Diane was not trying to steal my art career; I had given it up willingly. She was a decent, good woman who had devoted herself to the wrong man.

The regrettable truth is that I haven't been able to enjoy a meaningful relationship without my art career losing ground. Being an artist is an exercise in egotism, narcissism, and selfishness. The old saying "The only ideal mistress an artist can have is art" is probably true.

In the meantime the Art Gods had withdrawn their support. They need bodies to carry the creative art flame. If you stop giving one hundred percent, the art flame jumps to another body. "He's wasting our time. He's pigheaded and can't listen. Besides, he's a fire worshiper. Now he's backsliding. The world will never know his name. Pull the plug on him. We have others," the Art Gods concluded.

I received a phone call from the Bank Street Gallery in Palo Alto. They had sold one of my sculptures and had a check waiting for me. Now things are starting to turn my way, I thought. It was just a little slump.

Art sales seem to come in waves, and I was due for an incoming set. My gallery dealer Randy Simmons was slim and balding, wore black rimmed glasses, and dressed in a business suit. He was a transplanted New York gallery owner. Randy figured if he could make a go of the gallery business in New York, he could make a killing in the culturally deprived backwaters of the West Coast. He did his homework and discovered that Palo Alto had the highest per-capita income of any area in California. He decided to open The Bank Street Gallery, appropriately named since it was located on Bank Street. Two of my larger sculptures were placed in his gallery on consignment.

Upon arriving at the gallery, Randy met me at the glass entry door with an inconsolable look on his face. He had a pen in his hand and pointed to the sculpture that I thought he'd sold. "The client returned the piece an hour ago. The sale fell through," he told me, manically flicking the end of a ballpoint pen while scraping the carpet with his shoe. It turned out that the collector's interior designer, determining that my sculpture did not mesh with her masterfully composed interior design, had overridden the buyer's choice of art. Something inside me began breaking up, similar to ice on the edge of a glacier gaining momentum prior to plunging into the ocean. I said something to the director to the effect that we had given it our best effort. I then pulled both sculptures from the gallery, loaded them into the back of my van, and headed back to the studio. Driving back over the Dumbarton Bridge, I looked out over the vastness of the San Francisco Bay and knew it was over. The vessel that had sustained me for six years split

apart, and my remaining provisions, mainly my once-buoyant spirit, fell beneath me and sank into the mud flats of the San Francisco Bay.

Into my wrecked spiritual condition stepped the money monster, the same boogeyman of my youth who had hid in the hedges and waited to pounce on me when I was a kid. Only now he'd evolved and transformed into a demon with money on its greedy mind. That monster now hounded me, trying to destroy me and take away my dignity and dreams. In a satirical voice, whenever I felt weakest, it would say, "Oh, too bad. You're out of money."

It invaded my body like a virus, or perhaps it had always been there, like a genetic weakness. Devoid of form or corporeal substance, it could transform itself into different states and move from location to location. It made its best effort when I was stricken with typhoid fever. "What happened to you?" it asked. "Money all gone, and you're sick too."

The boogeyman now kept up relentless pressure. The physical symptoms started in my stomach as uneasiness and then turned into a stone dripping stomach acid. Soon, the ailment worked its way into my mind by shutting down my social life and then impeding my sexual function. The boogeyman can shrink your bank account and your dick at the same time by saying, "Too bad. No money, no honey."

The boogeyman of money can ride into your psyche via something seemingly ordinary, such as a TV commercial. He spammed me with outrageous material goodies, distracting my focus and commitment. A new car advertisement would subtly infer, "You can entertain this wafer-thin lady if you buy this new car." All the while the boogeyman softly repeated, "No money, no honey."

That artist thing is a false god; principles are an illusion. Embrace security and the good life."

The monster whispered in my ear, "If your dreams are slipping away and becoming a mirage, that's a good thing. Go with it. Give in and join us. The collective is waiting for you. Your previous resistance is forgivable."

This was the final straw. My relationship with Diane had been deteriorating for months. I couldn't tolerate the excessive, urban,

pressurized lifestyle any longer. I was through and couldn't go on. I had to tell her. How do you tell someone you love something like that? I decided to meet her after work in a quiet, out-of-the-way restaurant, not in her house where we shared so many beautiful memories. I arrived first at the restaurant and selected a secluded table. She arrived dressed in designer jeans and a flashy teal blouse she knew I liked. Her eyes were beautifully made up. She was wearing a pleasant smile.

"How was the drive," she cheerfully greeted me. "Not that bad," I replied as the tall, mustached waiter pulled out her chair. Diane sat, unfolding her napkin. "The drivers behaving themselves, were they?" she joked, trying to set a congenial tone. "Most of them," I answered, thinking she believed I was here to deliver favorable news. I have to get this over with rapidly, I thought. The waiter passed out two menus. I caught the waiter's glance, saying, "We'll need a little extra time this evening to study the menu." The waiter replied "no problem" and walked away. My request must have alarmed Diane because when I met her eyes the demeanor of her face had transformed from jovial to apprehensive. Now is the time—get this over with, you jerk, I thought to myself.

I paused, fumbling for the right words. "Diane . . . I love you but I can't continue and I'm not capable of changing. I couldn't be a property manager. It's not me," I clumsily announced. Her face tensed as she absorbed the moment. "Don't throw it all away," she implored in a hushed voice. Her eyes filled with tears and her lips began trembling. She used the napkin to dry her eyes and then hid her face. In a few moments she pulled the napkin down and glared at me. "Can't you at least try?" she demanded, showing her teeth in a low, scornful murmur.

I felt a phantom dagger plunge deep into my guts. I tried to say something but no words came out. I was emotionally depleted. Hurt and betrayal flashed on Diane's face. She hid behind the napkin once again. In the following seconds, the waiter returned to our table and I waved him off with an aggressive hand signal. She finally pulled the napkin down once again, unveiling a completely different face. Her makeup was smeared but she had regained her composure. Diane

was now wearing her attorney's mask, purposeful and expressionless. "Well, I guess it's time to pack your possessions and give back the key," she coolly informed me. She placed the napkin on the table, got up from her chair, and decisively exited the restaurant.

Unglued and mentally distressed, I moved my belongings out of Diane's house and decided to completely change my life. I would adopt a monk's lifestyle, completely dedicated to art. I shut down the studio and moved into my van and vowed I'd stay clear of serious relationships. Not to worry, no woman's going to want a man living in a van anyway, the money monster predicated.

The big city gave me towering moments, showed me love, seduced me with its cultural possibilities, but it ultimately kicked my ass, slapping me around with financial tension, overcrowding, and stress. The goal of supporting myself as an artist remained a riddle I just couldn't figure out. I felt as if I was trying to play basketball on a tennis court. It just wasn't happening.

My midlife crisis hit. Not everybody is lucky enough to get one. Here are the typical actions taken during a midlife crisis: Throw everything away, cut all ties, start over in a completely new environment, and relive all your screwed-up life decisions over and over again. Instead of "midlife crisis," a better name might be "midway madness" or "halfway hysteria." My crisis seemed to coincide with my father's passing. He died of stomach cancer a year earlier at the age of seventy-two. His last requests to me preceding an operation he didn't survive were "a clean shave and a good night's sleep." He was a modest man who never overcame a bad break, was the way I saw it. My midlife crisis was real. I believe it hits dreamers the hardest, because unfulfilled dreams leave gaping holes in one's psyche.

GYPSY ART CRUSADER

I DEVISED A NEW plan of freedom. I'd store my best sculptures and sell them off to support myself. I would become an art devotee and live cheaply in Santa Barbara. So, with my VW van packed with a small assortment of art supplies, I once again returned to Santa Barbara in crisis. On my drive, I thought about how messed up my life had become. Old, twisted cassette tape that I saw strung in the weeds along the freeway seemed to have more structure and purpose than me. When I arrived in Santa Barbara there were only two possible outcomes to my reappearance. The third time is the charm, or three strikes and you're out. The wealthy, beautiful, art-loving enclave of Santa Barbara would decide my fate.

My van was also my home. The windows had been treated and were darkened for privacy. The recently rebuilt engine ran well. In the back were a permanent bed, sink, large side mirrors, and privacy curtains. The floor and walls were carpeted. The van was also neatly packed with art supplies, oil paints, canvases, charcoals, pastels, and drawing boards. Tucked away under the bed were two of my best sculptures, destined for L.A. galleries. The customized space became my sleeping quarters for the next two years. Compared to the street life in the Bay Area, the streets of Santa Barbara were similar to a getaway vacation spot.

It was still the Reagan era, and the problem of homelessness had hit Santa Barbara hard. Merging with the mental patients on the streets was an indigent population from across the country, seeking

warm weather. I joined their ranks. Officially, I never thought of myself as homeless, because I rented a private garage in an apartment complex that served as my art studio. The small garage had a mail drop. Therefore, I had an address. FedEx could find me, and if they did, I had a box filled with mishap and misery waiting that they could return to sender. If they took two of those packages, I had another box labeled "The struggle makes it special" that they could have as well.

At that period in my life I was such an accomplished street survivor that you could have ejected me out of the clouds into any U.S. city with two hundred dollars in my pocket, and two weeks later I would be making artwork. I never thought of myself as a street person, just an artist.

I reconnected with Megan. She looked amazingly youthful and was still full of feisty progressive attitude. Megan now taught court reporting, continued to work on her paintings, and now was dating a much younger man. We started out just as friends.

She informed me about inexpensive living situations and job opportunities. I didn't want a job or even consider entering another relationship at the time. Either I had to make art or be with a woman; I couldn't do both. My quest now was to discover the missing password that would unlock the box containing my artistic success.

UCSB and the community of Isla Vista become my home base once again. I was familiar with the gym and used the campus facilities for swimming and showering. My old professors allowed me to sit in on informal figure drawing sessions. Santa Barbara City College offered classes in metal casting, and I began casting life-sized segments of the human form in aluminum.

During the evenings I would return to UCSB and study their extensive library system, though I focused mostly on their contemporary catalog collections. It was dedicated to catalogs of artists' shows. It was a good way to see what other current artists from around the world were doing. A strange coincidence occurred when I first entered that remote section of the graduate art library. An old girlfriend, Brigitte, happened to now be an assistant librarian. We'd first met ten years earlier when I was still recovering from typhoid.

She had brown curly hair, big dark lips, and sensuous curves, and was only twenty back then—a Magic Mountain, pixieland, Southern California goddess of naiveté and sexual confusion. We met while nude sunbathing at a campus swimming pool. We enjoyed a brief liaison over that summer. She now had the look of an attractive bureaucrat, wearing reading glasses while sitting behind her official-looking desk at the entrance to the library. Reminiscing and friendly, she revealed, "I was really young and naive then." I guess so were my thoughts. The Crisco kid with all of my tricks couldn't entice that chilly fish to warmer waters. I should have driven my van over to her place that night and turned her into my sex slave. But I wasn't having anything to do with intellectual, art ladies. If anything I had my sights set on another go-round with Megan.

In need of income, I began spreading my remaining sculptures around the Southern California galleries. Choosing half a dozen of my better ceramic sculptures, I drove them to Santa Barbara and stored them in my painting studio. I began scouting out new territories in the L.A. gallery scene, mostly around Beverly Boulevard. During scouting trips to L.A. I would obtain addresses and explore a gallery zone. Finally, wearing my best clothes, I loaded two sculptures in the back of my van and left early for Los Angeles. I parked in the designated gallery district and then started cold-calling art galleries with the intent of placing two sculptures on consignment before I returned to Santa Barbara. I found two galleries that were able to sell my remaining sculptures, and a Japanese man who owned a painting gallery showed my newest paintings. In the city of Santa Barbara I secured two galleries, which agreed to show my ceramic sculptures and my newly minted aluminum sculptures.

The first year in Santa Barbara was fun and full of adventure. I started hanging out with Megan again. Because of her younger boyfriend, I was having a hard time getting any attention, living out of my van and all. Sometimes I visited Megan at her quaint cottage. One day I waited in the cottage while she was out running errands. Her phone rang and I answered it. It was her young boyfriend. Dazed and confused he asked if Megan was there. "No, she's not here I

thought you might want to know, there's a new mule kicking in your stall," I informed in my combative voice. He hung up. Megan, upon hearing about the incident, asked me if I had really said that. She then scolded me about proper social etiquette.

I believe her fantasy was to have us be friends, but that was never going to happen. Megan and I rekindled the relationship, spent time together, and made plans to revisit Mexico. I'd met her father Lyle years earlier, liked him, and suggested we bring him along. Lyle a big man with thoughtful blue eyes, thought it was a great idea and suggested we tow his fourteen-foot boat and fish in the Sea of Cortez. It was an interesting adventure. We eventually ended up halfway down Baja on the Sea of Cortez side in a small town called Bahia de Los Angeles. The most memorable thing for me was how quiet the desert was. Absolutely no worldly noise, just God's eternal pulse.

The landscape was dry and barren. Only a few scrub bushes grew on the sandy, windswept soil. Every now and then a lizard scurried to a hiding place on the lifeless land. But once I put on a snorkel mask and swam beneath the surface of the Sea of Cortez, a world teeming with feisty sea life spread out before me.

That part of Mexico was sparsely populated, and we survived by camping out, eating fish, and making dusty trips into the local cantina to buy beer and supplies. A mile up the coast Megan and I discovered an isolated remote beach covered with brown sand. From a distance the sand seemed to be dotted with hundreds of white objects. When we reached the beach we saw that the white objects were actually bleached, four-inch-long bird skulls, half-buried in the wet sand. It was the final resting place of these adventurous seabirds. Likewise, the sandy beaches of Baja were the last place where my romance with Megan really blazed before dying out.

Back in Santa Barbara on a typical day I still woke up early in the morning, maintaining my sanity by sticking to a well-ordered routine. The van was parked in the university community of Isla Vista in an isolated area, close to trees and next to the ocean. As soon as I got up I dressed and ate a bowl of granola. Then, I would peek past the curtains at the rearview mirrors to see if any students or pedestrians

were coming. With great stealth I would jump from the sleeping area through the curtains and into the driver's compartment, grab my backpack, exit the van, and join up with students walking to campus. At the university gym I'd go for a swim, get some exercise, use the showers, and then return to the van and drive two miles to my garage studio, located in an out-of-the-way space in a housing complex. To get the maximum amount of ventilation and privacy, I would prop the garage door half open. The paintings I completed during this period were done in oils, some heavily textured. The standing human figure was my motif. My daily routine required discretion, stealth, canniness, wily survival traits, and other characteristics I had long ago mastered.

I would paint in the morning for two to four hours, then jump in my van and drive to Santa Barbara City College for an afternoon metal casting class, where I learned all phases of the lost wax process. In the evening I would drive back to UCSB and park next to the ocean on Del Playa Road. Locking my van, I would then stride into the Isla Vista business area, pick up half a baked chicken with beans and a bottle of beer, and then walk along the ocean until I found a comfortable spot to have dinner. Afterward I would hike to the library catalog section, where I would grab some catalogues, peruse them for an hour or two, and then return to the van. When I was sure no one was looking, I would slip into the back through the privacy curtains. Sometimes I would park along a natural sea sanctuary, open up the vents so the sea breeze would flow in, and let the songs of the mockingbirds put me to sleep.

How I could have carried on this routine for two years is unbelievable to me at this point in my life. At the end of the second year my unattainable quest began wearing me down. I was reaching the limits of my endurance and still couldn't find the answer. Endless digits of pi were spewing out in my life, with no solution in sight. I hadn't made any large discoveries or developments. Like a mud-covered Brazilian gold miner prospecting in a four-by-four foot hole in the Amazon, I just kept digging down deeper into my hole day after day. I didn't want to give up. After all, tomorrow might be the

day I would uncover the gold that would make me rich forever. If I surrendered now, all the work would be lost. I didn't realize that there was a bigger chance of me winning the hearts and minds of the Afghanistan people than there was of me discovering my artistic way at this time and place.

It was Memorial Day weekend and the campus gym was closed. I needed a shave and broke my own rules. Finding an out-of-the-way bathroom on campus, I grabbed a quick shave, then began walking out the bathroom just as a campus policeman, a middle-aged Afro-American in a blue rent-a-cop uniform, entered the restroom. He must have been following me. He eyed me from top to bottom as I exited. I'd used a new, sharp, plastic throw-away razor and in my haste had nicked myself. A tiny pool of blood had appeared on my face.

"Are you a student?" he asked, impeding my path.

"Yes," I told him.

He took out a notebook. "Let me see your student ID."

I opened my wallet and handed him my old ID from when I was a college student in the early '70s.

"This ID is over ten years old," he said with a strange look on his face.

"I'm bringing myself up to date on a couple of subjects," I informed him.

"Why don't you tell me what you were really doing in here?" he asked.

A strange, primal sensation, born from humiliation and anger, shot through my body. "I think you know what I was doing in here," I taunted.

"The restrooms are reserved for students and for sanctioned activities," he informed, writing my name in his book. "I'm putting you on the list."

"On a list. That's a good idea. Make sure I don't miss the next upcoming alumni bulletin," I ridiculed, sliding past him.

My self-imposed art exile of living on the borders was beginning to affect me. A blur of social anxiety enveloped me. It felt like anti-art agents from homeland security were using stop-and-harass tactics

to drive me away. The last thing I wanted was to appear on Santa Barbara's police radar. The police department's standard practice was to keep the homeless on the move, give them no rest, and drive them out of town.

Late one night I was trying to put the head on a nearly finished clay sculpture, but it kept falling off. I was working in a dilapidated old building, which served as my makeshift studio. It was a tightly enclosed space. The outside walls began closing in on me. Suddenly, I saw people milling around outside my studio trying to get in. I heard one of them say: "We know you're in there." They couldn't leave me alone. They were bugging me, and I was never going to be able to complete the sculpture. That's when the building suddenly began rocking and then caught fire. The people outside yelled, "Fire! Fire!"

Suddenly I awoke from the dream and became aware that it was nighttime, that I was sleeping in my van, and that it was now rocking. I heard a male voice yell, "Fire! Fire!" I looked through a crack between the darkened windows and saw a uniformed police officer jump off my back bumper. The van rocked one last time, and two laughing Santa Barbara police officers hopped into a police unit and drove off into the night.

A realization arrived in the morning. I was done and couldn't carry on another day. I could live without creature comforts, but I could not live without my dignity. My honor and pride were damaged; I no longer felt like a full citizen. My immune system stopped working, and I lost all fortitude. A cardboard box sloshing around in the Santa Barbara Channel had more rigidity than me at that point. My youth was gone. I had given it everything.

I was to blame, the one who made the choice to compromise his life. I had become an anonymous art warrior, living an outcast existence with a dead-end cause. An art poet of the impossible, I believed in myself beyond all reason. Was the seventh strand of my DNA twice the normal size—is that what compelled me to create? Why was I so completely obsessed with sculpture? And why such an esoteric art form, which held so little curiosity for the vast majority of people? Why not something like the movies, pop culture, or music? I would

have at least stood a chance in one of those categories. It seemed the biggest appreciation for sculpture for the masses was as a movie prop, something to be run over in a comedy car chase. But for my dumb ass, sculpture had become a life quest.

The ironic thing was that I was almost there. That was when the boogeyman stepped in and pushed my head down into the mud. "Not yet," he said.

Since returning to Santa Barbara I had engaged in an even more fanatical effort to succeed. I'd become a Gypsy roller-bed art crusader, living in a van and enduring a Franciscan monk's life of self-sacrifice on a pilgrimage of art irrelevance, which I performed with diligence and purpose. Adjust. Compromise. Try something that's more manageable. Try painting, learn color, and keep pushing the boundaries of sculpture. Study, analyze, and examine what notable contemporary artists have done. Keep pressing forward for that one little piece of information that is absent. Fill notebooks with ideas, experiment with new materials. Draw, draw, draw, and then draw some more. When you can't take it anymore, stop believing in yourself, and can't swim another stroke against the social riptide, you give up and quietly drift out into the vast, serene ocean.

The Art Gods, watching, indifferent and detached, said: "He had promise but he doesn't have it. He's wasting our time. Let's move on to others."

If I could have spoken directly to the Art Gods I would have asked: "What is it, and how do I find it?"

The Art Gods' mysterious answer would have likely been, "You have to find it within yourself."

"Where in the fuck is it?" I would have demanded in total frustration.

"It's right in front of you, but you can't see it. You've been told several times, but you won't listen," I imagine the Art Gods would have chided.

"Please tell me one more time . . . or is this a sick, incomprehensible joke? Is this what an enigma is? How about I buy an "F" and just

say fuck it, or better yet, find me Prometheus and we'll set your little chariots on fire."

A more appropriate title for this memoir could have been: *Curse of the Art Gods*. The Art Gods had no sympathy for my problems. Their duty is the service of man. Peaceful social evolution and holding humanity together is their mission. They realize culture resides inside the human psyche and are looking for artists who can tap into that reservoir and make it visible to other humans. They send out the clarion call, which only a limited number of souls receive. Of those, only a few act on the message, and fewer still are willing to throw their lives away chasing the illusive, unattainable art dream. Scarcer still are the few who endure the brutal rigors of the art gauntlet, put it all together, and become competent artists. At that point I was not ready. I could access my own spirituality, but could not express it in the material form of art.

My exempt status as an artist in Santa Barbara had expired. That day, I came to the realization that I was just another street person who thought he was unique, when in actuality I only existed as a ghost, lost in an empty chamber and submerged beneath the sidewalks of Santa Barbara. The beautiful city had been good to me, but I had overstayed my welcome. My shield, my cloak, my coat of fairy dust that had made me invisible blew away with the sea breezes. Everybody could see me now. I was thrown in with the indigent and vagrant population of Santa Barbara and was no longer considered an innovative artist who needed time to develop. The money monster was on my trail again and would soon track me down. I had not found the art answer and was an alienated, depleted copy of my former self. My midlife crisis was drawing to an end, and it was time for a change. I was kaput, spent. My will to continue was sapped. I called Megan and told her I was leaving Santa Barbara. She suggested options but none were to my liking. We were only friends and I had enough of my street lifestyle. I locked up my studio and left Santa Barbara.

Getting a job was the only way out. Mike, my old high school friend, landed me a truck driving job for the harvest season in

Northern California. My artistic fate could now be found in the deleted folder. For the next six months I drove a bobtail truck hauling fruit out of orchards, saving money, and contemplating my life. In some ways I enjoyed the undemanding twelve-hour days of driving a truck. It didn't allow me time to think about the dismal fiasco my life had become. There was nothing for me to gain artistically from the driving sabbatical—quite the opposite. The time away from creating art broke all the momentum I had acquired over the ten-year period I had survived as an artist. Painting and drawing were impaired the most, because two-dimensional skills are cerebral and abstract. Such cognitive abilities seem to deteriorate quickly without practice. Sculpture activity is more procedural, and you seem to retain the three-dimensional skills needed during a layoff.

Sunday was my day off, and I'd draw a self-portrait of myself with a ballpoint pen. Looking at those drawings today, to me they psychologically depict a man made of cracked crystal standing edgewise on a plate of glass, someone who was fragile, undone, and a missed step away from completely shattering.

Withdrawing into myself, I fortified my inner fortress further by installing a Norton firewall and an encrypted shield. I made sure all the back doors were locked so nobody could get in. I became a one-way street of information, gave nothing away, and wore more body armor that a Humvee in Syria. I wasn't interested in distributing back issues of my unsuccessful adventures or sharing my story, which had become a twisted tale of the American dream. It was as though I was living a modern-day Greek tragedy—just without all the incest and killing. I was the one to blame; all the decisions had been mine. During this working sabbatical from art, I began cultivating an unhealthy revenge mentality, aimed at all my perceived antagonists and adversaries: gallery directors, academics, and Reagan politics.

The Naumas orchards crew was composed of ten white guys in charge of driving the trucks, forklifts, tractors, and shakers. Two Mexican American foremen supervised a crew of thirty

Mexican nationals who picked the fruit. Some of the white guys were professional farmworkers. Others, like me, were just trying to get back on their feet. We knew we were expendable. The fever of the harvest was the only unifying quality we shared. Some people gained nicknames. Mine was "Hollywood," for I never took off my pair of cheap sunglasses and had a flair regarding the way I used a four-foot steel bar to winch down a load of fruit. I winched the way the military presents arms: honor guard flamboyant style.

One of my jobs there was to drive sixty miles and pick up a load of new pallets in the city of Chico, a Northern California college town. Chico intrigued me due to its rural beauty, commitment to trees, and large, beautiful municipal park. The following Sunday, on my day off, I returned in my van and checked out the campus. Lassen State University was an older campus with ivy-decorated brick buildings and a creek that ran through it. The university maintained a liberal arts program and offered a small art department.

Bidwell Park

I hadn't lived in the valley for twenty years. The city of Chico wasn't as exotic as some of the places I had become accustomed to. It wasn't the foreign countries on the Mediterranean, or the paradise of Hawaii, or a Southern California beach town, or even a cultivated urban environment. However, Chico struck me as a little oasis of culture in a vast rural setting. A plan began to formulate in my brain. Maybe I could rid myself of the bogeyman, gain access to models, and do a little art in this sleepy, backwater college town.

I drove a truck through the entire harvest season starting in June and ending in October. We harvested pears, apples, persimmons, peaches, and prunes. The last days of October finally arrived, and the orchards had become eerily quiet after giving their fruit. The rushed haste and urgency of the harvest had been replaced by a tranquil Indian summer. Spent green leaves had changed color, fallen to the ground, and become covered with dust. The hushed stillness was occasionally pierced by the high-pitched squeal of flickers announcing their arrival from Canada as they settled in to their winter homes. Those flickers

signaled the end of my truck-driving days. I received my green layoff slip the next week. The job was a nostalgic experience, giving me time to decompress and digest the past twenty years of my life. However, as far as my art career went, I was still stuck and trapped in a fervid dream, living the same day over and over again, gazing into space and waiting for the computer to reboot.

UNDER THE CANOPY OF LIES GROWS RAGE

NOW THAT I had some free time, my first order of business was to drive to San Francisco and check up on two galleries that represented my work. I drove over the Golden Gate Bridge on that magnificent fall day to check up on the Aaron Watts Gallery. Aaron was a thick man with a large head. His hazel eyes glowed with the same indifference and intensity of large jungle cats, as though he was looking through you. Some galleries are shady, won't pay you after selling an artwork, and will hold onto the money as long as possible. Aaron Watts was like that. The man held onto a hundred-dollar bill so tightly that Ben Franklin choked and gasped for air, changed color from green to blue, and then let out a scream before passing out in his fist.

Aaron was in the category of dealers I didn't trust. The only way to find out the status of your artwork for certain was to physically walk into the gallery and see if the artwork was present. I gave him two pieces. He sold one and was evasive about the whereabouts and status of my second piece. Aaron received two thousand dollars for the piece he sold and owed me one thousand for my share. He kept putting off the payment month after month until finally giving me five hundred dollars, half of what I was due for the sculpture. The next month he paid me 250 dollars. The following month he paid me 125. A month afterward he paid me sixty-seven dollars, then thirty-three

dollars and fifty cents, then seventeen dollars and seventy-five cents. Finally, he paid off the remainder. That was an insight into Aaron's underappreciated creative genius.

On the day I arrived at the Aaron Watts Gallery, I wore my truck-driving glasses—my shield and constant companion of indifference. I was fed up with Aaron's hipster bullshit and abusive character and wanted my missing sculpture or a check. His gallery was located on Bush Street, three blocks west of Union Square in downtown San Francisco. The sun was poking through the fog, and the sidewalks were full of pedestrians. A one-way street containing three lanes of frenzied traffic zoomed by his gallery. Upon entering the establishment I scanned the area for my white figurative sculpture. It wasn't there. What I did see was a mix of surreal images and oddities. He seemed to have lost his artistic direction.

I really don't know what Aaron's motivations were. I surmise his rationale and thoughts went something like this: Aaron, whose office is above his gallery and offers a commanding overall view of the medium-sized gallery below, sees me enter his gallery and thinks, "There's Corbin. He won't go away. I'm not giving him money today. I'll give him the Aaron Watts' treatment. Maybe use his car for an art delivery. If he gets difficult I'll take him up the ladder to the four states of Aaron Watts. State number one: blow him off; I'm too busy. State number two: evasive bullshit. State number three: heavy-handed persuasion—threaten to drop him as an artist. State number four: go nuclear in his face.

Not locating my sculpture and seeing Aaron upstairs, I held onto the staircase railing, looked up at him, and said, "Hi Aaron. Just came by to pick up my piece."

"Not today. I'm on a deadline. See this?" Aaron held up a piece of paper and continued, "It's for a 45,000-dollar commission. At the rate I'm working with you it will be another forty years before you and I get there." Changing the subject, he continued, "What's with the inane sunglasses? You find them at a rodeo truck stop? Corbin, you're going to have to dress a little better. You're going to have to pick up the show if we're going to get anywhere." In rapid-fire fashion he added, "Did

you bring your car today? I have to make a delivery in Mill Valley. Where's it parked?"

"I'm not here to deliver artwork. I'm here to pick up the piece or a check," I clarified, and began walking up the wooden staircase toward the upstairs office.

"Don't come up here. It's off-limits," he ordered with a steely stare.

"I didn't see my piece downstairs. I wanted to see if it's up here," I said, still ascending.

Arriving at his upstairs personal office, I glanced around, checking for my large white sculpture. It wasn't there. The office was well lit by a bank of windows that provided natural lighting. Placed on top of a polished natural wood table was the first tabletop computer I'd ever seen in use. I glanced at it and thought to myself, I'm going to throw this over the counter and onto the gallery floor. The cables might be a problem, I thought. "I don't see my piece. Where is it? Did you sell it?" I asked.

At that point Aaron was probably thinking to himself, You don't want to take me there, you dumb fucking yokel. My shit was trained in New York. "Get the fuck out of my gallery," Aaron shouted in a commanding voice. "I'm working on a 75,000-dollar commission for an artist who has his shit together. For your dumb ass, I gave you a shot. You don't have it. What's with the idiotic glasses? Hokey shit doesn't make it in the city. I worked my ass off for you and every other screwball artist. Do you know how many artists I have? Twenty-five. You know how hard it is to sell your fucking work or anybody else's? You think I have time for you?"

Aaron was red in the face by then and had worked himself into quite a lather. His category-five threat display was twirling on its axis and he had slung flaming onions in all directions. His blood vessels were bulging, and spit was coming out of both sides of his mouth. I just let him keep building monuments to his arrogance. It was a pretty impressive performance and would scare the crap out of anybody who hadn't seen it. What Aaron didn't know was that I'd seen his crazy act before. A couple of years earlier I had tiptoed by his old gallery and kept out of sight as he was throwing a similar tirade prompted

by an artist who had wanted to know what happened to his missing prints.

I let Aaron go on for another three minutes. As he continued, I could sense the gunk and mucus oozing from his soul. When he finally started slowing down, I interrupted his rant and said, "You sold my sculpture, and you don't want to pay me."

All of a sudden he was speechless.

I made a move toward his computer. The next thing I knew he had dropped me to the floor and held me in a powerful headlock. This is the kind of shit I'm good at, a voice in my head said. My warrior friends, the Slavic subhuman and the Viking warrior, coolly arrived to join the fight. From my lowly position on the floor I slowly and gently worked my hand onto the top of his right hand, then slid my head forward toward his hand. Simultaneously I froze his right hand by squeezing his fingers, opened my mouth, and with my front teeth ripped and pulled the skin off the top of his hand; it was rather similar to peeling back the skin of an orange. I spit out his skin. He let go, and I swung his hand out, jumped to my feet, and punched him in the mouth. I put more charge into the next punch, and he bounced off a wall, which kept him erect. I started throwing medium-strength punches into his head region. I was hot-wired. The punches flowed through me, their energy absorbing into Aaron's body. I threw a right hand, and his head jolted left after the impact. I threw a left hand, and his head jerked right. I didn't want to kill him, just beat him up. He stood there and took the punishment as though he liked it. Aaron could have run, but his arrogant compunction dictated he undergo the pounding. Blood was dripping from his mouth, and he began blowing red bubbles. I decided it was time to leave and landed precise punches to both eye sockets.

I descended the stairs, exited the gallery, and started striding briskly around pedestrians down the street, heading toward my parked car. I turned around and to my surprise saw Aaron running after me. Blood was trickling out of his mouth and down his neck.

That really pissed me off. Now I wanted to fuck him up and smash his teeth out, sending them bouncing across the sidewalk. I spun

around and ran after him. He changed his mind and fled back into the gallery. I turned around and continued striding toward my parked van. He came out of the gallery once again and in a frantic rant started urging pedestrians and shop owners to call the cops. He tried once again to chase me. He was hysterically agitated, a ghastly sight. Blood was smeared over his mouth, and now a flow of blood was dripping from his soaked hand. He pursued me for two blocks, ranting and raving, still pleading with everyone on the street to call the cops. He slowed down, and his arms swung at his sides high in the air, like a child throwing a temper tantrum. Finally, totally crazed, he gave up the chase.

I jumped in my van, drove out of the city, and went camping for a couple of days. He had scratched my face with his fingernails, and I needed time to heal. I waited three days and called him up from a pay phone. "Aaron, I'm coming to town, and I'm going to sue you." I may have pushed it a bit too far with the phone call.

Two days later Robert, my defense lawyer/brother, talked to me on the phone. He said that the police had been trying to find me for questioning and asked me what had happened.

"One of my dealers wouldn't pay me, so I beat him up," I explained.

"How bad?" he asked.

"I blacked his eyes and split his lip," I told him, leaving out the part about biting the sleazy bastard.

"Danny, you have to find another way to resolve these things. This is not the way to do it," he said, then added, "You're probably okay. San Francisco is a large city, and a black eye and a split lip wouldn't be a high priority in a large police department's workload. Besides, the cops probably figured out what happened after they questioned the guy for a little while."

That was the end of the incident, but I was forever changed. I never again resolved disputes with frontier justice. Somewhere in my mind I thought if I kicked the guy's ass for not paying me it'd change the way galleries treated me. My frustration was unmanageable. Maybe I needed somebody to beat up. I was reckless and experiencing more symptoms and side effects than someone who had taken a recently

introduced antidepressant drug. I suffered from aggression, anxiety, anger, antagonism, and feelings of isolation and persecution. Plus, I felt like my act of vengeance had been a wasted effort.

To this day I keep thinking about how important the smallest amount of money was to me back then. The income from the sale might have sustained me, buoyed me, kept me going. That was just one in a long list of grievances I had over the years regarding dishonest gallery dealers. The difficulties continually revolved around money. Not getting paid for a sale and the loss of inventory were the most aggravating.

This is a good time in the memoir to explore the relationship between artists and galleries. I've had mutually beneficial relationships with dealers who were honest, paid on time, became my friend, and helped facilitate my career. Some were agents of hope who taught me how to soar, art mentors who instructed me on how to navigate the art industry. Unfortunately, artists seem to remember the dealers who screwed them more than the ones who simply lived up to their responsibilities as business partners.

In that last portion of the narrative I had to summon up all my Edward Snowden audacity to expose an art dealer's unscrupulous conduct. I might be overstating dishonest dealers' behavior, but not by a lot. If there are three things shady art dealers silently agree upon, it's control, secrecy, and keeping artists in their place. It's comparable to the present-day unspoken treatment of illegal aliens. You can get away with treating illegals however you want because at the end of the day they have no rights. In the minds of dishonest dealers, artists are supposed to zip it up and keep on taking it. That brings to mind advice given to me by a psychiatrist concerning the proper way to deal with abuse.

"To fix it, sometimes you have to shed a little light on this type of thing," he said.

To the casual observer, black magic rituals make more sense than the art business. Here's how the art industry works: The business model has basically remained the same for the past one hundred years. The art business partnership is a symbiotic relationship between artists

and dealers. However, galleries hold the power in the artist-gallery alliance. The only time the relationship tilts in the artist's favor is when he is in demand. After all the fluff and pretense are removed, the art industry practices straightforward supply and demand capitalism. Unfortunately, there are more artists than there are collectors and buyers. Gallery directors have no problem finding artists, but they have a problem finding accomplished artists who can continuously lay the sophisticated and innovative platinum egg.

It's my belief that artists and galleries are two incongruous elements, similar to water and oil. Pour them both into a glass, and the only place they'll meet is at a thin membrane between the two. With vigorous stirring the two participates can become one for a period of time, but eventually they seem to grow apart and separate.

Below is my profile of a scheming art dealer. I might be embellishing, but not greatly. Most art dealers have a Copernican mindset. They think of their artists as personal property that orbits around their dynamic, cult-like personalities. Dealers like to control their artists on two terrains: the mental terrain and the physical one. A dealer's objectives on the mental terrain are manipulation and control. Conniving art dealers manipulate artists the same way a hobbyist maneuvers a remote-controlled drone. You press the joystick up, and the artist goes up. Press it down, and the artist goes down. Dealers can have a little fun with their art drones by making them go round and round in circles. A dealer just says to his artist, "Make another piece just like the last one we sold. I have a collector who will buy it."

Controlling the physical terrain is a must for art dealers and involves gaining jurisdiction over the artist's production and places where the work is shown. The ice queen of art dealers says to her artist, "I don't want you showing any place within the region. It cheapens your work. I'm putting money into your career, and I want to reap the rewards." The real reason dealers don't want you showing anywhere else is due to the fact that they are insanely jealous of other galleries and can't stand losing a sale to a competitor. It drives them absolutely nuts. They could care less about exposure and your art career. They want money, the illusion of culture, and most of all, to be in charge.

Any competent gallery director can psychologically profile an artist in a two-minute conversation and grasp his desires, wants, and needs. That's when they can start pushing buttons to get the artist to perform in a way that's advantageous to their interests. If an artist craves women, men, or fame, the dealers can act on those desires. If the artist needs money, the art pimps have a line for that. They'll simply say, "We can sell everything you make. Let's start out by buying a piece from you. Bring in a couple, and let's get started." The dealer then finds a reason not to buy one, and so begins the deceitful parade of broken promises.

In the spirit of the memoir genre, I would like to insert a disclaimer at this point. The truth is that I really don't respect most art dealers. I believe a quarter of them need an introduction to the judicial system. I give the U.S. Congress a higher job approval rating. However, to be fair to the other side, some of my former gallery partners would probably say, "Corbin is volatile, a liar, full of himself, and delusional."

Next, I will include my biased assessment of an unscrupulous art dealer. Please forgive my negative ramblings; I'm a bit jaded after having spent thirty-five years in the art business. Check out a gallery director some time. He may look human, maybe a little overdressed, and his cologne may smell funny, but he'll still appear human. What you don't see is the long-ago vanished love of art that brought them to this high position of cultural and sophistication in the first place. They may have all started out as altruistic art saviors but soon evolved into greedy businessmen and masters of art-speak. Dealers often become bullshit spin-masters with a street degree in perception, specializing in aloof, highbrow, head-shrinking mindfucks, calculated to sell artwork on snob appeal. Now, they thrive on their ability to control and dictate the kill—or in this case, the sale. Even though you can't see the physical transformation that takes place within these dealers over time, they become, as the Aussies say, "the men in the gray suits." Sharks, in other words. They patrol, hunt, look for an advantage, and, as predators, have no sympathy for prey or respect for weakness. Since most gallery directors are frustrated artists who found it easier to sell artwork than to make it, most of them don't really like other

artists. The directors just assimilate the power generated by the artist's work and vicariously become the artists whom they represent while harboring unspoken jealousy toward them. Furthermore, dealers consider themselves actual artists, since they developed a name for the gallery and have a cult following of rich and influential people. They are the enablers, dealing between the rich and powerful who desire the artwork and the cookie artists who produce it. Eventually, dealers grow to prefer the company of their wealthy clients and begin to shun their artists. It's only human nature; once you have monetarily screwed your artist you can no longer respect him.

A gallery is much bigger than any one artist since it typically has twenty-five artists in its stable. The dealers get fifty percent of all sales. Here's the kicker: Since most of the work is loaned on consignment, the dealers get their entire inventory for free.

What are the events that cause this eventual continental drift toward the dark side? I believe it's an accumulation of shady deals, lies, false perception, and the denial of the slag and slug that becomes attached to their souls. If you could chart the path of a politician and an unscrupulous art dealer and then hold those paths up side by side, I believe there would be a similar downward trajectory toward sleaziness over time. I hope that the CIA's motto—The truth shall set you free—applies here. Otherwise, could someone please enter me into a witness protection program and guard me from the vindictive, gossiping tongues of art dealers? Thanks for bearing with me. I've held this in for far too long.

I drove south to Santa Barbara, checked up on my locked studio, and began contemplating my next move. One of my old professors thought I had an excellent chance of being accepted into the graduate program at UCSB and suggested that I apply. I thanked him for his support but turned down his suggestion. Santa Barbara was just too expensive. I needed to find an environment with less stress and was more favorable to making art.

I decided to set up a studio in Chico, live inexpensively, and recommit myself to clay sculpture, but more importantly I would now be able to work from live models. Upon arriving in Chico I scoured

barn
studio

the classified ads and found a place listed under the building rentals section as a rustic multipurpose work area and storage unit. I rented it out, affectionately calling it "the barn studio."

My artistic life can be measured by the studio spaces I've inhabited. A studio to an artist is not just a building or work area; it's a sacred space where you can let your life force roam freely. Under the studio's roof is where all the aspirations, work, dreams, and ideas can swirl, churn, blend, ferment, and synthesize into innovation and new discoveries. It's also a meditative place where you can tap the deepest recesses of your soul and a private space in which to examine your being, put your visions into material form, and create new and unseen vistas and panoramas. With a lot of labor, imagination, and experimentation, slowly out of the mists visions can become reality.

The barn studio was a unique and distinct segment of my development as an artist during the late 1980s. I was the last tenant to inhabit the structure, which was burned down two years later in a firefighting exercise. The building was situated on an acre of flat land, the last property in advance of the rolling, uninhabited Sierra Nevada foothills.

The studio lacked good natural light, which I remedied by framing in shower doors into the side of the building. The glass emitted boundless, defused, directional light, perfect for illuminating models. After setting up the studio I began working with a host of live models. An active group of professional models working in and around the university augmented their student incomes by modeling for art classes. Once you've worked with a couple of models they start telling their friends, and then you're in the modeling loop. Good models show up on time, are ready to work, can hold still, and remember the pose. Exceptional models have the unique ability to project.

Once in Chico, I began making new artist friends. The first person I let back into my life was Lowell Jones. He was full of integrity mentally and physically. Lowell's blue eyes sat calmly in between a full head of gray hair and a trimmed gray beard. His wide, square shoulders suggested his solid personality. Lowell and I were veterans and held a common love of sculpture. Lowell had retired from

teaching in Iowa and moved to California in pursuit of a sculpture career, where he enjoyed modest success. Lowell was laboring on a New York commission and constructing a twenty-foot-high kinetic sculpture powered by solar energy when I first met him. His sculpture was ultimately installed near the entrance of the Holland Tunnel.

I trusted him as an art confidant and invited him to my place. We stood inside the barn studio amongst my sculptures and paintings. The studio doors were flung wide open, and afternoon shadows fell long, stretching out toward the foothills.

I asked him if he knew of anybody who had a large kiln. He mentioned that the university should fit my needs. Understanding my situation, he suggested I might want to think about taking classes at Lassen State, which would gain me access to their substantial sculpture facilities. The university art department acted as an outreach program and was a great resource for artists like myself, he told me, and emphasized that no artist could make it on their own in this backwater art scene.

"You have to use everything at your disposal. You have to get a support system. This lone wolf, rugged, individual stuff doesn't work around here. It will drive you mad. It didn't work for Captain Jack, and it won't work for you," Lowell told me, stretching his wide shoulders. He went on to suggest that I should consider working toward an MA degree, since there were a number of part-time art teaching jobs in the area that revolved around the junior college's programs. "Give yourself an income. Use the facilities and develop your art," he recommended.

For the past six months I'd been making new clay sculptures; however, it had become evident that I was further behind than in former years. The glass wall of my flawed technique blocked my voyage once again. I found myself alone, once again standing on the translucent cusp. It was peacefully quiet there. A silent wind blew, and away gusted the feather of my Dollar Tree art journey, floating into the unknown.

FALLEN DREAMS DROP THROUGH WITHOUT A SOUND

AN UNEXPECTED CATHARSIS landed. I was running low on money, with few possibilities of making sales; I'd sold all my competent work, was 150 miles from my market in San Francisco and four hundred miles from my market in L.A., wasn't producing worthy new sculptures, and didn't have access to a kiln. If I were to compare my life to the movie *Castaway*, Wilson would be my art dream, and it was drifting further and further from my grasp. It was as though I was playing a video game pitted against a swarming zombie army, and no matter how many crawling and stumbling zombie art dealers I dispatched they eventually caught up and devoured me. I gave what I had, and now there was nothing left. I don't think it was any singular event that caused my catharsis, just the accumulation of many.

A recurring surreal dream paralleled my existence. In it I would be speeding on an unfamiliar freeway, thinking I was on the road to New York; instead I was lost and kept driving further and further. A dashboard light came on, and the car soon ran out of gas. I fell asleep in my car and awoke in the middle of the night, waiting for a sunrise that would never come. Outside, art barkers were howling in the moonlight. Suddenly the highway was completely blocked up ahead by a lit-up art gallery, built inside-out and constructed out of weird and untried art fantasies. A ring of fire blasted from the top of

the building, lighting up the sky. Artwork was displayed outside of the gallery. Standing around the bizarre edifice and pimping art were well-dressed culture hunters with phony foreign accents, barking out the meaning of art using unintelligible art-speak. One culture hunter shouted out, "Archaism." Another barked, "Pentimento." A third bellowed, "Deconstructionism." Another cried, "Fame and fire are inseparable." Still another screamed, "The architects of nihilism are the unfulfilled." Round and round they went. The dialogue was as esoteric and confused as an incomprehensible art review. Art's brilliant vocabulary was lost forever in a dream of what would never be.

Back in reality, I decided to call it quits for good. I'd climbed the ladder of my art quest for twenty difficult years and had reached my highest point. I rocked back on the ladder and let go, softly falling back to earth. All aspects of my dream came floating down around me. I was over forty years old and had a receding hairline. I decided it was time for me to come in from the cold and live an ordinary life.

I enrolled at Lassen State University and landed a student job shelving books in the library. My new life plan was to earn a Master of Art degree and find a part-time teaching job. The wild and independent art lion who had roamed free on the great savanna now attempted to move into a residential area. I took graduate classes and began working twenty hours a week in the university's library. It wasn't long until I was not working in my studio at all. Instead I studied art history and wrote papers. Wilson, my art dream, floated over the horizon line and disappeared. The pump house I saw as a kid, the dancing mirage, my art vision, had finally vanished. The money monster sardonically asked, "Now, isn't everything much better, Danny?"

At college I tried to fit in, keep my mouth shut, and go along with the academic flow. My goal was to receive a little piece of paper. You must understand, I really did try, but I had a chip on my shoulder. Actually, it was more like a cinderblock. No matter how hard I tried to remove the cinderblock it remained attached to my shoulder. The cinderblock began agitating and attracting other cinderblocks;

together, they began an insurgency and built a fortification around me, rallying against absurd academic protocol. The truth is, at the time I didn't respect the proficiency or commitment of the tenured art professors. They hadn't put their asses on the line, art-wise. They hadn't been stationed in a forward operating outpost in Anbar Province, hadn't fought in the art octagon, blocking punches, parrying leg kicks, and being thrown about the cage dripping blood. They hadn't been chocked out and left gasping for air on the octagon floor. At the time, I viewed the professors as tentative beings who were caught in their age, only using the Internet browser instead of navigating art's deep, expansive web.

How was it possible that a tenured professor who taught drawing at a university didn't have the competency to draw a lick? The students in my drawing classes had a better chance of finding WMDs in Iraq than they did of learning how to draw. It was as though Lassen State was on a sound loop and was just now receiving ideas espoused twenty years earlier in New York. Art historians were telling me a stack of bricks or mounds of cigarette butts were the latest unsurpassed cutting-edge sculptures. For me it was just more fad and fashion. I heard the same cajoling arguments for the theory of linear progression twenty years earlier at UCSB. Linear progression, an outmoded sixty-year-old art theory, was first espoused by Clement Greenberg in the 1950s. The theory is now kept alive in a cryogenic freezing chamber in the back of the Metropolitan Museum. Linear progression outlived its usefulness for artists long ago, but politically, the outmoded theory is a distinguished concept backing intellectualism as the legitimate and authorized art broker for the Western art world. You can expect headline-snatching art fashion, made from recycled creativity and stuck together with mediocre technique, to be our overpriced art diet for years to come. In my opinion, anything goes in the art world, as long as you can do it well. To all the artists out there: You are free to create whatever you want. Find a branch on the art tree you like, and graft on your personal vision.

Not caring for the sculpture program, I changed lanes and began pursuing a graduate degree in drawing rather than sculpture.

I didn't want academic debutants messing around with my sculpture technique. In the fall of 1990, David Best, a professor from the San Francisco Art Institute, taught a guest graduate seminar class in sculpture. David's compactly muscular body throbbed with energy. He possessed a head of thick black hair that he occasionally straightened with his hand. I knew of and respected David Best's artwork and enrolled in his seminar. David is a master of materials and was a groundbreaking participant in the Burning Man festival, which takes place in the Black Rock Desert and has become a worldwide cultural phenomenon. I mostly remember his lively spirit and his ability to peg my wryly character so quickly.

David introduced himself to seven graduate students at the first symposium. "My goal is to give each one of you something which will help you out," he told us as he casually walked around the room. For our second meeting David asked us to bring in examples of our work. I showed him photos of my sculptures.

He asked me, "How can I help you?"

I said I'd been working on ceramic figures and would like to fire them in the university's kilns. He gave me permission. "Bring in a couple of fired sculptures, and let's talk about them the next time we get together," he suggested.

Two weeks later we met again in the main sculpture room, a well-equipped sculpture facility with a high-arching roof. Natural afternoon sunlight bathed the area below. I brought in two finished clay figures for him to examine. There were six other graduate students standing around listening as he began critiquing my work.

His critique of my ceramic torsos punched me in the gut.

"You ought to take one out and break it. Maybe both," David cynically stated, which to me sounded like a putdown.

The rational part of my brain shut down, and an instantaneous flash of anger pulsated through me. I thought to myself, I'm going to track down this son of a bitch in San Francisco and fuck him up.

He continued, "Because they're all going to get broken anyway."

I quickly realized I had misinterpreted his meaning. Now that he had my attention he advised, "Clay doesn't work well as a finished

Clay breakable

product. It's breakable. You might want to consider looking around for another medium. I can help you if you want," he offered. A momentary fissure of opportunity spread apart my body armor, and through it flowed information. He knew the drawbacks of clay, for he had started out as a clay sculptor and went through the same progressions as myself years earlier.

I thought and toiled and pondered over his suggestion for three days. How could I give up clay? I was so good at it. I was simply the best, able to build life-sized figures out of clay, fire it, and have the work come out in one piece. If I was born to do anything, it was work with clay. It would be like starting over again and admitting I had taken the wrong freeway. All those years of work and expertise thrown away; what a wasted effort. If I was going to change I would have to swallow my pride and admit I was off course and needed to readapt. For me to accept outside help was a monumental step, but so also was confronting the possibility that unresolved issues of my past were determining my present.

Next, David Best and I had a private meeting, and I gave him a proposal for a new way of making sculptures using a different material than clay as a finished product. The transforming and life-changing advice David gave me was the same bit of information I had received from Richard Frooman ten years earlier while attending classes at the University of Hawaii. "Try bronze, something more durable than clay," Frooman had said. This time I listened to the offered counsel, and it sunk in. I was finally ready to give up fire, my lifelong buddy. Finally, I was able to swallow my pride, accept advice, act upon it, and change.

I enrolled in college to receive a master's degree in order to find a part-time teaching job; it was a straightforward paper chase. Inadvertently and by misguided intent, I discovered the missing PIN, which allowed me to unlock my artistic box. For the past ten years I had wrapped myself in an all-knowing, self-sufficient crystal cocoon. However, with one liberating, arduous kiss of knowledge, I metamorphed into a proficient and skilled artist.

PUPPET MASTERS OF COINCIDENCE

THE NEW GAME plan was to make an original life-sized figure out of clay using a live model for reference and for proper anatomical detail. That would require using a model three times a week for two-hour-long sessions over a span of two months. I decided to use Moe, a long, skinny tomboy-like female model with eye-catching beauty. Her long legs hypnotized and befuddled men's attention as she swayed by on city streets. We had worked together on previous projects. She was cheerful and reliable and enjoyed offbeat humor. We selected a walking pose and had been working on the life-sized clay sculpture for a month.

Moe arrived at the studio during a mid-morning. The temperature was eighty degrees that day and rising, perfect for modeling. She hopped out of her convertible, slid through the studio double doors, and announced, "I'm here."

"Great," I said. "Everything's ready for you." For two hours I'd been anticipating her arrival, prepping the clay, organizing the agenda, not wanting to waste a precious moment of modeling time. A life-sized clay walking figure was positioned in the middle of the studio on a revolving sculpture stand. The side windows of the studio emitted a strong directional light, illuminating the clay project. I had already completed the feet, legs, and midsection of the clay sculpture. Now, I balanced a hollow clay torso on top, completing the piece from the feet to the shoulders.

Moe stood there, taking in the project with her hands on her hips.

"The sculpture is really coming along. It has a chest now," she noted with a crooked smile.

I explained to her how I thought the day's work should progress. "I've positioned the torso on top and wanted to make sure everything was right before I attached it. Let's work on a profile view first. I'd like to check measurements and angles," I clarified.

"Sounds good," Moe said. She pulled her shirt over her head, slipped out of her sweatpants, and kicked off her Birkenstocks. "Are you ready now?" she asked, totally at ease with her nudity.

"Yes," I replied.

She stepped onto a wooden pedestal the same height as the clay sculpture we were working on and positioned her feet on top of the box inside a silhouette drawing of her feet. This assured she kept the same position. I examined her pose and decided that it looked a little off. "Could you rock forward a bit? That's it. Straighten your back," I directed.

She made the small adjustment.

"Good. Right there. That's the pose we're after," I said, and then positioned a second spotlight on Moe's torso. "I'd like to work on the rib area first. Can you make your ribs stick out?"

She took a small breath and pushed out her rib cage. The additional light cast readable anatomical shadows on her body, while the softer spotlight sent shadows wrapping around the curvature of her breasts, and reflected shadows highlighted her rib area.

The standing clay figure was positioned an arm's length in front of me. Directly behind the clay was Moe, assuming the same pose. I grabbed a handful of malleable clay and a butter knife and looked past the clay sculpture at Moe's body. I observed each anatomical detail of her ribs and then replicated it three-dimensionally on the clay sculpture in front of me.

I pounded the clay with a wooden paddle and scraped the clay with a saw-toothed scraper, using a sponge to smooth out recently worked gooey areas. Within easy reach were coils and slabs of fresh clay waiting to be worked into the figure. Occasionally, I would reach into a wooden box and retrieve a tool from the toolbox next to me,

which contained calipers, plumb bobs, levels, foldable rulers, wooden rulers, and cloth measuring tapes—the kind used by sewers. The secret to accurately sculpting human anatomy is the proper application of measurement, proportion, and direction.

Moe held the pose for twenty long minutes. "I'll need a break in two minutes," she mentioned.

"Okay," I agreed. "That will give me time to finish this area, and when we start up again let's work on the frontal view," I requested.

"Sounds like a plan," she said.

Shortly afterward, Moe came out of the pose and began leaning side to side, stretching her back to work out the kinks. She then flexed both legs and gingerly stepped down from the box.

Moe stopped by every other day until we completed the life-sized figure. I then fabricated a latex and fiberglass template matrix mold, a negative of the completed clay original figure. With the fiberglass matrix completed, I could now make one-of-a-kind, life-sized sculptures in a series, changing each sculpture as I went along. However, I still needed to find a material other than clay that would be feasible as a finished product.

Using a method of experimentation and note-taking I began with the usual suspects: cement, plaster, resin, papier-mâché, roofing compounds, and various glues. Then, a thought occurred to me. Why not try the sample of bauxite I had kept for eight years and now was buried away in a storage unit? I had received the gallon sample of powdered bauxite (refined aluminum ore) from a minerals dealer in West Oakland eight years earlier when I worked and lived in Berkeley. The day I received that sample is etched in my mind. It was damp and overcast as I drove toward Pyro Minerals to pick up a carton of firebricks. On the way I drove past discarded mattresses, trash, old torn sofas, and abandoned shopping carts discarded in culverts. Everything was gloomy and dreary, but I had been an obsessed artist on a mission of discovery, and to me, within the confines of that company, were the endless possibilities of unearthing yet-unknown materials. I parked my station wagon in front of the minerals company, which edged the West Oakland black ghetto. The front gate was the highest steel gate

I'd ever seen, and it was topped with concertina wire. The warehouse was designed around eight forklift bays, and at the back of each I saw pallets stacked high with exotic building materials. Jim, owner of the company and another Berkeley educated industrious Bay Area urbanite, was a balding man in his forties, although he compensated for his receding hairline with a distinctive black goatee that appeared huge on his chin. He wore Levi's and a brown leather jacket when I met him. Jim was a chemist who knew materials and their properties. If he had time, I would pick his brain regarding materials.

I was loading my station wagon with a carton of soft firebricks I'd purchased when Jim approached carrying a one-gallon can heaped full of bauxite.

He held out the can. "You might want to experiment with this. It's called bauxite. It's refined aluminum ore, has a lot of interesting properties. It's a superior cement. Comes from France," he said, giving me the sample. This small gesture from a decent man fortifies my belief that artists are of the people.

It wasn't until eight years later that I started to experiment with the material, but it helped transform and revolutionize my life. I found the elusive PIN, the last piece of my art puzzle. Bauxite was the versatile and durable material I had been looking for. Using my brand-new matrix template and the malleable bauxite material, I created my first freestanding life-sized sculptures.

The first sculptures were made in a new studio. The old barn studio property had been slated for redevelopment and was burned to the ground in a fire department live training exercise. I drove by to watch the flames that shot twenty feet into the air. The blazing studio symbolized an exorcism, a Greek funeral of my unsuccessful former self. It was as though my body was placed inside the studio on piles of wood. David Best, my figurative shaman, positioned two coins upon my eyes so I could see in my next artistic embodiment. The abstract fire was started with stacks of rejection letters I'd received during my long years of struggle. The flames raged and vaporized the dysfunctional essence of my former self. In my new incarnation, I was free to open up, take advice, and make my best work.

I began looking around for a new studio and soon learned of a cooperative art studio, which would later be known as the Drive-By Gallery, that was starting up in downtown Chico. The light industrial building was formally a laundry facility in the 1960s and was located a half mile from the university campus. Across the street was an auto body shop, and on the corner of the block stood Cruise Classic Cars. The cooperative neighbored an older motel, and a large parking lot ran between the buildings. The windows of the motel had been bricked up and painted white, so the cooperative had privacy. It also had one bathroom and a leaky tin roof. The interior was a shell with movable walls that could be maneuvered to accommodate the needs of the co-op members.

I discovered in back of the main structure another separate and detached smaller building: a flat-roofed, empty, 350-square-foot cinderblock structure the size of a large bedroom that had once housed the boiler. That room became my indoor studio space. Surrounding the boiler room was a cemented patio area, encircled by two-story windowless brick buildings. My new space totaled 1,500 square feet and was a secluded courtyard oasis in the middle of downtown. A fenced gate opened to the parking lot, providing me with a private entryway. I could see the potential and rented it immediately. The cinderblock building was cool during the summer months; during the winter a wood stove provided sufficient heat to cure the sculptures. To a sculptor that cemented courtyard was a gift, providing ample space for storage and allowing me to work on multiple projects and then wash it all down with a hose. My perfect gorilla art space started out at seventy-five dollars a month.

I made just enough income from my part-time job at the library to keep affairs afloat. I kept the studio for seven years. It became my new power spot, my laboratory, my cave, and my meditation room. From that studio I sent crated sculptures to New York, which would propel me into a nationally recognized sculptor.

At this time a new mentor entered my life, Ben Braxton. He was a portly man with a wide face, pronounced cheekbones, and a well-trimmed mustache. His face assumed an arrogant demeanor, though

he was quite the opposite; a compassionate engaging man. He was part Buddha disciple, part art connoisseur, and all-round rabid free enterprise devotee. Ben owned a small local gallery called the Blue Herring Gallery. He became my friend and business mentor. Ben had learned the art business from his uncle, a noted artist, and now possessed a comprehensive understanding of the art industry. Ben's gallery provided income; however, he worked a day job as a food service manager at the university. In the back of the Blue Herring Gallery on Friday nights Ben and his brunette, curvaceous wife, Gina, ran a figure drawing group. When the session ended we would put away our drawing supplies, bring out our musical instruments, and play blues late into the night. On weekends Ben and I played golf and talked art.

It was two o'clock in the afternoon on a hot valley day in the summer of 1991. I had just gotten off my four-hour shift at the university's library and drove my van to the studio parking lot. The student population had departed for the summer, and Chico now radiated a tranquil vibe. The temperature during the days soared above the hundred-degree mark. Such blistering days were hard on the body but accelerated the curing time of sculptures. I unlocked the swinging wire gate and quickly passed through the courtyard toward my boiler room studio. Traversing the courtyard could be challenging; it was cluttered with stacks of sheet metal, boxes of automobile paints, and piles of exotic woods such as mulberry, chokecherry, and buckeye. Stored in boxes were women's cosmetics I'd purchased at second-hand stores. Old perfume bottles were my favorite. To me, those bottles were just waiting to be surrounded in resin and embedded into the sculptures. You could smell the old fragrance floating in the air as you crossed the courtyard. Rancid perfume mixed with the dry heat and became attached to the insides of your nostrils.

I unlocked the large door to the studio, propped it open wide, entered the dark cool interior of the cinderblock building, and arrived at my art temple ready for my newest revelation. I'd made four life-sized sculptures in succession from the matrix templet,

each one different, each one better than the last, and all beyond my wildest expectations. My new flexible technique allowed me to express pent-up ideas that had been gestating for the past ten years. The new sculptures revealed an intriguing industrial look, alluding to the process of how they were constructed and leaving an imprint of the materials. The sculptures also conveyed life-like anatomical details, expressing a titillating feeling of sensuality. I embedded areas of color next to sheets of lead, creating a curious juxtaposition. The art world was currently obsessed with sculptures made from non-traditional art materials, and during that moment I was in sync and standing high on the cutting edge of innovation. I had uncovered the elusive "it." An art analogy of my new sculpture style goes as follow: Rodin meets an Australian aboriginal conceptualist, and they began having kids.

The previous day, in the studio, I had bolted together the contents of the loaded matrix, a culmination of three weeks of intense sculptural activity. That evening the bauxite had progressed through its thermal reaction, emitting steam that reached 165 degrees. The bauxite sculpture was now cured and had cooled down to room temperature, ready to be opened and viewed for the first time. Placed in the middle of the room was a reinforced bee box. Standing on top of the box was the matrix mold fastened with form nails in an upright walking position. Within the matrix template was the newest life-sized sculpture waiting to be liberated; it sat directly below natural light that was streamed through a large circular vent, lighting up the dark windowless room in a theatrical fashion. The interior of the studio was a confined space, and all the tools needed—a reversible drill with a seven-sixteenths-inch socket attached, rasps, chisels, screwdrivers, pry bars, box end wrenches, sandpaper, and a sculpture hammer—were on worktables, all in easy reach. Doing is the juice; that's what it's always been about for me. I enjoyed the physical activity of making sculptures and thought of myself as part-athlete, part-craftsman, and part-shaman when working on them. With urgency I worked to liberate the life-sized sculpture. Ben often stopped by after work, and I wanted a moment to view the new creation in private before his

finally a sculptor

arrival. The final tools used to release the sculpture were a rubber hammer and a specialized pry bar.

I stood in awe of my latest creation. My reemergence as a sculptor was complete; my journey of discovery as an artist had reached its own distinct orbit. My plan was not to control and dictate the look of the sculpture but to allow spontaneity and serendipity to occur within the framework of my process. Moments like those are the real reason I make sculptures. For me it's an incredible revelation to unveil something that has never been viewed and to arrive at a place no person has explored. Such moments assured me I was where I belonged. After so many years of seeking, I had finally found my transcendental home.

Immediately upon viewing the new sculpture, while the first impressions were still in my mind, I jotted down in a fourteen-by-eighteen sketchbook all the things that worked and imagined new ways to improve the next sculpture. Within a half hour I had a new game plan. In my notes were thumbnail sketches of new experiments, along with colors and concepts to be included in the next piece.

In such times I'd empty my mind and keep still, allowing a portal to the source to open, finding a special place in my consciousness, and letting the ideas flow. In the beginning my inspiration and ideas would come at random moments. Later, I learned how to coax them on invitation. I'd feel a warm sensation as inspiration would hit me. A fledgling notion would emerge from the fog of nothingness and take shape as an idea. The headlights of mysticism penetrated my consciousness. I would explore the different directions the idea could take and record my insights with notes and sketches. My flashes were fleeting and only existed in the real world after they were written down and recorded.

Hearing Ben arrive in the back, I left the interior of the cinderblock studio, crossed the patio, and opened the gate. Ben carried a brown paper sack containing two chilled bottles of Sierra Nevada beer. He handed me a cold one.

"Thanks. How was work?" I asked, closing the gate behind him.

"I'm glad this work week is behind me," Ben said, rolling his eyes

and blowing out a tired breath. Ben was dressed in his managerial wardrobe. A long-sleeved dress shirt was neatly tucked into his creased black dress pants, held up by a stylish black belt. Ben's meticulous appearance was quite a contrast to the dusty, jumbled, chaotic studio he was entering. "How's the new sculpture?" Ben asked, twisting the bottle cap off and making a mini shot into a garbage can.

"I think it's a good one. Let's take a look," I said, leading Ben across the patio and into the dark boiler room. I was eagerly awaiting Ben's feedback on my new piece.

Ben had developed a courteous bedside manner around artists. He studied the dramatic light sculpture for a few moments, slightly nodding his head. "You're onto something here. Very unique. They're really coming along," he said, examining all sides of the piece.

"Thanks." I accepted Ben's compliment; however, his body language said it all. Ben's aroused reactions firmly reinforced what I was certain of: I'd uncovered my mature style and it was dynamite. "It's starting to happen," Ben said, tightening his jaw. "You should be able to sell these. They'll find collectors," the art dealer and staunch believer in the merits of the art industry and free enterprise preached.

"I've been thinking about taking them to San Francisco," I ventured. However, the truth was that after my last disturbing gallery experience in San Francisco I didn't have a plan. "I don't know if I'm ready yet." I sidetracked the subject.

"Sell them here. Sell them yourself," Ben emphasized, taking a swig of beer.

"Okay," I said slowly just to appease him, even though I thought it was a ridiculous idea.

"I'll help you out," Ben offered. "It could probably work, but you'd have to let people in." He paused for emphasis, then continued. "That would be the hard part. Share your results."

"Do you really think I could sell my own work here in Chico?" I asked skeptically.

"Gandhi started in his own backyard making salt," Ben said. He again paused to let things sink in, then added, "Get a local following. This is a way to make it on your own." Ben began pressing my buttons.

"It's a way to get around all the political bullshit at the university."
Ben was referring to my latest brouhaha with the art department.
"I've seen their act. Any time someone comes along who can outshine
them artistically they banish them from the fiefdom, won't let them
on the playing field. Do it on your own. You're your own master."
Ben would stroke his mustache with his thumb and forefinger in a
downward motion when he was on a roll. "There are half a dozen
people in Chico who'd love to help you out. They want to be part of
something." He nodded, agreeing with his own thoughts. Pushing his
glasses back, he continued. "Get a local following. It will take you to
the next step. Get the process down. Know why people are buying
your work. Put some money in your pocket. Allow it to happen,
and when it really starts, you'll be ready," Ben finished, pressing his
lips together.

"Do you really think I could do something like that?" I asked
doubtfully.

Ben, assuming his most motivational air, continued, "The first
thing you need to do is let people know what you're doing."

"Like how?" I almost laughed.

"Put a couple of sculptures out in the front gallery. Put out a press
release. Pound the drum. Make some smoke; enough smoke and the
fire will start."

"In the front of this studio?" I asked incredulously.

Ben launched into a monologue. "Make a couple of eight-by-ten,
black-and-whites of the new work. I'll show you how to make a press
release. Then, make a list of all the possible places you can show in
a one-hundred-mile radius: art centers, museums, whatever. Send
them a press release. Enter shows. Start a mailing list." Ben stroked
his mustache between each rapid-fire thought. "Make the work, show
the work, and sell the work. It's almost like a perfect cycle. There's
a mystical connection between all people, a group consciousness.
We're all linked by a shared essence, and if the work is as good as
I think it is, it will self-generate. When it does, you can take it
to a larger market," he concluded, sounding absolutely certain of his
opinion.

After Ben left the studio my initial thoughts were: Why would I show in a local art scene such as Chico? I had a one-man show ten years earlier in San Francisco. I'd shown in L.A., Santa Barbara, and Palm Springs, all regional if not national art centers.

However, that whole business about Gandhi intrigued me. Maybe it was time to open up and let the public in. Get a personal following by starting on my home ground. Ben's ideas dovetailed nicely with my newfound notion that the art journey is also a quasi-spiritual trip. Lately I had been entertaining the belief that art might be out of my control. Conceivably, I was a short-lived transitory art vehicle overseen by celestial art deities.

Broke and barely getting by, I needed a new plan. My idea of becoming a teacher wasn't working out. I had suffered a falling out with the newly imported chair of the art department, which had ended with him calling the campus cops. I didn't set foot in the art department for a year. The hullabaloo was caused by politics; in this case nepotism. The new incoming chairman, a husky, shaved-headed man with sloping shoulders, decided to give away my graduate studio, which I needed at the time, to a famous artist's daughter. I didn't threaten or cuss him out over the phone, but I did tell him what I thought. He used the phone conversation as grounds and called the campus police. They arrived at my private residency, took a statement, and then sent me to the provost marshal. The provost sanctioned and disciplined me by taking away my graduate studio. I was ostracized and shunned by the art department. The incident was maddening. One day I'm the golden boy, the next I'm an untouchable. As it stood, I had nothing to lose and everything to gain. Why not give Ben's idea a shot? As it turned out, my friend was right. Chico was fertile ground for my transplanted art dream. The handful of art collectors who happened to be in town supported me in my newly resurrected art career.

When you are ready; have struggled, sacrificed, and learned enough; have put it all together; have the drive and ability to do the Art Gods' work; and when the Art Gods think you can carry the torch of social change, only then do they give you their

cherished blessing and begin working full-time for you behind the scenes.

The Art Gods are the puppet masters of coincidence and make the connections. They manufacture miraculous providence and visit it as chance and luck on their favored artists. First, I sold two sculptures out of my studio to local collectors. It was during this period in my life that I started entertaining the possibility that maybe the Art Gods are my source. When you can't control events, especially fortuitous ones, and they seem random, you start entertaining the unfathomable belief in the unknown. Perhaps such belief is real, and all it takes to keep it going for you is a little reverence and worship. Why not? I practiced my devotion to the Art Gods by working day in and day out. I kept a unique place in my mind open for all likelihoods. Stay humble and don't brag about your accomplishments. What you receive is for your private consumption. Contemplate your good fortune and give some thanks. That was my method of worshiping the Art Gods.

In quick succession I received validation from two art museums. Henry Hopkins juried a museum show at the Crocker Kingsley Art Museum and bestowed upon me a major award, resulting in a Sacramento TV interview. After that, the Redding Museum of Art gave me a one-man show. Over the years I had forged a sturdy art vessel; now, the Art Gods began filling it to capacity. Sales continued nonstop. I was slotted on the fortuitous ride of artist success. Next I fashioned a sharp and penetrating stake out of hundred dollar bills and drove it through the heart of the money monster.

Ben's plan laid the foundation for me to return to San Francisco two years later and culminated in a one-man show in New York two years after that. After the New York show there was a demand for everything I made. My career took off. I opened up, let it happen, and did the thing I really loved: making sculptures. I hired studio assistants to help in the work. We created sculptures and exhibited in twenty one-man shows across the country. For a figurative sculptor I had an incredible run of shows, along with recognition and financial success.

In hindsight, looking back at my long struggle to support myself, I was my own worst enemy. I held the keys. I was my own jail keeper. My perceived antagonists, the dragons and demons who throttled my art career and held me back, were actually myself. The construct I had set up was flawed. Brute strength, dedication, willpower, and self-reliance were not enough in the end. When I began letting people in and taking advice from my mentors, my career soared.

CAN I GET IT RIGHT?

FAST-FORWARD TO OCTOBER 5, 2012—twenty years later. I was now an accomplished artist living and working in my country studio, showing around the nation, helping support my partner, Paula, and our three kids. My life had evolved over the years. I had met Paula while working at the library. I remember the first time I saw her working as a student pushing a mail cart, her long, beautiful amber hair flowing down her athletic ballerina body. Paula has blue eyes, an engaging, happy, gregarious smile, and knows half the people in town. Later, after she returned from a teaching gig in Korea, we starting dating. We were two people flying solo, who fell in love and started a family. Paula is the force and bond behind the family. Fatherhood was challenging for me in the beginning but now is something I have grown to cherish. Our relationship has been a dizzying balancing act of maintaining two careers and raising three kids. We've made the commitment and are giving it our best effort as a family.

I've now worked in my secluded country studio for the last twelve years. The shop is perfectly set up for making sculptures. My large studio complex and modest house are located in Northern California amongst orchards and farms.

I woke up October 5 in my studio to a beautiful, fall, sunshiny day. I had worked my tail off all year, swamped with commissions and sculpture requests. I planned to take the day off as a reward, celebrating the fortuitous past two decades I'd had as a father and

sculptor. In the morning I figured I'd take care of a routine medical exam and then drive to Grey Lodge, a national wildlife refuge. There, I'd trek through my oldest spiritual sanctuary, where I could observe wildlife in its divine cathedral. I wanted to use that day to celebrate, reflect, and give gratitude. My speech was prepared, and I was ready to deliver it in my temple.

If you had seen me that morning you would have noticed how upbeat I was. I shaved my head, my standard look for the past fifteen years, showered, dressed, jumped into the car, and drove an hour to the veteran's hospital to undergo a routine exam. On the drive there I was a little anxious, since I had not followed the fasting instructions. I hadn't eaten food, but the instructions mandated that I not drink any fluids, and I had inadvertently drank a glass of water by mistake. Nevertheless, I parked my car and headed toward the hospital entrance.

The Veterans Administration had been my primary care facility for the past ten years. I had never suffered any major health problems, save for a high blood pressure issue. Hanging out near the hospital entrance door was a Vietnam-era veteran, mumbling to himself and communicating with voices only he heard. I slid past him and entered the main waiting area of the hospital. Twenty other veterans populated the large amphitheater-like waiting room. Most of them were older, some on oxygen, and I thought to myself, I'm in better shape than most of these old geezers. After checking in I waited my turn to be called. Finally, I was ushered in, and they prepared to start a routine ultrasound on my heart.

Turning sixty-five had triggered the routine exam. While lying on a table in a hospital gown I received the ultrasound procedure in a darkened room. The tall, lanky nurse performing the ultrasound began to look perplexed as she went over and over an area near my stomach. She withdrew the device, recalibrated it, and when she returned it to my abdomen I detected a nervous tick in her hand.

"Did you have anything to drink?" she asked.

"Just a bit," I answered, thinking that I had messed up the test by drinking a glass of water.

The nurse finished the exam and sent for the resident doctor.

The resident doctor, Dr. Yap, was no more than five feet tall and appeared to be Asian—most likely Chinese. She had a thick accent and kept apologizing for her poor English. "Please forgive me. I hard to understand," she said.

"Hey, you speak two languages. I only speak one, and I'm not a doctor," I reassured her.

"We give you more tests," she said, studying my medical chart. "We give you a EKG. You might have an aneurysm." She informed me and then rushed out of the room.

Assistants quickly performed the EKG. Then, Dr. Yap came back into the room flipping through my chart. "Nothing wrong with your heart, but something not right. You not leave hospital until we figure it out. Have you been losing weight?" she asked.

"Yes, I've worked hard to lose a couple of pounds," I replied, wondering why she asked that question.

"We give you a CT scan," she said, quickly leaving the room to make arrangements for the procedure.

At this point I was getting anxious thinking I'd messed the test up by drinking water or they were looking for something serious. For those of you who have not received a PET or CT scan, it goes like this: A drip system is attached to your hand containing a radioactive tracer, which enters your bloodstream. You drink a quart of some kind of medium with a banana-ish flavor. Then you wait an hour. Finally, you're placed in a circular tube under a mechanism that moves back and forth, taking a 3-D image of your body.

The test was completed, and the results were given to the radiologist to interpret. He made his diagnosis and gave the information to Dr. Yap, who then invited me into her private office.

Prior to her saying anything I asked, "Everything okay?" It was a nervous attempt to lighten the situation.

Wearing a sympathetic expression, she slowly shook her head.

I had been preparing myself for this moment most of my sculptural life. The final surprise. Sculptors who immerse themselves in as many toxins as I have simply don't live long. She informed me that I had

a three- to five-centimeter lump as big as a tennis ball next to my stomach, along with swollen lymph glands and water in my left lung.

I asked, "What is the diagnosis?"

In response she read off a list of possible cancers.

I began quickly writing them all down, trying to approximate the spelling.

"In truth, we don't know what it is. It might better you wait until we know for sure," she told me. Dr. Yap made an appointment for me a week from then to see the chief surgeon at Mather Hospital in Sacramento. "Let me give you a hug," she offered with her arms held open.

When she hugged me I noticed she was balancing on the tiptoes of her elevator shoes.

"I don't know how you can do this job," I said. Either I was being gracious under fire or I meant it. I'm not sure.

For me it was like being in a glass dream in which my mind had never been more focused and alert. I had been preparing my whole life for this type of diagnosis, but I simply didn't think it was true. I felt a little rundown at first, but that was about it. I thought there had to be a false reading due to the water I had mistakenly drank prior to the initial test. I was not acting rationally, probably due to some level of shock or denial. Then, I became slaphappy, upbeat, elated, and celebratory; my fate had finally arrived. I wasn't going to let life deal me a devastating blow on the day I set aside to celebrate my life. I wasn't going to let the lightest light and the darkest dark get me twice in life. Cosmic indifference could go fuck itself. I wanted my spirit to be bigger than this disconcerting news. As I confidently strode out of the hospital in the late afternoon, another veteran observing me might have thought, Poor guy. That's the same way I acted when I received my diagnosis.

I saw the chief surgeon a week later. He was a large, square-jawed man with silver hair, dressed in a doctor's white lab coat. He had not one extra second to spare and was followed by two assistants. In a room he showed me the radiograph. A white mass was wrapped around my mesenteric artery and appeared to be hooked to my

pancreas. "Something has jumped into your body," he said in a voice that made it seem ordinary. He scheduled me for a biopsy in ten days.

Thinking there was a possibility I might have pancreatic cancer, I began taking stock of my life. My friend Lowell Jones had died of pancreatic cancer five years earlier, and I knew it was a quick killer. What actions should I take to wrap up my life? I began taking stock of my existence. On the domestic side, with my partner Paula, we had three children who were now ages eleven, fourteen, and fifteen. If I died, I'd be leaving the kids without a father and the family in a reduced economic state.

On the career side I'd be leaving another giant mess: a four thousand-square-foot studio full of tools, materials, and partly finished and completely unfinished sculptures. The art business is such an obscure esoteric profession that no one in my family would know how to handle the chaos of my estate.

On the mental side there was an unexpected sense of relief. A burden had been lifted from my shoulders. You see, a peculiar unrecognizable vacuum resided in the center of my being. I don't know if the void was caused by my artistic indifference or by the vacating Art Gods. By now the deities had found other willing torchbearers. I didn't care any longer. I had done my part, my share, and had probably made myself susceptible to cancer by my sculptor activities. At this point I had no real desire to make sculptures, only to begin bundling and wrapping up my life.

The other side of me was coming to terms with my mortality. The next weekend on a Saturday, I was sitting in my van parked in front of Paula's house. It was my turn to take our youngest son, Phillip, who was eleven, black-haired with an angelic face, to his flag football game. Not knowing precisely what was wrong with me left me in a disquieting emotional limbo.

Phillip opened the sliding door on the van. "Let's go, Dad," he said, buckling his seat belt. I took a long look at him, thinking he has my eyes. He was dressed in his football uniform, black shorts, and spiked shoes, and wore a shirt with the number 11 on it. Around his arm was a plastic armband that contained all of his football plays. He kept

his black mouthpiece on in the car because he thought it made him look cool. This was his last game of the season—his team hadn't won any of them—and he was one of the smallest kids on the team. Due to the randomness of the city league their team hadn't received the two or three outstanding athletes necessary to thrive; they needed to compete as a squad. On the ride to the game I talked to my son about not winning a match and asked how he would feel if they lost the last one.

"Dad, I don't care. I had a great time playing and being with the guys," he replied.

When we arrived at the outdoor expansive sports facility, the simple task of parking the car was beyond me. I pulled the car in and out of the space a couple of times but still failed to get it right. Finally, I shut the engine off.

"There's Matt," Phillip said, grabbing his water bottle as he opened the sliding door to exit.

"Good luck," I managed to say.

Phillip turned around and began running backward, taking out the mouthpiece so he could be understood. "Meet you after the game," he called to me, then spun around and ran full-tilt after his buddies.

The late valley afternoon sun was bearing down, and a hot northern breeze was blowing. I watched the sports complex fill with people. It was a melee of activity, a joyful, colorful occasion, the epitome of a family sports day in rural America. Lining the field of play, two deep, were the mothers, fathers, and friends, rooting and watching the children play flag football. Most of the spectators were in their sports attire: Hawaiian shirts, shorts, and casual footwear. They sat in folding chairs; some people brought large, multicolored umbrellas to block the harsh angle of the afternoon sun, with water coolers placed by their sides.

The closer I came to the field, the more chaotic the movement. The panoramic view was a mass of activity; at its center were children running, yelling, screaming, and throwing and kicking balls. Footballs flew in every direction, one just missing my head. Mothers were teaching babies how to walk, and toddlers were jubilantly

chasing their own shadows. Dogs on troublesome, retractable leashes presented tripping hazards. Teenage girls, all gussied up, dressed in their compulsory tight cut-off shorts and glad to be away from their mothers for a few minutes, cruised the large sports complex in groups of threes and fours while giggling and whispering to each other. The hot valley afternoon sun, in all its glory, bore down on us all.

I meandered around anonymously, keeping a slight distance from the action, and then spun around to face the setting sun. The fiery ball now lingered just above the dry mountains of the foreboding, distant coastal range. Within a half hour, the skies would turn red to announce the arrival of sunset. I started imagining the end of the day, the conclusion. I couldn't shake the notion that the cancer was growing in me, taking its sugary feast, eating me from the inside. I smacked that depressing thought away and began wandering through the empty chambers of my mind. In one I found a vision of an Egyptian Ra boat. I imagined myself wrapped up in a blanket on the boat, making my last journey and floating through the red skies to the desolate western land of the nonliving, the entry point of the underworld.

A man's voice brought me out of my melancholic vision. "Hot day today. The sun's hotter than Penelope Cruz."

I turned toward the voice and saw a familiar smiling face. I had joked around with the man many times before, but my mind was a blank as to his identity. I tried to say something witty but came up empty. I had nothing. I couldn't remember his name or his kid's name. "It's . . . it's . . . hot," I managed.

"Phillip playing today?" he asked.

"Yeah, yeah. He's here. You, uh, your son . . ."

"Yes, Carl's playing today," he said helpfully, then, sensing something wasn't right, he concluded with, "Well, I better head on over. Carl's game's beginning soon. See you." He turned and headed toward the playing field.

My barrier, the electromagnetic field surrounding my emotions, began to leak and soon broke down. I wandered around as my son played his game. I saw people I knew but wasn't able to talk to anyone.

I couldn't get the words out right. I stopped trying. I hid behind my sunglasses and tried to maintain my exterior façade. On the inside, however, I was inconsolable, emotionally crushed.

I took in the whole scene and remembered thinking, Life goes on. Life continues, and I'm really going to miss this life. It's time to tell my story. Do I have long enough? Can I get it down on paper, and can I get it right?

POSTSCRIPT

IT HAS BEEN four and a half years since I began writing this book. Meanwhile I have reclaimed my health and have had a relatively easy go at getting well. I'm saving the strange and haunting recovery details for my next book, titled *Kill the Sugar Cannibal*. Currently I'm spending my days writing, raising kids, and working on sculptures. Thanks for allowing me to share my story, and I wish you the best of luck and good health.